VINCENT by Himself

VINCENT by himself

A selection of his paintings and drawings

Edited by Bruce Bernard

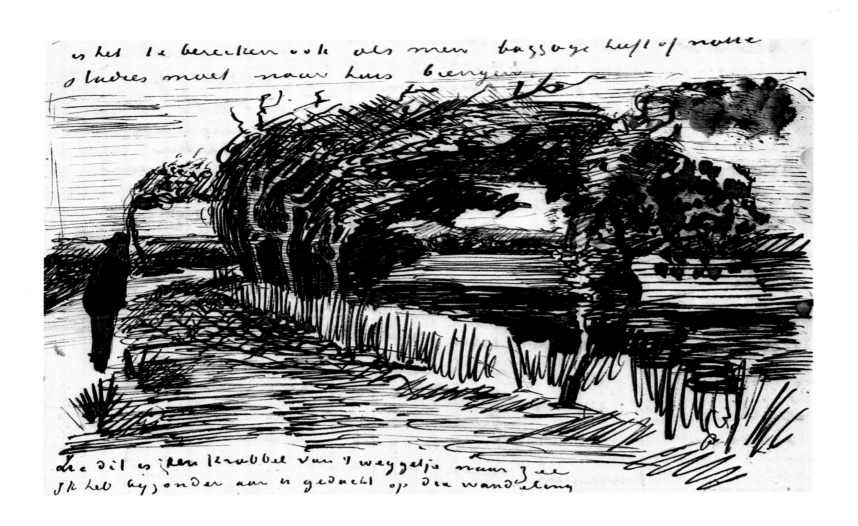

together with extracts from his letters

BCA

LONDON · NEW YORK · SYDNEY · TORONTO

For my brothers, Oliver and Jeffrey Bernard

A Little, Brown Book

© Little, Brown and Company (UK) Ltd
First published in Great Britain in 1985 by Orbis Publishing
Limited, London.

Reprinted 1986, 1987, 1990 (three times), 1991, 1992.

This edition published 1992 by BCA by arrangement with
Little, Brown and Company (UK) Ltd.

British Library Cataloguing in Publication Data

Gogh, Vincent van
 Vincent by himself: a selection of his paintings and
 drawings together with extracts from his letters.
 1. Gogh, Vincent van
 I. Title II. Bernard, Bruce
 759.9492 ND653.G7

ISBN 0-356-14867-X

Filmset by Jolly & Barber Ltd, Rugby
Printed and bound in Italy by Vicenza Bona S.r.l.

Designed by Derek Birdsall RDI

The letter extracts have been taken from *The Complete
Letters of Vincent Van Gogh,* published by New York
Graphic Society Books/Little, Brown and Company.
Reprinted by permission.

Title-page: *Path to the Beach*

Little, Brown and Company (UK) Ltd
165 Great Dover Street
London SE1 4YA

Contents

Introduction

This compilation is intended to offer Vincent van Gogh's host of admirers a relatively simple evocation of his art and his written thoughts, not only about that extraordinary art (and the other artists and writers he admired so much), but also what he felt most keenly about human life – including his own uncertainties and his much threatened but abiding certainty. His letters also vividly describe his material hardships and his painful emotions concerning his family and those who set out to discourage him, as they also intimate his impossible dreams of personal happiness. The point of it all, his painting and drawing, is shown in this book in sections separated from his words so that they can be studied either apart from or in conjunction with each other as the spirit moves.

Vincent's art describes an unprecedented progress over ten years from what we know seemed almost nothing (although now we can value every step of it) to an unsurpassable peak of intensity and originality. There has surely never been such a combination of painful struggle and personally unrewarding triumph in the whole of what we can only call Promethean art. The only other artist to whom Theo could compare Vincent was Beethoven, and after a moment's surprise we can see just what he meant. It seems as certain as anything does that, as with the composer, his work will continue indefinitely to excite the admiration and engage the human sympathies of the widest imaginable audience.

Vincent often saw his extraordinary brother Theo as an equal partner in his production and his letters to him are, in the annals of the great artists, unique in quantity, quality of writing, and scope. Theo was responsible not only for eliciting but also for preserving them as carefully as he preserved the life of the marvellously intelligent and sublimely obstinate man who sent them to him over a period of seventeen years. There has never existed such an entirely indispensable patron and friend in the history of great art of any kind as Theo was, and although the strain broke him as it did Vincent, the body of great work produced provided both Theo's widow and son with a proud vocation as well as enabling Vincent to repay his family, with princely interest, the debt of money that had tormented him so much.

I hope that the way this book has been assembled, with its inevitable imperfections of selection, will give readers a clear and uncomplicated way of considering Vincent's work and life and that it will provoke in them an even stronger desire to look at the actual pictures and read the complete letters, as well as the books which convey the information and speculations that this one could not set out to offer.

Bruce Bernard

A brief account of Vincent's life

GROOT ZUNDERT – BRUSSELS 1853–1881

Vincent Willem van Gogh was born on 30 March 1853 at Groot Zundert, a small village near the Belgian border. His father, Theodorus, a pastor of the Reformed Church, was a conscientious and conventional man who never came to understand his difficult son. His mother was Anna Cornelia Carbentus, a well respected and strong character, who nevertheless had hardly any more sympathy with Vincent's temperament and aspirations than had her husband. The family eventually consisted of three boys and three girls. Vincent was the eldest, although he had been born a year to the day after the still-birth of his parents' first child who had also been named Vincent Willem, a most curious circumstance and surely an unquantifiable influence on his view of himself. His younger brothers were Theodorus (Theo) and Cornelius (Cor) and his sisters were Anna, Elizabeth and Wilhelmina (Wil).

Vincent was a taciturn boy who smiled rarely and was often bad tempered. But he had a passion for nature – birds, insects, plants and flowers of which he made careful studies occasionally until the last weeks of his life and this interest shows itself in varying degrees throughout his entire work. A few of his childhood drawings survive; they bear witness to his future preoccupations but are otherwise undistinguished.

Vincent went first to his local village school, later to a private boarding school and finally to high school, without either achieving distinction or suffering disgrace. On leaving the last in 1869, for reasons which are not known, his uncle Vincent, an art dealer, found him a position as a clerk at the Goupil Art Gallery in The Hague under the supervision of H. G. Tersteeg, a man eight years older than Vincent. Tersteeg's disdain of Vincent's later efforts as an artist was to sadden him particularly, but for some time he did very well in his employer's eyes and in 1873 he was sent to the London branch of the gallery. While in The Hague he had been visited by his younger brother Theo, the only member of his family with whom he could feel in any way at ease, and they had sworn an oath of lifelong friendship, which neither of them ever forgot.

In London his passion for pictures grew and he formed an intense interest in British literature and art, particularly in the black and white illustrators of English magazines such as *The Graphic*. He also became a fluent speaker of English. He lodged at a house identified only very recently (1977) as 87 Hackford Road, Lambeth (page 17), where he was very happy until his intense love for his landlady's daughter Eugenie (formerly thought to be called Ursula) was rejected. This had a crushing effect on his morale as well as making him aware once more of an underlying discontent with his whole life and work. His performance at the gallery suffered and in October 1874 he was transferred to Paris. After a brief

return to London, he was posted permanently to Paris in May 1875. Eleven months later, however, in April 1876, he was dismissed. It seems certain that he had revealed the obstinate side of his character and was no longer able to conceal his impatience with customers whose judgment he did not respect. Later, when at odds with Theo, he would harshly reproach him for conforming to the necessities of the profession that he had entered in his turn, adapting himself to it much more readily than Vincent had succeeded in doing.

Not knowing what to do next (Theo had suggested that he might become a painter), in mid-April Vincent willingly took a job as a teacher in Ramsgate, where, in spite of being paid no salary and sleeping in a bug-infested room, he seemed relatively content. Vincent's preoccupation with religion was growing fast — indeed, assuming an almost fanatical character. In July 1876 he took up the offer of a position as an assistant from a Methodist minister, the Rev. Mr Jones of Isleworth. He very soon preached sermons at Turnham Green, Petersham and elsewhere in the district and the sense of triumph and fulfilment that this afforded him is eloquently expressed in his letters to Theo. In early 1877, however, he returned to Holland, where he worked in a bookshop in Dordrecht. There he attended churches of all the denominations and spent as much time writing sermons and copying passages from the Bible as he did working in the shop. This was reported of him by someone who shared lodgings with him there and liked him very much for his personal qualities.

In May 1877 he began preparations for the entrance examinations to the faculty of theology at the University of Amsterdam. Despite his evident talent for languages, however, Latin and Greek seemed irrelevant to his urgent sense of vocation. In August 1878 he went to Brussels instead on a much shorter course that would enable him to become a lay preacher. A fellow student in Brussels wrote of his warm-heartedness punctuated by irascibility and also of his passion for self-denial and mortification. After three months Vincent was told he had failed the course but he managed to get himself sent to the Belgian coal-mining district of the Borinage near Mons as a lay preacher. At Wasmes, where he was based between January and July 1879, his self-denial became something like a mania. He gave everything away, including nearly every article of his clothing, and slept in an outhouse on straw, provoking his sponsors to withdraw their support on the grounds of his undeniably poor talent as a public speaker — though it must really have been because the state of uncleanliness and raggedness to which he had reduced himself seemed to them entirely improper in a man of his vocation.

So, in August, he moved to nearby Cuesmes and continued his extraordinary ministry on his own, giving away the little money he was sent from home and hardly eating. Although he finally admitted the exhaustion of his religious passion, he had made a deep impression on some of the miners' families and had endured for nearly two years a life which might well have killed many others. He had done many drawings meanwhile, some painfully clumsy but also energetic and poignant (page 26), and others, like the houses in Cuesmes (page 23), showing the beginnings of a truly judicious draughtsmanship that was the foundation of his art in all its manifestations.

In October 1880, when he returned to Brussels, Rembrandt, Millet and several other painters were gradually taking the place of Christ and the Saints in his mind. He continued drawing there, meeting and working with Anthon van Ridder Rappard, a painter with private means who became one of the few close artist friends Vincent made during his life, but with whom he eventually quarrelled. He stayed in Brussels for six months, possibly working at the Academy there for a short time, but eventually coming to think that for his work's sake he should go home to Etten, where his parents had moved to over five years before. He also certainly needed a degree of reconciliation with his family, particularly with his parents.

ETTEN April 1881–December 1881

Vincent worked hard and systematically at Etten, making primitive but increasingly proficient and always remarkable drawings — copies from Millet and portraits of local people, gardeners and peasants at work or at the fireside and also one or two interesting and remarkably accomplished landscapes. He used water-colour washes and body colour sparingly; although he experimented with oil paint, he was determined that he should first become a draughtsman. The idea of making money by drawing for magazines like many of his mostly British heroes did not leave him entirely for a long time. He sought and was given encouragement by Anton Mauve, a successful painter of The Hague school related to his mother, and by H. G. Tersteeg, under whom he had formerly worked. In the summer a happy or at least hopeful time was threatened by Vincent's hopelessly unrequited love for his widowed cousin Kee Vos, who had come to stay at Etten. At first they became very friendly but she fled back to Amsterdam as soon as he had declared himself. He followed her, using money given him by Theo, but was prevented — with her whole-hearted agreement — from seeing her again.

Back in Etten his relations with his parents deteriorated rapidly and he left for The Hague following a furious argument with his father after refusing to attend church on Christmas Day.

THE HAGUE December 1881–September 1883

Vincent's leaving Etten marked the beginning of his almost complete dependence on Theo, although at first he also found Mauve very willing to help him and even Tersteeg not unsympathetic. He took a room and started work straight away, eagerly accepting Mauve's advice. In January 1882, in his search for models, Vincent met Clasina or Christine Hoornik (called Sien by Vincent), an occasional prostitute older than himself, unwell and addicted to drink. He became determined to save her from her wretchedness and ill-health and he made many drawings of her – notably 'Sorrow' (page 82), one of his earliest truly personal works. He set up house with her and did not conceal the fact from anyone. It much distressed his father and worried Theo, as well as helping to alienate Mauve and Tersteeg, who not only had doubts about his talent (Tersteeg particularly), but also found him uncouth and intractable. This saddened him immeasurably, although no discouragement could stop him working. In July 1882 Christine gave birth to a boy who it has recently been suggested was Vincent's. This is most unlikely, but his devotion to the child, whom he later wrote of as 'my little boy', was an intense one. His letters give us a glimpse of a real if very brief period of domestic happiness which was never to recur for him. Quite soon, however, Vincent was both hurt and indignant when Theo had to warn him that the family were considering having him committed to an asylum, no doubt influenced by Tersteeg's opinion that he was actually mad.

All this time, though, he had made great progress in his work, producing some beautiful drawings of landscapes, 'orphan men' from the almshouses, some townscapes and the coast at Scheveningen. He had also begun to paint in earnest with oils and with great promise for the future. But his relations with Christine deteriorated as she seemed to revert to her former life under the influence of her mother and he realized that he would have to leave her – though with real reluctance and with his concern for her and her little boy undiminished.

DRENTHE September–November 1883

In September 1883, to the relief of Theo and his parents, Vincent broke with Sien and went off to the remote peat fields of Drenthe in the north of Holland, which he had been attracted to by Van Rappard's account of the landscape and the harsh simple life of the peasants there. He was not disappointed with the look of the place and made some very interesting and elegiac drawings and small paintings there (many works do not survive). A kind of perversity arising from his dependence on Theo made Vincent suggest to him

that he should give up his job and become an artist too. Although one can believe that he thought Theo had it in him, it would of course have been a disaster for them both.

The loneliness and isolation were too much for Vincent after The Hague, and he soon realized that it would probably be best for Theo as well as himself if he tried to work at home in Nuenen, where his family had recently moved. Drenthe had confirmed his feeling, though, that it was the life of the fields that he wanted to paint rather than that of the city or shore, and he entertained hopes of returning there.

NUENEN December 1883–November 1885

At Nuenen, Vincent's relations with his parents didn't improve. They regarded him, he wrote to Theo, as they would a barking dog with wet paws, a 'foul beast' unfit for the house. But he also came to feel that Theo was letting their partnership down and harried him with questions about his position in the art trade and his lack of faith, as a dealer, in Vincent's own pictures. He saw him for a time as a 'van Gogh', a term that represented what Vincent had come to dislike most about his father and uncles; his hostility to these qualities was the main reason he signed his work with only his Christian name.

But he steadily worked out of doors, in weavers' cottages and in the wash house that had been allowed him as a studio, making rapid progress towards his first great drawings and paintings.

In August an unhappy woman complicated his life for a time at Nuenen. She was Margo Begemann, the only woman ever known certainly to have been in love with him and who attempted suicide because of her respectable family's opposition to their friendship – and also no doubt because of Vincent's less than whole-hearted response to her feelings – although the question of marriage did arise. He seems to have behaved towards her with honour and sympathy.

Occasionally he visited Eindhoven, where he gave lessons to some amateur painters and made friends with them. He also made some oil sketches for a goldsmith living there, who commissioned them in order to paint panels from them himself for his dining-room. He may have paid Vincent with some paint but certainly gave him no money. Vincent also tried taking piano lessons in an attempt to correlate musical harmony with Delacroix's theories of colour, which were to become of central importance to his art. He had conceived a passion for Wagner of a kind his teacher could not understand and the lessons were not pursued for long.

The many studies in oils he had been making of peasants' heads were to lead to 'The Potato Eaters' (page 115), a work which is now widely recognized as the summation of Vincent's

artistic faith at the time. However, its audacity and intelligence were not recognized by Van Rappard, whose comments, made with insensitive candour, sadly brought the friendship between the two artists to an end.

In March 1885 Vincent's father died suddenly of a stroke and it must have affected Vincent deeply and also provoked feelings of guilt. A few months later, by way of tribute, he painted a still-life that was both ironic and ambivalent: a large open Bible and a copy of *Joie de Vivre* by Zola (page 129), whose novels Vincent loved and his father had abhorred.

Soon after his father's death, Vincent rented two rooms from a verger of the local Catholic church. He worked and slept there, only joining his family for meals. He continued to paint with great industry, also making the black crayon drawings of peasants at work, which are as great in their way as the later ones made with the reed and steel pen at Arles and St Rémy. He also visited the Rijksmuseum in Amsterdam, where the paintings of Frans Hals and Rembrandt affected him more deeply than ever.

In November 1885, after some trouble with groundless innuendos concerning the pregnancy of one of his peasant models, Vincent was given notice to quit his studio. It now seemed high time for him to leave Nuenen so he went to Antwerp, as he had often wanted to, leaving a quantity of work behind him which was eventually destroyed or sold for a few cents in the market place at Breda and mostly lost for ever. Vincent never set foot in Holland again.

ANTWERP November 1885–February 1886

In Antwerp Vincent was much stimulated by the liveliness of the docks and dance halls. He took a small room (where he pinned up some of the Japanese prints that were to have so much influence on him) and cherished hopes of painting portraits or at least tradesmen's signboards for money.

He also went to see the great pictures there and was newly impressed by Rubens, particularly in the way he painted flesh. This can be clearly seen in the few portraits that survive of this period. As he could not afford to pay any models he enrolled in the Antwerp Academy and soon astounded his fellow pupils by the boldness and rapidity of his drawing. Some sense of a new approach is evident though, and his drawings of hands, for instance, although they bear his unmistakable stamp, do not quite compare in quality with the extraordinary ones he had made at Nuenen. His teachers were not impressed and the man who had already proved himself one of the great European draughtsmen was relegated to the elementary course, fortunately not until after his sudden departure for Paris.

For some time he had been intimating his desire to join Theo in Paris but his brother had been evasive and obviously wanted to postpone the move. Vincent arrived without warning though, announcing himself with a note sent by hand from the Gare du Nord. It invited Theo to meet him in the Louvre to talk things over.

He had been feeling very ill in Antwerp and had lost several of his teeth. But he never admitted in writing to Theo that while there an advanced stage of syphilis had been diagnosed. It puts all his later illness and nervous attacks in Arles and St Rémy in a different perspective as well as his passionate resolution to work as hard and as quickly as he could in the last years of his life. In Antwerp he had painted an extraordinary picture of a skeleton smoking a cigarette (one wonders why it is not Vincent's own pipe instead), which seems like a most bitter complaint against all his physical and nervous suffering.

PARIS March 1886–February 1888

Vincent's stay in Paris naturally brought his correspondence with Theo to an end until he resumed it from Arles. From the Paris period there are three letters to his brother, when Theo visited Holland, and a few to other friends, so much less is known about his life in the capital than elsewhere. The two brothers moved into a large apartment together in Montmartre and Vincent started studying at the famous studio run by Fernand Cormon, where he stayed only three or four months. He was reported by his future brother-in-law Andries Bonger to be continually quarrelling with everyone and Theo confirms this. Relations between the brothers became strained to breaking point and only improved to a state of unprecedented harmony towards the end of Vincent's stay in Paris. But it is also evident that he impressed many of the painters there. Seurat, Pissarro, Émile Bernard, Anquetin, Lautrec, Signac, Gauguin – all seem to have been well disposed toward him, and Lautrec produced a very striking and sympathetic portrait of him in pastel. He made extraordinary progress in Paris and the pictures he painted there range from essays in basic Impressionism (although always unequivocally his own) to a more personal form of divisionism and astonishingly radical adumbrations of the style and key of his later work in Arles, St Rémy and Auvers. He also painted many very interesting self-portraits in a wide stylistic range. Although he exhibited pictures in cafés and Père Tanguy's colour shop, he is not known to have sold any of his work for money.

It has been said that Lautrec suggested to Vincent that Arles would be a good place for him to go to but it is certain that he had felt the pull of the South for a long time before he left and he had mentioned it in a letter eighteen months before.

It is evident that he worked furiously as always in Paris

but he also taxed his strength when not at work, reducing himself before his departure to a state of acute physical distress with absinthe and an erratic diet, no doubt assisted by his grievous ailment. Curiously the last self-portrait from Paris (page 171), although of deathly pallor, is perhaps the most sanguine in mood of all of them.

ARLES February 1888–May 1889

Vincent, as has often been told, arrived on 20 February 1888 at an Arles blanketed in snow. He took a room at the Hotel-Restaurant Carrell and two days later bought some paint and started work. During the first month before the spring weather arrived he painted a portrait and some landscapes and still-lifes. His letters to Theo at this time show how he had sublimated his once passionately declared desire to sell his own work in a more active and unequivocal one to help sell his friends' pictures in London and, curiously and compulsively, through his old tormentor Tersteeg in The Hague.

As soon as the orchards came into blossom at the end of March Vincent set to work in them with great enthusiasm, producing at least ten canvases within three weeks. While doing so he heard of the death of Mauve, his ultimately dismissive mentor in The Hague. Despite Mauve's former attitude towards him, Vincent was deeply moved and inscribed a picture of two peach trees to him (page 217) which he sent to Theo for Mauve's widow.

In May he rented the famous Yellow House, which was in very bad condition, and shortage of cash meant he was unable to make it habitable until September. After a dispute with the Hotel Carrell about money (he was later judged to be in the right) he went to the Café de la Gare, where he stayed until he could move in. The proprietors of the café, named Ginoux, became his friends and Mme Ginoux was the subject of the 'L'Arlésienne' portraits (page 293).

Vincent soon started making the drawings mostly with a reed pen that were to become such an important part of his work in Arles and St Rémy, and which aroused Theo's very positive enthusiasm. He also made an expedition to Les Saintes-Maries-de-la-Mer on the Camargue, where he stayed for five days, producing two canvases and making drawings from which, on his return, he produced paintings of fishing boats and houses (pages 224, 225, 226 and 227). He worked on through an uneven summer, often plagued by the Mistral, the cold and violent wind of Provence. He painted harvest scenes and made portraits of two Zouaves (colonial troops), one of them a concupiscent 2nd lieutenant called Milliet (page 187), who liked to draw and became a good friend, later delivering a consignment of Vincent's paintings to Theo in Paris.

On 29 June, after lengthy efforts at persuasion, he was delighted to hear that Gauguin was prepared to share the Yellow House with him. Gauguin's arrival was delayed until 23 October, and by then Vincent had done a great deal of work. Apart from landscapes, he had painted the famous 'Night Café' (page 244) and several notable portraits – of a young girl called 'The Mousmé' (page 236), of the peasant Patience Escalier (page 239) and of Joseph Roulin, the post office official who proved a touchingly faithful friend during Vincent's later crisis (pages 237 and 261). He had also painted pictures of sunflowers and the 'Poet's Garden', a view of the public gardens by the Place Lamartine (pages 245, 246 and 247) for the decoration of the house in honour of Gauguin. Vincent also wanted other painters to come and stay there later for either a length of time or *en route* for Africa or other tropical places, where he felt the future of painting lay. During this time of phenomenal activity his state of health was often very poor; although he sometimes resolved to work less for his own good, he could only stop when virtually incapable. Gauguin's arrival raised his spirits and during bad weather unsuitable for painting outside he found it possible to work from memory indoors in Gauguin's company, something that he wrote he could not have done on his own. One or two of the pictures bear an unmistakable sign of Gauguin's presence but it seems that underneath Vincent's welcoming of the advice that his admired friend so freely dispensed, his influence disturbed the inner certainty, so powerful and yet so vulnerable, which had always kept him going. He never really believed, for himself, in working from anything else but life.

Gauguin stayed at the Yellow House for two whole months and until December the relationship of the painters seemed amicable enough. However, heated arguments began to take place and on 14 December Gauguin wrote to Theo that he would have to return to Paris because of 'temperamental incompatibility' with Vincent. He withdrew the threat four days later, dismissing the episode as a 'bad dream', but there were soon more violent arguments. Finally, according to Gauguin, Vincent approached him with an open razor in his hand but was repelled by a steady stare. That evening, after Gauguin had retreated to an hotel, Vincent cut off the lower part of his left ear with the same razor and delivered it at 11.30 pm to a prostitute named Rachel in a nearby brothel with the words, 'Keep this object carefully.' He then went home to bed.

On the next day, Christmas Eve, he was found, by the police, apparently close to death and taken to hospital, where Dr Felix Rey attended him. Theo, whom Gauguin had summoned by telegram, arrived, greatly upset, from Paris. Two days later he returned, probably with Gauguin, almost resigned to Vincent's imminent death, 'but my heart breaks when I think of it', he wrote to Johanna Bonger,

sister of Andries, to whom he was about to become engaged.

Vincent had several crises during the next week and was visited by Mme Roulin. But Joseph, her husband, was not allowed to see him for nearly another week until on 4 January they went to the Yellow House together. They stayed there for some hours, Vincent seeming entirely recovered and very pleased to see his canvases again. He started painting on 8 January and before the end of the month had completed some remarkably serene pictures (pages 262 and 263) including two replicas of his earlier 'Sunflowers', one of which perhaps surpasses all the others (page 259). He also painted two memorable self-portraits with his ear bandaged (page 257) and a portrait of the friendly Dr Rey. On 7 February, however, he was taken back to hospital for ten days suffering from delusions of being poisoned and hearing voices. On his release, thirty citizens of Arles petitioned the mayor to send him home to his family or to an asylum, and he was ordered to hospital, to be isolated in a cell without tobacco, books or paint. The Yellow House was bolted and barred. Fortunately the hospital staff did not regard him as just a madman, but the privation and sense of being punished must have been immensely disheartening for him.

The painter Signac visited him on 23 March and they both managed to break into the Yellow House, where Vincent presented the young artist with a picture. Signac afterwards wrote to Theo: 'I found your brother in perfect health, mentally and physically.' Soon Roulin visited him for the last time before moving to Marseilles, and most of the pictures, many of which had suffered from the damp, were sent to Theo. Vincent, not feeling capable of fending for himself again in Arles, had decided of his own free will to go to the asylum at nearby St Rémy, which had been found for him by a friendly Protestant pastor, Dr Salles, who took him there on 8 May.

During his stay at Arles, which lasted 444 days, Vincent had painted something like 200 paintings and made over 100 drawings. He had also written 200 letters. Even under ideal circumstances this would have been a quite phenomenal output.

ST RÉMY May 1889–May 1890

'. . . when I took my leave of him he thanked me warmly and seemed somewhat moved, thinking of the new life he was going to lead in that house,' wrote Dr Salles to Theo. That life was going to be a mixture of great loneliness, more extended and painful nervous attacks and the production of some pictures unsurpassed in his whole œuvre. Vincent had certainly made the right decision for his art, as it is impossible to imagine him having produced as many pictures of such

beauty and intensity anywhere else under the circumstances.

He was given two cells, one for sleep and one for work and he started painting straight away – producing some pictures of great power that convey an intense exhilaration, wonderfully contained by his own kind of serenity (pages 264, 265 and 266). Initially he was afraid to leave the hospital or its garden and for a time contented himself with painting and drawing the view from his window (leaving out the bars). In June he painted 'The Starry Night' (page 269), an extraordinary leap of imagination, which again combined calmness with a sense of ecstasy. The cypress, for which he had conceived an intense love, seemed to become a symbol of dark immutable principle compared with the combative but beleaguered energy expressed by his olive trees.

Vincent was soon struck down again by an attack which lasted about six weeks, keeping him indoors for two whole summer months. He was unable to work while it lasted but when he came out of it he painted two remarkable self-portraits, some marvellously sunlit visions of harvest scenes after woodcuts by Millet (pages 280, 281 and 289) and a version of a Pietà by Delacroix. In October he could work out of doors again.

On 22 October, Theo sent Vincent a copy of an article on him – the first ever printed – by a painter friend of Theo, J. J. Isaacson. It was fulsome in a manner seldom met with today and the artist was described as 'this remarkable hero . . . a solitary painter, he stands alone struggling in the dark night, his name, Vincent, is for posterity.' It gave its subject at least as much anxiety as pleasure and it seems clear he had lost any real desire for public success or recognition some time before. In his condition it could have interfered with his work rather than helped it and his indebtedness to Theo was too mountainous by now to imagine any meaningful reduction of it.

Theo sent 'The Starry Night' and the 'Irises', painted in May, to the Salon des Indépendants. They aroused both interest and bewilderment. Soon afterwards he sent six canvases to be shown with an exhibiting group, Les XX, in Brussels, where they created a minor sensation. One of them, 'The Red Vineyard', was sold to Anna Boch, the sister of Eugène Boch, a Belgian artist friend whom Vincent had painted in Arles. Vincent was very gratified by this, particularly as she was a painter. He then had two more short attacks, continuing to work between them. When in the grip of an attack, Vincent had a dangerous impulse to swallow paints and drink kerosene.

On 31 January Theo's wife gave birth to a boy, who was named Vincent Willem. Vincent protested anxiously that they should have named it after their father and then painted some branches of almond in blossom (page 209) for the child's nursery, a picture on which he worked hard and one he was very pleased with. Soon he received another

article about himself printed in the *Mercure de France* and written by the critic Albert Aurier. It was a bold and indeed courageous piece, which is full of interest as a record of one of the two very early announcements of Vincent's Pyrrhic victory, and the following prediction is intriguing: 'This robust and true artist, with the brutal hands of a giant, with the nerves of an hysterical woman, with the soul of a mystic, so original and so alone in the midst of the pitiful art of our time, will he experience some day – anything is possible – the joy of rehabilitation, the repentant cajoleries of fashion? Possibly. But whatever happens, and even if it should become fashionable, as is very unlikely . . . I do not think that much real sincerity will ever enter into the belated admiration of the public at large . . . he will never be understood except by his brothers, the true artists, and the happy ones among the little people, the very little people.'

Vincent seems to have been pleased with it but, in a letter to the writer, protested that he had overestimated the quality of his work and that Monticelli and Gauguin were much more important than himself. He then added two figures to a remarkable painting he had recently made of cypresses (page 274) and sent it to Aurier as a token of his appreciation.

Vincent then painted at least five portraits from a Gauguin drawing of Mme Ginoux ('L'Arlésienne', page 293) of his old café in Arles, to whom he had written and about whose health he was worried. He was allowed to make the journey there by himself to give her one of the pictures but failed to return in the evening and an attendant who was sent to look for him found him wandering about in a helpless condition. He had entered his longest phase of acute illness but this time he produced some work before it was over. It consisted of several very striking paintings and drawings which he called 'Memories of the North' (pages 294 and 295), all with a curious pathological aspect. One painting is of thatched cottages with cypress trees (in the South there is no thatch and in the North there are no cypresses). The drawings are of peasant subjects and have great incisiveness while being curiously obsessive and sometimes (for example, page 294) seeming to overfulfil his much earlier achieved ambition to represent active physical work convincingly.

When Vincent finally recovered, he pleaded with Theo to get him moved to the country near Paris, writing that he was 'overwhelmed with boredom and grief'. So the kindly Pissarro, who greatly admired Vincent's work, easily persuaded Dr Gachet of Auvers-sur-Oise, a friend of many painters, to keep an eye on him if he came to live nearby.

On 16 May Vincent left the asylum, having during his last fortnight of work produced eleven pictures of marvellous quality (see, for example, pages 298 and 299). He took the train to Paris, where his anxious sister-in-law was amazed to greet such a cheerful and healthy-looking man.

AUVERS-SUR-OISE 21 May–29 July 1890

Vincent stayed with Johanna and Theo in Paris for three days, inspecting with great interest the hundreds of his works which crammed the apartment. The atmosphere was cheerful, despite underlying anxiety, and Vincent took great pleasure in seeing his nephew and godson. But the noise of Paris troubled him and he wanted to move on to his next place of work.

He liked Dr Gachet at once but also got the impression that he was probably as nervously unstable as himself. He also liked the look of Auvers, particularly the thatched roofs, which he had always loved and not seen for four and a half years. He took a room at a café run by the Ravoux family only five minutes walk from the doctor, and visited him regularly, taking a keen interest in his collection of mainly Impressionist paintings and working in his garden. Before a month was out he had painted Gachet's portrait (page 301), one of his best, 'with the broken-hearted expression of our time', he wrote to Gauguin. He also painted the doctor's daughter, Marguerite, at the piano (page 303) as well as Adeline Ravoux. There is some evidence that Marguerite fell in love with Vincent and that his death affected her profoundly.

His work in Auvers was as uneven as his spirits were. He had moments of profound pessimism and could see no future for himself but on occasions he cheered up and worked as well as ever. When Theo and Johanna brought little Vincent to see him he took great pleasure in showing the uncomprehending baby all the animals in the nearby farmyard and presented him with a bird's nest. He also at one time thought about an exhibition in Paris (although only in a café) and even of travelling abroad with Gauguin. But he easily became downcast by Theo's worries about his relations with his employers and could not be reassured. He made one visit to Paris, where Theo had invited Lautrec and Albert Aurier among others to see him. Although he enjoyed their company, he left very suddenly as if the strain had been too much for him. But he worked tirelessly in Auvers and painted one picture for every day he spent there as well as making drawings, one or two of which share the odd and disturbing quality of those done from memory during his crisis at St Rémy. He also drew a few plants (page 305), which with their humble accuracy remind us what a naturalist Vincent had always been at heart and made other drawings of an unprecedented near gaiety (pages 310 and 311). He painted several great landscapes; particularly haunting are the long shallow ones of his last weeks. The symbolism understandably felt in the 'Wheat Field under Threatening Skies with Crows' (page 318) has made it overshadow its companions, such as the view of Auvers in the rain (page 312) and 'Wheat Field under Clouded Skies' (page 314). In a strange sentence he

seems to contradict himself, writing of attempting to express 'sadness and extreme loneliness' and hoping that the same pictures convey 'the health and restorative forces that I see in the country', although perhaps he was thinking of other canvases, such as 'Wheat Fields' (page 316).

In later July his despair was eating at him relentlessly and he picked a quarrel with Dr Gachet over not having framed a picture by Guillaumin in his possession, threatening him in a way very reminiscent of his behaviour at his last meeting with Gauguin in Arles. Theo wrote in distress to Johanna, who was visiting Holland: 'I have had a letter from Vincent which seems quite incomprehensible; when will there come a happy time for him? He is so thoroughly good.'

On Sunday, 27 July, he lunched with the Gachets but left the table suddenly as if to get back to work and that evening he failed for the first time to turn up to supper with the Ravoux. After they had finished theirs they saw him striding unsteadily towards the house. When Mme Ravoux asked him solicitously about his absence he said, 'Oh nothing. I am wounded,' and went upstairs to his room. Her husband followed him soon after and Vincent, who was in bed, showed him the gunshot wound on his chest. 'I shot myself . . . I only hope I haven't botched it,' he said. Dr Gachet was sent for and, when he arrived, while Vincent puffed at his pipe, his friend tried to raise his hopes for a new recovery. But Vincent just said: 'I will do it all over again.' On Theo's arrival from Paris, the slowly dying man tried to comfort him, saying, 'Don't cry. I did it for the good of us all.' When Theo tried to convince him of his good chances of survival he simply said, 'La tristesse durera' (There is no end to sadness). He asked Theo's forgiveness for all the trouble and expense he had caused him and he died in his arms at about one o'clock in the morning on Tuesday, 29 July 1890.

Vincent's brother died quite broken in spirit and health six months later, but Johanna lived on long enough to translate Vincent's letters to him with devotion, and to see her brother-in-law acknowledged as a major artist. During his long lifetime, her son saw Vincent become an historical figure of the first magnitude. In 1973 he presided at the opening of the spacious Rijksmuseum van Gogh in Amsterdam, not far from another museum which houses great Dutch pictures. Among them is a Frans Hals that nearly ninety years before had seemed such a revelation to an unkempt and seemingly impossible Dutchman, and also Rembrandt's great and tender 'Jewish Bride', which he once told a friend he could have looked at for a whole fortnight and that it seemed painted 'with a hand of fire'.

Finding the vocation

To Theo . . . I am very busy just now at the beginning of the year.

My new year began well: my salary was raised 10 guilders, so that I now earn 50 guilders a month, and in addition I got 50 guilders as a present. Isn't that splendid! I hope now to be able to shift for myself. . . .

*

. . . Theo, I strongly advise you to smoke a pipe; it is a good remedy for the blues, which I happen to have now and then lately. . . .

*

. . . Thanks for your letter. I wish you a happy New Year with all my heart. I know that you are doing well at The Hague, for I heard it from Mr Tersteeg. From your letter I see that you take a great interest in art; that is a good thing, boy. I am glad you like Millet, Jacque, Schreyer, Lambinet, Frans Hals, etc., for as Mauve says, 'That is *it*.'

Yes, that picture by Millet, 'The Angelus', that is *it* — that is beauty, that is poetry. How I should like to talk with you about art; instead, we must write about it often. *Admire* as much as you can; *most people do not admire enough*. The following are some of the painters whom I like especially: Scheffer, Delaroche, Hébert, Hamon, Leys, Tissot, Lagye, Boughton, Millais, Thijs [Matthijs] Maris, De Groux, De Braekeleer Jr, Millet, Jules Breton, Feyen-Perrin, Eugène Feyen, Brion, Jundt, Georg Saal, Israëls, Anker, Knaus, Vautier, Jourdan, Compte-Calix, Rochussen, Meissonier, Madrazo, Ziem, Boudin, Gérôme, Fromentin, Decamps, Bonington, Diaz, Th. Rousseau, Troyon, Dupré, Corot, Paul Huet, Jacque, Otto Weber, Daubigny, Bernier, Émile Breton, Chenu, César de Cock, Mlle Collart, Bodmer, Koekkoek, Schelfhout, Weissenbruch, and last but not least Maris and Mauve. But I might go one like that for I don't know how long. Then there are the old masters, and I am sure I have forgotten some of the best modern ones. . . .

*

To Mrs C. Van Stockum-Haanebeek . . . I live a rich life here 'having nothing yet possessing all.' At times I am inclined to believe that I am gradually turning into a cosmopolite; that is, neither a Dutchman, nor an Englishman, nor yet a Frenchman, but simply a *man*. . . .

*

To Theo . . . There are beautiful things in the Royal Academy this year. Tissot has three pictures there. Lately I took up drawing again, but it did not amount to much. . . .

*

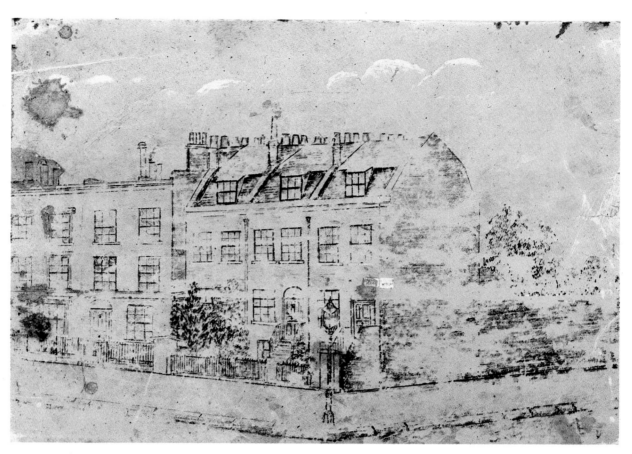

THE LOYERS' HOUSE, LONDON (HACKFORD ROAD)

. . . I am glad you have read Michelet and that you understand him so well. Such a book teaches us that there is much more in love than people generally suppose.

To me that book has been both a revelation and a Gospel at the same time: 'No woman is old.' (That does not mean that there are no old women, but that a woman is not old as long as she loves and is loved.) And then such a chapter as 'The Aspirations of Autumn' – how beautiful it is.

That a woman is quite a different being from a man, and a being that we do not yet know – at least, only quite superficially, as you said – yes, I am sure of it. And that man and wife can be one, that is to say, one whole and not two halves, yes, I believe that too.

. . . Since I have been back in England, my love for drawing has stopped, but perhaps I will take it up again some day or other. I am reading a great deal just now. . . .

*

. . . Don't regret that your life is rather easy; mine is too.
I think that life is pretty long and that the time will come soon enough when 'another shall gird thee, and carry thee whither thou wouldest not.' . . .

*

. . . I don't know whether I have already written to you about it or not, but there has been a sale here of drawings by Millet. When I entered the hall of the Hotel Drouot, where they were exhibited, I felt like saying, 'Take off your shoes, for the place where you are standing is Holy Ground.' . . .

<p style="text-align:center">*</p>

. . . You know the etching by Rembrandt, 'Burgomaster Six', standing reading before the window? I know that Uncle Vincent and Uncle Cor are very fond of it, and I sometimes think they must have resembled him when they were younger. You also know the portrait of Six when he was older. I think there is an engraving of it in the gallery at The Hague. His life must have been beautiful and serious.

<p style="text-align:center">*</p>

. . . A feeling, even a keen one, for the beauties of nature is not the same as a religious feeling, though I think these two stand in close relation to one another. Almost everybody has a feeling for nature – some, more; some, less – but a few feel that God is a spirit and whoever worships Him must worship Him in spirit and in truth. . . .

<p style="text-align:center">*</p>

. . . Father wrote to me once, 'Do not forget the story of Icarus, who wanted to fly to the sun, and having arrived at a certain height, lost his wings and dropped into the sea.' You will often feel that neither you nor I are what we hope to become someday, that we are still far beneath Father and other people, and are wanting in stability, simplicity and sincerity. One cannot become simple and true in one day. But let us persevere, *above all, let us have patience; those who believe hasten not*. Still, there is a difference between our longing to become real Christians and that of Icarus to fly to the sun. I think there is no harm in having a relatively strong body; take care to feed yourself well, and if sometimes you are very hungry – or rather have an appetite – eat well then. I assure you that I often do the same, and certainly used to. Especially bread, boy, 'Bread is the staff of life' is a proverb of the English (though they are very fond of meat too, and in general take too much of it).

And now write me soon, including things about everyday life. Keep up your courage and give my compliments to everybody who asks after me; within a month or two I hope we shall see each other. With a firm handshake. . . .

<p style="text-align:center">*</p>

. . . I have not written to you since we saw each other; in the meantime something happened to me that did not come quite unexpectedly. When I saw Mr Boussod again, I asked him if he approved of my being employed in the house for another year, and said that I hoped he had no serious complaints against me. But the latter was indeed the case, and in the end he forced me, as it were, to say that I would leave on the first of April, thanking the gentlemen for all that I may have learned in their house.

When the apple is ripe, a soft breeze makes it fall from the tree; such was the case here; in a sense I have done things that have been very wrong, and therefore I have but little to say. . . .

<p style="text-align:center">*</p>

To his father and mother

. . . At dawn the next morning on the train from Harwich to London it was beautiful to see the black fields and green meadows with sheep and lambs and an occasional thornbush and a few large oak trees with dark twigs and grey moss-covered trunks; the shimmering blue sky with a few stars still, and a bank of grey clouds at the horizon. Before sunrise I had already heard the lark. When we were near the last station before London, the sun rose. The bank of grey clouds had disappeared and there was the sun, as simple and grand as ever I saw it, a real Easter sun. The grass sparkled with dew and night frost. But I still prefer that grey hour when we parted. . . .

*

To Theo

. . . Many happy returns, my best wishes for this day; may our mutual love increase with the years.

I am so glad that we have so many things in common, not only childhood memories, but also that you are working in the same house as I did until a short time ago and know so many people and places that I do and that you have so much love for nature and art. . . .

*

. . . There is such a longing for religion among the people in the large cities. Many a labourer in a factory or shop has had a pious childhood. But city life sometimes takes away the 'early dew of morning'. Still, the longing for the 'old, old story' remains; whatever is at the heart's core stays there. In one of her novels Eliot describes the life of factory workers who have formed a small community and hold their services in a small chapel in Lantern Yard; she calls it the 'kingdom of God on earth' – no more and no less. There is something touching about all those thousands of people crowding to hear these evangelists. . . .

*

. . . Do not be unhappy about your 'luxurious' life, as you call it; go quietly on your way. You are more simple-hearted than I am, and probably you will succeed sooner and to a greater extent. . . .

*

. . . It is God who makes real men and who can enrich our lives with moments and periods of higher life and higher feeling. Has the sea made itself, has an oak tree? But men like our father are more beautiful than the sea. Yet the sea is very beautiful; there were many bugs at Mr Stokes's, but the view from the school window made one forget them. . . .

*

. . . It is a beautiful morning; the sun is shining through the tall acacia trees in the playground and glitters on the roofs and windows visible beyond the garden. There are already gossamer threads in the garden; it is cool in the morning and the boys trot back and forth to get warm.

. . . I read the Bible with them every day, and that is something more than a pleasure. No day passes without praying to God and without speaking about God. At present my talks about Him aren't much, but with God's help and blessing they will become better.

Did I ever tell you about that picture by Boughton, 'The Pilgrim's Progress'? It is toward evening. A sandy path leads over the hills to a mountain, on the top of which is the Holy City, lit by the red sun setting behind the grey evening clouds. On the road is a pilgrim who wants to go the city; he is already tired and asks a woman in black, who is standing by the road and whose name is 'Sorrowful yet always rejoicing':

Does the road go uphill all the way?
'Yes, to the very end.'
And will the journey take all day long?
'Yes, from morn till night, my friend.'

The landscape through which the road winds is so beautiful – brown heath, and occasional birches and pine trees and patches of yellow sand, and the mountain far in the distance, against the sun. Truly, it is not a picture but an inspiration. . . .

<p style="text-align:center">*</p>

. . . Theo, your brother has preached for the first time, last Sunday, in God's dwelling, of which is written, 'In this place, I will give peace.' Enclosed a copy of what I said. May it be the first of many.

It was a clear autumn day and a beautiful walk from here to Richmond along the Thames, in which the great chestnut trees with their load of yellow leaves and the clear blue sky were mirrored. Through the tops of the trees one could see that part of Richmond which lies on the hill; the houses with their red roofs, uncurtained windows and green gardens; and the grey spire high above them; and below, the long grey bridge with the tall poplars on either side, over which the people passed like little black figures.

When I was standing in the pulpit, I felt like somebody who, emerging from a dark cave underground, comes back to the friendly daylight. It is a delightful thought that in the future wherever I go, I shall preach the Gospel; to do that *well*, one must have the Gospel in one's heart. May the Lord give it to me. . . .

<p style="text-align:center">*</p>

LITTLE CHURCHES OF PETERSHAM AND TURNHAM GREEN

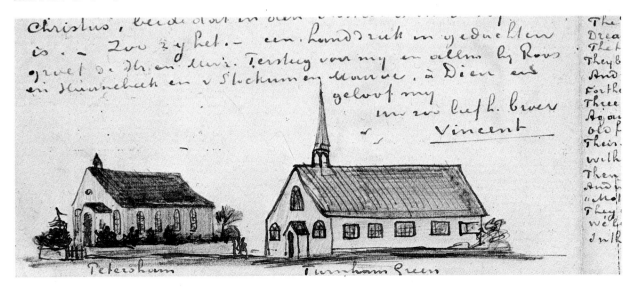

20

. . . A phrase in your letter struck me: 'I wish I were far away from everything; I am the cause of all, and bring only sorrow to everybody; I alone have brought all this misery on myself and others.' These words struck me because that same feeling, exactly the same, neither more nor less, is also on my conscience. . . .

*

. . . Now and then when I am writing, I instinctively make a little drawing, like the one I sent you lately: this morning, for instance, Elijah in the desert, with the stormy sky, and in the foreground a few thorn bushes. It is nothing special, but I see it all so vividly before me, and I think that at such moments I could speak about it enthusiastically – may it be given me to do so later on. . . .

*

. . . I have heard the Reverend Mr Laurillard three times; you would like him too, for it is as if he paints, and his work is at the same time high and noble art. . . .

*

. . . once I met the painter Millais on the street in London, just after I had been lucky enough to see several of his pictures. And that noble figure reminded me of John Halifax. Millais once painted 'The Lost Mite', a young woman who early in the morning, at dawn, is looking for the mite she has lost (there is also an engraving of 'The Lost Mite'), and not the least beautiful of his pictures is an autumn landscape, 'Chill October'. . . .

*

. . . How are you boy? Every day I think of you so very often. May God help us in our struggle to keep straight; you are right in associating with good artists – I, too, cling fast to the memory of many of them. . . .

*

. . . Thanks for yesterday's letter; it was a good one – there was so much in it, it was quite refreshing to me.

I found a few stamps enclosed, for which many thanks, and then you say you will send a money order so that I can come to The Hague to see the exhibition of drawings. The money order arrived today, Sunday; thanks for it and for your kind offer, but I am sending it back and will not come, much as I should like to see the beautiful and interesting things which you write about.

. . . I'm not sorry that I don't always have money in my pocket. I have such a craving for thousands of things, and if I had money, I would perhaps soon spend it on books and other things which I can very well do without, and which would divert my attention from the strictly necessary studies. Even now it is not always easy to fight against distractions, and if I had money, it would be worse still. And here on earth one always remains poor and needy, I have already learned that; but in one thing we can be rich, in God, and it is the part that will not be taken from us. And there may come a time when we can spend our money better than on the best books, etc., and when we shall be sorry to have had too many expenses in our youth – when we shall perhaps have a household of our own, and others to care for and to think about.

. . . For a change last week I made an excerpt from the journeys of Paul and drew a map of them; it is a good thing to have. . . .

*

. . . This morning I saw a big dark wine cellar and warehouse, with the doors standing open; for a moment I had an awful vision in my mind's eye – you know what I mean – men with lights were running back and forth in the dark vault. It is true you can see this daily, but there are moments when the common everyday things make an extraordinary impression and have a deep significance and a different aspect. De Groux knew so well how to put it in his pictures and especially in his lithographs. . . .

*

. . . It is almost time for you to start on your business trip for Messrs Goupil & Co., and I am already savouring the prospect of seeing you again. I want to ask you one thing: couldn't you arrange it so that we could be together, quiet and undisturbed, for at least one whole day? . . .

*

. . . Boy, studying Latin and Greek is very difficult, but still it makes me feel happy, and I am doing what I longed to do. I cannot sit up so late in the evening any more – Uncle has strictly forbidden it. Still, I keep in mind the phrase under the etching by Rembrandt, 'In medio noctis vim suam lux exerit' ['In the middle of the night, the light diffuses its strength'], and I keep a small gaslight burning low all night; in medio noctis I often lie looking at it, planning my work for the next day and thinking of how to arrange my studies best.

. . . It is a good thing to be fond of thorns, like the thorn hedges around English country churches, or of the roses in a churchyard – they are so beautiful these days – yea, if we could make ourselves a crown of the thorns of life, wearing it before men and so that God may see us wearing it, we should do well. . . .

*

. . . I must set to work now, Latin exercises for tomorrow morning and other things. Write me soon if you can, and have as good a time as possible. I hope to have copied a few more of those maps by Stieler before Christmas. Now I am studying, though it may cost a little more effort, *it must be done well*, and I will try to do it the way I see others who take their work seriously do; *it is a race and a fight for my life* – no more, no less. Whoever gets through this course of study and perseveres in it to the end will not forget it as long as he lives; to have done this will be something to treasure. . . .

*

. . . I feel I must write you without further delay, especially because I have to thank you for three things. In the first place for your nice four-page letter; it was the greatest treat for me, for it does one good to feel that one still has a brother living and walking on this earth. When one has many things to think of and to do, one sometimes gets the feeling, Where am I? What am I doing? Where am I going? and one's brain reels. But then a well-known voice such as yours, or rather a well-known handwriting, makes one feel firm ground under one's feet again. . . .

*

. . . Uncle Cor then asked me if I should feel no attraction for a beautiful woman or girl. I answered that I would feel more attraction for, and would rather come into contact with, one who was ugly or old or poor or in some way unhappy, but who, through experience and sorrow, had gained a mind and soul. . . .

*

. . . Whoever lives sincerely and encounters much trouble and disappointment without being bowed down is worth more than one who has always sailed before the wind and has only known relative prosperity. For who are those who show some sign of higher life? They are the ones who merit the words, 'Laboureurs, votre vie est triste, laboureurs, vous souffrez dans la vie, laboureurs, vous êtes bien-heureux' ['Labourers, your life is dreary, labourers, you suffer during life, labourers, you are blessed']; they are the ones who bear the signs of 'toute une vie de lutte et de travail soutenu sans fléchir jamais' ['a whole life of struggle and constant work without ever faltering']. It is good to try to become like this. . . .

*

. . . When I was in England, I applied for a position as evangelist among the coal miners, but they put me off, saying I had to be at least twenty-five years old. You know how one of the roots or foundations, not only of the Gospel, but of the whole Bible is 'Light that rises in the darkness', *from darkness to light.* Well, who needs this most, who will be receptive to it? Experience has shown that people who walk in the darkness, in the centre of the earth, like the miners in the black coal mines, for instance, are very much impressed by the words of the Gospel, and believe them, too. Now in the south of Belgium, in Hainaut, near Mons, up to the French frontier — aye, even far across it — there is a district called the Borinage, which has a unique population of labourers who work in the numerous coal mines. . . .

*

HOUSES AT CUESMES

HOUSES AT CUESMES

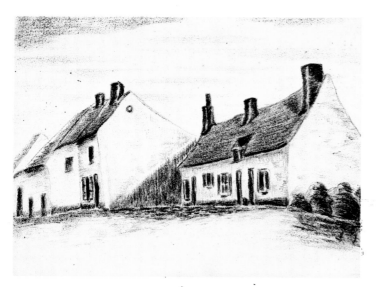

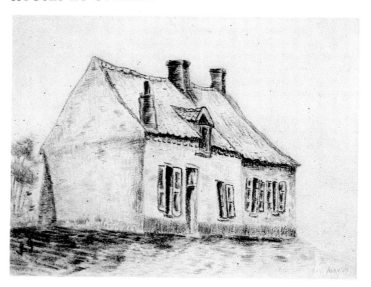

. . . Now, all jesting aside, I really think it would be better if the relation between us became more friendly on both sides. If I had to believe that I were troublesome to you or to the people at home, or were in your way, of no good to anyone, and if I should be obliged to feel like an intruder or an outcast, so that I were better off dead, and if I should have to try to keep out of your way more and more — if I thought this were really the case, a feeling of anguish would overwhelm me, and I should have to struggle against despair. This is a thought I can hardly bear, and still harder to bear is the thought that so much discord, misery and trouble between us, and in our home, is caused by me. If it were indeed so, then I might wish that I had not much longer to live.

But when this thought sometimes depresses me beyond belief — almost too deeply — after a long time another occurs simultaneously. Perhaps it is only a terrible nightmare, and later on we shall learn to understand and look at things in a more constructive way. But after all, is it not the truth, and will it not get better instead of worse? Many people would undoubtedly think it foolish and superstitious to continue to believe in a change for the better. . . . Sometimes in winter the cold is so biting that one says, It is too cold; what do I care if a summer will follow, the evil far surpasses the good. But with or without our permission, an end to the bitter frost comes at last, and on a certain morning the wind has turned and we have a thaw. Comparing the state of the weather to our state of mind and circumstances — subject to changes and variety like the weather — I still have some hope of a change for the better. . . .

*

. . . I am writing you with some reluctance, not having done so in such a long time, for many reasons.

To a certain degree you have become a stranger to me, and I have become the same to you, more than you may think; perhaps it would be better for us not to continue in this way. Probably I would not have written you even now if I were not under the obligation and necessity of doing so, if you yourself had not given me cause. At Etten I learned that you had sent 50 francs for me; well, I have accepted them. Certainly with reluctance, certainly with a rather melancholy feeling, but I am up against a stone wall and in a sort of mess. How can I do otherwise? So I am writing you to thank you.

. . . Involuntarily, I have become more or less a kind of impossible and suspect personage in the family, at least somebody whom they do not trust, so how could I in any way be of any use to anybody? Therefore, above all, I think the best and most reasonable thing for me to do is to go away and keep at a convenient distance, so that I cease to exist for you all.

. . . Now, though it is very difficult, almost impossible, to regain the confidence of a whole family, which is not quite free from prejudices and other qualities as fashionable and honourable, I do not quite despair that by and by, slowly but surely, a cordial understanding may be renewed between some of us. And in the very first place, I should like to see that *entente cordiale*, not to put it stronger, re-established between Father and me; and I desire no less to see it re-established between us two. An *entente cordiale* is infinitely better than misunderstandings.

Now I must bore you with certain abstract things, but I hope you will listen to them

patiently. I am a man of passions, capable of and subject to doing more or less foolish things, which I happen to repent, more or less, afterward. Now and then I speak and act too hastily, when it would have been better to wait patiently. I think other people sometimes make the same mistakes. Well, this being the case, what's to be done? Must I consider myself a dangerous man, incapable of anything? I don't think so. But the problem is to try every means to put those selfsame passions to good use. For instance, to name one of the passions, I have a more or less irresistible passion for books, and I continually want to instruct myself, to study if you like, just as much as I want to eat my bread. *You* certainly will be able to understand this. When I was in other surroundings, in the surroundings of pictures and works of art, you know how I had a violent passion for them, reaching the highest pitch of enthusiasm. And I am not sorry about it, for even now, *far from that land, I am often homesick for that land of pictures.*

. . . So you would be wrong in persisting in the belief that, for instance, I should now be less enthusiastic for Rembrandt, or Millet, or Delacroix, or whoever it may be; the contrary is true. But, you see, there are many things which one must believe and love. There is something of Rembrandt in Shakespeare, and of Correggio in Michelet, and of Delacroix in Victor Hugo; and then there is something of Rembrandt in the Gospel, or something of the Gospel in Rembrandt — whichever, it comes to the same if only one understands it properly, without misinterpreting it and considering the equivalence of the comparisons, which do not pretend to lessen the merits of the original personalities. And in Bunyan there is something of Maris or of Millet, and in Beecher Stowe there is something of Ary Scheffer.

. . . Well, what shall I say? Do our inner thoughts ever show outwardly? There may be a great fire in our soul, yet no one ever comes to warm himself at it, and the passers-by see only a wisp of smoke coming through the chimney, and go along their way.

. . . But to speak of other things, if I have come down in the world, you, on the contrary, have risen. If I have lost the sympathy of some, you, on the contrary, have gained it. That makes me very happy — I say it in all sincerity — and always will. If you hadn't much seriousness or depth, I would fear that it would not last; but as I think you are very serious and of great depth, I believe that it will. But I should be very glad if it were possible for you to see me as something more than an idle man of the worst type.

If ever I can do anything for you, be of some use to you, know that I am at your disposal. As I have accepted what you have given me, you might, in case I could render you some service, ask me to; it would make me happy, and I should consider it a proof of confidence. We are rather far apart, and perhaps we have different views on some things, but nevertheless there may come an hour, there may come a day, when we may be of service to one another.

For the present I shake hands with you, thanking you again for the help you have given me.

If you wish to write me one of these days, my address is c/o Ch. Decrucq, Rue du Pavillon 3, Cuesmes, near Mons. And know that a letter from you will do me good.

*

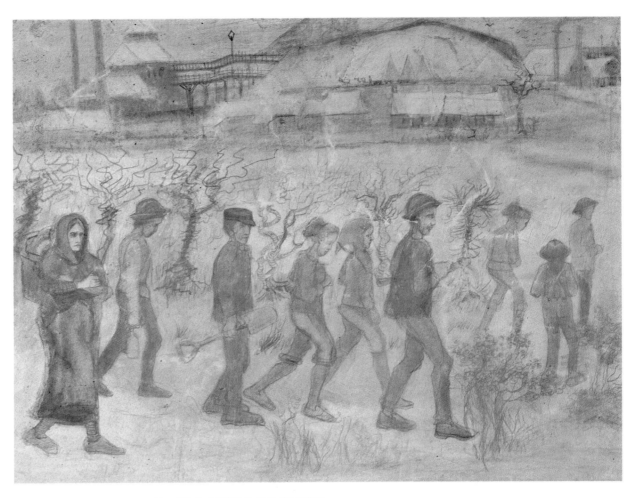

MEN AND WOMEN MINERS GOING TO WORK

. . . Send me what you can, and do not fear for me. If I can only continue to work, somehow or other it will set me right again. Your doing this will help me a great deal. If you should take a trip to Holland, I hope you will not pass by here without coming to see the sketches.

I write to you while I am busy drawing, and I am in a hurry to go back to it, so good night, and send me the prints as soon as possible. . . .

*

. . . So you see that I am in a rage of work, though for the moment it does not produce very brilliant results. But I hope these thorns will bear their white blossoms in due time, and that this apparently sterile struggle is no other than the labour of childbirth. First the pain, then the joy.

. . . Though every day difficulties crop up and new ones will present themselves, I cannot tell you how happy I am to have taken up drawing again. I had been thinking of it for a long time, but I always considered the thing impossible and beyond my reach. But now, though I feel my weakness and my painful dependence in many things, I have recovered my mental balance, and day by day my energy increases.

. . . The thing for me is to learn to draw well, to be master of my pencil or my crayon or my brush; this gained, I shall make good things anywhere, and the Borinage is just as picturesque as old Venice, Arabia, Brittany, Normandy, Picardy or Brie.

. . . Wait, perhaps some day you will see that I too am an artist; I do not know what I can do, but I hope I shall be able to make some drawings with something human in them. . . .

*

. . . As to your thinking I should not want to be among the mediocre artists, what shall I say? It quite depends on what you call mediocre. I shall do what I can, but I do not at all despise *mediocre* in its simple sense. And one certainly does not rise above the mark by despising what is mediocre. In my opinion one must at least begin by having some respect for the mediocre, and know that it always means something, and is only reached with great difficulty. . . .

*

. . . I love landscape very much, but I love ten times more those studies from life, sometimes of startling realism, which have been drawn so masterfully by Gavarni, Henri Monnier, Daumier, De Lemud, Henri Pille, Th. Schuler, Ed. Morin, G. Doré (e.g. in his 'London'), A. Lançon, De Groux, Félicien Rops, etc., etc. Now without in the least pretending to compare myself to those artists, still, by continuing to draw those types of working people, etc., I hope to arrive at the point of being able to illustrate papers and books. Especially when I am able to take more models, also female models, I shall make more progress – I feel it, and know it. And I shall also probably learn to make portraits. But the condition is to work hard, 'Not a day without a line', as Gavarni said. . . .

*

. . . In the first place this. I hear from Father that without my knowing it you have been sending me money for a long time, in this way effectively helping me to get on. Accept my heartfelt thanks, I firmly believe that you will not regret it. In this way I am learning a handicraft, and though it certainly will not make me rich, I will at any rate earn my 100 fr. a month, which is the least one needs to live on, as soon as I become a better draftsman and get some regular work.

. . . As to the expenses, I suppose they would amount to at least 100 fr. a month; to do with less is impossible: 'Thou shalt not muzzle the ox when he treadeth out the corn.' . . .

The Dutch period

To Theo . . . I think I shall find a good model here in Piet Kaufman, the gardener, but I think it will be better to let him pose with a spade or plough or something like that – not here at home, but either in the yard or in his own home or in the field. But what a tough job it is to make people understand how to pose. Folks are desperately obstinate about it, and it is hard to make them yield on this point: they only want to pose in their Sunday best, with impossible folds in which neither knees, elbows, shoulder blades nor any other part of the body have left their characteristic dents or bumps. . . .

*

. . . I spent an afternoon and part of an evening with Mauve, and saw many beautiful things in his studio. My own drawings seemed to interest Mauve more. He gave me a great many hints which I was glad to get, and I have arranged to come back to see him in a relatively short time when I have some new studies. He showed me a lot of his studies and explained them to me – not sketches for drawings or pictures, but real studies, seemingly of little importance. He thinks I should start painting now. . . .

*

. . . I have drawn five times over a man with a spade, a Digger [un Bêcheur], in different positions, a sower twice, a girl with a broom twice. Then a woman in a white cap, peeling potatoes; a shepherd leaning on his staff; and, finally, an old, sick farmer sitting on a chair near the hearth, his head in his hands and his elbows on his knees. And of course I shall not stop here – when a few sheep have crossed the bridge, the whole flock follows. Diggers, sowers, ploughers, male and female, they are what I must draw continually. I have to observe and draw everything that belongs to country life – like many others have done before, and are doing now. I no longer stand helpless before nature, as I used to. . . .

*

. . . Nature always begins by resisting the artist, but he who really takes it seriously does not allow that resistance to put him off his stride; on the contrary, it is that much more of a stimulus to fight for victory, and at bottom nature and a true artist agree. Nature certainly is 'intangible', yet one must seize her, and with a strong hand. And then after one has struggled and wrestled with nature, sometimes she becomes a little more docile and yielding. I do not mean to say that I have reached that point already – no one thinks so less than I – but somehow I get on better. The struggle with nature sometimes reminds one of what Shakespeare calls 'the taming of the shrew' (that means conquering the opposition by perseverance, bon gré et mal gré). In many things, but especially in drawing, I think that 'serrer de près vaut mieux que lâcher' [pressing hard is better than letting go].

More and more I feel that drawing the figure is a good thing which indirectly has a good influence on drawing landscape. If one draws a willow as if it were a living being – and after all, it really is – then the surroundings follow in due course if one has concentrated all one's attention only on that same tree, not giving up until one has put some life into it. . . .

*

. . . There is something in my heart that I must tell you; perhaps you know about it already and it is no news to you. I want to tell you that this summer a deep love has grown in my heart for Kee; but when I told her this, she answered me that to her, past and future remained one, so she could never return my feelings.

Then there was a terrible indecision within me about what to do. Should I accept her 'no, never never', or, considering the question not finished or decided, should I keep some hope and not give up?

I chose the latter. And up to now I do not repent the decision, though I am still confronted by the 'no, never never'. Of course, since that time I have met with many 'petites misères de la vie humaine' which, written in a book, would perhaps serve to amuse some people, but can hardly be termed pleasant sensations if one has to experience them oneself.

. . . Theo, are you perhaps in love too? I wish you were, for believe me, even its little miseries have their value. One is sometimes in despair, there are moments when one seems to be in hell, but – there are also other and better things connected with it. There are three stages.

1. Not to love and not to be loved.
2. To love and not to be loved in return.*
3. To love and to be loved.

Now, I tell you that the second stage is better than the first – but the third, that is the *best*.

Now, old boy, fall in love too, and then tell me about it. In my case give me your sympathy and take my part. . . .

*Which is my case.

*

To Anthon van Rappard . . . And when Mauve is here, I go where Mauve goes. Suppose you were staying here when Mauve came, would you think that so unpleasant? I don't think you would; I don't know whether you know Mauve personally, but I think meeting him or meeting him again would be a good thing indeed. Mauve gave me courage when I needed it not long ago. He is a man of genius.

. . . Your remark about the figure of the Sower – that he is not a man who is sowing, but one who is posing as a sower – is very true.

However, I look upon my present studies purely as studies after the model, they have no pretension to being anything else.

Only after a year or a couple of years shall I have gained the ability to do a sower who is sowing; there I agree with you.

. . . I have good news from my brother Theo – he sends his kind regards. Do not neglect to keep up your acquaintance with him by writing him once in a while. He is a clever, energetic fellow, and I am very sorry he isn't a painter, although it is a good thing for the painters that there are such persons as he. This you will find out if you keep up your acquaintance with him. . . .

*

. . . Please, don't get angry – read on – to the very end – if you get angry – don't tear up this letter without reading it – first count to ten. One . . . two . . . three . . . and so on.

That's tranquilizing . . . for you know, there now follows something dreadful indeed. What I want to say is this.

Rappard, I believe that, though you were working at the academy, you are trying more and more to become a true realist, and that even at the academy you will stick to reality – however, without being conscious of it yourself. Without knowing it, this academy is a mistress who prevents a more serious, a warmer, and more fruitful love from awakening in you. Let this mistress go, and fall desperately in love with your real sweetheart: Dame Nature or Reality.

I fell in love the same way too – desperately, I tell you – with a certain Dame Nature or Reality, and I have felt so happy ever since, though she is still resisting me cruelly, and does not want me yet, and often raps me over the knuckles when I dare prematurely to consider her mine. Consequently I cannot say that I have won her by a long shot, but what I *can* say is that I am wooing her, and that I am trying to find the key to her heart, notwithstanding the painful raps on the knuckles.

But never think that there is only one woman called Dame Nature or Reality; no, it is only the family name of many sisters with different Christian names. So we need not be rivals. . . .

*

To Theo
. . . That higher feeling which I cannot do without is love for Kee. Father and Mother argue in this way: *She says No, so you must resign yourself.* I do not see the necessity of this at all, on the contrary. And I would rather give up the work just begun and all the comforts of this home than resign myself to not writing her or her parents.

Well, I write to you about it because at least my work certainly concerns you, for you are the one who has already given so much money to help me succeed. Now I am getting on, it progresses, I begin to see some light; and now I tell you, Theo, this threatens me. I ask no better than to work on quietly, but Father seems to want to put me out of the house, at least he said so this morning.

A strong word from you can perhaps settle this matter. *You* will understand what I tell you: In order to work and to become an artist, one needs *love*. At least one who wants sentiment in his work must first feel it himself, and live with his heart. . . .

*

To Anthon van Rappard
. . . Well, well! So after all I am a fanatic! All right, for your words have gone home, right through my skin! So be it – thanks for your revelation, yes, thank God, at first I dared not believe it, but you have made it clear to me – so I have a

will, a *conviction*, I am going *in a definite direction*, and what is more, not being contented with this, I want others to go along with me! Thank God, so I am a fanatic! Well, from now on I won't be anything else. And now I should like to have my friend Rappard as a fellow traveller – it is not a matter of indifference to me to lose sight of him – do you think I am wrong in this? . . .

*

To Theo

. . . Not that you or I really bow to that Mr Mammon and serve him, but it is true that he worries you and me a great deal. Me, by poverty through many a year; you, through a high salary. These two both present the temptation to bow to the power of money. We may be more or less strong in those temptations, but I hope neither you nor I are destined to become entirely the prey of that money devil; but won't he get some hold on us? Now that money devil may not play you the trick of making you think it a crime to earn much money and making me think that there is some merit in my poverty. No indeed, there is no merit in being so slow to earn money as I am, and I shall have to remedy that; and you will give me many a useful hint, I hope. . . .

*

. . . If I repent anything, it is the time when mystical and theological notions induced me to lead too secluded a life. Gradually I have thought better of it. When you wake up in the morning and find yourself not alone, but see there in the morning twilight a fellow creature beside you, it makes the world look so much more friendly. Much more friendly than religious diaries and whitewashed church walls, with which the clergymen are in love. She lived in a modest, simple little room: the plain paper on the wall gave it a quiet grey tone, yet warm like a picture by Chardin; a wooden floor with a mat and a piece of old crimson carpet, an ordinary kitchen stove, a chest of drawers, and a large simple bed – in short, the home of a real working woman. She had to stand at the washtub the next day. Very good, quite right. She would have been as charming to me in a black petticoat and dark blue camisole as she was now in a brown or reddish-grey dress. . . .

THEODORUS VAN GOGH
(VINCENT'S FATHER)

SCHEVENINGEN
WOMAN STANDING

. . . Thanks for your letter and the enclosed. I was in Etten again when I received it; as I told you, I had arranged this with Mauve. But now you see I am back again in The Hague. On Christmas Day I had a violent scene with Father, and it went so far that Father told me I had better leave the house. Well, he said it so decidedly that I actually left the same day.

The real reason was that I did not go to church, and also that if going to church was compulsory and if I was *forced* to go, I certainly should never go again out of courtesy, as I had done rather regularly all the time I was in Etten. But oh, in truth there was much more at the back of it all, including the whole story of what happened this summer between Kee and me.

I do not remember ever having been in such a rage in my life. I frankly said that I thought their whole system of religion horrible, and just because I had gone too deeply into those questions during a miserable period in my life, I did not want to think of them any more, and must keep clear of them as of something fatal.

Was I *too* angry, *too* violent? Maybe — but even so, it is settled now, once and for all. . . .

. . . Of course I must ask you, Theo, if you will occasionally send me what you can spare without inconveniencing yourself. And send it to me rather than give it to others, for if it is possible, we must not get Mauve mixed up in the financial affairs. His helping me with advice in art matters is already of such enormous value. But he insists on my buying, for instance, a bed and a few pieces of furniture. He says, I will lend you the money if necessary. And according to him I must dress somewhat better and not try to skimp too much. . . .

*

. . . Shall I continue to have regrets? No, I really haven't time for regret. Drawing becomes more and more a passion with me, and it is a passion just like that of a sailor for the sea. Mauve has now shown me a new way to make something, that is, how to paint water-colours. Well, I am quite absorbed in this now and sit daubing and washing out again; in short, I *am* trying to find a way. 'Puisqu'il faut faire des efforts de perdu. Puisque l'exécution d'une aquarelle a quelque chose de diabolique. Puisqu'il y a du bon en tout mouvement énergique.' ['Because one must make efforts like those of the lost souls. Because there is something diabolical about executing a water-colour. Because there is something good in every energetic motion.'] . . .

*

. . . I feel, Theo, that there is a power within me, and I do what I can to bring it out and free it. All the worry and troubling over my drawings is hard enough, and if I had too many other cares and could not pay the models, I should lose my head. It is bad enough that you have to pay for everything, but things are not so bad as they were last winter. I feel that I am nearer success. I shall do what I can, I shall work hard, and as soon as I have more power over my brush, I shall work even harder than I do now. And if we push on energetically now, it will not be long before you need not send me money any more. . . .

*

. . . Perhaps someday when people begin to say that I can draw a little but not paint, I shall suddenly come out with a picture at a moment when they least expect it. But I certainly won't as long as it looks as though I were *obliged* to, and as though *I must not* do something else.

There are two ways of thinking about painting, how not to do it and how to do it; *how to do it* – with much drawing and little colour; *how not to do it* – with much colour and little drawing.

*

. . . Since I wrote Mauve: 'Do you know that those two months you spoke of have long since passed? Let us shake hands, then each go his own way, rather than have a quarrel between you and me', I repeat, since I wrote this and received no sign of reply, my grief chokes me.

Because – and you know this – I love Mauve, and it is so hard that all the happiness he pictured to me will come to naught. For I am afraid that the better my drawings become, the more difficulty and opposition I shall meet. Because I still have to suffer much, especially from those peculiarities which I *cannot* change. First, my appearance and my way of speaking and my clothes; and then, even later on when I earn more, I shall always move in a different sphere from most painters because my conception of things, the subjects I want to make, inexorably demand it.

Enclosed is a little sketch of diggers; I will tell you why I am sending it. Tersteeg said to me, 'You failed before and now you will fail again – it will be the same story all over again.'

*

. . . Today I met Mauve and had a very painful conversation with him, which made it clear to me that Mauve and I are separated forever. Mauve has gone so far that he cannot retract, at least he certainly wouldn't want to. I had asked him to come and see my work and then talk things over. Mauve refused point-blank: 'I will certainly not come to see you, that's all over.'

At last he said, 'You have a vicious character.' At this I turned around – it was in the dunes – and walked home alone.

Mauve takes offence at my having said, 'I am an artist' – which I won't take back, because, of course, these words connote, 'Always seeking without absolutely finding.' It is just the opposite of saying, 'I know, I have found it.'

. . . Last winter I met a pregnant woman, deserted by the man whose child she carried.

A pregnant woman who had to walk the streets in winter, had to earn her bread, you understand how.

I took this woman for a model, and have worked with her all winter. I could not pay her the full wages of a model, but that did not prevent my paying her rent, and, thank God, so far I have been able to protect her and her child from hunger and cold by sharing my own bread with her. When I met this woman, she attracted my attention because she looked ill. I made her take baths and as much nourishing food as I could afford, and she has become much stronger. . . .

*

. . . Thank God I have my work; but instead of earning money by it, I need money to be able to work, so that is the difficulty. When in a year – or I don't know how long – I shall be able to draw that Geest or any other street as I see it, with those figures of old women, workmen, girls, then Tersteeg, etc., will be very kind. But then they will hear me thunder, 'Go to hell'; and I shall say, You deserted me when I was in trouble, friend, *I don't know you*, go away, you're standing in my light.

. . . Now I want to lay a straight path for my feet. If I postpone marriage, there is something crooked in my position which is repulsive to me. She and I will skimp and be as frugal as possible if only we can marry. I am thirty years old and she is thirty-two, so we are no longer children. As to her mother and her child, the latter takes away all stain from her; I respect a woman who is a mother, and I don't ask about her past. I am glad that she has a child – it gives her exactly the experience she needs.

. . . I believe, or rather it begins to dawn on me, that there might be a shadow of a chance that the thought, 'Theo will withdraw his help if I contradict him', is perhaps quite unnecessary. But, Theo, I have seen such things happen so often that I shouldn't think less of you and shouldn't be angry with you if you did, because I would think, He doesn't know any better; they all act like that – from thoughtlessness, not malice. . . .

*

. . . Last year I wrote you a great many letters full of reflections on love. Now I no longer do so because I am too busy putting those same things into practice. She for whom I felt what I wrote you about is not in my path, she is out of my reach in spite of all my passionate longing. Would it have been better to have kept thinking of her always and to have overlooked what came my way? I cannot decide myself whether I acted consistently or inconsistently. . . .

*

To Anthon van Rappard . . . I am very much pleased with the model I have; I mean that woman who was in my studio when you were here, for she is learning more every day, and understands me. For instance, when something goes wrong and I fly into a rage and get up and say, 'Damn it, it's all wrong!' or something even worse than that, she does not take it as a personal affront, as of course most others would, but lets me calm down and start all over again. And she undergoes the tedious work of finding the right light and the right pose patiently. So I think her a darling.

. . . Oh, there is gossip enough, because I am always in her company, but why should that bother me? – I never had such a good assistant as this ugly (???), faded woman. In my eyes she is beautiful, and I find in her exactly what I want; her life has been rough, and sorrow and adversity have put their marks on her – now I can do something with her.

When the earth is not ploughed, you can get no harvest from it. She has been ploughed – and so I find more in her than in a crowd of unploughed ones. . . .

*

To Theo

. . . I will readily admit that to an eye that is accustomed to water-colours exclusively, there must be something crude in drawings in which one has scratched with a pen and lights have been rubbed out or put in again with body-colour. But there are people who are not afraid of that crudeness, just as there are people who think it sometimes pleasant and invigorating for a healthy man to take a walk during a storm. . . .

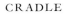

. . . I have my books on perspective here, and a few volumes of Dickens, including *Edwin Drood*; there is perspective in Dickens, too. Good God, what an artist! There's no one like him. . . .

*

. . . What I want to explain is this — what exists between Sien and me is *real*; it is not a dream, it is *reality*! Look at the result. When you come, you will not find me discouraged or melancholy; you will enter an atmosphere which will appeal to you, at least it will please you — a new studio, a young home in full swing. No mystical or mysterious studio but one that is rooted in real life — *a studio with a cradle*, a baby's pot — where there is no stagnation, but where everything pushes and urges and stirs to activity.

Now, if anybody should come and tell me that I am a poor financier, I shall show him my domain. I have done my best, brother, to take care that you will see (and not only you, but anyone with eyes in his head) that I aim at and sometimes succeed in doing things practically.

CRADLE

. . . Do not imagine that I think myself perfect or that I think that many people's taking me for a disagreeable character is no fault of mine. I am often terribly melancholy, irritable, hungering and thirsting, as it were, for sympathy; and when I do not get it, I try to act indifferently, speak sharply, and often even pour oil on the fire. I do not like to be in company, and often find it painful and difficult to mingle with people, to speak with them. But do you know what the cause is – if not of all, of a great deal of this? Simply nervousness; I am terribly sensitive, physically as well as morally, the nervousness having developed during those miserable years which drained my health. Ask any doctor, and he will understand at once that nights spent in the cold street or in the open, the anxiety to get bread, a continual strain because I was out of work, the estrangement from friends and family, caused at least three-fourths of my peculiarities of temper, and that those disagreeable moods or times of depression must be ascribed to this. But you, or anyone who will take the trouble to think it over, will not condemn me, I hope, because of it, nor find me unbearable. I try to fight it off, but that does not change my temperament; and even though this may be my bad side, confound it, I have a good side too, and can't they credit me with that also? . . .

*

. . . I want to do drawings which *touch* some people. 'Sorrow' is a small beginning, perhaps such little landscapes as 'Laan van Meerdervoort', 'Rijkswijk Meadows', and 'Fish Drying Barn' are also a small beginning. In those there is at least something straight from my own heart.

In either figure or landscape I should wish to express, not sentimental melancholy, but serious sorrow.

In short, I want to progress so far that people will say of my work, He feels deeply, he feels tenderly – notwithstanding my so-called roughness, perhaps even because of it.

It seems pretentious to talk this way now, but this is the reason why I want to push on with all my strength.

What am I in most people's eyes? A nonentity, or an eccentric and disagreeable man – somebody who has no position in society and never will have, in short, the lowest of the low. Very well, even if this were true, then I should want my work to show what is in the heart of such an eccentric, of such a nobody.

This is my ambition, which is, in spite of everything, founded less on anger than on love, more on serenity than on passion. It is true that I am often in the greatest misery, but still there is a calm pure harmony and music inside me.

. . . Personally, I find in many modern pictures a peculiar charm which the old masters do not have.

For me one of the highest and noblest expressions of art is always that of the English, for instance, Millais and Herkomer and Frank Holl. What I mean about the difference between the old masters and the modern ones is this – perhaps the modern ones are deeper thinkers.

There is a great difference in sentiment between 'Chill October' by Millais and 'Bleaching Ground at Overveen' by Ruysdael; and also between 'Irish Emigrants' by Holl and 'The Bible Reading' by Rembrandt. Rembrandt and Ruysdael are sublime, for us as well as their contemporaries; but there is something in the modern painters that appeals to us more personally and intimately. . . .

. . . As for me, brother – though the mill is gone and the years and my youth are gone as irrevocably – deep within me has risen again the feeling that there is some good in life, and that it is worth while to exert oneself and to try to take life seriously. Perhaps, or rather certainly, this is more firmly rooted than it used to be, when I had less experience. The question for me now is how to express the poetry of that time in my drawings. . . .

*

. . . As to the money value of my work, I do not pretend to anything less than that it would greatly astonish me if in time my work did not become just as saleable as that of others. Of course I cannot tell whether that will happen *now* or *later*, but I think the surest way, which *cannot* fail, is to work from nature faithfully and energetically. Sooner or later feeling and love for nature meet a response from people who are interested in art. It is the painter's duty to be entirely absorbed by nature and to use all his intelligence to express sentiment in his work so that it becomes intelligible to other people. In my opinion working for the market is not exactly the right way; on the contrary, it means fooling art lovers. The true painters have not done this; the sympathy they eventually received was the result of their sincerity.

. . . Now sometimes I too sit and improvise, so to speak, at random on a piece of paper, but I do not attach any more value to this than to a rag or a cabbage leaf.

. . . And one is almost inclined to say, Confound it, the painters are almost like a family, a fatal combination of persons with contrary interests, each of whom is opposed to the rest; and two or more are of the same opinion only when it's a question of combining together to annoy another member. . . .

*

. . . Still quite under the spell of your visit, I write to you a word or two, not a little pleased that I can go ahead vigorously with my painting.

I should have liked to see you off at the station the next morning, but I thought you had already given me so much of your time that it would have been indiscreet to ask to see you again that morning. I am so thankful that you have been here. I think it a delightful prospect to be able to work a whole year without anxiety, and a new horizon has been opened to me in painting through what you gave me.

I think I am privileged over thousands of others because you removed so many barriers for me.

. . . I attach great importance to having good stuff to work with, and I should like my studio to look well – not with antiques or tapestry or rugs, but simply because of the studies on the wall and because of good material; but this will come in time through hard work. . . .

*

. . . You must not take it amiss if I write you again – it is only to tell you that painting is such a joy to me.

Last Saturday night I attacked a thing I had been dreaming of for a long time. It is a view of the flat green meadows, with haycocks. It is crossed by a cinder path running along a ditch. And on the horizon in the middle of the picture the sun is setting, fiery red. I cannot possibly draw the effect in such a hurry, but this is the composition.

But it was surely a question of colour and tone, the variety of the sky's colour scheme – first a violet haze, with the red sun half covered by a dark purple cloud which had a brilliant fine red border; near the sun reflections of vermilion, but above it a streak of yellow, turning into green and then into blue, the so-called *cerulean blue*; and then here and there violet and grey clouds, catching reflections from the sun.

The ground was a kind of carpetlike texture of green, grey and brown, but variegated and full of vibration – in this colourful soil the water in the ditch sparkles.

. . . Then I have painted a huge mass of dune ground – thickly painted and sticky.

And as for these two, the small marine and the potato field, *I am sure no one could tell that they are my first painted studies.* . . .

*

. . . There is something infinite in painting – I cannot explain it to you so well – but it is so delightful just for expressing one's feelings. There are hidden harmonies or contrasts in colours which involuntarily combine to work together and which could not possibly be used in another way. . . .

*

. . . What I like so much about painting is that with the same amount of trouble which one takes over a drawing, one brings home something that conveys the impression much better and is much more pleasant to look at – and at the same time, more correct too. In a word, it is more gratifying than drawing. But it is absolutely necessary to be able to draw the right proportion and the position of the object pretty correctly before one begins. If one makes mistakes in this, the whole thing comes to nothing. . . .

*

. . . I know for sure that I have an instinct for colour, and that it will come to me more and more, that painting is in the very marrow of my bones. Doubly and twice doubly I appreciate your helping me so faithfully and substantially. I think of you so often. I want my work to become firm, serious, manly, and for you also to get satisfaction from it as soon as possible.

*

. . . You see there is a blond, tender effect in the sketch of the dunes, and in the wood there is a more gloomy, serious tone. I am glad both exist in life.

*

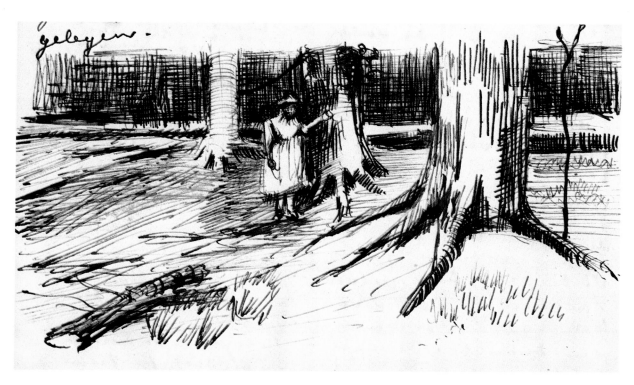

A GIRL IN A WOOD

. . . Enclosed is another sketch of the woods. I made a large study of it.

I feel such creative power in myself that I know for sure that the time will arrive when, so to speak, I shall regularly make something good every day.

But very rarely a day passes that I do not make something, though it is not yet the real thing I want to make. . . .

*

. . . I brought home many sketches that time, it was extraordinarily intriguing – but it may serve as an example of The Hague public's politeness toward painters that suddenly a fellow from behind me, or probably from a window, spat his quid of tobacco onto my paper. Well, one has trouble enough sometimes. But one need not take it so very seriously; those people are not bad, they do not understand anything about it, and probably think I am a lunatic when they see me making a drawing with large hooks and crooks which don't mean anything to them. . . .

*

To Anthon van Rappard . . . I don't even dream of exhibiting my work. The idea leaves me absolutely cold. Now and then I wish some friend could have a look at what I have in my studio – which happens very seldom; but I have never felt the wish and I think I never shall – to invite the general public to look at my work. I am not indifferent to appreciation of my work, but this too must be something silent – and I think a certain popularity the least desirable thing of all. . . .

To Theo

. . . Sometimes I have such a longing to do landscape, just as I crave a long walk to refresh myself; and in all nature, for instance in trees, I see expression and soul, so to speak. A row of pollard willows sometimes resembles a procession of almshouse men. Young corn has something inexpressibly pure and tender about it, which awakens the same emotion as the expression of a sleeping baby, for instance.

The trodden grass at the roadside looks tired and dusty like the people of the slums. A few days ago, when it had been snowing, I saw a group of Savoy cabbages standing frozen and benumbed, and it reminded me of a group of women in their thin petticoats and old shawls which I had seen standing in a little hot-water-and-coal shop early in the morning. . . .

*

. . . I do not know whether you will think me conceited when I tell you that the following pleased me very much. Smulders's workmen at the other store on the Laan saw the stone [lithograph] of the old man from the almshouse, and asked the printer if they could have a copy to hang on the wall. No result of my work could please me better than that ordinary working people would hang such prints in their room or workshop. . . .

*

. . . This also is something unbearable for many a painter, or at least almost unbearable. One wants to be an honest man, one is that, one works as hard as a slave, but still one cannot make both ends meet; one must give up the work, there is no chance of carrying it out without spending more on it than one can get back, one gets a feeling of guilt, of shortcoming, of not keeping one's promises, one is not honest, which one would be if the work were paid for at its natural, reasonable price. One is afraid of making friends, one is afraid of moving; like one of the old lepers, one would like to call from afar to the people: Don't come too near me, for intercourse with me brings you sorrow and loss. With all that huge burden of care on one's heart, one must set to work with a calm everyday face, without moving a muscle, live one's ordinary life, get along with the models, with the man who comes for the rent – in fact, with everybody. With a cool head, one must keep one hand on the helm in order to continue the work, and with the other hand try not to harm others. . . .

*

. . . What is called Black and White is in fact *painting in black*, meaning that one gives the same depth of effect, the same richness of tone value in a drawing that ought to be in a painting.

. . . Some artists have a nervous hand at drawing, which gives their technique something of the sound peculiar to a violin, for instance, Lemud, Daumier, Lançon – others, for example, Gavarni and Bodmer, remind one more of piano playing. Do you feel this too? – Millet is perhaps a stately organ. . . .

*

. . . Now today I had to pay the rent and the three models whom I hadn't been able to pay before, and I also absolutely needed various drawing materials. I am working very hard at present, and I must not stop, but really the models eat me out of house and home. . . .

*

GROUP OF PEOPLE ON A BEACH
WITH FISHING BOAT ARRIVING

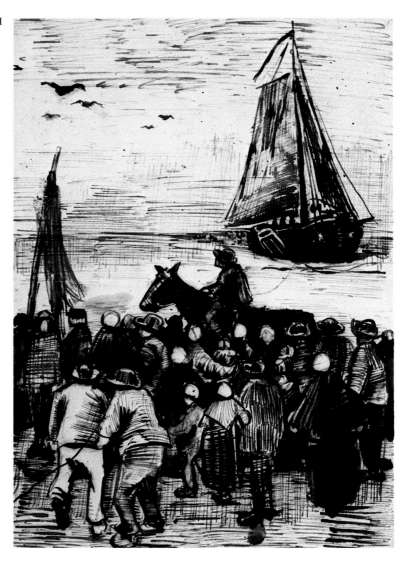

. . . Boy, I still feel poorly, and I've had a rather plain warning that I must be careful — my eyes felt so tired sometimes, but I wouldn't pay attention to it. Now, last night, especially, there was a rather strong secretion of the tear glands, and the lashes stuck together, and my eyes are giving me trouble and my sight is poor.

Ever since the middle of December I have been drudging incessantly, especially on those heads. This last week I have been out-of-doors a good deal to refresh myself. I have taken baths, washed my head often with cold water, etc., etc. But one feels so miserable at such a time; I have a large pile of studies, but they don't interest me then, and I find them all bad. . . .

*

. . . Poor woman! If women do not always show the same energy and elasticity of thought as those men who are inclined to reflection and analysis, we cannot blame them, at least in my opinion, because in general they have to expend so much more energy than we in suffering pain. They suffer more and are more sensitive.

And though they do not always understand our thoughts, they are sometimes quite capable of understanding that one is good to them. Not always, though, but 'the spirit is willing', and sometimes there is a curious kind of goodness in women.

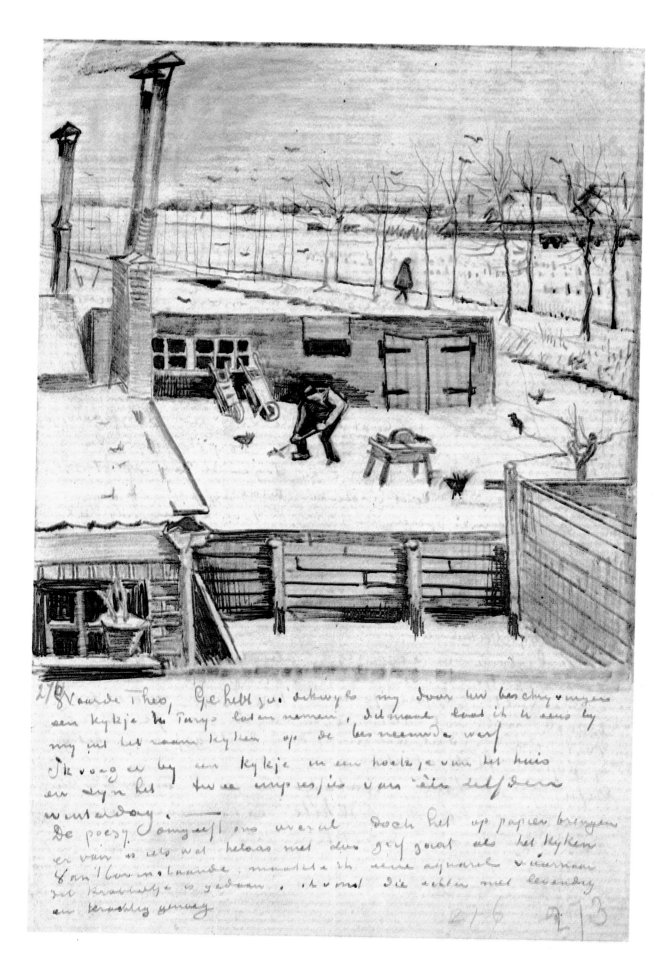

SNOWY YARD

. . . I am increasingly eager to see more Daumiers. He has pith
and a staid profundity, he is witty and yet full of sentimental passion; sometimes, for
instance in 'The Drunkards' – and possibly also in 'The Barricade', which I do not know –
I find a passion which can be compared to the white heat of iron. . . .

*

. . . There is a soul and life in that crayon – I think conté
pencil is dead. Two violins may look the same on the outside, but in playing them, one
sometimes finds a beautiful tone in one, and not in the other.

Now that crayon has a great deal of tone or depth. I could almost say, That crayon
knows what I want, it listens with intelligence and obeys; the conté pencil is indifferent and
unwilling.

The crayon has a real gypsy soul; if it isn't asking too much of you, send me some of it. . . .

*

. . . Know it well, dear brother, how strongly and intensely
I feel the enormous debt I owe you for your faithful help.

It would be difficult for me to express all my thoughts about it. It remains a constant
disappointment to me that my drawings are not yet what I want them to be. The difficulties
are indeed numerous and great, and cannot be overcome immediately. Making progress is
like miners' work: it doesn't advance as quickly as one should like, and also as others expect;
but faced with such a task, patience and faithfulness are essential. In fact, I don't think much
about the difficulties, because if one thought of them too much, one would get dazed or
confused.

. . . In my opinion, I am often *rich as Croesus* – not in money,
but (though it doesn't happen every day) rich – because I have found in my work
something which I can devote myself to heart and soul, and which inspires me and gives a
meaning to life.

Of course my moods change, but the average is serenity. I have a firm *faith* in art, a firm
confidence in its being a powerful stream which carries a man to a harbour, though he
himself must do his bit too; at all events, I think it such a great blessing when a man has
found his work that I cannot count myself among the unfortunate. . . .

*

. . . My ideal is to work with more and more models, quite
a herd of poor people to whom the studio would be a kind of harbour or refuge on winter
days, or when they are out of work or in great need. Where they would know that there
was fire, food and drink for them, and a little money to be earned. At present this is so only
on a very small scale, but I hope it will grow. . . .

*

To Anthon van Rappard . . . I just can't believe that a painter should have no other task
and no other duty than painting only. What I mean to say is, whereas many consider, for
instance, reading books and such things what they call a waste of time, on the contrary,
I am of the opinion that, far from causing one to work less or less well, rather it makes one
work more and better to try to broaden one's mind in a field that is so closely allied with

this work — and that at any rate it is a matter of importance, which greatly influences one's work, from whatever point of view one looks at things, and whatever conception one may have of life.

I believe that the more one loves, the more one will act; for love that is only a feeling I would never recognize as love. . . .

<div align="center">*</div>

To Theo
 . . . I should like to be proud of Father, because he is truly a poor village preacher in the pure sense of the Gospel, but I think it so rotten that Father stoops to such considerations as something not being in keeping with 'the dignity of his calling'.

My opinion is that one might expect Father to co-operate as soon as the question of saving a woman arises. It would be right to be on *her* side, because she is poor and deserted.

 . . . Oh, I know very well that nearly all clergymen would use the same language as Father — and for this reason I reckon the whole lot of them the most ungodly men in our society.

 . . . Now I say to myself, If the *Graphic* and Harper's send their draftsmen to Holland, perhaps they would not be unwilling to take on a draftsman from Holland if he can produce some good work and not too expensively.

I should prefer being put on regular monthly wages to selling a drawing now and then at a relatively high price. And I should like to make a contract for a series of compositions, for instance, following up these two drawings I am working on now, or those I am going to do. I should think it advisable to go to London myself with studies and drawings and to visit the managers of the various establishments or, better still, the artists Herkomer, Green, Boughton (but some of them are in America at present) or others, if they are in London. And there, better than anywhere else, I should be able to get information about the different processes. Perhaps Rappard would come with me, and take drawings with him too. Such a thing, more or less modified, ought to be done, I think.

Personally I could undertake to do one large drawing for a double-page engraving for illustration every month, and I will also apply myself to the other sizes, whole page and half page.

 . . . But I repeat, the money from you is absolutely indispensable to me as long as I have not found employment. Out of what I received from you today, I have to pay exactly as much as I received: I have *still to pay* three models who have posed several times. I have to pay the carpenter, to pay the rent, to pay the baker and the grocer and also the shoemaker, and I have to lay in some provisions. Then I have in front of me two blank sheets for new compositions, and must set to work on them. I shall again have to take a model every day, and struggle hard till I have got it down. *Quand bien même* I'll get started, but you will understand that in a few days I shall be absolutely penniless, and then those terrible eight long days of not being able to do anything but wait, wait for the tenth of the month. . . .

<div align="center">*</div>

. . . This morning I was in a charitable home, boy, to see a little old woman (with whom I had to arrange about posing), and thus far she has brought up two natural children of her daughter's, who is a so-called kept woman. Several things struck me: in the first place, the neglected appearance of the poor little creatures, though the grandmother does her best, and many are much worse off; and secondly, I was deeply touched by the devotion of that little grandmother, and it struck me that when an old woman puts her wrinkled hands to such a task, we men must not let ours be idle.

. . . One finds great inner calm in a permanent relationship, and I think it in harmony with nature; whereas one transgresses the eternal moral law as soon as one tries to shirk the consequences of a relationship with a woman. My opinion is that a man who regulates his life in harmony with the eternal laws of nature as well as of morality contributes his share towards the reform and progress and amelioration of things which have become disorientated in present-day society. . . .

*

. . . Do you know what Rappard's drawing is like? It is exactly like reading a description of a factory by Zola, Daudet or Lemonnier. I underlined a passage in his letter – that about *drawing in painting*. Well, it comes to about the same thing as what I said last year to some people who told me, 'Painting is drawing in colour'. I answered, 'Exactly, and drawing in black and white is, in fact, painting in black and white.'

They said 'painting is drawing', and I said 'drawing is painting'. But my technique was then too weak for me to express it in anything but words; now I say it less in words but more silently in my work. . . .

*

To Anthon van Rappard . . . When once I *feel* – I *know* – a subject, I *usually* draw three or more *variations* of it – whether it is figure or landscape – but every time and for each one I consult nature. And I even *do my best not to give details* – for then the dreaminess goes out of it. And when Tersteeg and my brother, and others, say, 'What is this, is it grass or cabbage?' – then I answer, *Delighted* that *you* can't make it out.'

And yet they are sufficiently true to nature for the honest natives of these parts to recognize certain details which I have hardly paid any attention to; they will say, for instance, 'Yes, that's Mrs Renesse's hedge', or, 'Look, there are Van de Louw's beanpoles'. . . .

*

To Theo . . . And when one thinks how at the time there were a few persons whose character, intention and genius were rather suspect in the public's opinion – persons about whom the most absurd things were told, Millet, Corot, Daubigny, etc., who were thought of the way the village policeman views a stray shaggy dog, or a tramp without a passport – and time passes, and violà 'les cent chefs-d'oeuvre', and if a hundred are not enough, then innumerable ones. And what becomes of the policemen? Very little remains of *them* except a number of summonses as curiosities.

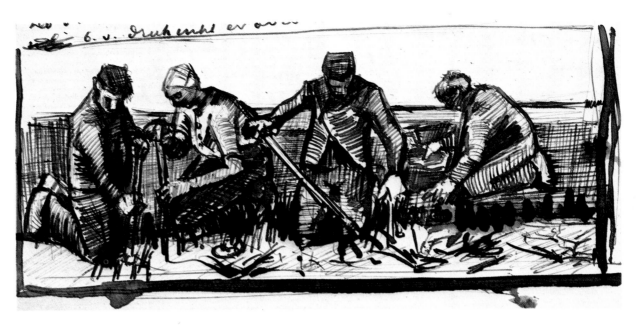

POTATO GRUBBERS, FOUR FIGURES

. . . Theo, when you come to the studio someday, I shall be able to show you a collection which you certainly won't find everywhere. I can show you something which might be called the 'Hundred Masterpieces' in wood engraving by modern artists. The work of men whose names are unknown even to most connoisseurs.

Who knows Buckman? Who knows the two Greens, and who knows Regamey's drawings? Only a very few.

Seen together, one wonders at that firmness of drawing, that personal character, that serious conception and that penetration and artistic elevation of the most ordinary figures and subjects found in the street, in the market place, in a hospital or almshouse. . . .

*

. . . As to my eventually going to London for a shorter or longer time, I quite agree with you that there would be more chance of selling my work, and I also think that I could learn a great deal if I came into contact with some artists there. And I can assure you, I should have no lack of subjects there. What beautiful things one could make at those dockyards on the Thames! . . .

*

. . . Thanks for your letter, thanks for the enclosure, though I cannot repress a feeling of sadness at your saying, 'I can give you little hope for the future.'

If you mean this only in a financial sense, I shouldn't mind it so much, but if it's in reference to my work, I don't quite understand why I deserve it. It comes just at the moment when I can send you the prints of the photographs of a few of my latest drawings which I had promised you before, but couldn't get because I had no money.

I do not know what you mean by that expression, how can I know it? Your letter is too short, but it hit me unexpectedly right in the heart.

But I should like to know what you really mean by it, whether you have noticed that I have made some progress or not.

. . . It wouldn't make me so melancholy, brother, if you hadn't added something which worries me. You say, 'Let us hope for better times.'

You see, in my opinion that is one of those things one should beware of. *To hope for better times must not be a feeling but an action in the present.* My actions depend on yours in that if you should stop sending me money, I couldn't go on and should be in a desperate position.

Just because I felt the hope for better times strongly, I threw all my strength into the present work, without thinking of the future other than to trust the work would find its wages, though we must pinch ourselves as to food, drink and clothes more and more every week. . . .

*

. . . It may be feverishness, or nerves, or something else, I don't know, but I don't feel well. Perhaps I am thinking more than is necessary about that expression in your letter concerning various things; I hope so. And I have an uneasy feeling I can't shake off, though I have tried to overcome it.

There isn't any reason for it, is there? If there is anything, then tell me straight out what kind of obstacles there are.

. . . In fact, I have no real friend but you, and when I am low in spirits, I always think of you. I only wish you were here, that we might again talk together about moving to the country.

. . . If you can't send anything at once, brother, at all events try to write me by return of mail if possible. And as to the future, if there is some danger, tell it straight out, 'homme avisé en vaut deux', it is better to know exactly what one has to fight against.

. . . And now I thought, I am sorry that I didn't fall ill and die in the Borinage that time, instead of taking up painting, for I am only a burden to you. And yet I cannot help it, for one must go through many phases to become a good painter, and what one makes in the meantime is not exactly bad if one tries one's utmost; but there ought to be people who see it in the light of its tendency and objective, and who do not ask the impossible. . . .

*

. . . Oh, Theo, the work brings its troubles and cares, but what is it in comparison to the misery of a life of inactivity?

So let's not lose courage, but comfort each other, instead of distressing or disheartening each other.

. . . Well, I hope to keep courage after all, whatever may happen, and I hope that perhaps a certain frenzy and rage for work may carry me through, like a ship is sometimes thrown over a cliff or sandbank by a wave, and can make use of a storm to save herself from wrecking. But such manoeuvres do not always succeed, and it would be desirable to avoid the spot by tacking a little. After all, if I fail, what does my loss mean? I don't care so much after all. But one generally tries to make one's life bear fruit, instead of letting it wither, and at times one feels that after all one also has a life of one's own, which is not indifferent to the way it is treated. . . .

. . . Coming home from Scheveningen just now, I find your letter, for which many thanks.

Many things in it please me. In the first place, I am glad that the darkness of the future cannot change our friendship or interfere with it; futher, I am glad that you will come soon, and that you find progress in my work.

The division of your income, directly or indirectly, among no less than six persons is certainly remarkable. But the subdivision of my 150 francs among four human beings, with all the expenses for models, drawing and painting material, house rent, is also rather remarkable, isn't it? . . .

. . . You must try to come soon, brother, for I do not know how long I shall be able to hold out. Things are getting too much for me. I feel my strength failing. I tell you plainly that under such circumstances, I am afraid I shall never hold out. My constitution would be good enough if I hadn't had to fast so long, but it was always a question of fasting or working less, and I chose the former as much as possible, till I have become too weak now. How to bear up against it? It influences my work so obviously and clearly that I don't see the way to get on. You must not speak to others about it, brother, for if certain persons knew it, they would say, 'Oh, of course it's what we foresaw and prophesied long ago.' And not only would they not help me, they would cut off all possibility for me patiently to regain my strength and to get over it. . . .

*

. . . This morning a man came who had repaired a lamp for me three weeks ago, and from whom I bought some crockery at the same time, which he forced upon me.

He came to make a row because I had just paid his neighbour and not him, and accompanied it with the customary cursing, noise, invectives, etc. I told him I would pay him as soon as I received money, but that for the moment I was absolutely without a cent, but that was just pouring oil on the fire. I begged him to leave the house, and at last I pushed him out the door; but he, perhaps having waited for this, seized me by the neck, threw me against the wall, and then flat on the floor.

Now you see, this is the kind of small misery one has to face. . . .

*

. . . When I am at work, I have an unlimited faith in art and the conviction that I shall succeed; but in days of physical prostration or when there are financial obstacles, I feel that faith diminishing, and a doubt overwhelms me, which I try to conquer by setting to work again at once. It's the same thing with the woman and the children; when I am with them and the little boy comes creeping toward me on all fours, crowing for joy, I haven't the slightest doubt that everything is right.

How often that child has comforted me. . . .

*

. . . I have sometimes wondered why I was not more of a colourist, because my temperament decidedly seems to indicate it — but up till now it has developed very poorly.

. . . Without any definite motive, I can't help adding a thought which often occurs to me. Not only did I begin drawing relatively late in life, but it may also be that I shall not live for so very many years.

. . . So I go on like an ignoramus who knows only this one thing: *'In a few years I must finish a certain work.'* I need not rush myself too much — there is no good in that, but I must work on in complete calmness and serenity, as regularly and fixedly as possible. The world concerns me only insofar as I feel a certain indebtedness and duty toward it because I have walked this earth for thirty years, and, out of gratitude, want to leave some souvenir in the shape of drawings or pictures — not made to please a certain taste in art, but to express a sincere human feeling. So this work is my aim — and when one concentrates on that one idea, everything one does is simplified in that it is not chaotic, but all done with one object in mind.

<div align="center">*</div>

. . . This is the way I regard myself — as having to accomplish something with heart and love in it within a few years, doing this with energy.

If I live longer, 'tant mieux', but I don't count on it.

Something must be done in those few years; this thought dominates all my plans for my work. You will now understand better my desire to push on. At the same time, I am certainly resolved to use simple means. And perhaps you will also understand that I do not consider my studies things made for their own sake, but am always thinking of my work as a whole. . . .

<div align="center">*</div>

. . . As to my relative coolness towards Father, I will explain that to you now that you mention it.

About a year ago, Father came to The Hague for the first time since I had left home seeking peace which I didn't find there, either. I was already living with the woman then, and said, 'Father, as I cannot blame those who disapprove of my conduct, given the prevailing conventions, I purposely avoid those whom I think would be ashamed of me. And you understand: I do not want to worry you, and as long as my affairs are not straightened out and I have not found my way, don't you think it would be better for me not to come home?'

If Father had answered something like, 'No, that's carrying things too far', I would certainly have felt more warmly toward him; but Father's answer was something between Yes and No: 'Well, you must do as you think best.'

. . . And it's true that I haven't paid the slightest attention to my clothes.

If that's the only thing, it's not so difficult to correct, is it? Especially now that I have that new suit of yours.

I just wish with all my heart that they would bear with my shortcomings, instead of gossiping about them.

. . . And now I will tell you once more what I think about selling my work. My opinion is that the best thing would be to work on until art lovers feel drawn toward it of their own accord, instead of having to praise or explain it. At all events, when they refuse it or do not like it, one must bear it calmly and with as much dignity as possible.

. . . I am awfully sorry that I am a burden to you – perhaps things will clear up – but if you stagger under it, tell me so plainly. I would rather give up everything than put too heavy a burden on your shoulders. Then I shall definitely go to London at once to work at 'n'importe quoi', even carrying parcels, and I will leave art till better times, at least the painting and having a studio.

. . . Dear brother, don't think of me as anything other than an ordinary painter who is confronted by ordinary difficulties, and do not think the worries at all unusual.

I mean, don't think of the future as a darkness or as a dazzling light; it will be better to believe in the grey.

I try to do the same, and think it wrong of myself to deviate from it. . . .

*

. . . To have patience till it turns out well, not to give up before the end, not to doubt – that is what I wish you and I together would do and continue to do. I do not know to what extent we shall have financial success if we stick to that, but I feel sure of one thing, that – *provided there is co-operation and harmony* – we shall be able to continue as long as we live, sometimes not selling anything, and having hard times, then again selling and living more comfortably. That's the long and short of it. Success depends on our will to stay together: as long as that remains, it is possible. . . .

*

. . . One of these days I shall write you a letter; I shall write it carefully and try to make it short, but say everything I think necessary. You might keep that letter then, so that in case you should meet somebody who might be induced to buy some of my studies, you could tell that man my own thoughts and intentions exactly. My thought in this being especially: one of my drawings taken separately will never give complete satisfaction in the long run, but a number of studies, however different in detail they may be, will nevertheless complement each other. In short, for the art lovers themselves it is in my opinion better to take a number of them than just a single one. As to the money, I would rather deal with an art lover who takes cheaply but regularly than with one who buys only once, even if he paid well then.

. . . We spoke about Drenthe. He [Van Rappard] is going there again one of these days, and he will go even further, namely to the fishing villages on Terschelling. Personally I should love to go to Drenthe, especially after that visit from Rappard. So much so that I have already inquired if it would be easy or difficult to move the furniture there.

. . . Once there, I think I would remain permanently in that country of heath and moorland, where more and more painters are settling down, so that perhaps, after a time, a kind of colony of painters might spring up. . . .

*

. . . I am very glad about your *revised* opinion about my work – your revised opinion tallies with Rappard's – Van der Weele also thinks there is something in my work. Personally, I believe that in every painter's life there is a period when he makes absurdities, and for myself, I think that period is already a long time behind me. Further, I think that I am making progress slowly but steadily, and that the better work I do later will cast a reflection on the work I am doing now, and will show more clearly that even now there is already some truth and simplicity in it, a manly conception and perception.

So that if you now find something in a study, you will not have to retract that opinion, and later better work will never make you indifferent to the first.

Last year Weissenbruch [a Hague painter who thought Van Gogh talented] already said something like that to me – Go your own way quietly, and in your old age, you will look back on your first studies with satisfaction. . . .

*

. . . I talked it over with her [Christina Hoornik] seriously, explaining to her fully what my situation is, that I *must* go away for my work, and *must* have a year of few expenses and some earnings, in order to make up for a past that has been rather too much for me. That I foresaw that if I stayed with her, I should very soon be unable to help her any more, and should get into debt again here, where everything is so expensive, and there would be no way out. So that, in short, she and I must be wise and separate as friends. That she must get her people to take the children, and that she must look for a job.

. . . I told her, 'Perhaps you will not be able to stay quite straight, but go as straight as possible; I will try to do the same, but I know beforehand that my course in life will be far from safe.'

So I said, 'As long as I know that you are trying your best and are not losing hold of *everything* and that you are good to the children, as you know I have been to them – if only you act so that the children always find a mother in you, though you are just a poor servant, though you are just a poor whore, with all your damned faults, you will always be *good* in my eyes. And though I do not doubt for a moment that I have the same kind of faults, I hope I shall not change in this respect, that when I see a poor woman with a swollen belly, I shall always try to do what I can to help her.' I said, 'If you were in the same condition as when I found you, well, you would find a home with me – a shelter in the storm as long as I have a piece of bread and a roof over my head; but now it is different, the storm is over, you can go straight without me, I think – well, you must try to. For my part, I must also try to find a straight path, I must work hard; you do the same.' That's the way I said it.

Oh brother, you see how it is, we would not part if we didn't have to. I repeat, we would not part if we didn't have to. Haven't we forgiven each other's faults time after time, and made it up again? We know each other so well that we can see no evil in each other. Is it love? I do not know, but there is something between us which cannot be undone. . . .

*

. . . I saw splendid figures out-of-doors – striking because of a
sober quality. A woman's breast, for instance, has that heaving movement which is quite the
opposite of voluptuousness, and sometimes, when the creature is old or sickly, arouses pity
or respect. And the melancholy which things in general have here is of a healthy kind, like
in Millet's drawings. Fortunately, the men here wear short breeches, which show the shape
of the leg and make the movements more expressive. . . .

<p style="text-align:center">*</p>

. . . I tell you, brother, I am not good from a clergyman's point
of view. I know full well that, frankly speaking, prostitutes are bad, but I feel something
human in them which prevents me from feeling the slightest scruple about associating with
them; I see nothing very wrong in them. I haven't the slightest regret about any past or
present association with them. If our society were pure and well regulated, yes, then they
would be seducers; but now, in my opinion, one may often consider them more as sisters of
charity.

And *now*, as in other periods when civilization is in a decline, the corruption of society has
turned all the relations of good and evil upside down, and one falls back logically on the old
saying, 'The first shall be last, and the last shall be first.'

Like you, I have visited 'Père Lachaise' [a Paris cemetery]. I have seen three graves of
marble, for which I have an indescribable respect. I feel the same respect before the humble
tombstone of Beranger's mistress, which I looked for on purpose (if I remember correctly,
it is in a corner behind his own), and there I particularly remembered Corot's mistress too.
Silent muses these women were, and in the emotion of those gentle masters, in the intimacy,
the pathos of their poetry, I always feel a woman's influence everywhere.

. . . As to Millet, he is, above all others, the man who has this
white light. Millet has a gospel, and I ask you, isn't there a difference between a drawing of
his and a nice sermon? The sermon becomes black by comparison, even supposing the
sermon to be good in itself. . . .

<p style="text-align:center">*</p>

. . . As I feel the need to speak out frankly, I cannot hide from
you that I am overcome by a feeling of great anxiety, depression, a 'je ne sais quoi' of
discouragement and despair more than I can tell. And if I cannot find comfort, it will be too
overwhelming.

I take it so much to heart that I do not get on better with people in general; it worries
me a great deal, because so much of my success in carrying out my work depends on it.

Besides, the fate of the woman and the fate of my poor little boy and the other child cut
my heart to shreds. I would like to help them still, and I cannot. I am at a point where
I need some credit, some confidence and warmth, and, look here, I find no confidence.
You are an exception, but it makes me feel even more how hopeless everything is just
because you have to bear the brunt of it all.

And if I look at my equipment, everything is too miserable, too insufficient, too dilapidated.
We have gloomy rainy days here, and when I come to the corner of the garret where I have
settled down, it is curiously melancholy there; through one single glass pane the light falls
on an empty colour box, on a bundle of worn-out brushes, in short, it is so curiously

melancholy that fortunately it also has a comical aspect, enough not to make one weep over it, but to take it gaily. For all that, it is very disproportionate to my plans, very disproportionate to the seriousness of my work – so here is an end of the gaiety.

 . . . It is especially this rainy weather, which we may expect to continue for months, which handicaps me so much.

And then, what shall I say? – sometimes my thoughts go this way: I have worked and economized, and yet I have not been able to avoid getting into debt; I have been faithful to the woman, and yet I had to leave her; I have hated intrigues, and yet I have neither credit nor any money. I do not think lightly of your faithful help, on the contrary, but I cannot help asking myself if I must not tell you, 'Leave me to my fate, there is no help for it; it is too much for one person, and there is no chance of getting help from any other side. Isn't that proof enough that we must give it up?'

Oh, boy, I am so melancholy – I am in a splendid country, I want to work, I absolutely need it – at the same time, I am absolutely at a loss as to how to overcome the difficulties, when I think that all my things are in a most miserable condition, and that I am here without a studio or anything, and shall be handicapped on all sides until I can mend matters. . . .

*

 . . . This morning the weather was better again, so I went out to paint. But it was impossible, I was missing four or five colours, and I came home so miserable. I am sorry to have risked myself so far without a sufficient supply. . . .

*

 . . . This once I write to you from the very remotest part of Drenthe, where I came after an endless expedition on a barge through the moors. I see no possibility of describing the country as it ought to be done; words fail me, but imagine the banks of the canal as miles and miles of Michels or Th. Rousseaus, Van Goyens or Ph. de Konincks.

Level planes or strips of different colour, getting narrower and narrower as they approach the horizon. Accentuated here and there by a peat shed or small farm, or a few meagre birches, poplars, oaks – heaps of peat everywhere, and one constantly meets barges with peat or bullrushes from the marshes. Here and there lean cows, delicate of colour, often sheep – pigs. The figures which now and then appear on the plain are generally of an impressive character; sometimes they have an exquisite charm. I drew, for instance, a woman in the barge with crêpe around her golden head-plates [traditional head-pieces worn by Frisian women] because she was in mourning, and afterward a mother with a baby; the latter had a purple shawl over her head. There are a lot of Ostade types among them; physiognomies reminding one of pigs or crows, but now and then a little figure that is like a lily among thorns. . . .

*

 . . . But as to that despairing struggle without getting light anywhere, I know how awful it is too – with all one's energy one cannot do anything, and thinks oneself crazy, or Heaven knows what. In London how often I stood drawing on the Thames Embankment, on my way home from Southampton Street in the evening, and it

came to nothing. If there had been somebody then to tell me what perspective was, how much misery I should have been spared, how much further I should be now! Well, let bygones be bygones. It has not been so. I spoke once or twice to Thijs Maris [a Hague painter]. I dared not speak to Boughton because his presence overawed me; but I did not find it there either, that help with the very *first* things, the A B C.

. . . One finds here the most wonderful types of Nonconformist clergymen, with pigs' faces and three-cornered hats. Also adorable Jews, who look uncommonly ugly amidst Millet-like types or on this naïve, desolate moor. But they are very characteristic. I travelled with a party of Jews who held theological discussions with some farmers. How is it possible for such absurdities to exist in a country like this? Why couldn't they look out of the window or smoke their pipes, or at least behave as reasonably as, for instance, their pigs, which make no disturbance whatever, though they are pigs, and are in place in these surroundings and in harmony with them. But before the clergymen of the type I saw here reach the cultural and rational level of pigs, they must improve considerably, and probably it will take ages before they arrive at this point. Now any pig is better, as far as I can see. . . .

*

. . . But I need not tell you that here on this beautiful moor I haven't the slightest longing for Paris, and I wouldn't think about it at all if it hadn't been for your letter. And I simply say this, If it must be, all right, I shall go to Paris; if it must be, all right, I shall stay on the moors.

I shall find things to paint everywhere. It is splendid here, and I think I learn to paint somewhat better while painting. And *my heart is in it*, I need not tell you that.

Besides, I believe that knowing a handicraft is the most solid profession after all, one reason more for me to stick to it. . . .

MAN PULLING
A HARROW

. . . If you hear a voice within you saying, 'You are not a painter', *then by all means paint*, boy, and that voice will be silenced, but only by working. He who goes to friends and tells his troubles when he feels like that loses part of his manliness, part of the best that's in him; your friends can only be those who themselves struggle against it, who raise your activity by their own example of action. One must undertake it with confidence, with a certain assurance that one is doing a reasonable thing, like the farmer drives his plough, or like our friend in the scratch below, who is harrowing, and even drags the harrow himself. If one hasn't a horse, one is one's own horse — many people do so here. . . .

*

. . . Some time ago you wrote me about a certain difference in our respective physiognomies. All right. And your conclusion was that I was more of a thinker. What can I say to that? I do feel in myself a faculty for thinking, but that faculty is not what I feel especially organized in me. I think myself to be something other than specially a thinker. When I think of you, I see very characteristic action, that is well and good, but also most decidedly not isolated but on the contrary accompanied by so much sentiment, and real *thought* too, that for me the conclusion is that there is more resemblance than difference between you and me. I do not say there is no difference — but having learned to know you better of late, the difference seems smaller to me than I used to think sometimes in former years.

When I consider our temperament and type of physiognomy, I find similarity, and very pronounced resemblance between, for instance, the Puritans and ourselves besides. I mean the people in Cromwell's time or thereabouts, the little group of men and women who sailed from the Old World to America in the *Mayflower*, and settled there, firmly resolved to live simple lives.

. . . And *my* aim in *my* life is to make pictures and drawings, as many and as well as I can; then, at the end of my life, I hope to pass away, looking back with love and tender regret, and thinking, 'Oh, the pictures I might have made!' But this does not exclude making what is possible, mind you. Do you object to this, either for me or for yourself?

. . . Theo, I have heard from the poor woman a few times; she seems to be doing her best, working, washing for people, going out as a charwoman.
Her writing is almost indecipherable and incoherent, she seems to regret some things in the past. The children are well and happy.

My pity and affection for her are certainly not dead, and I hope that a bond of affection may remain between us, though I do not see the possibility or the good of living together again — pity may not be love, but for all that it can be rooted deeply enough. . . .

*

. . . Now hardly a day passes that I do not make something. As practice makes perfect, I cannot but make progress; each drawing one makes, each study one paints, is a step forward. It's true, it is the same as on a road, one sees the church spire in the distance, but as the ground undulates, when one thinks one has arrived, there is another bit one had not seen at first, and which must still be covered. But one gets nearer and nearer. After a longer or shorter time, I do not know how long, I shall arrive at the point of beginning to sell. . . .

*

. . . Then be wise, you, then be calm, then be sensible, and
listen to what I tell you about the thorny little path of painting, which at first leads to all
sorts of humiliations, etc., but which for all that will eventually lead to a more lasting victory
and a more definite peace than commerce ever can give. . . .

*

. . . The entrance to the village [Zweeloo] was splendid:
enormous mossy roofs of houses, stables, sheepfolds, barns.

The broad-fronted houses here stand between oak trees of a splendid bronze. In the moss
are tones of gold green; in the ground, tones of reddish or bluish or yellowish dark lilac grey;
in the green of the cornfields, tones of inexpressible purity; on the wet trunks, tones of
black, contrasting with the golden rain of whirling, clustering autumn leaves – hanging in
loose tufts, as if they had been blown there, and with the sky glimmering through them –
from the poplars, the birches, the lime and apple trees.

The sky smooth and clear, luminous, not white, but a lilac which can hardly be deciphered,
white shimmering with red, blue and yellow in which everything is reflected, and which one
feels everywhere above one, which is vaporous and merges into the thin mist below –
harmonizing everything in a gamut of delicate grey. I didn't find a single painter in Zweeloo,
however, and people said *none* ever came *in winter*.

I, on the contrary, hope to be there *just* this winter.

. . . And in that swamp a rough figure – the shepherd – a heap
of oval masses, half wool, half mud, jostling each other, pushing each other – the flock.
You see them coming – you find yourself in the midst of them – you turn around and follow
them. Slowly and reluctantly they trudge along the muddy road. However, the farm looms
in the distance – a few mossy roofs and piles of straw and peat between the poplars.

The sheepfold is again like the silhouette of a triangle – dark. The door is wide open like
the entrance to a dark cave. Through the chinks of the boards behind it gleams the light of
the sky. The whole caravan of masses of wool and mud disappear into that cave –
the shepherd and a woman with a lantern shut the doors behind them.

That coming home of the flock in the twilight was the finale of the symphony I heard
yesterday. . . .

*

. . . What you wrote me about Serret greatly interests me.
Such a man, who finally produces something poignant as the blossom of a hard, difficult life,
is a wonder, like the black hawthorn, or better still, the gnarled old apple tree which at a
certain moment bears blossoms which are among the most delicate and most virginal things
under the sun.

When a rough man bears blossoms like a flowering plant, yes, that is beautiful to see; but before
that time *he* has had to stand a great deal of winter cold, more than those who later
sympathize with him know.

The *artist's life*, and *what an artist is*, it is all very curious – how deep it is – how infinitely
deep. . . .

*

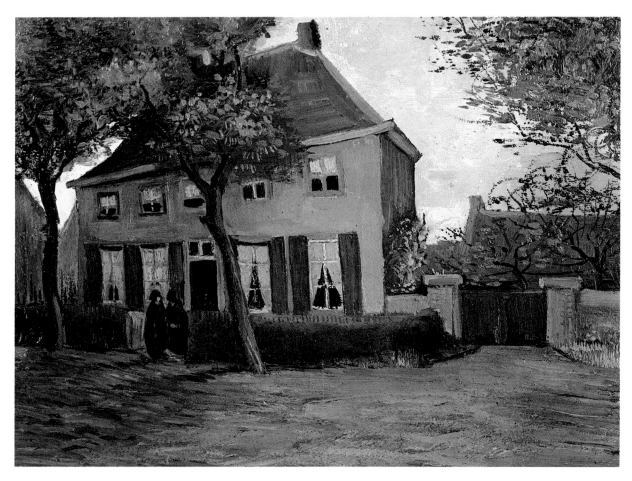

THE PARSONAGE AT NUENEN

. . . Perhaps you were rather astonished when I told you briefly that I intended to go home for a while, and that I should write you from there. But first I have to thank you for your letter of December 1, which I just now received here at Nuenen.

For the last three weeks already I have not felt quite well — all kinds of little troubles arising from having caught a cold, and also from nervousness.

One must try to conquer such a thing, and I felt it would get worse if I did not get a change.

So for several reasons I made up my mind to go home for a while. A thing which, however, I was very loath to do. . . .

*

. . . I was lying awake half the night, Theo, after I wrote you last night.

I am sick at heart about the fact that, coming back after two years' absence, the welcome home was kind and cordial in every respect, but basically there has been no change whatever, not the slightest, in what I must call the most extreme blindness and ignorance as to the insight into our mutual position. And I again feel almost unbearably disturbed and perplexed.

. . . If I had not had the same feeling at the time which I now have again, namely that notwithstanding all good intentions, notwithstanding the kindness of the reception, notwithstanding anything you like, there is a certain hardness in Father, like iron, or icy coldness – something that gives the impression of dry sand or glass or tinplate – for all his outward gentleness – if, as I said, I had not had this feeling already, I should not have resented it so much. . . .

*

. . . Look, brother, in my opinion Father is forever lapsing into *narrow*-mindedness, instead of being bigger, more liberal, broader and more humane. It was clergyman's vanity that carried things to extremes at the time; and it is still that same clergyman's vanity which will cause more disasters now and in the future.

I do not beg for your mediation, I do not beg for anything personal on your part; but I ask you point-blank how we stand – are you a 'Van Gogh' too? I have always looked upon you as 'Theo'.

In character I am rather different from the various members of the family, and essentially I am *not* a 'Van Gogh'. . . .

*

To Anthon van Rappard . . . And in case our ideas about the worthlessness of mankind were unfounded, our mistake would be all the worse for us. In my opinion the worst evil of all evils is self-righteousness, and exterminating it in ourselves is an everlasting weeding job . . . all the more difficult for us Dutchmen, as so often our very education must induce us inevitably to become highly self-righteous. . . .

*

To Theo . . . I feel what Father and Mother think of me *instinctively* (I do not say *intelligently*).

They feel the same dread of taking me in the house as they would about taking a big rough dog. He would run into the room with wet paws – and he is so rough. He will be in everybody's way. *And he barks so loud.* In short, he is a foul beast.

All right – but the beast has a human history, and though only a dog, he has a human soul, and even a very sensitive one, that makes him feel what people think of him, which an ordinary dog cannot do.

And I, admitting that I am a kind of dog, leave them alone. . . .

*

. . . I myself find in Father and Tersteeg something of the school of Delaroche, Muller, Dabuffe, and so on – I may think it clever, I may be silent about it, I may take it at its face value, I may even have a certain respect for it – but all this does not prevent my saying, The least painter or man who wrestles directly with the naked truths of nature is more than you are. . . .

*

. . . Please write me some more details about the Manet exhibition; tell me which of his pictures are there. I have always found Manet's work very original. Do you know that article of Zola's on Manet? I am sorry to have seen so very few

of his pictures. I should especially like to see his figures of nude women. I do not think it exaggerated that some people, for instance Zola, *rave* about him, although I, for my part, do not think he can be reckoned among the very first of this century. But his is a talent which *certainly* has its *raison d'être*, and that is a great thing in itself.

. . . I consider *Millet*, not Manet, to be that essentially modern painter who opened a new horizon to many. . . .

*

. . . Just listen — after having read your letter about the drawings, I at once sent you a new water-colour of a weaver, and five pen drawings. For my part I will also tell you frankly that I think it true what you say, that my work must become much better still, but at the same time, that your energy to sell them for me may become somewhat stronger too.

You have *never sold a single one for me* — neither for much nor for little — and in fact *you have not even tried*.

You see, I am not *angry* about it, but — we must call things by their names. In the long run, I would certainly not put up with that. You, on your part, can also continue to speak out frankly.

As to being saleable or unsaleable, that is an old file, on which I do not intend to blunt my teeth. Well, you see my answer is that I send you some new ones, and I will go on doing so very willingly — I ask no better.

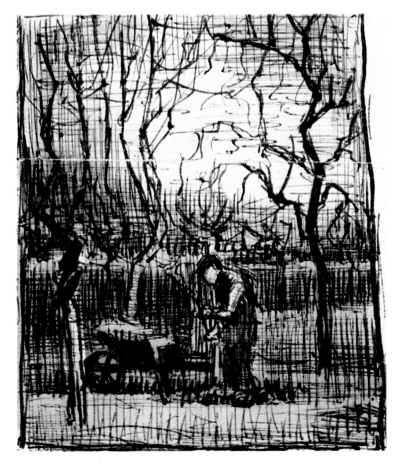

GARDENER WITH
A WHEELBARROW

. . . What I have objected to in you during the past year is your kind of relapsing into a cold respectability, which I think sterile and useless – diametrically opposed to what is action and, in particular, what is artistic.

I tell you so because I mean it, and not in order to make you wretched, but I want you to see and if possible to feel what is wrong, what makes me no longer able to think with the same pleasure of you as a brother and a friend. . . .

*

To Anthon van Rappard . . . As for me, what I intend to do – even when I have a much more thorough command of my brush than I have now – is to tell those fellows systematically *that I cannot paint*. Do you hear? – *even when* I have achieved a manner of my own, more complete and concise than the one I have now. I thought what Herkomer said when he opened his own art school – for a number of fellows *who could already paint* – was excellent; he urgently begged his pupils to be so kind as *not* to paint the way he did himself, but according to their own selves. 'What I want to do', he said, 'is to set originalities free, not to recruit disciples for Herkomer's *theory*.'

Entre lions on ne se signe pas [Lions don't ape each other].

. . . What I am saying in this letter amounts to this. Let us try to master the mysteries of technique to such an extent that people are deceived by it and will swear by all that is holy that we have *no* technique. Let our work be so savant that it seems naïve and does not stink of our sapience. . . .

*

To Theo . . . Allons, brother – I suppose you will not think it 'brotherly' of me if I class our friendship, such as it is at present, very decidedly among the things without pith and marrow – but in the past I should have been greatly worried by that question of being brotherly or not brotherly. And now – I shall not be worried by it. And I shall feel pretty indifferent to what you think of my doings. I know that for myself, just because we began as friends and with a feeling of mutual respect – I know that for myself I will not suffer its degenerating into protection – I decline to be your protégé, Theo. Why? Because! And more and more it threatens to degenerate into this.

What you say about my work is silly – I call it silly when you tell me how the Salon's jury would judge my work when I never said a syllable about sending it to the Salon – I think it silly and insipid . . . oh, there are more things I think silly and insipid. . . .

*

. . . So to cut matters short – leaving caring for each other or not out of it – can I count on it that there is a definite agreement for one year that in exchange for the work I shall supply you, I shall go on receiving the usual monthly amount? The reason why I have to know this is that, if I can definitely count on it, I shall get a more spacious apology for a studio somewhere, a studio I need in order to work from the model.

The one I have at present has the following geographical situation:

Studio immediately adjoining coal hole, sewers and dung pit, and my imagination is not strong enough to see in this an *advance* on last year's situation. However, this does not alter the fact that, as soon as I complain about something, I find passages in your letter like 'I (Theo) am of the opinion that now your situation is better than last summer' – you see? . . .

*

. . . The *laws* of the colours are unutterably beautiful, just because they are *not accidental*. In the same way that people nowadays no longer believe in fantastic *miracles*, no longer believe in a God who capriciously and despotically flies from one thing to another, but begin to feel more respect for and faith in nature – in the same way, and for the same reasons, I think that in art, the old-fashioned idea of innate genius, inspiration, etc., I do not say must be put aside, but thoroughly reconsidered, verified – and greatly modified. However, I do not deny the existence of genius, or even its being innate. But I certainly do deny the inference that theory and instruction should, as a matter of course, always be useless. . . .

*

. . . I just want to drop you a line while you are in London. Thanks for your last letter and the enclosed 150 francs.

How I should love to walk with you in London, particularly in real London weather when the City, especially in certain old parts near the river, has aspects that are very melancholy but at the same time have a remarkably striking character, which some present-day English artists have begun to make after they learned to observe and to paint from the French. But unfortunately it is very difficult to get to see that English art which is the most interesting to you and me. Generally *most* of the pictures in the exhibitions are *not* sympathetic.

I hope, however, that you will come across things here and there which will make you understand. Now I for my part have always remembered some English pictures such as 'Chill October' by Millais and, for instance, the drawings by Fred. Walker and Pinwell. Just notice the Hobbema in the National Gallery; you must not forget a few very beautiful Constables there, including 'Cornfield', nor that other one in South Kensington called 'Valley Farm'. . . .

*

. . . Oh, I am no friend of the present Christianity, though its *Founder* was sublime; the present Christianity I know only too well. That icy coldness hypnotized even me in my youth, but I have taken my revenge since – how? – by worshipping the love which they, the theologians, call *sin*, by respecting a whore, etc., and *not* respecting many would-be respectable pious ladies.

For one group *woman* is always heresy and devilish. To me it is just the reverse.

. . . I tell you, if one wants to be active, one must not be afraid of failures, one must not be afraid of making some mistakes. Many people think that they will become good by *doing no harm*; that's a lie, and you yourself used to call it a lie.

It leads to stagnation, to mediocrity.

Just dash something down when you see a blank canvas staring you in the face with a certain imbecility.

You do not know how paralysing that staring of a blank canvas is; it says to the painter, *You can't do anything*. The canvas stares at you like an idiot, and it hypnotizes some painters, so that they themselves become idiots. Many painters are afraid of the blank canvas, but the blank canvas is afraid of the really passionate painter who is daring – and who has once and for all broken that spell of 'you cannot'. . . .

*

. . . Look here now — I must paint 50 heads just for experience, because right now I am hitting my stride. As soon as possible and one after the other. I have calculated, but *without* a little extra money, it is not possible to work with that vigour which, as far as taking pains and exertion go, I would willingly spend on it. I had to buy an overcoat because I am more particular about my clothes than before, and some other things; the bills for colours also take *much* out of what I get, so that in order to carry out my plans in a short time, working at full speed (instead of half speed for economy's sake, which never can be real economy), I must manage to get an extra 100 francs. In order to win Tersteeg and Mauve over, I *must* do something decidedly energetic, having now broached the matter. Is it absolutely impossible for you to let me have it now? I *must* strike while the iron is *hot*; but dear brother and friend, *stir up the fire*.

*

. . . And every day I am more convinced that people who do not first wrestle with nature *never* succeed.

I think that if one has tried to follow the great masters attentively, one finds them all back at certain moments, deep in reality, I mean one will see their so-called *creations* in reality if one has similar eyes, a similar sentiment, as they had. And I do believe that if the critics and connoisseurs were better acquainted with nature, their judgment would be more correct than it is now, when the routine is to live only among pictures, and to compare them mutually.

. . . And what Michelangelo said in a splendid metaphor, I think Millet has said without metaphor, and Millet can perhaps best teach us to see, and get 'a faith'. When I do better work later on, I shall certainly not work *differently* than now, I mean it will be the same apple, only riper; I shall not change my mind about what I have thought from the beginning. And that's the reason why I say for my part, if I am no good now, I won't be any good later on either; but if later on, then now too. For corn is corn, though city people may take it for grass at first, and vice versa. . . .

*

. . . And I am also looking for blue all the time. Here the peasants' figures are as a rule blue. That blue in the ripe corn or against the withered leaves of a birch hedge — so that the faded shades of darker and lighter blue are emphasized and made to speak by contrast with the golden tones of reddish-brown — is very beautiful and has struck me here from the very first. The people here instinctively wear the most beautiful blue that I have ever seen.

It is coarse linen which they weave themselves, warp black, woof blue, the result of which is a black and blue striped pattern. When this fades and becomes somewhat discoloured by wind and weather, it is an infinitely quiet, delicate tone that particularly brings out the flesh colours.

Well, blue enough to react to all colours in which hidden orange elements are to be found, and discoloured enough not to jar. . . .

*

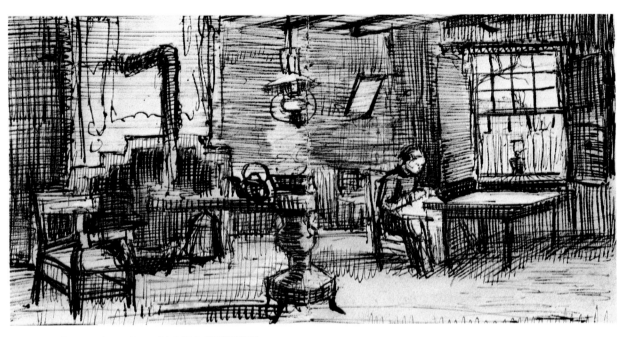

INTERIOR WITH A WOMAN SEWING

. . . Only it is an established fact that Mother is unable to grasp the idea that painting is a *faith*, and that it imposes *the duty* to disregard public opinion – and that in painting one conquers by *perseverance* and not by making *concessions* – and that 'I cannot give thee the faith' – this is exactly what is the matter between her and me – as it was with Father, and remained so. Oh dear.

Till then, I shall continue to work from the model in the evening also.

This week I intend to start that composition of those peasants around a dish of potatoes in the evening, or – perhaps I shall make daylight of it, or both, or 'neither of the two' you will say. But whether it may succeed or not, I am going to begin the studies for the various figures. . . .

*

. . . I repeat, let us paint as much as we can and be productive, *and, with all our faults and qualities, be ourselves*; I say *us*, because the money from you, which I know costs you trouble enough to get for me, gives you the right, if there is some good in my work, to consider half of it your own creation. . . .

*

. . . When the weavers weave that cloth, which I think is called Cheviot, or also the peculiar Scottish plaids, then you know their aim is, for the Cheviot, to get special broken colours and greys, and for the multicoloured chequered cloth, to make the most vivid colours balance each other so that, instead of the issue being crude, the *effet produit* of the pattern is harmonious at a distance.

A grey woven from red, blue, yellow, dirty white and black threads, a blue that is *broken* by a green, and orange-red, or yellow, thread, are quite different from *plain colours*, that is to

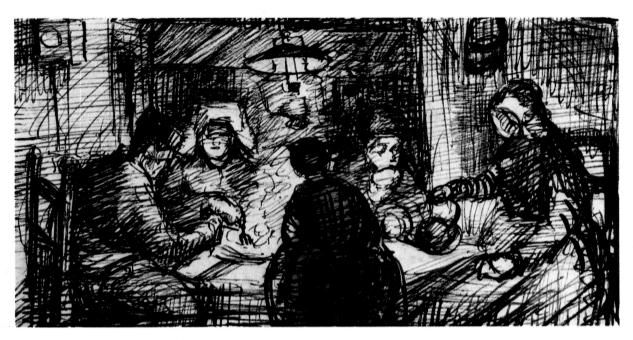

FIVE PERSONS AT A MEAL

say they are more iridescent, and primary colours become *hard*, cold and *dead* in comparison. But for the weaver, or rather the designer of the pattern or the combination of colours, it is not always easy to determine his estimation of the number of threads and their direction, no more than it is easy to blend the strokes of the brush into a harmonious whole.

If you could compare the first painted studies I made on my arrival here at Nuenen and the picture I'm now working on, I think you would see that things are getting a little more lively as to colour. . . .

. . . I have tried to emphasize that those people, eating their potatoes in the lamplight, have dug the earth with those very hands they put in the dish, and so it speaks of *manual labour*, and how they have honestly earned their food.

I have wanted to give the impression of a way of life quite different from that of us civilized people. Therefore I am not at all anxious for everyone to like it or to admire it at once.

All winter long I have had the threads of this tissue in my hands, and have searched for the ultimate pattern; and though it has become a tissue of rough, coarse aspect, nevertheless the threads have been chosen carefully and according to certain rules. And it might prove to be a real *peasant picture*. *I know it is*. But he who prefers to see the peasants in their Sunday-best may do as he likes. I personally am convinced I get better results by painting them in their roughness than by giving them a conventional charm. . . .

*

. . . I just received *Germinal*, and started to read it at once. I have read about fifty pages, which I think splendid; I once travelled through those same parts on foot.

. . . If all goes well – if I learn a little more – so that I can travel more – then I hope to go and paint the miners' heads someday.

But I shall work on till I am absolute master of my hand, so that I can work even more quickly than now, and, for instance, bring home about thirty studies within a month. I do not know if we shall earn money, but if it is only enough to let me work terribly hard, I shall be satisfied; the main thing is to do what one wants to do.

Yes, we must do the miners someday. . . .

<div align="center">*</div>

. . . Today I sent off the small box in question, containing, except what I mentioned already, another picture, *'Cimetière de Paysans'*.

I have omitted some details – I wanted to express how those ruins show that *for ages* the peasants have been laid to rest in the very fields which they dug up when alive – I wanted to express what a simple thing death and burial is, just as simple as the falling of an autumn leaf – just a bit of earth dug up – a wooden cross. The fields around, where the grass of the churchyard ends, beyond the little wall, form a last line against the horizon – like the horizon of the sea.

And now those ruins tell me how a faith and a religion mouldered away – strongly founded though they were – but how the life and the death of the peasants remains forever the same, budding and withering away regularly, like the grass and the flowers growing there in that churchyard.

'Les religions passent, Dieu demeure' ['Religions pass away, God remains'], is a saying of Victor Hugo's whom they also brought to rest recently. . . .

<div align="center">*</div>

. . . But just go and paint out-of-doors on the spot itself! then all kinds of things happen; for instance, I had to wipe off at least a hundred or more flies from the four paintings you will receive, not counting the dust and sand, not counting that when one carries them across the heath and through the hedges for several hours, some thorns will scratch them, etc. Not counting that when one arrives on the heath after some hours' walk in this weather, one is tired and exhausted from the heat. Not counting that the figures do not stand still like professional models, and the effects one wants to catch change with the progressing day.

. . . As far as I know there isn't a single academy where one learns to draw and paint a digger, a sower, a woman putting the kettle over the fire or a seamstress. But in every city of some importance there is an academy with a choice of models for historical, Arabic, Louis XV, in short, *all really nonexistent figures.*

. . . I ask you, do you know a single digger, a single sower in the old Dutch school??? Did they ever try to paint a 'labourer'? Did Velasquez try it in his water carrier or types from the people? No.

The figures in the pictures of the old masters do not *work.* I am drudging just now on the figure of a woman whom I saw digging for carrots in the snow last winter.

. . . Tell Serret that *I should be desperate if my figures were correct*, tell him that I do not want them to be academically correct, tell him that I mean: if one photographs a digger, *he certainly would not be digging then*. Tell him that I adore the figures by Michelangelo though the legs are undoubtedly too long, the hips and the backsides too large. Tell him that, for me, Millet and Lhermitte are the real artists for the very reason they do not paint things as they are, traced in a dry analytical way, but as *they* – Millet, Lhermitte, Michelangelo – feel them. Tell him that my great longing is to learn to make those very incorrectnesses, those deviations, remodellings, changes in reality, so that they may become, yes, lies if you like – but truer than the literal truth. . . .

*

. . . Let me give you this hint: don't consider this painting business of mine a burden, and don't treat it in a stepmotherly way, because it may prove to be *a little lifeboat* when the big ship is wrecked. My hint is now, and will be in the future: Let's try and keep the little boat trim and seaworthy, whether the tempest comes, or my uneasiness proves unfounded. At present I am a tiny vessel which you have in tow, and which at times will seem to you so much ballast. . . .

*

. . . I am now busy painting still lifes of my birds' nests, four of which are finished; I think some people who are good observers of nature might like them because of the colours of the moss, the dry leaves and the grasses. . . .

*

BIRD'S NEST

. . . I have been to Amsterdam this week. I hardly had time to see anything but the museum. I was there three days, I went on Tuesday and came back on Thursday. The result is that I am *very* glad that I went in spite of the cost, and I made up my mind not to go so long without seeing pictures again.

. . . I do not know whether you remember the one to the left of the 'Night Watch', as pendant of 'The Syndics', there is a picture (unknown to me till now) by Frans Hals and P. Codde, about twenty officers full length [the so-called 'Lean Company']. Did you ever notice that??? that alone – that one picture is worth the trip to Amsterdam – especially for a colourist. There is a figure in it, the figure of the flag-bearer, in the extreme left corner, right against the frame – that figure is in grey, from top to toe, I shall call it pearl-grey – of a peculiar neutral tone, probably the result of orange and blue mixed in such a way that they neutralize each other – by varying that keynote, making it somewhat lighter here, somewhat darker there, the whole figure is as if it were painted with one same grey. But the leather boots are of a different material than the leggings, which differ from the folds of the trousers, which differ from the waistcoat – expressing a different material, differing in relation to colour – but all one family of grey. But just wait a moment!

Now into that grey he brings blue and orange – and some white; the waistcoat has satin bows of a divine soft blue, sash and flag orange – a white collar.

Orange, 'blanc', bleu, as the national colours were then – orange and blue, side by side, that most splendid colour scale, against a background of a grey, cleverly mixed by uniting just those two, let me call them poles of electricity (speaking of colours though) so that they annihilate each other against that grey and white. Further, we find in that picture – other orange scales against that grey and white. Further, we find in that picture – other orange scales against another blue, further the most beautiful blacks against the most beautiful whites; the heads – about twenty of them, sparkling with life and spirit, and a technique! a colour! the figures of all those people superb and full size.

But that orange blanc blue fellow in the left corner . . . I seldom saw a more divinely beautiful figure. It is unique.

. . . Bürger has written about Rembrandt's 'Jewish Bride', just as he wrote about van der Meer of Delft, as he wrote about 'The Sower' by Millet, as he wrote about Frans Hals, with devotion, and surpassing himself. 'The Syndics' is perfect, is the most beautiful Rembrandt; but 'The Jewish Bride' – not ranked so high, what an intimate, what an infinitely sympathetic picture it is, painted d'une main de feu. You see, in 'The Syndics' Rembrandt is true to nature, though *even there*, and always, he soars aloft, to the very highest height, the infinite. But Rembrandt could do more than that – if he did not have to be *literally* true, as in a portrait, when he was free to *idealize*, to be poet, that means Creator. That's what he is in 'The Jewish Bride'. How Delacroix would have understood that picture. What a noble sentiment, infinitely deep.

'Il faut être mort plusieurs fois pour peindre ainsi' [One must have died several times to paint like that], how true it is here. As to the pictures by Frans Hals – he always remains on *earth* – one can speak about them. Rembrandt is so deeply mysterious that he says things for which there are no words in any language. Rembrandt is truly called *magician* . . . that's not an easy calling. . . .

*

. . . What struck me most on seeing the old Dutch pictures again is that most of them *were painted quickly*, that these great masters, such as a Frans Hals, a Rembrandt, a Ruysdael and so many others – dashed off a thing from the first stroke and did not retouch it so very much.

. . . It is a bad thing for me when they say I have 'no technique'; it is possible that this will blow over, as I make no acquaintances among the painters; it is true that, on the contrary, *those who talk most about* technique are in my eyes weakest in it! . . .

*

. . . A portrait by Courbet is much truer – manly, free, painted in all kinds of beautiful deep tones of red-brown, of gold, of colder violet in the shadow with black as repoussoir, with a little bit of tinted white linen, as a rest for the eye – finer than a portrait by whomever you like, who has imitated the colour of the face with horrible punctilious *precision*.

A man's head or a woman's head, well observed and at leisure, is divinely beautiful, isn't it? Well, one loses that *general harmony* of tones in nature by painfully exact imitation; one keeps it by recreating in a parallel colour scale which may be not exactly, or even far from exactly, like the model.

. . . Here is another example: suppose I have to paint an autumn landscape, trees with yellow leaves. All right – when I conceive it as a symphony in yellow, what does it matter if the fundamental colour of yellow is the same as that of the leaves or not? It matters *very little*.

Much, everything depends on my perception of the infinite variety of tones of one *same family*.

. . . I'll write again soon, and I am sending this letter in haste to tell you that I was quite pleased with what you say about black.

*

SOWER (AFTER MILLET)

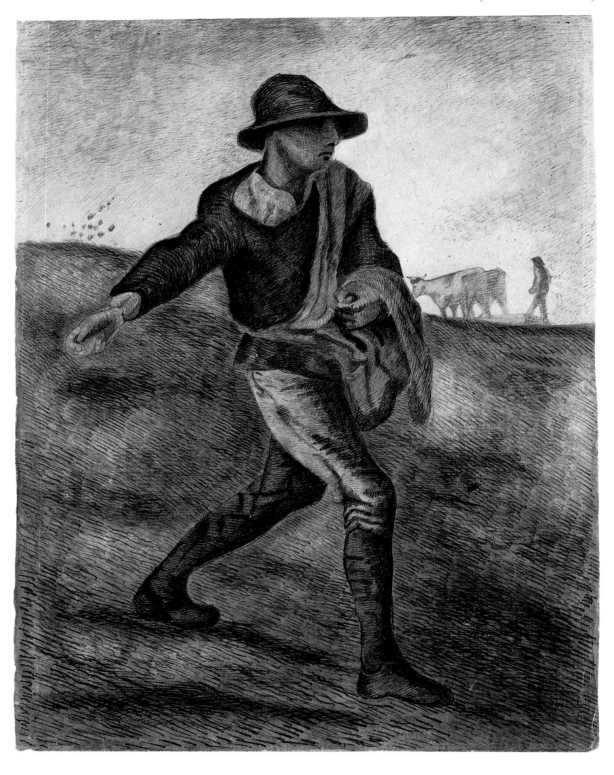

DIGGER

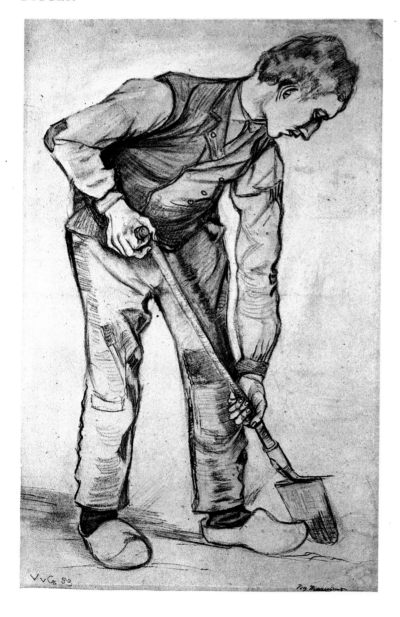

BOY CUTTING GRASS WITH A SICKLE

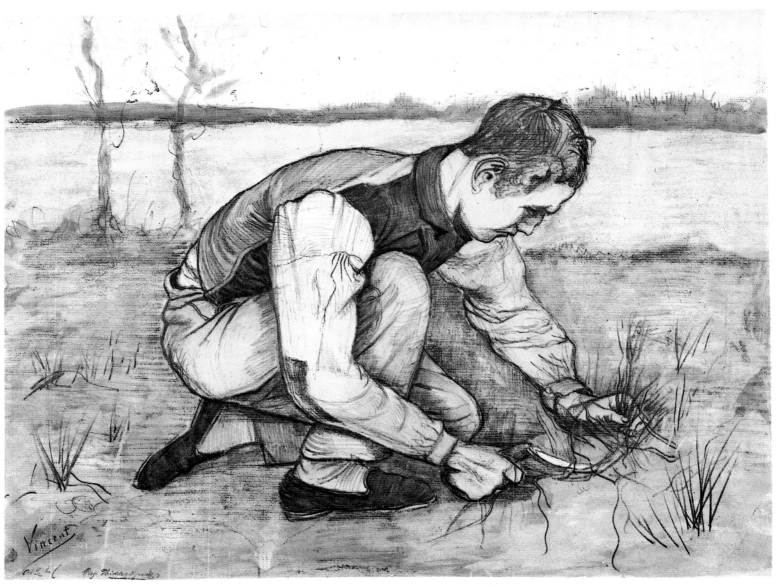

MARSH

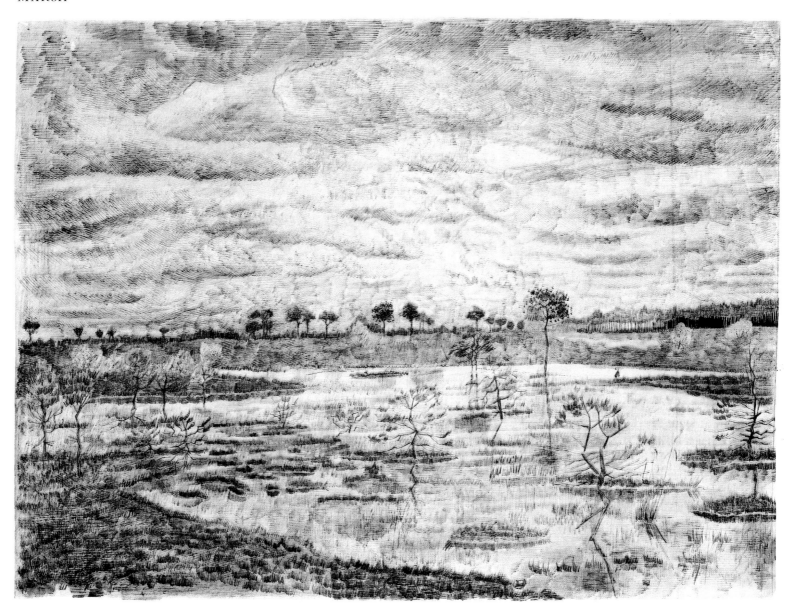

ORCHARD

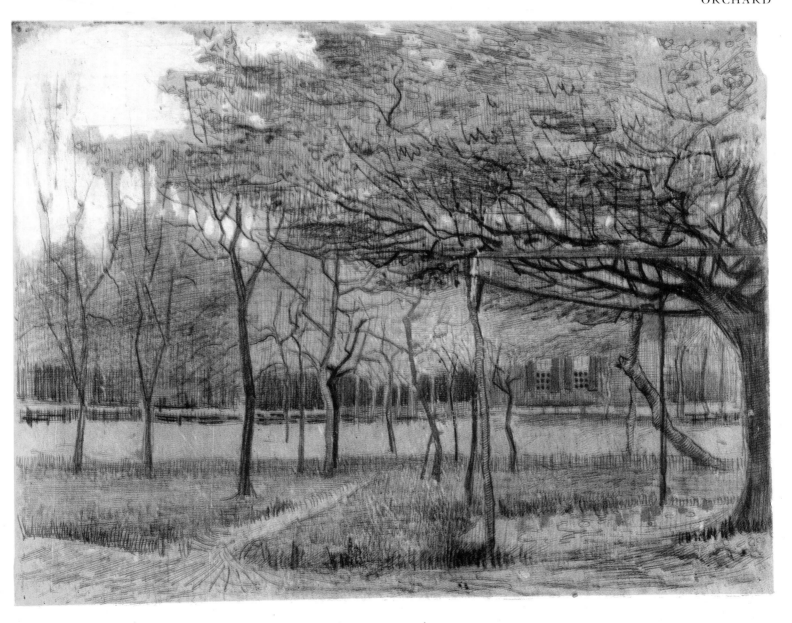

STILL-LIFE WITH CABBAGE AND CLOGS

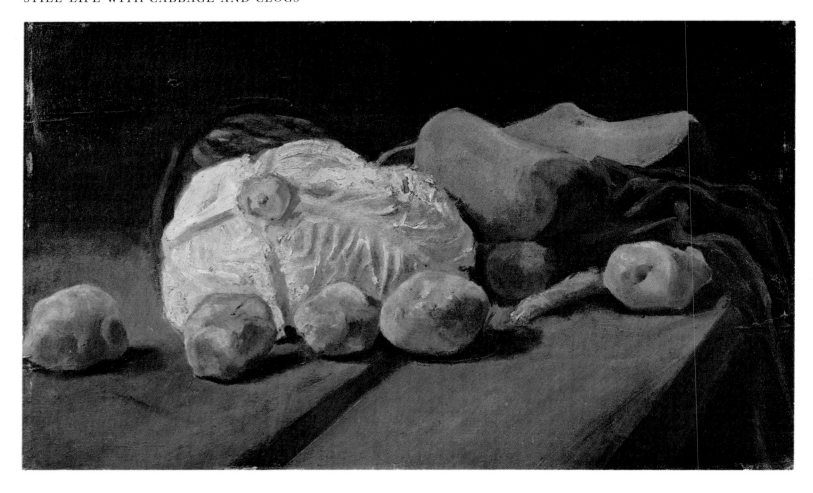

MOTHER AT THE CRADLE AND CHILD SITTING ON THE FLOOR

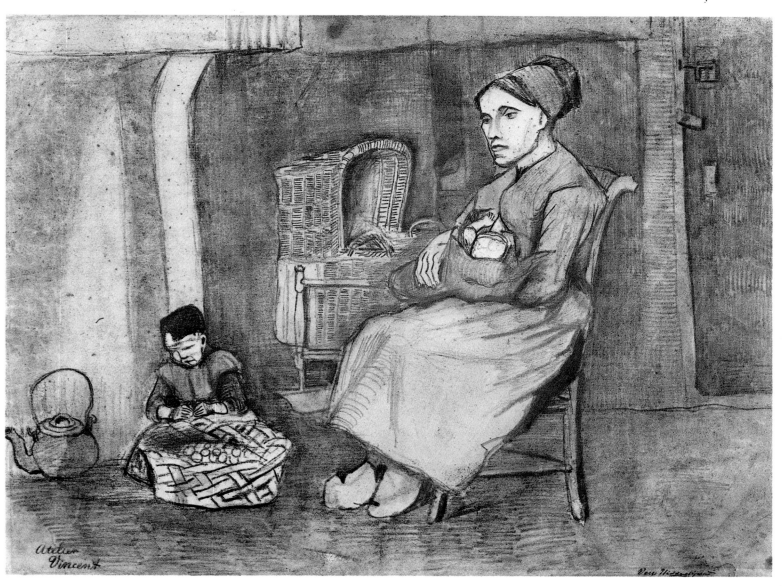

OLD WOMAN SEEN FROM BEHIND

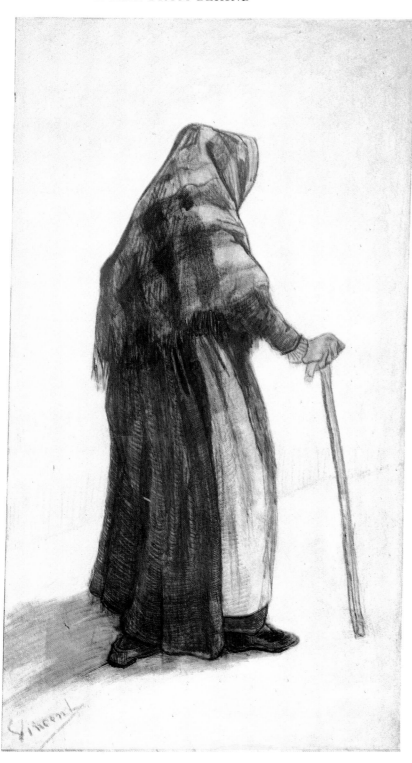

TORN-UP STREET WITH DIGGERS

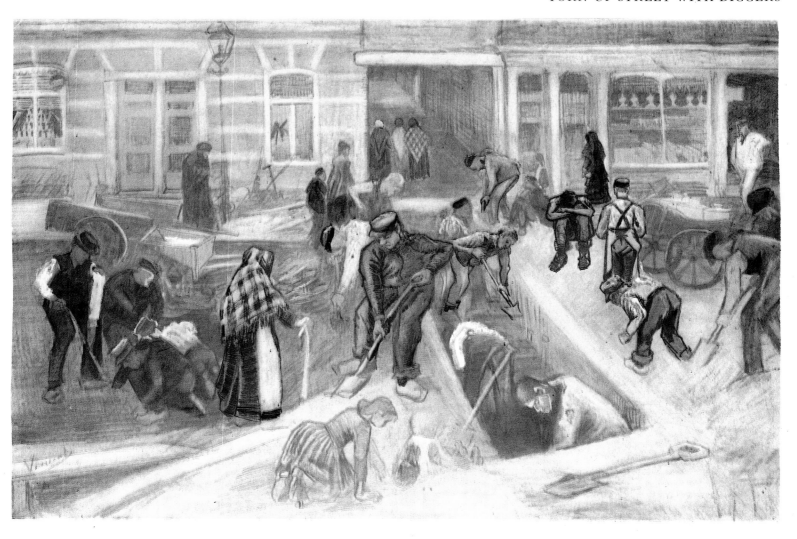

COUNTRY ROAD IN LOOSDUINEN NEAR THE HAGUE

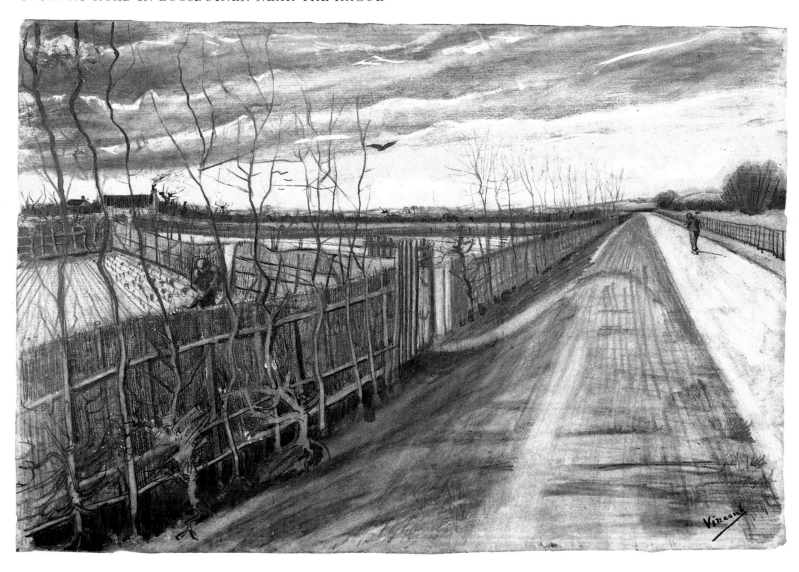

STUDY OF A TREE

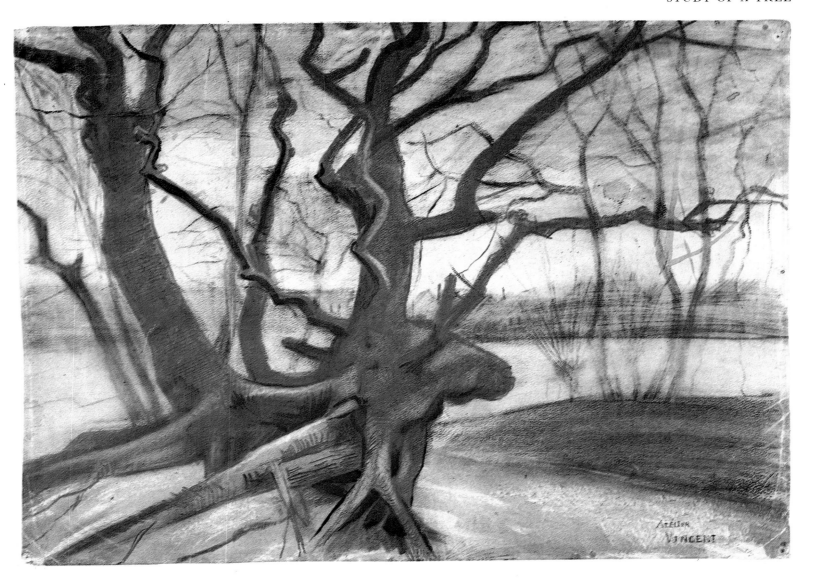

'SORROW' (SIEN)

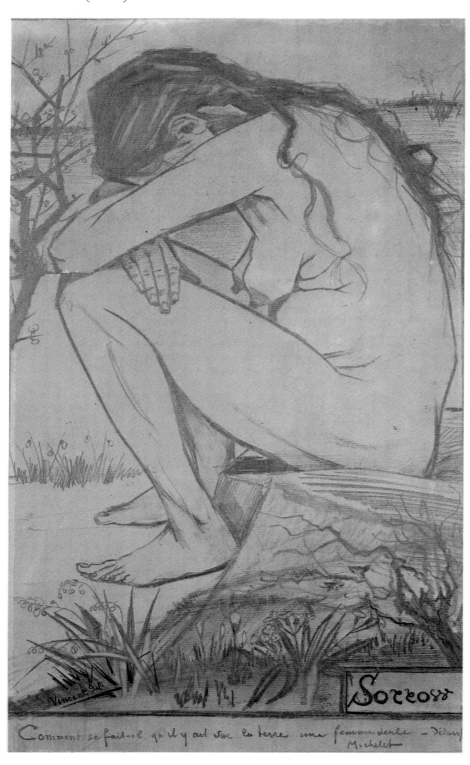

BEACH WITH FIGURES AND SEA WITH A SHIP

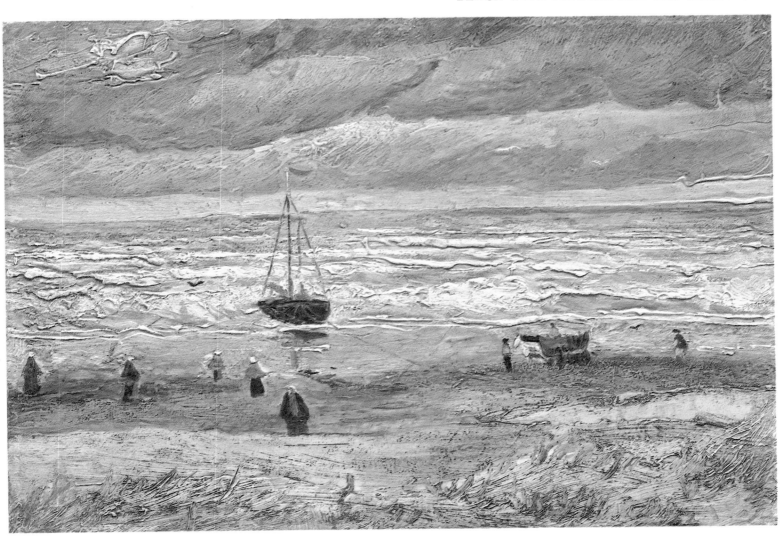

WOMEN MINERS

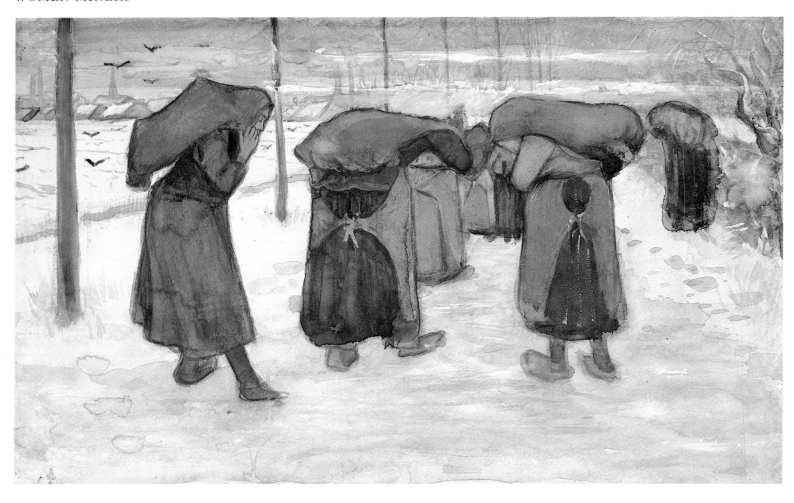

OLD MAN WITH HIS HEAD IN HIS HANDS, HALF-FIGURE

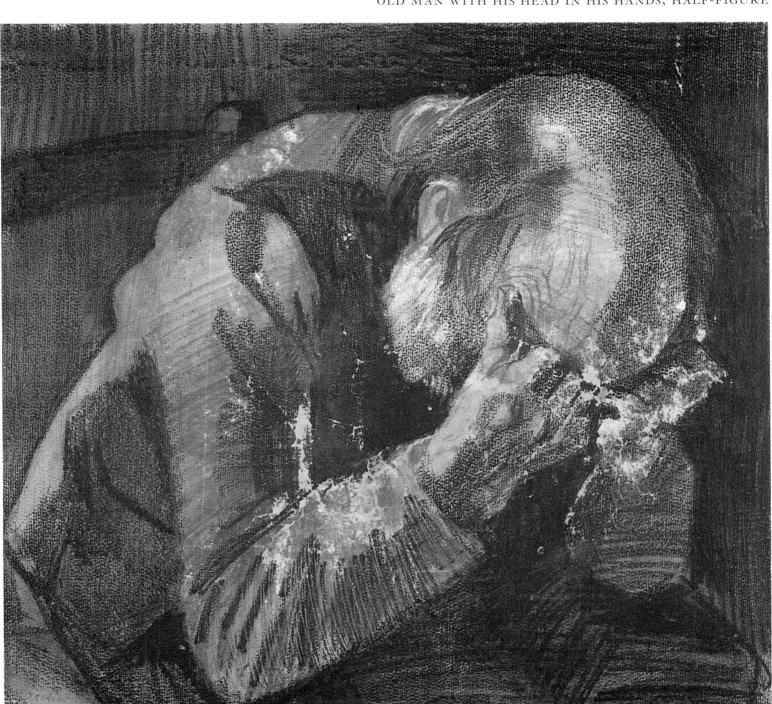

THE STATE LOTTERY OFFICE

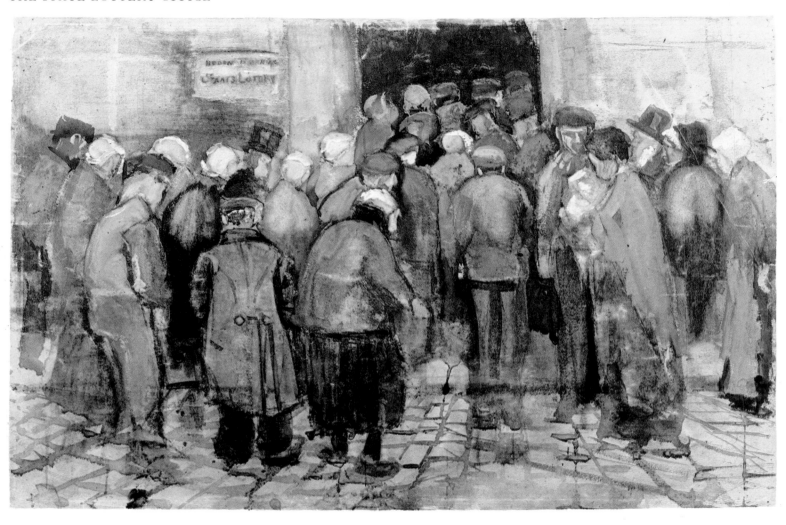

ORPHAN MAN WITH LONG OVERCOAT,
GLASS AND HANDKERCHIEF

ORPHAN MAN WITH TOP HAT AND STICK,
SEEN FROM BEHIND

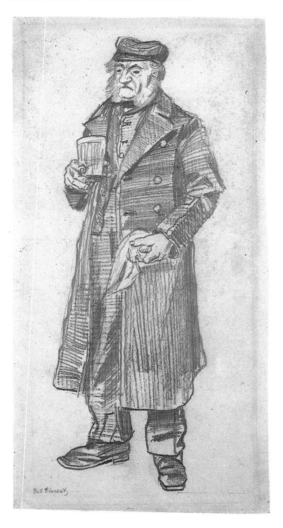

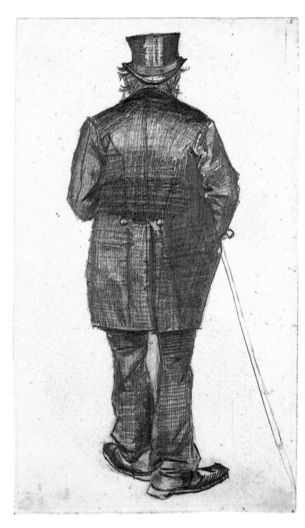

DIGGER

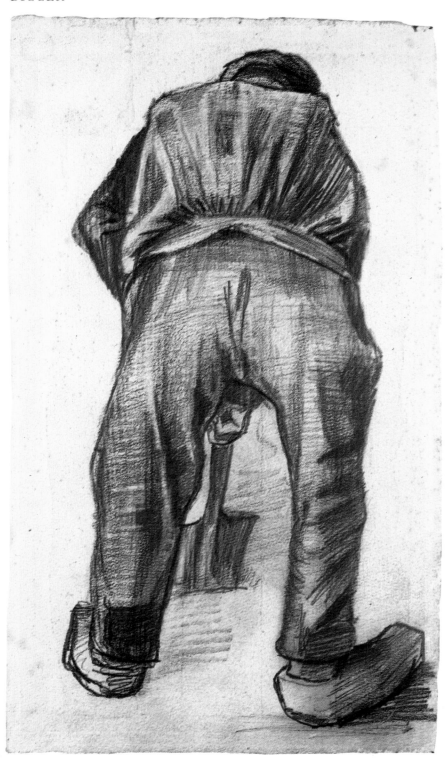

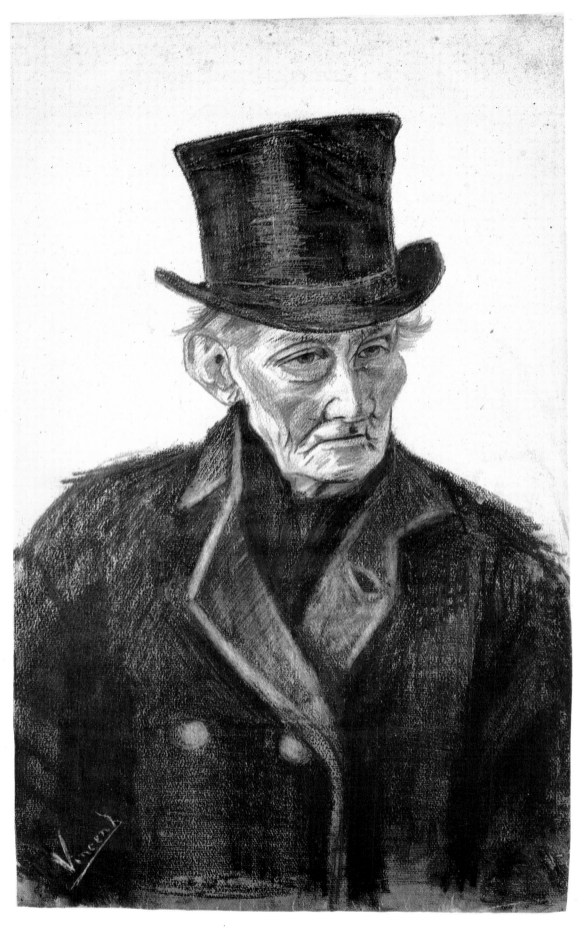

WOMAN, BAREHEADED (SIEN'S MOTHER?), HEAD

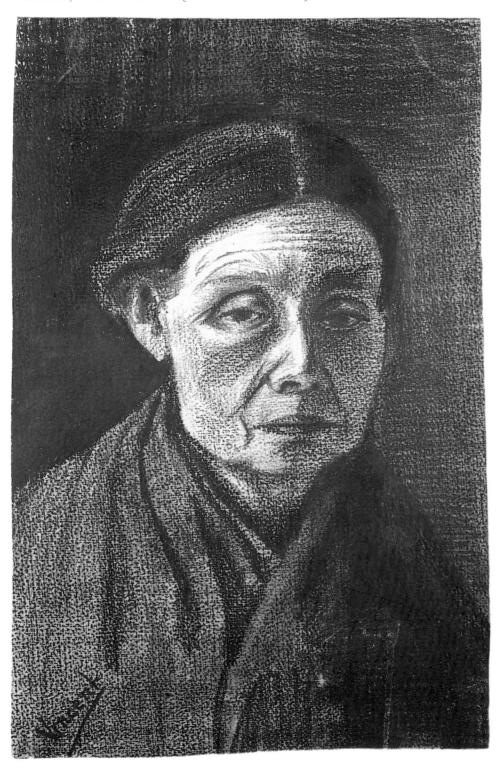

The Hague/March 1883

WOMAN SITTING ON A BASKET, HEAD IN HANDS

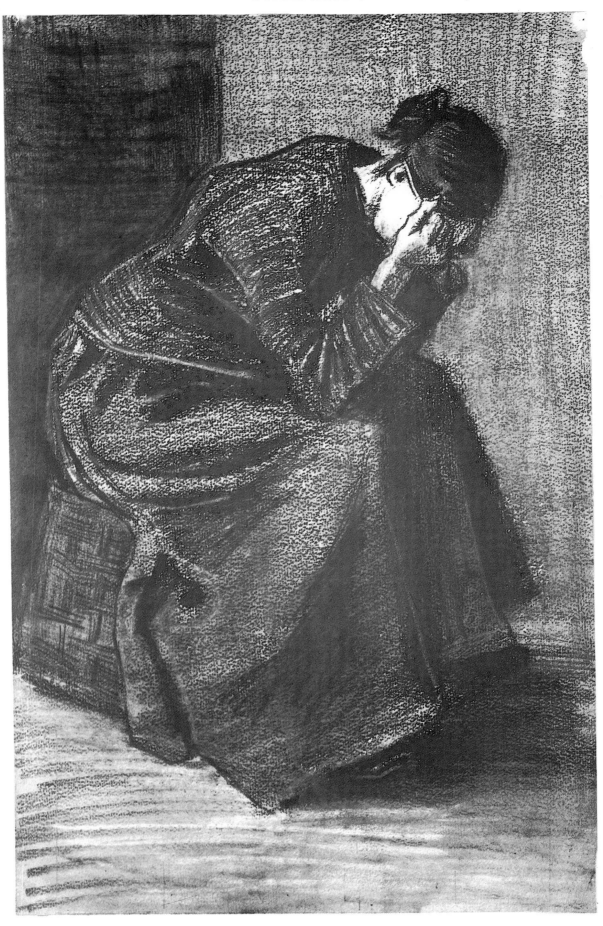

BABY

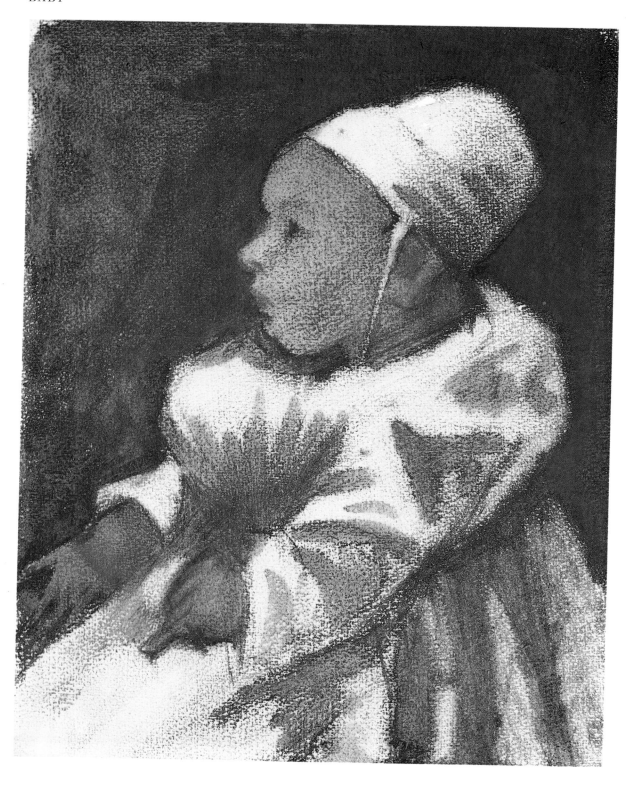

POTATO FIELD IN THE DUNES

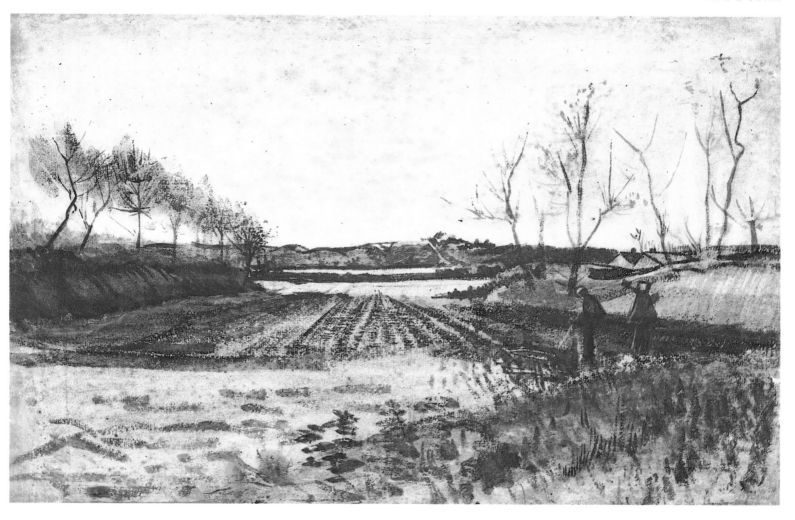

FARMS

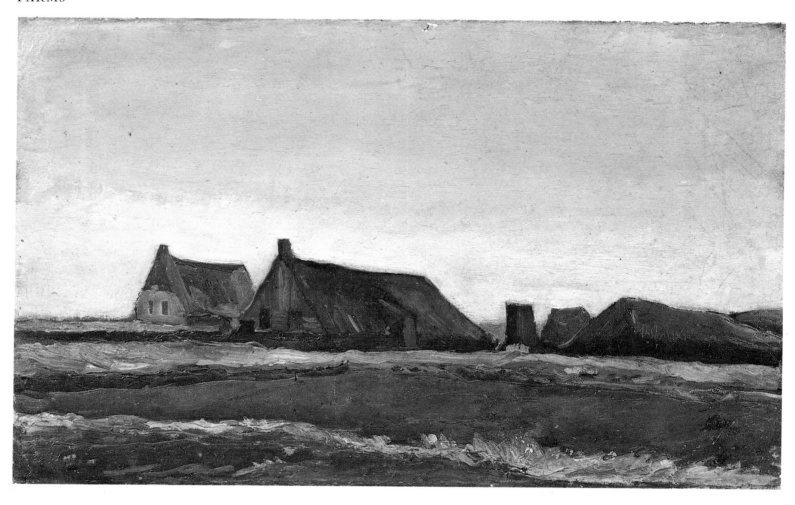

LANDSCAPE AT NIGHTFALL

TWO WOMEN WORKING IN THE PEAT

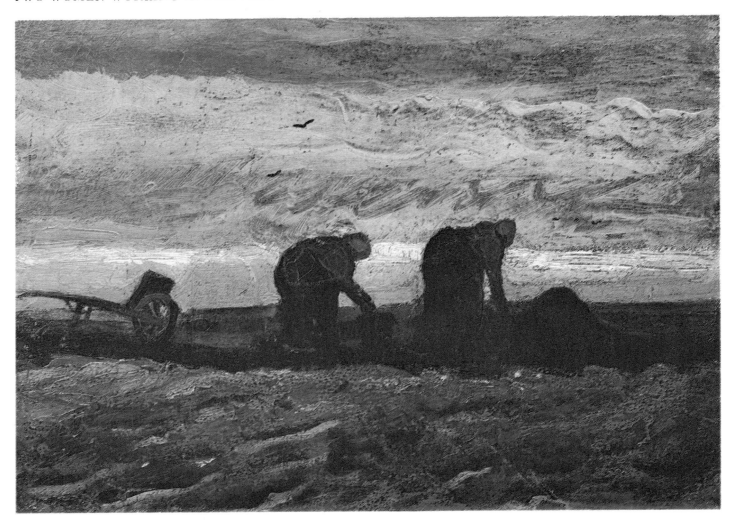

PEAT BOAT WITH TWO FIGURES

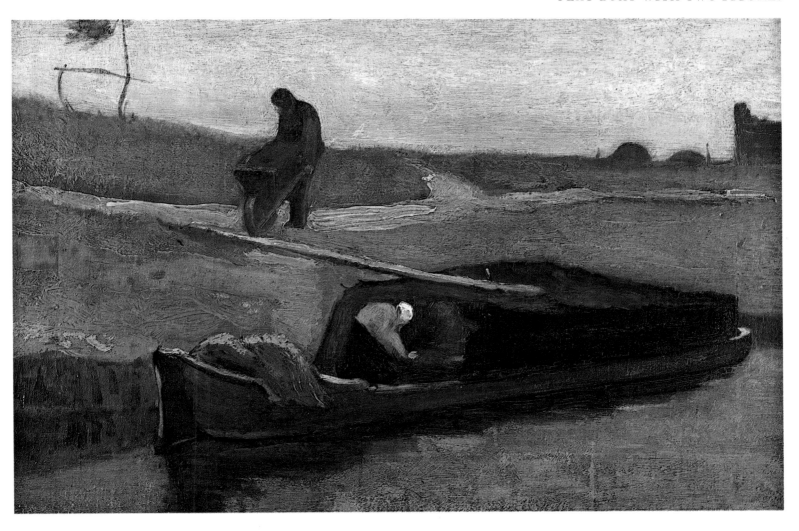

BEHIND THE HEDGES

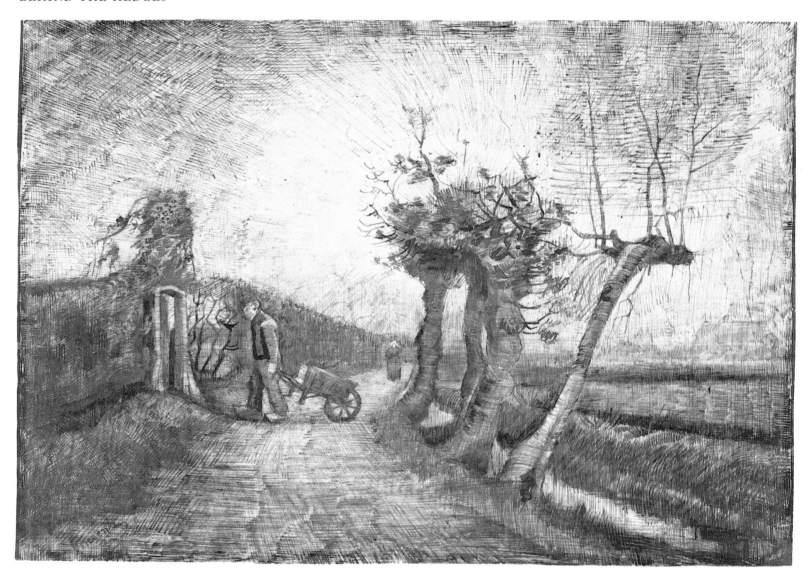

POLLARDED BIRCHES WITH WOMAN AND FLOCK OF SHEEP

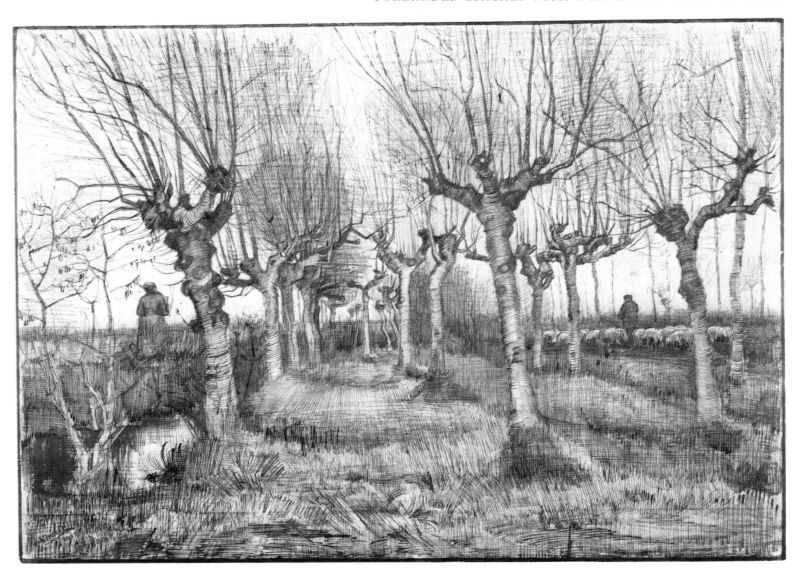

WEAVER, INTERIOR WITH THREE SMALL WINDOWS

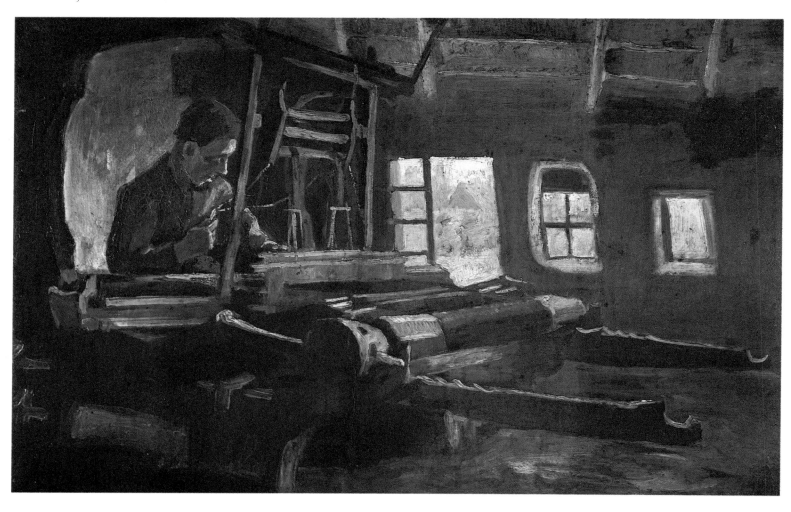

WEAVER, SEEN FROM THE FRONT

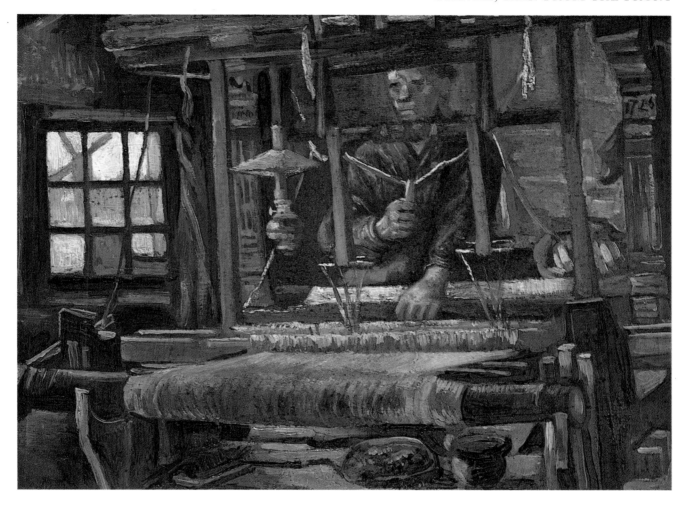

LANE OF POPLARS AT SUNSET

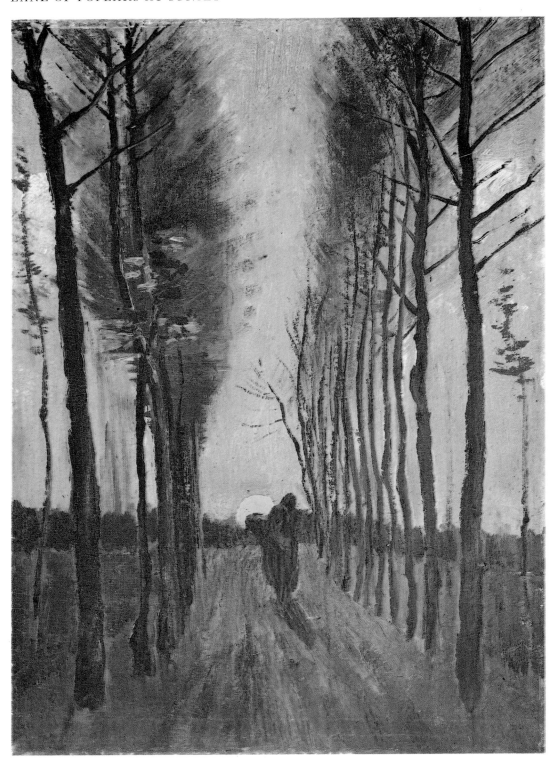

PEASANT WOMAN, HEAD

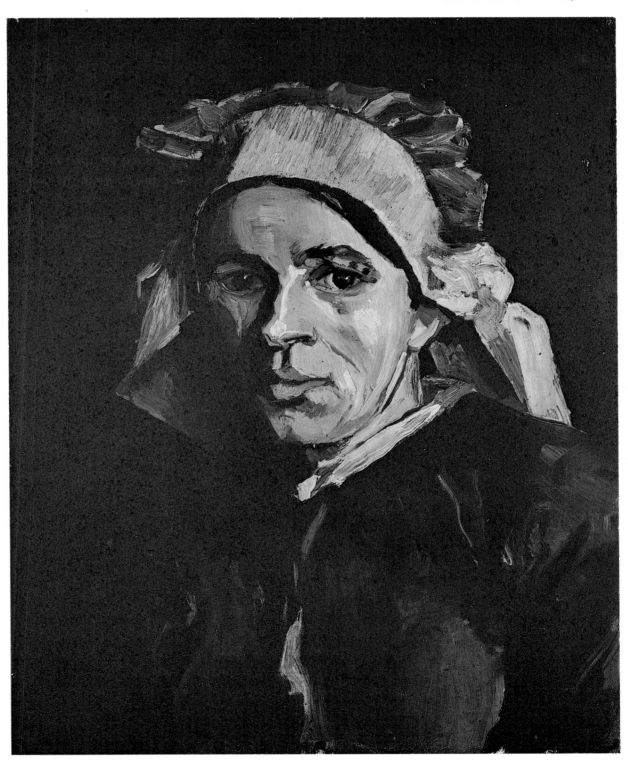

PEASANT, HEAD

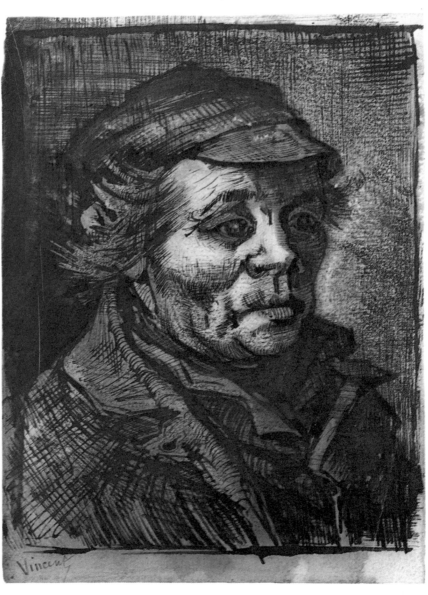

PEASANT WOMAN, HEAD

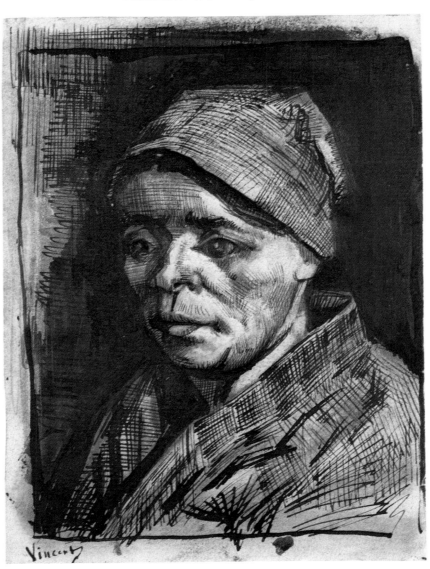

THE OLD TOWER IN THE SNOW

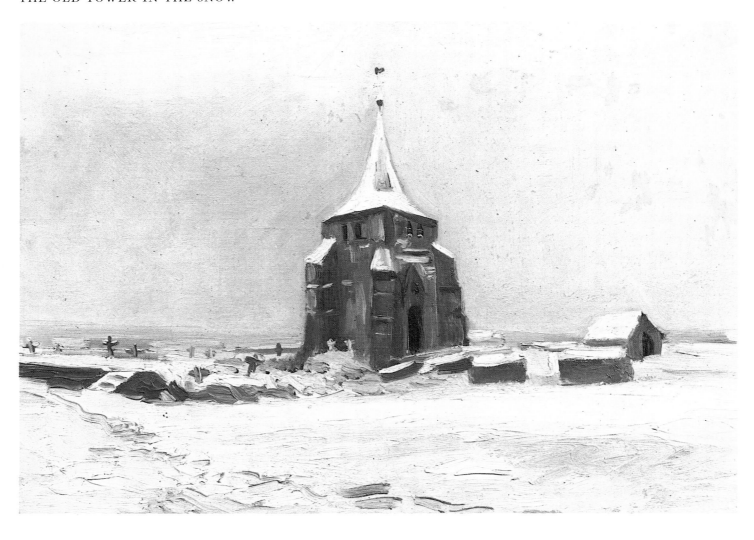

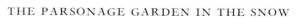

THE PARSONAGE GARDEN IN THE SNOW

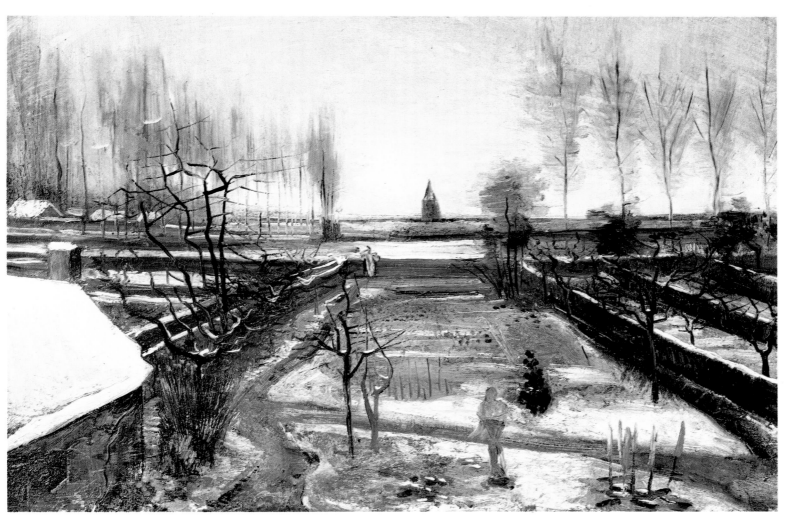

HANDS

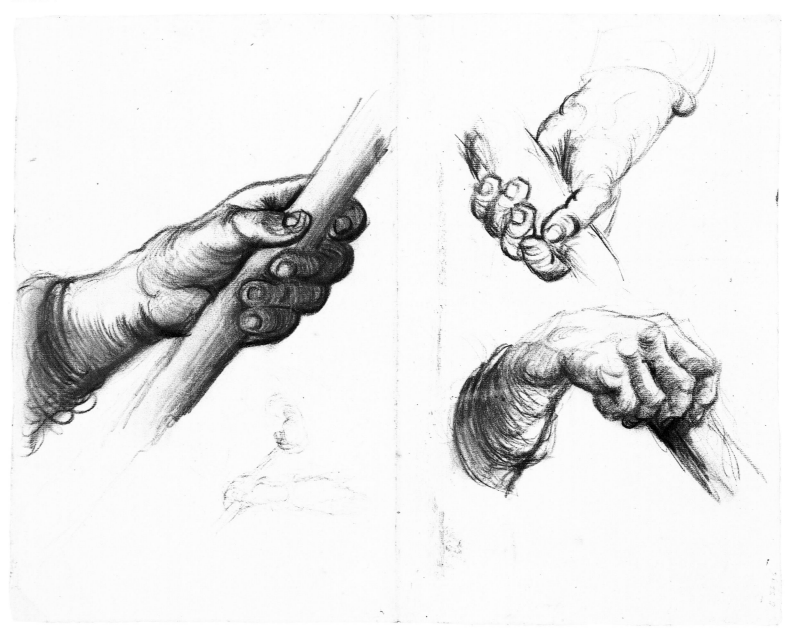

TWO HANDS

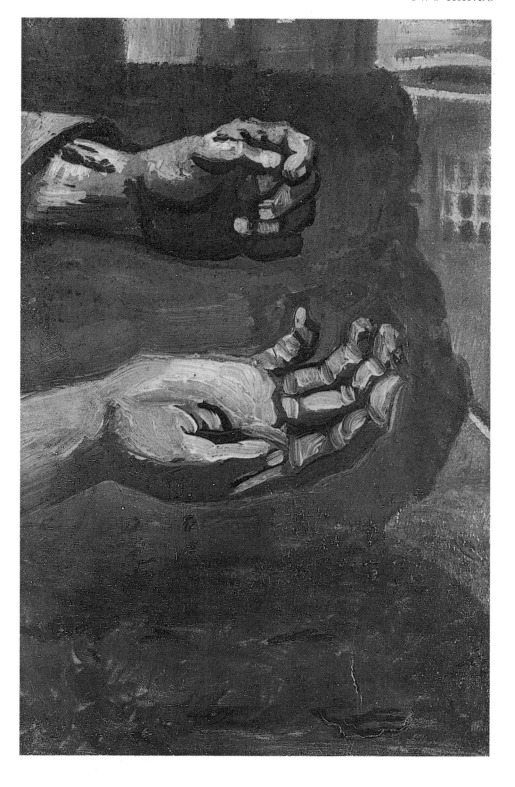

HANDS IN REPOSE

STUDIES OF A DEAD SPARROW

PEASANT, HEAD

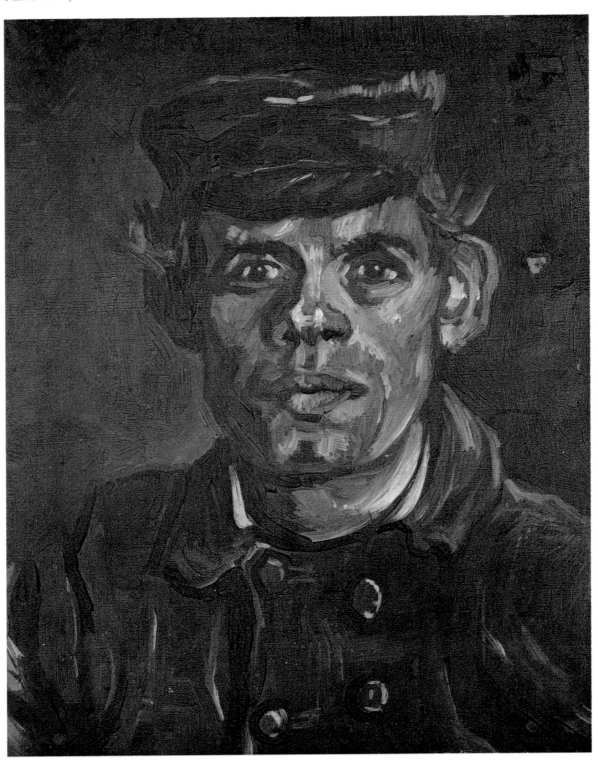

SKETCHES OF THE OLD TOWER AND FIGURES

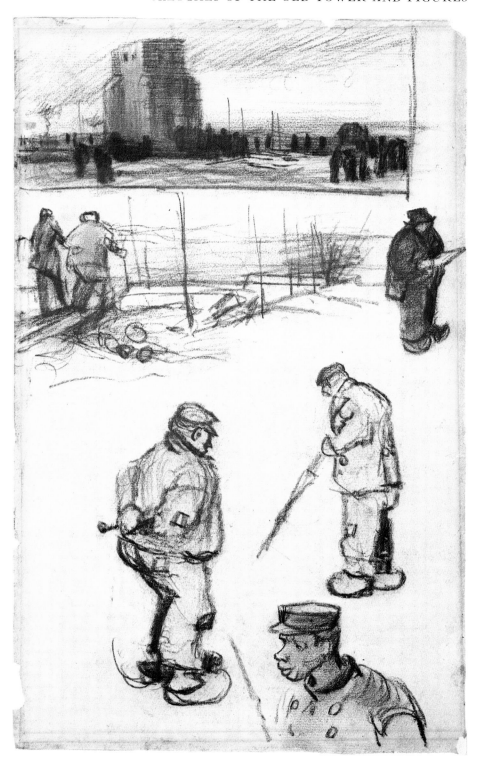

PEASANT WOMAN, HEAD

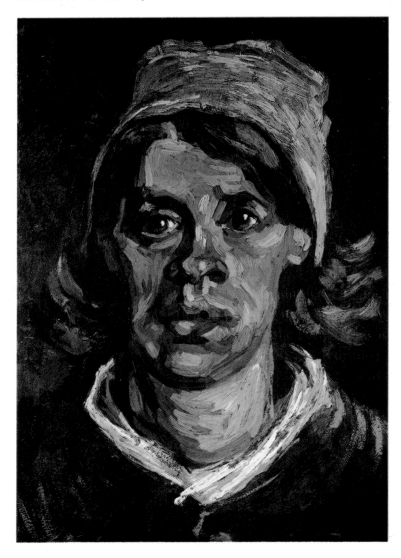

FIVE PERSONS AT A MEAL (THE POTATO EATERS)

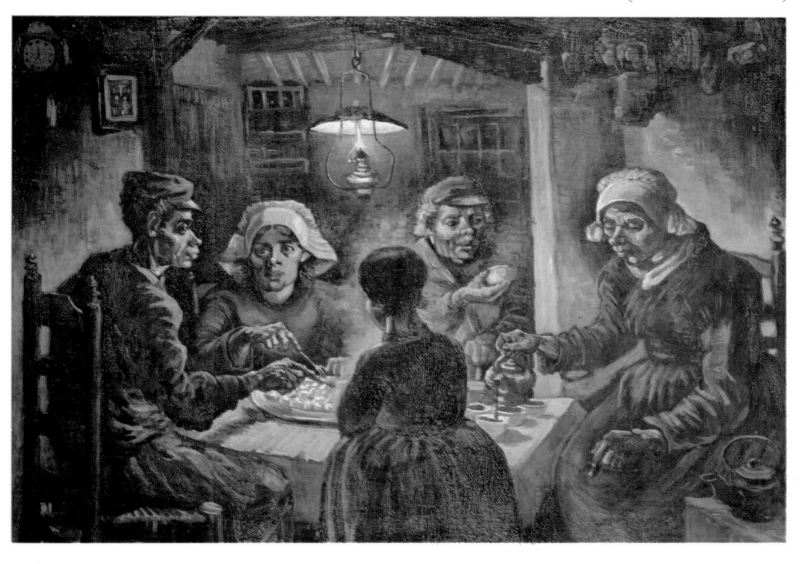

AUCTION OF CROSSES NEAR THE OLD TOWER

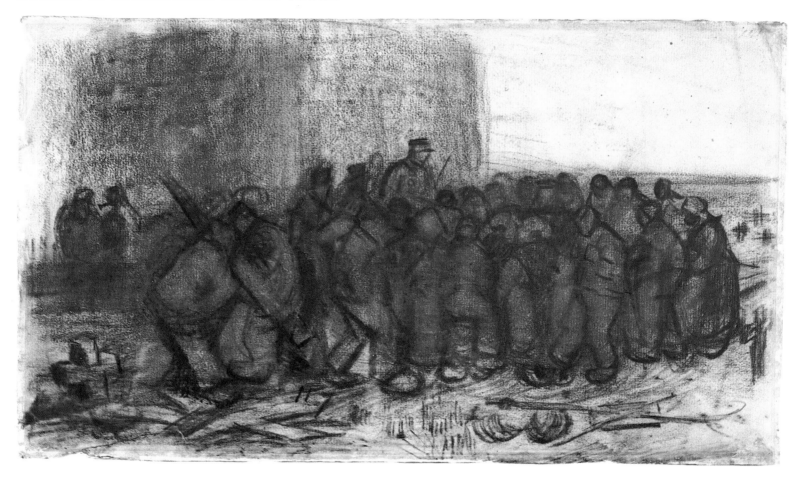

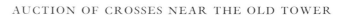

AUCTION OF CROSSES NEAR THE OLD TOWER

PLATE, KNIVES AND KETTLE

PEASANT

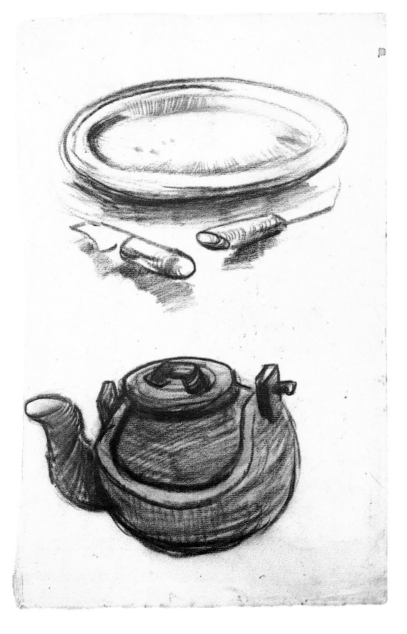

PEASANT WOMAN, SITTING BY THE FIRE

COTTAGE WITH DECREPIT BARN AND STOOPING WOMAN

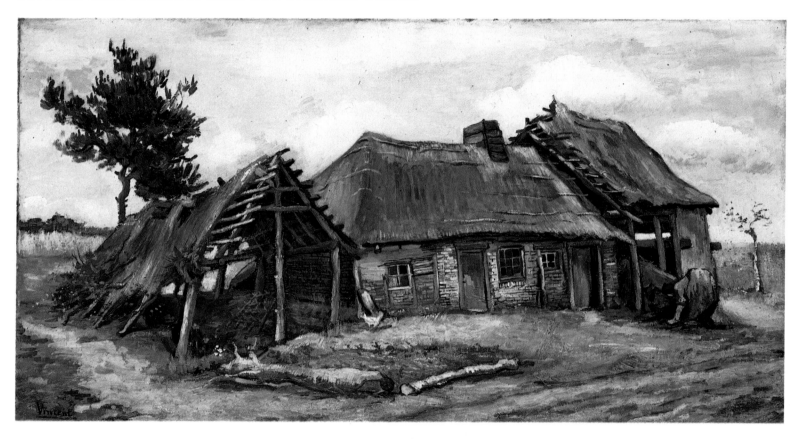

TWO PEASANT WOMEN, DIGGING

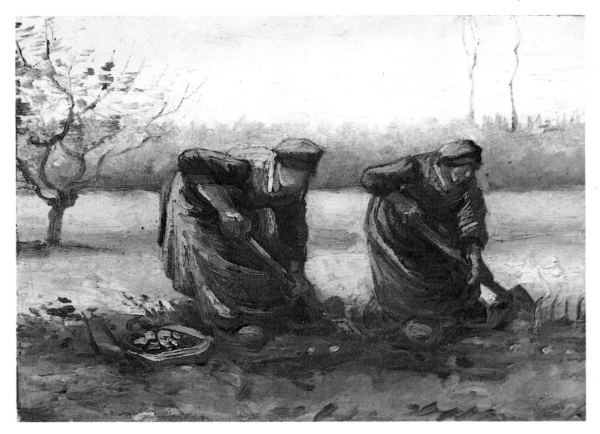

PEASANT WOMAN, STOOPING AND GLEANING

PEASANT WOMAN, DIGGING

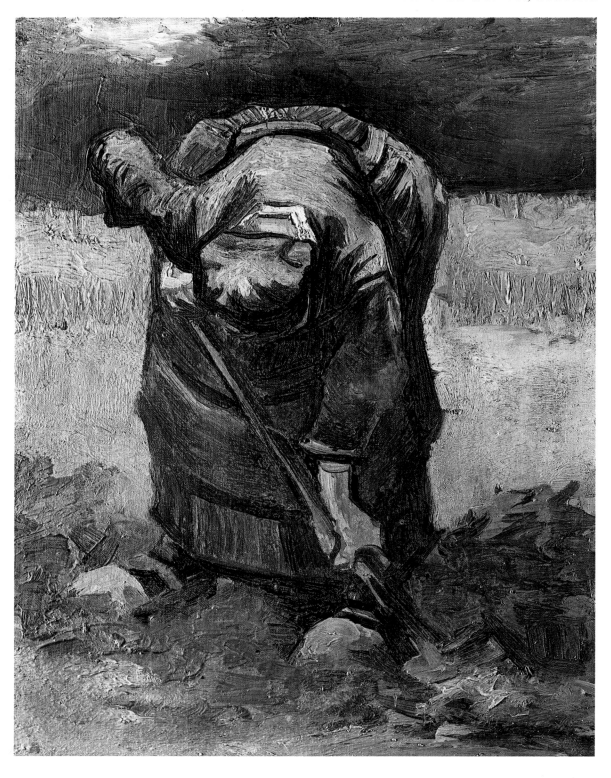

SHORT-LEGGED MAN WITH FROCK COAT

OLD PEASANT WOMAN WITH SHAWL OVER HER HEAD

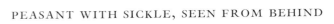

PEASANT WITH SICKLE, SEEN FROM BEHIND

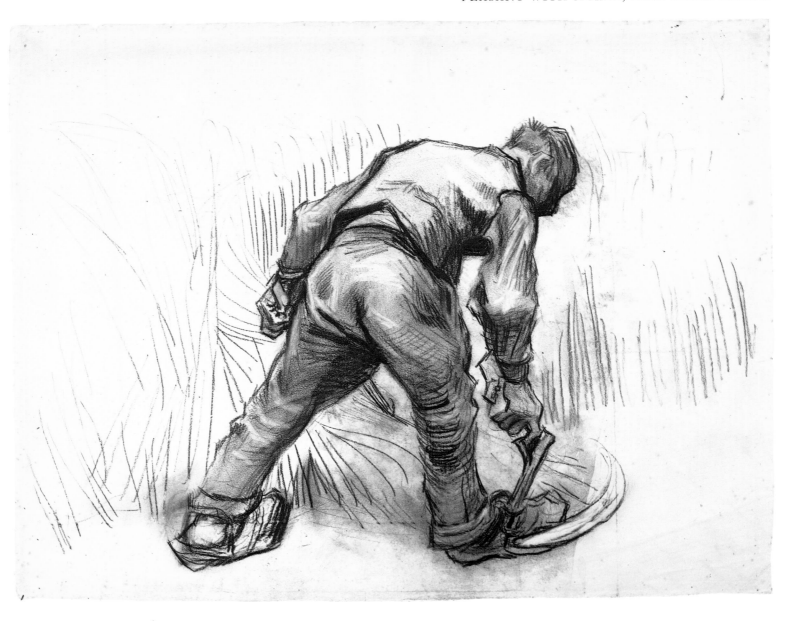

STILL-LIFE WITH A BASKET OF POTATOES

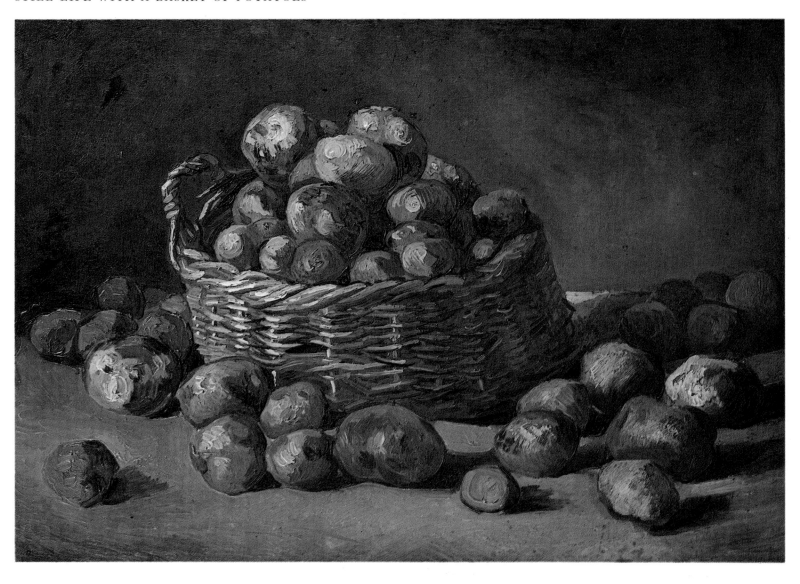

STILL-LIFE WITH AN EARTHEN BOWL WITH POTATOES

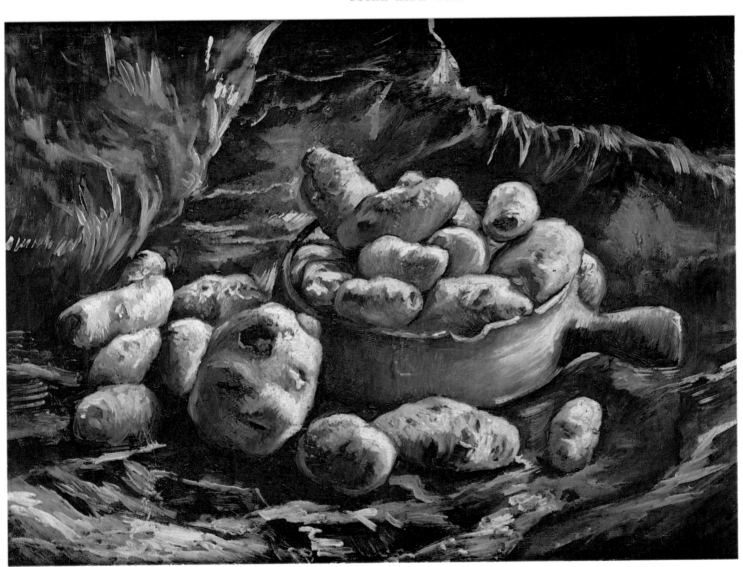

STILL-LIFE WITH BIRDS' NESTS

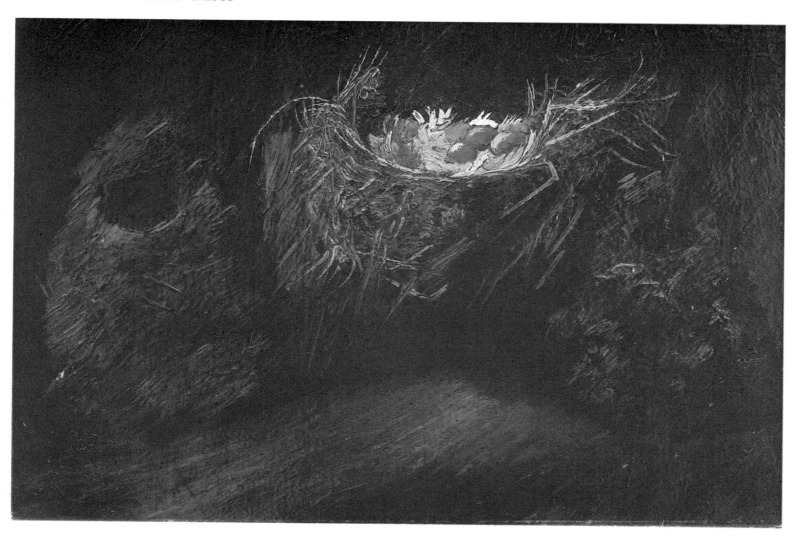

STILL-LIFE WITH OPEN BIBLE, CANDLESTICK AND NOVEL

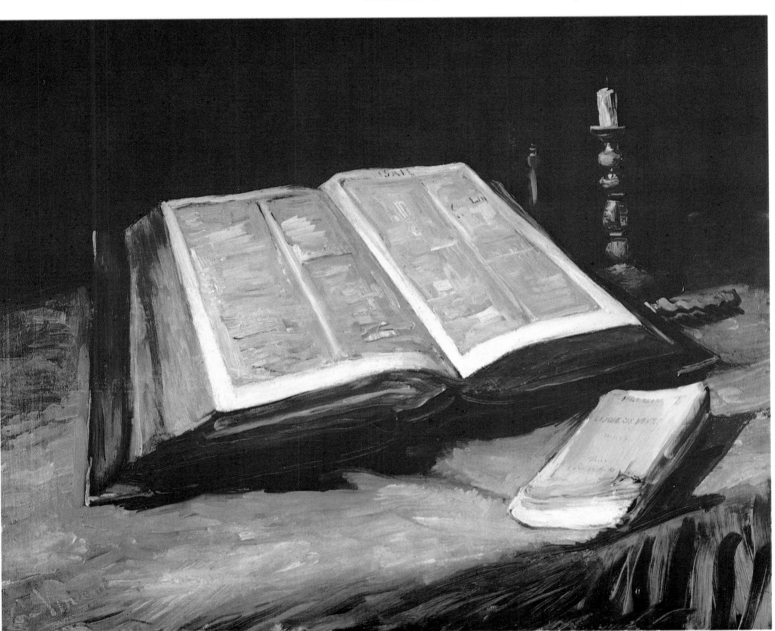

130

LANE WITH
POPLARS

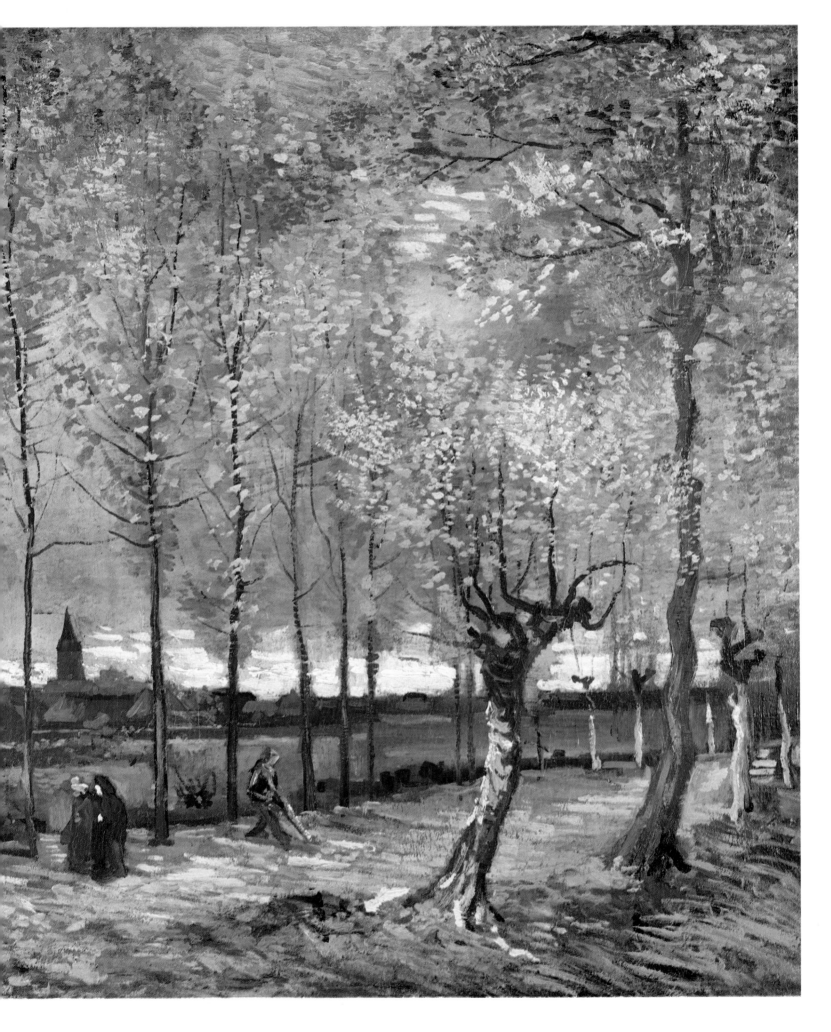

Antwerp & Paris

To Theo

. . . That street is long, every moment one sees something striking. Now and again there is a noise, intenser than anywhere else, when a quarrel is going on; for instance, there you are walking, looking about, and suddenly there is a loud cheering and all kinds of shouting. In broad daylight a sailor is being thrown out of a brothel by the girls, and pursued by a furious fellow and a string of prostitutes, of whom he seems rather afraid – at least I saw him scramble over a heap of sacks and disappear through a warehouse window.

. . . Now one sees a girl who is splendidly healthy, and who looks or seems to look loyal, simple and jolly; then again, a face so sly and false that it makes one afraid, like a hyena's. Not to forget the faces damaged by smallpox, having the colour of boiled shrimps, with pale grey eyes, without eyebrows, and sparse sleek thin hair, the colour of real pig's bristles or somewhat yellower; Swedish or Danish types. It would be fine to work here, but how and where?

. . . My studio is not bad, especially as I have pinned a lot of little Japanese prints on the wall, which amuse me very much. You know those little women's figures in gardens, or on the beach, horsemen, flowers, knotty thorn branches. . . .

*

. . . Antwerp is beautiful in colour, and it is worth while just for the subjects. One evening I saw a popular sailors' ball at the docks; it was most interesting and they behaved *quite decently*. However, that will not be the case at all those balls.

Here, for instance, nobody was drunk, or drank much.

There were several very handsome girls, the most beautiful of whom was plain-faced. I mean, a figure that struck me as a splendid Jordaens or Velazquez, or Goya – was one in black silk, most likely some barmaid or such, with an ugly and irregular face, but lively and piquant à la Frans Hals.

She danced perfectly in an old-fashioned style. Once she danced with a well-to-do little farmer who carried a big green umbrella under his arm, even when he waltzed very quickly.

Other girls wore ordinary jackets and skirts and red scarves; sailors and cabin boys, etc., the funniest types of pensioned sea captains, who came to take a look, quite striking. It does one good to see folks actually enjoy themselves.

. . . I also have an idea for a kind of signboard, which I hope to carry out. I mean, for instance, for a fishmonger, still life of fishes, for flowers, for vegetables, for restaurants. I think that if one takes well-composed subjects, 1 m by $\frac{1}{2}$ or $\frac{3}{4}$ m in size, for instance, such a canvas would cost me 50 fr., not more, even perhaps 30 fr., and if possible I will try to make a few. . . .

*

. . . Rubens is certainly making a strong impression on me; I think his drawing tremendously good — I mean the drawing of heads and hands in themselves. I am quite carried away by his way of drawing the lines in a face with streaks of pure red, or of modelling the fingers of the hands by the same kind of streaks. I go to the museum fairly often, and then I look at little else but a few heads and hands of his and Jordaens'. I know he is not as intimate as Hals and Rembrandt, but in themselves those heads are so alive. . . .

*

. . . I do not feel faint as long as I am painting, but in the long run those intervals are rather too melancholy, and it grieves me when I don't get on, and am always in a bad fix. Do you know, for instance, that in the whole time I've been here, I've had only three warm meals, and for the rest nothing but bread? In this way one becomes vegetarian more than is good for one. Especially as it was the same thing at Nuenen for half a year, and even then I could not pay my colour bill.

. . . As I have received a letter from Mother asking me to write her and informing me that she has asked you to give her my address, will you let them know that I am not going to write, which for that matter I told them quite simply when I went away. You will understand that things like what happened in March [Vincent's father had died in March 1885] are decisive.

Then I left the house, from which may be inferred as a matter of course that they got what *they* wanted; for the rest, I think of them extremely, extremely little, and I do not desire them to think of me, as far as that goes. . . .

*

. . . Some of the fellows have seen my drawings, one of them, influenced by the drawing of my peasant figures, has started at once to draw the model in the nude class with a much more vigorous modelling, putting the shadows down firmly. He showed me this drawing and we talked it over; it was full of life, and it was the finest drawing I have seen here by any of the fellows. Do you know what they think of it here? The teacher Silbert expressly sent for him, and told him that if he dared to do it again in the same way he would be considered to be mocking his teacher. And I assure you, it was the only drawing which was well done, like Tassaert or Gavarni. . . .

*

. . . But, Theo, this indisposition is a damn bad thing just now; I regret it terribly, *but yet I keep courage*. It will right itself.

. . . But, Theo, just because my health is decidedly impaired, I am resolved to apply myself to the higher figure, and to try to refine myself. It overtook me so unexpectedly, I had been feeling weak and feverish, but I went on anyway; but I began to feel worried when more and more of my teeth broke off and I began to look more and more sick. Well, we will try to remedy it.

I think having my teeth attended to will already help, because my whole mouth being painful, I swallowed my food as quickly as possible; and it may help to improve my looks also.

. . . The main thing will be not to fall ill this month, which is not easy to achieve; it certainly might happen. I always believe that I have a certain toughness in common with the peasants, who also do not eat so particularly well, and yet live and work on. . . .

*

. . . I received your letter and enclosed 25 fr., and thank you very much for both. I am very glad that you are not opposed to my intention of coming to Paris. I think it will help me to make progress, and if I did not go, I am afraid I should get into a mess, and continue to go in the same circle and keep on making the same mistakes. Besides, I do not think it will do you any harm to come home to a studio in the evening. . . .

*

. . . This one thing remains — *faith*; one feels instinctively that an enormous number of things are changing and that everything will change. We are living in the last quarter of a century that will end again in a tremendous revolution.

But suppose both of us see its beginning at the end of our lives. We certainly shall not see the better times of pure air and the rejuvenation of all society after those big storms.

. . . What cuts me to the heart is the beautiful serenity of the great thinkers of the present, as, for instance, that last walk of the two de Goncourts, of which you will read the description. The last days of the old Turgenev were the same way, too; he was with Daudet a great deal then. Sensitive, delicate, intelligent like women, also sensitive to their own suffering, and yet always full of life and consciousness of themselves, no indifferent stoicism, no contempt for life. I repeat — those fellows, they die the way women die. No fixed idea about God, no abstractions, always on the firm ground of life itself, and only attached to that. I repeat — like *women* who have loved much, hurt by life, and as Silvestre says of Delacroix, 'Ainsi il mourut presqu'en souriant' ['Thus he died, with a hint of a smile on his lips']. . . .

*

. . . If I am not mistaken in this, I think we cannot join each other soon enough, and I keep objecting to a stay in the country. For though the air is bracing, I should miss there the distraction and the pleasant company of the city, which we should enjoy so much more if we were together. And if we were together soon, I should disappoint you in many things, yes, to be sure, but not in everything, and not in my way of looking at things, I suppose.

Now that we are discussing things, I want to tell you to begin with that I wish both of us might find a wife in some way or other before long, for it is high time, and if we should wait too long, we should not be the better for it.

But I say this in all calmness. However, it is one of the first requisites for our more hygienic life. And I mention it because in that respect we may have to overcome difficulty, on which a great deal depends. And herewith I break the ice on the subject; we shall always have to return to it. And in the intercourse with women one especially learns so much about art.

It is a pity that, as one gradually gains experience, one gradually loses one's youth. If that were not so, life would be too good. . . .

*

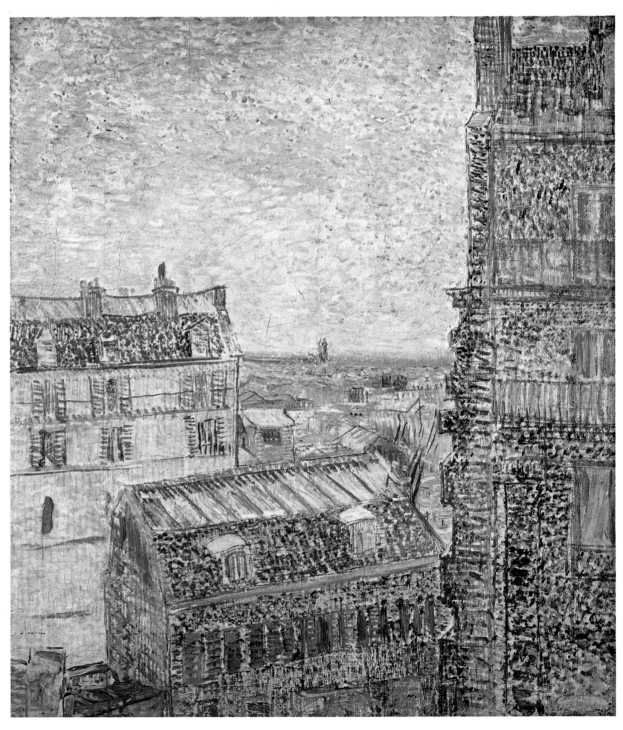

VIEW FROM VINCENT'S WINDOW

To Theo . . . Do not be cross with me for having come all at once like this; I have thought about it so much, and I believe that in this way we shall save time. Shall be at the Louvre from midday on, or sooner if you like.

Please let me know at what time you could come to the Salle Carrée. As for the expenses, I tell you again, this comes to the same thing. I have some money left, of course, and I want to speak to you before I spend any of it. We'll fix things up, you'll see.

So, come as soon as possible.

I shake your hand.

Ever yours, *Vincent*

*

. . . As for me – I feel I am losing the desire for marriage and children, and now and then it saddens me that I should be feeling like that at thirty-five, just when it should be the opposite. And sometimes I have a grudge against this rotten painting. It was Richepin who said somewhere:

The love of art makes one lose real love.

(L'amour de l'art fait perdre l'amour vrai.)

I think that is terribly true, but on the other hand real love makes you disgusted with art.

And at times I already feel old and broken, and yet still enough of a lover not to be a real enthusiast for painting. One must have ambition in order to succeed, and ambition seems to me absurd. I don't know what will come of it; above all I should like to be less of a burden to you – and that is not impossible in the future – for I hope to make such progress that you will be able to show my stuff boldly without compromising yourself.

And then I will take myself off somewhere down south, to get away from the sight of so many painters that disgust me as men. . . .

. . . I saw Tanguy yesterday, and he has put a canvas I've just done in his window. I have done four since you left, and am working on a big one.

I know that these big long canvases are difficult to sell, but later on people will see that there is open air in them and good humour.

So now the whole lot would do for the decoration of a dining room or a country house.

And if you fall very much in love, and then get married, it doesn't seem impossible to me that you will rise to a country house yourself someday like so many other picture dealers. If you live well, you spend more, but you gain ground that way, and perhaps these days one gets on better by looking rich than by looking shabby. It's better to have a gay life of it than commit suicide. Remember me to all at home. . . .

*

To Wilhelmina . . . My own adventures are restricted chiefly to making swift progress toward growing into a little old man, you know, with wrinkles, and a tough beard and a number of false teeth, and so on. But what does it matter? I have a dirty and hard profession – painting – and if I were not what I am, I should not paint; but being what I am, I often work with pleasure, and in the hazy distance I see the possibility of making pictures in which there will be some youth and freshness, even though my own youth is one of the things I have lost.

If I did not have Theo, it would not be possible for me to get what I have a right to;

but seeing that he is my friend, I believe I shall make still further progress, and give free rein to it.

 . . . As far as I myself am concerned, I still go on having the most impossible, and not very seemly, love affairs, from which I emerge as a rule damaged and shamed and little else.

And in my opinion I am quite right in this, because I tell myself that in the years gone by, when I should have been in love, I gave myself up to religious and socialistic devotions, and considered art a holier thing than I do now.

Why is religion or justice or art so very holy?

 . . . What I think of my own work is this — that the picture I did at Nuenen of those peasants eating potatoes is the best one after all. . . .

<p style="text-align:center">*</p>

DANCE HALL WITH DANCING WOMEN

TWO WOMEN IN A BOX AT THE THEATRE

SPIRE OF THE CHURCH OF OUR LADY

WOMAN WITH HER HAIR LOOSE, HEAD

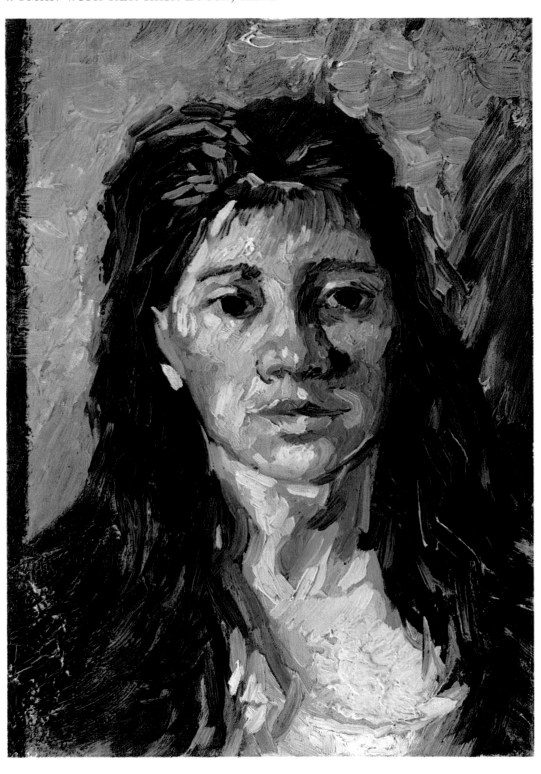

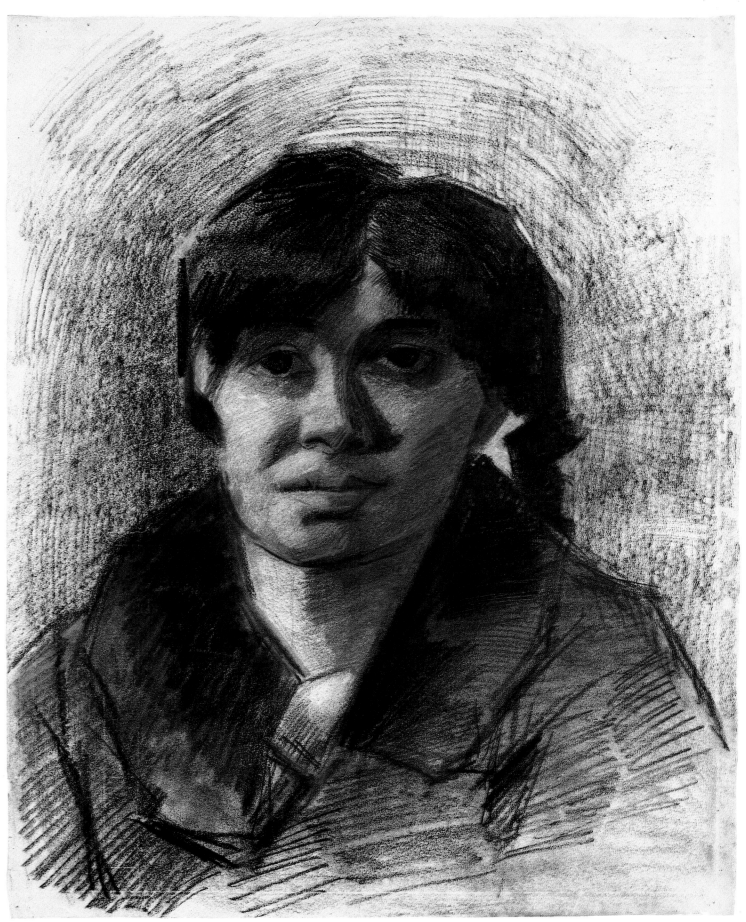

SKETCH OF A KNEE

FEMALE NUDE, STANDING, SEEN FROM THE SIDE

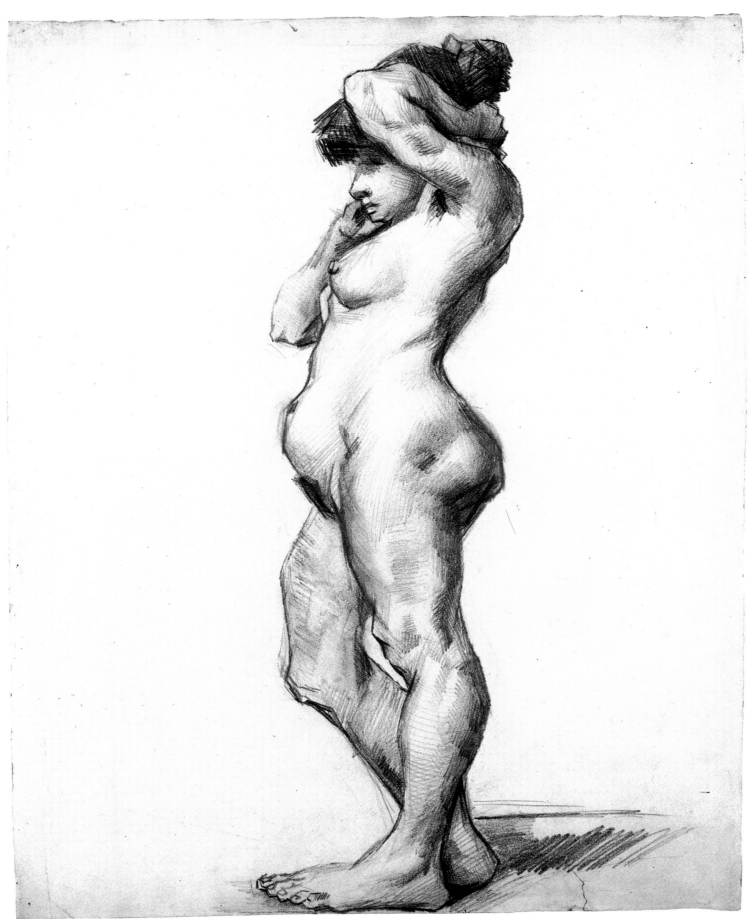

SELF-PORTRAIT WITH DARK FELT HAT

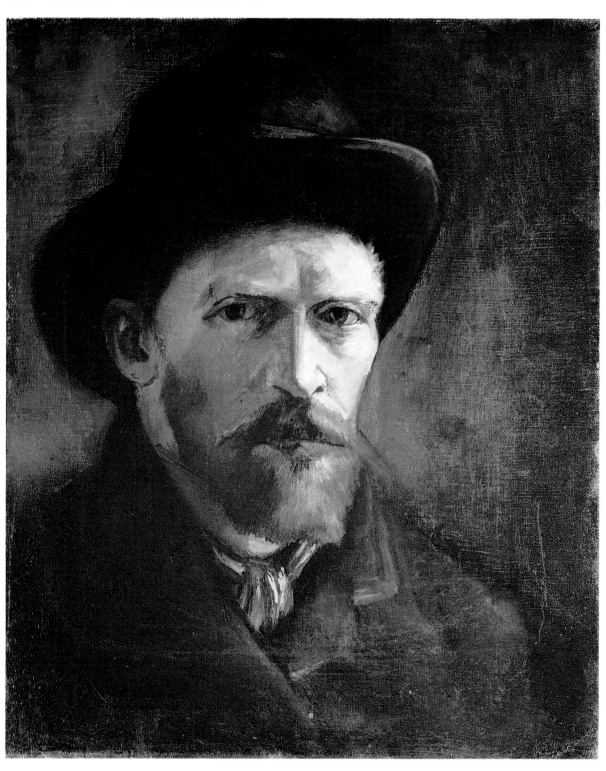

PARIS/April–June 1886

THE ROOFS OF PARIS

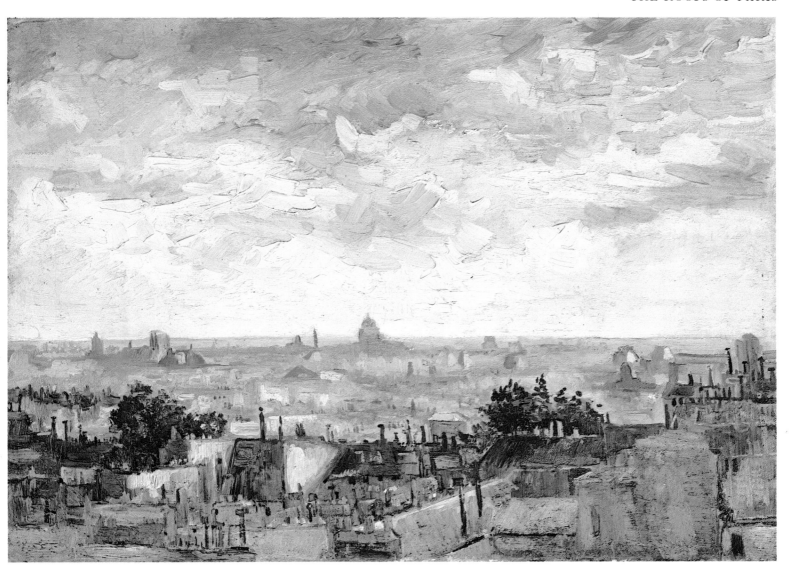

PLASTER STATUETTE (TYPE B)

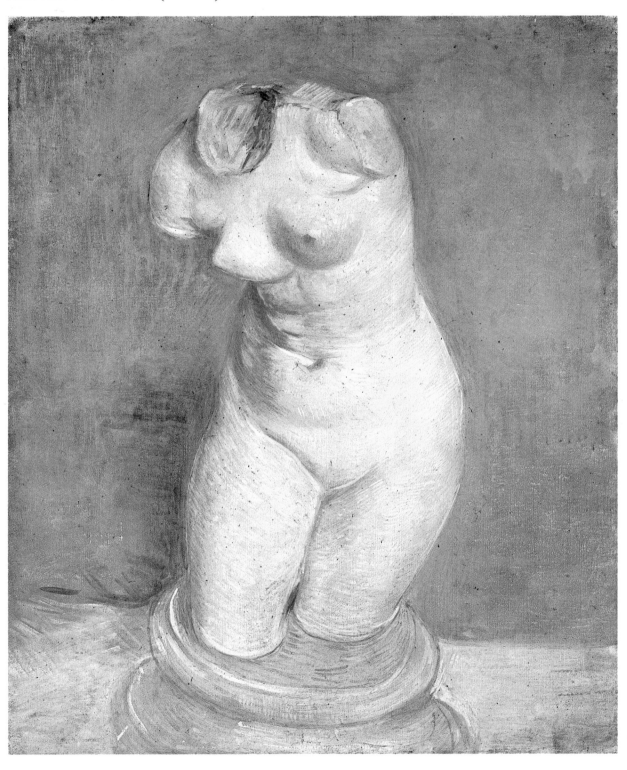

Paris/April–June 1886

PLASTER STATUETTE (TYPE C), SEEN FROM THE BACK

THE MOULIN DE BLUTE-FIN

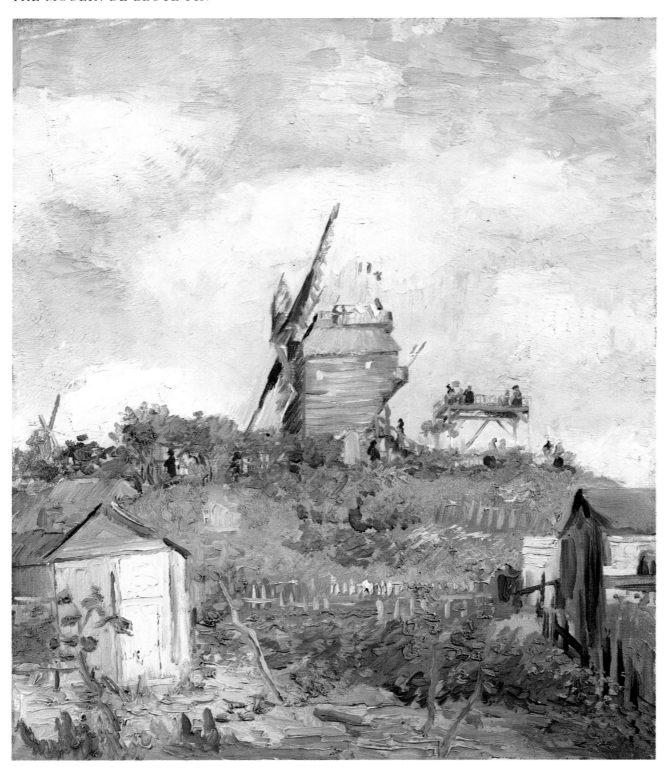

BOWL WITH ZINNIAS

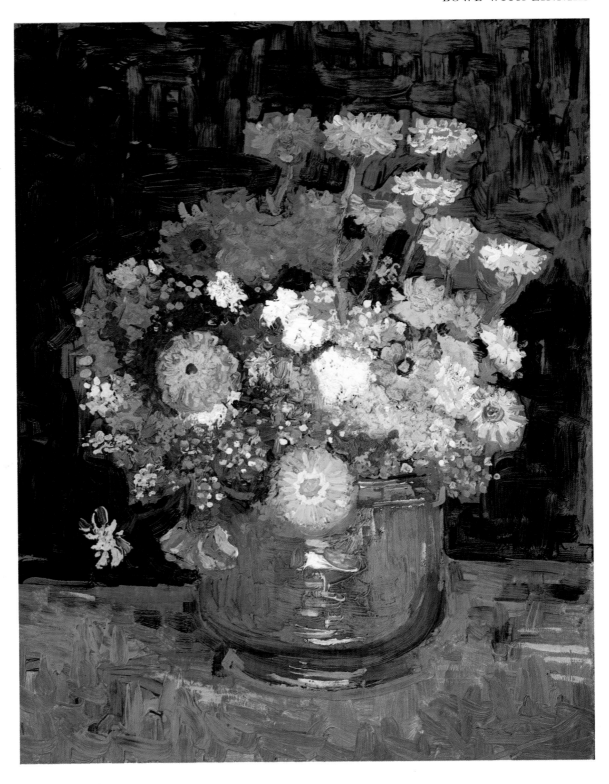

VIOLINIST

Paris/July—September 1886

DOUBLE-BASS PLAYER

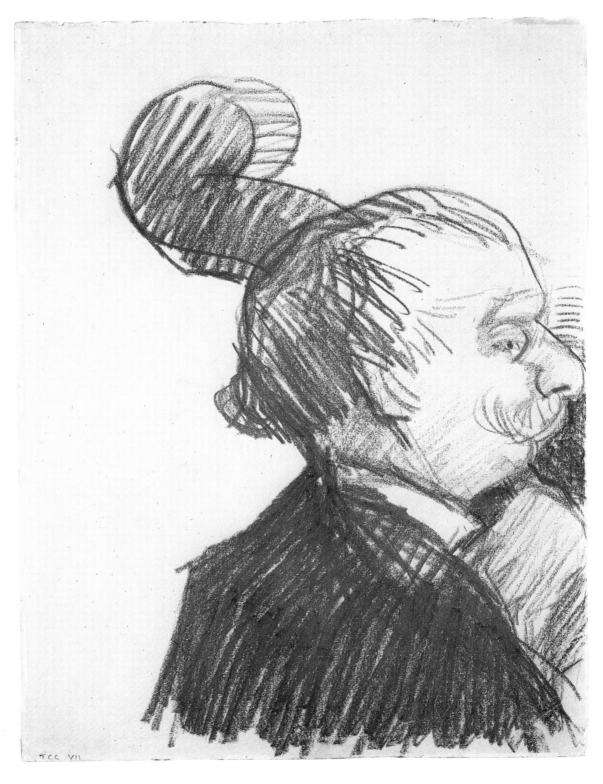

TCC VII

BOWL OF SUNFLOWERS, ROSES AND OTHER FLOWERS

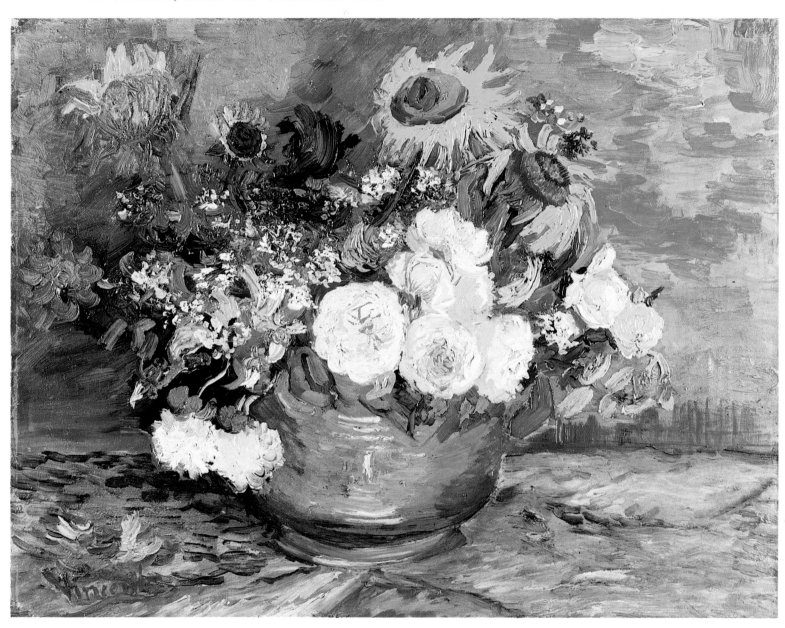

Paris/July–September 1886

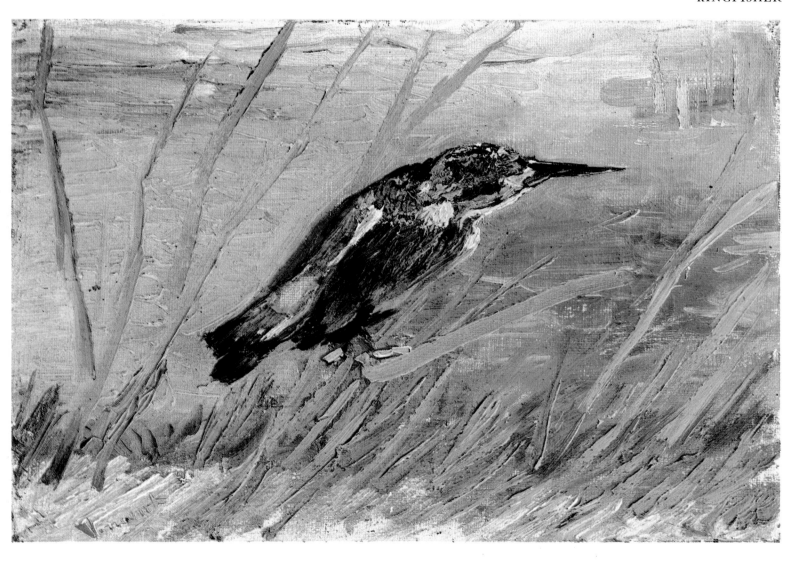

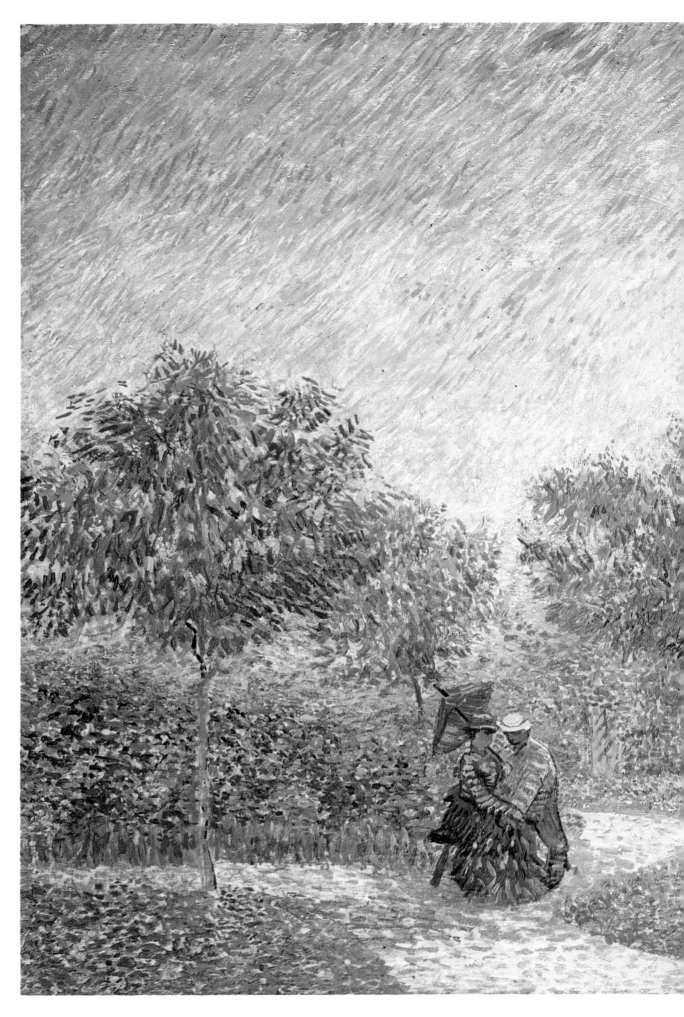

PEOPLE
WALKING IN A
PUBLIC GARDEN
AT ASNIÈRES

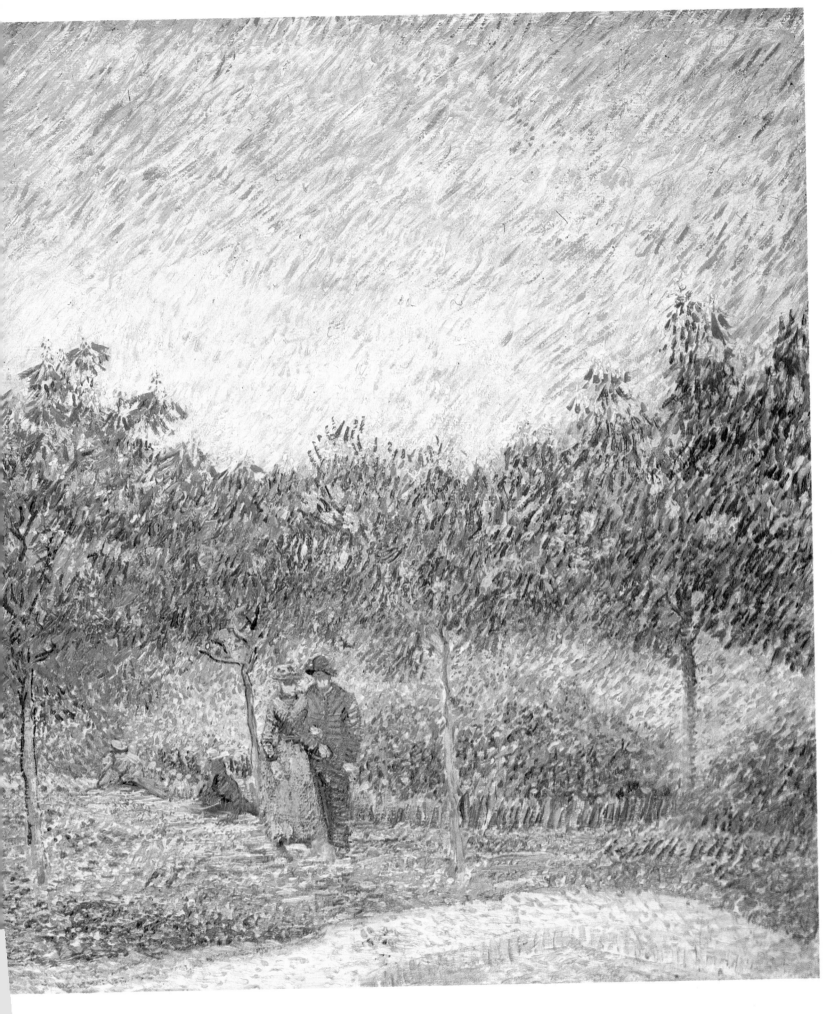

EDGE OF A WHEAT FIELD WITH POPPIES AND A LARK

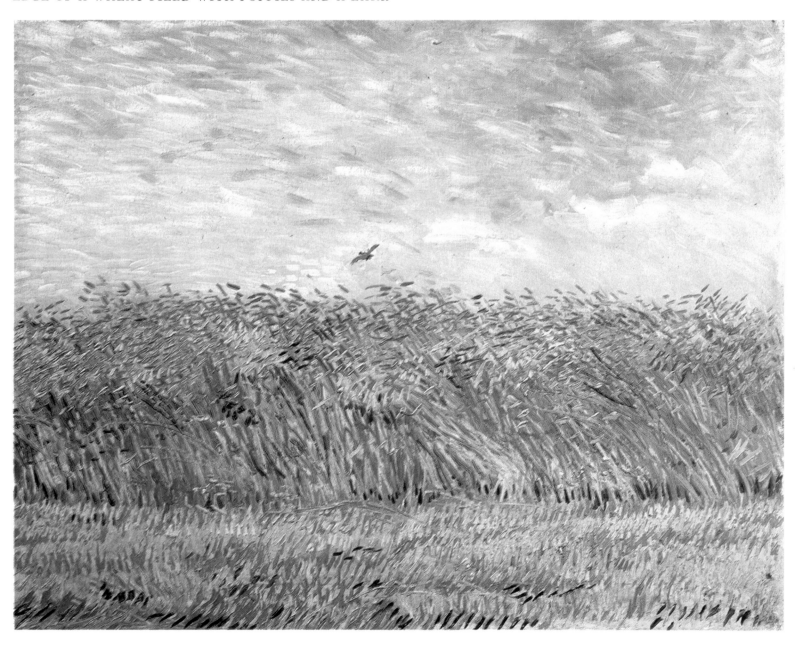

PASTURE IN BLOOM

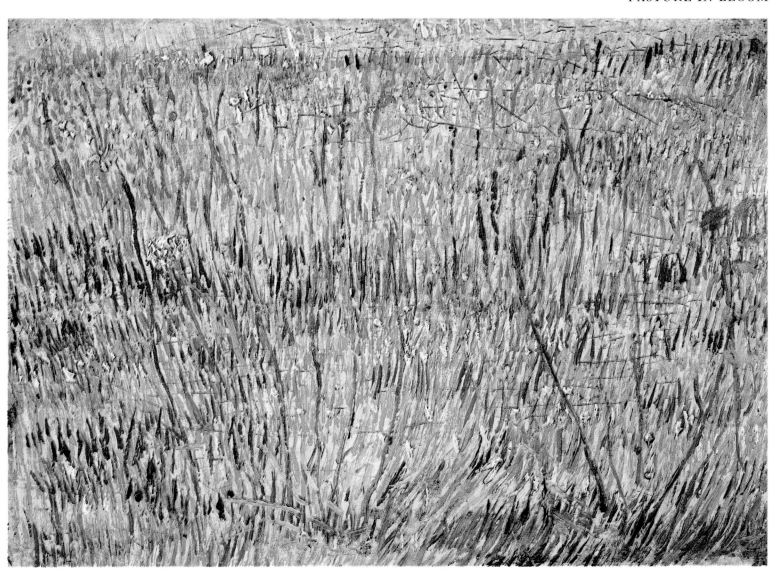

PORTRAIT OF A MAN

SELF-PORTRAIT WITH GREY FELT HAT

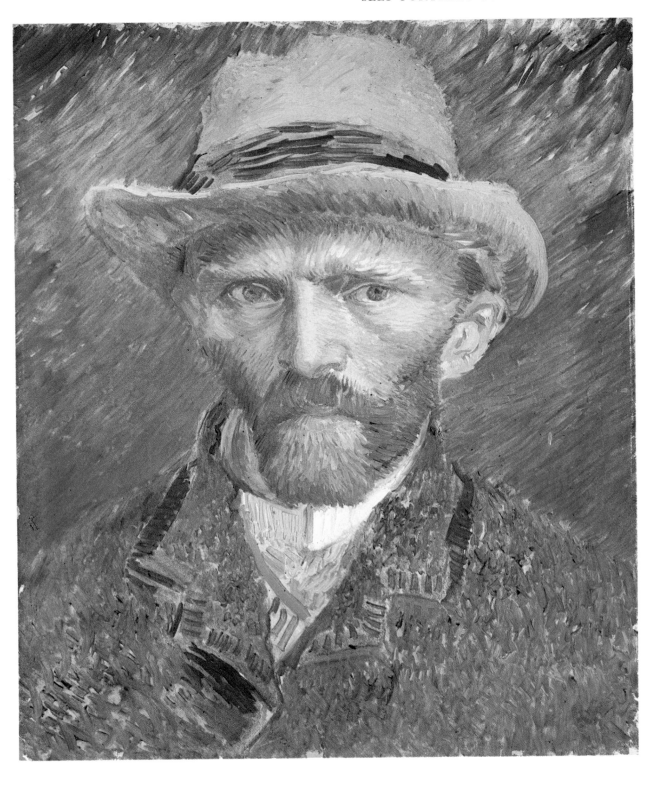

FRITILLARIAS IN A COPPER VASE

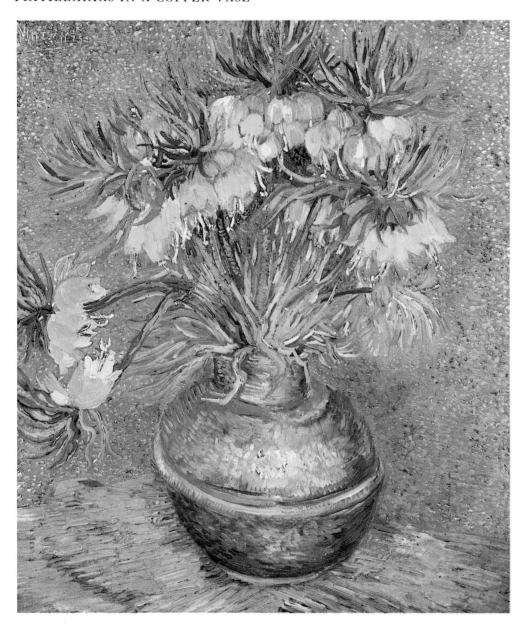

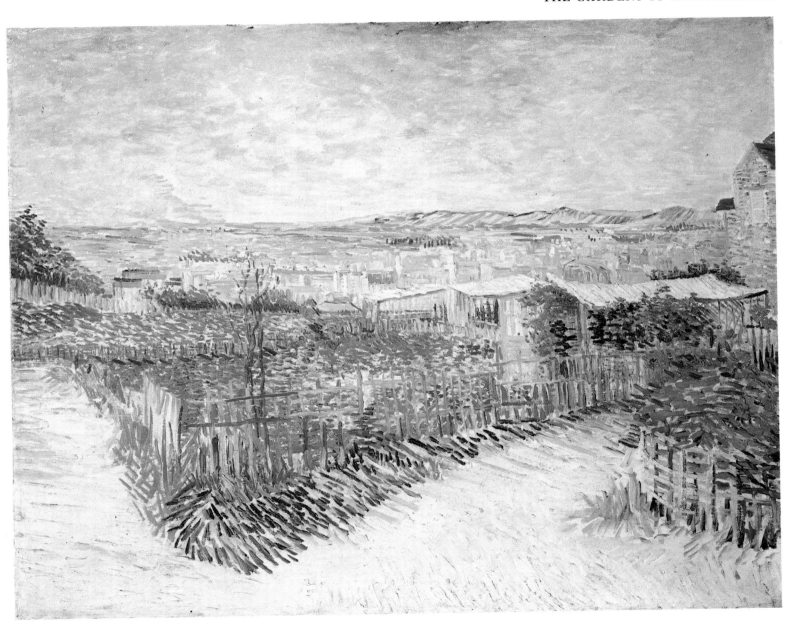

THREE PAIRS OF SHOES, ONE SHOE UPSIDE DOWN

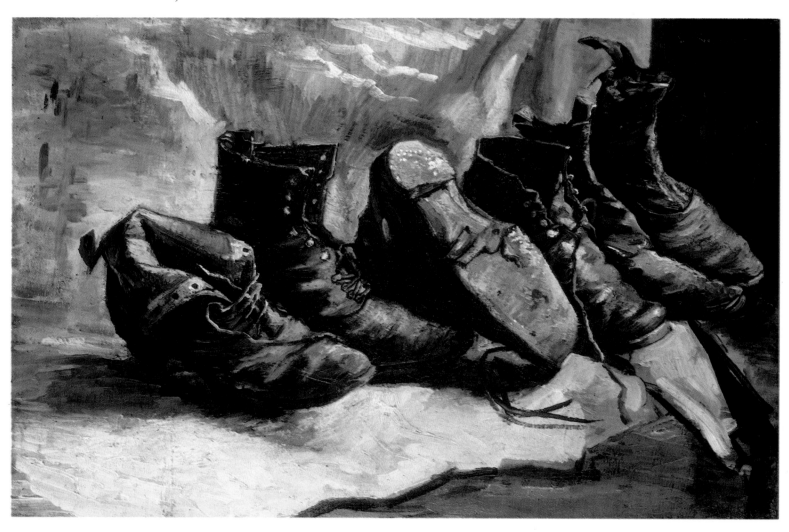

A BASKET OF BULBS

IN A WOOD

EXTERIOR OF A RESTAURANT WITH OLEANDERS IN POTS

TWO CUT SUNFLOWERS

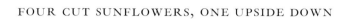

FOUR CUT SUNFLOWERS, ONE UPSIDE DOWN

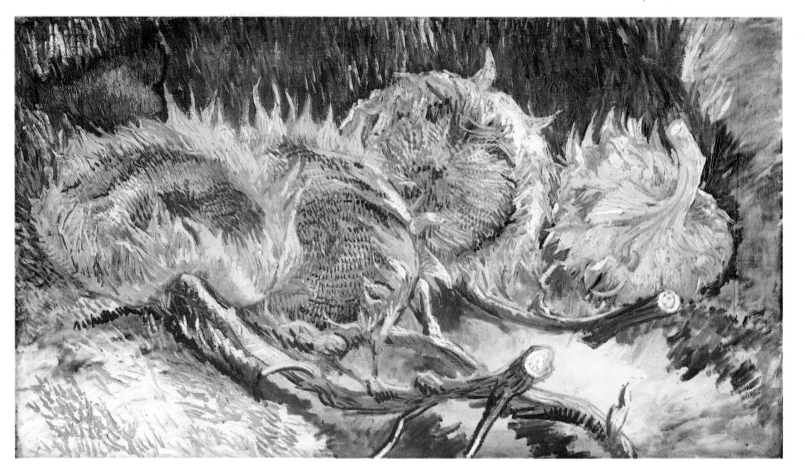

BLUE AND WHITE GRAPES, APPLES, PEARS AND LEMONS

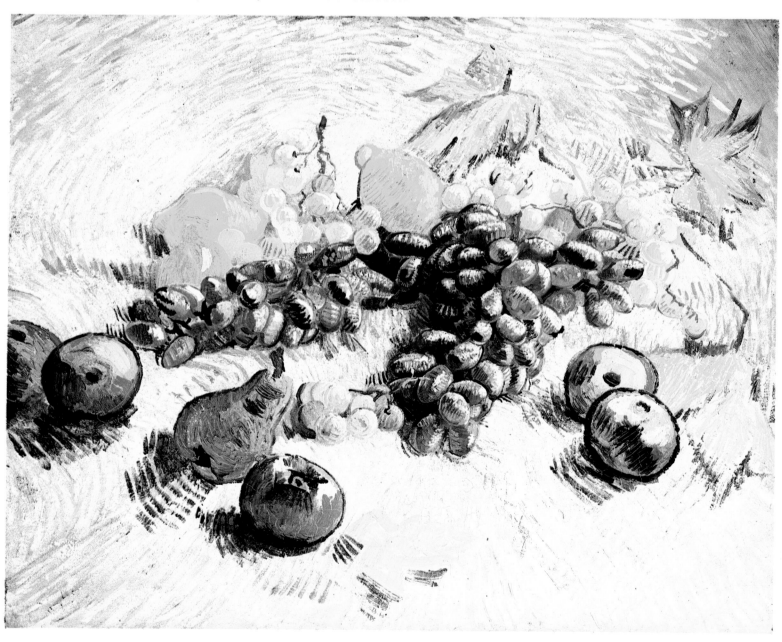

PORTRAIT OF A WOMAN WITH CARNATIONS (L'ITALIENNE)

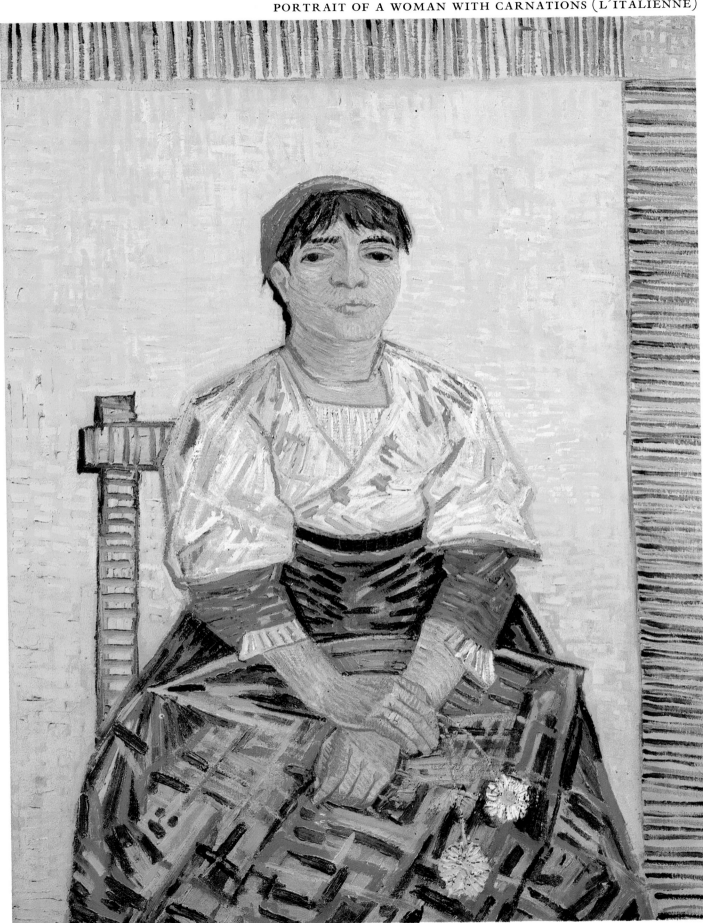

SELF-PORTRAIT

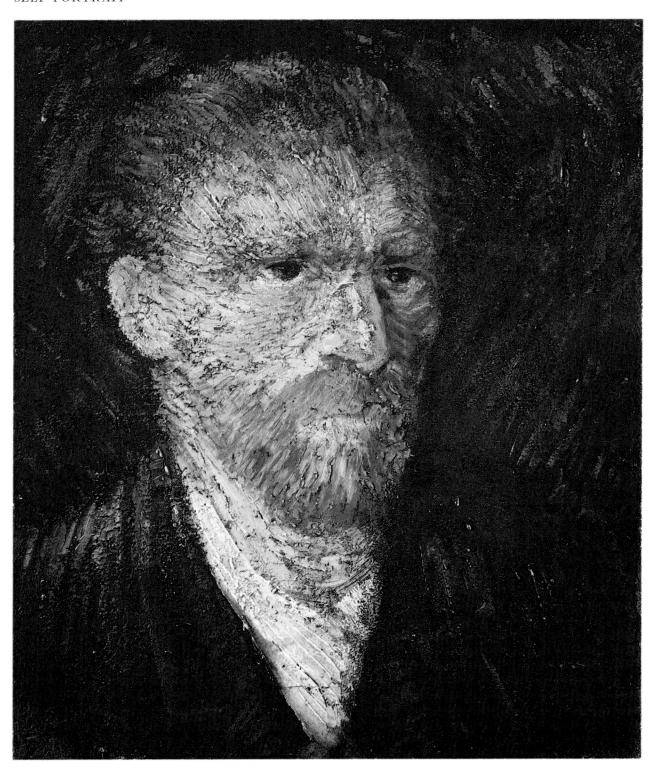

SELF-PORTRAIT IN FRONT OF THE EASEL

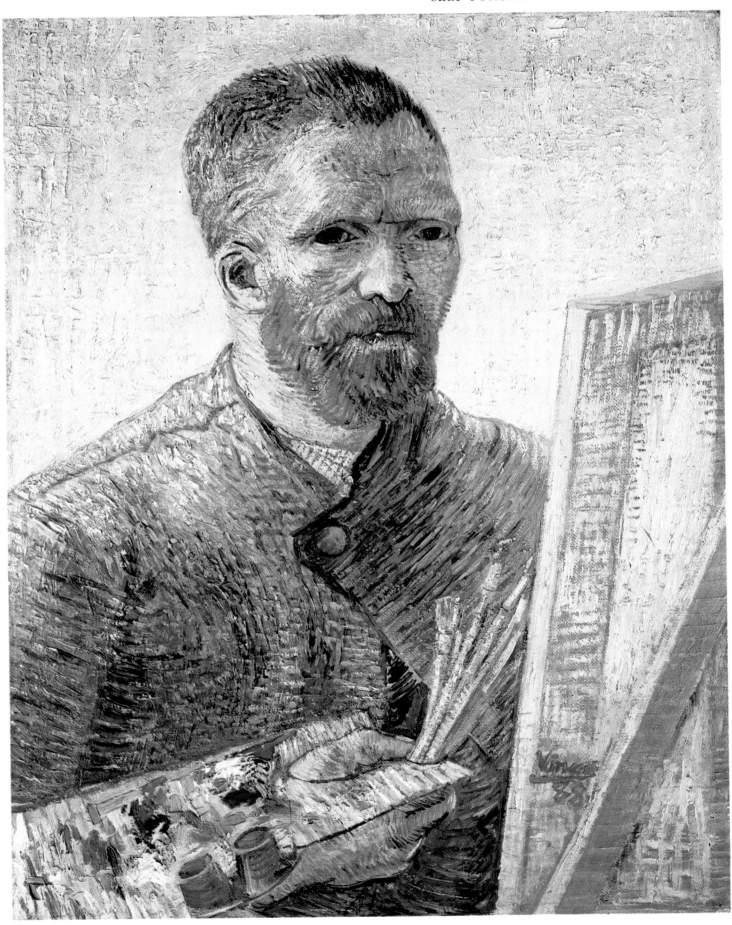

Arles, St Rémy & Auvers-sur-Oise

To Theo

. . . Poor Gauguin has no luck. I am very much afraid that in his case convalescence will last even longer than the fortnight which he has had to spend in bed.

My God! Shall we ever see a generation of artists with healthy bodies! Sometimes I am perfectly furious with myself, for it isn't good enough to be either more or less ill than the rest; the ideal would be a constitution tough enough to live till eighty, and besides that, blood in one's veins that would be right good blood.

It would be some comfort, however, if one could think that a generation of more fortunate artists was to come. . . .

*

. . . But old boy, you know, I feel as though I were in Japan – I say no more than that, and mind, I haven't seen anything in its usual splendour yet.

That's why – even though I'm vexed that just now expenses are heavy and the pictures worthless – that's why I don't despair of the future success of this idea of a long sojourn in the Midi.

Here I am seeing new things, I am learning, and if I take it easy, my body doesn't refuse to function.

For many reasons I should like to get some sort of little retreat, where the poor cab horses of Paris – that is, you and several of our friends, the poor impressionists – could go out to pasture when they get too beat up.

I was present at the inquiry into a crime committed at the door of a brothel here; two Italians killed two Zouaves. I seized the opportunity to go into one of the brothels in a small street called 'des ricolettes'.

That is the extent of my amorous adventures among the Arlésiennes. . . .

*

. . . Must I tell the truth and add that the Zouaves, the brothels, the adorable little Arlésiennes going to their first Communion, the priest in his surplice, who looks like a dangerous rhinoceros, the people drinking absinthe, all seem to me creatures from another world? That doesn't mean that I'd feel at home in an artistic world, but that I would rather fool myself than feel alone. And I think I should feel depressed if I did not fool myself about everything. . . .

*

To Wilhelmina

. . . You will understand that nature in the South cannot be painted with the palette of Mauve, for instance, who belongs to the North, and who is, and will remain, a master of the grey. But at present the palette is distinctly colourful, sky blue, orange, pink, vermilion, bright yellow, bright green, bright wine-red, violet.

But by intensifying *all* the colours one arrives once again at quietude and harmony. There occurs in nature something similar to what happens in Wagner's music, which, though played by a big orchestra, is nonetheless intimate. . . .

*

To Theo . . . I have been working on a size 20 canvas in the open air in an orchard, lilac ploughland, a reed fence, two pink peach trees against a sky of glorious blue and white. Probably the best landscape I have done. I had just brought it home when I received from our sister a Dutch notice in memory of Mauve, with his portrait (the portrait, very good), the text, poor and nothing in it, a pretty water-colour. Something – I don't know what – took hold of me and brought a lump to my throat, and I wrote on my picture

Souvenir de Mauve

Vincent Theo

and if you agree we two will send it, such as it is, to Mrs Mauve. I chose the best study I've painted here purposely; I don't know what they'll say about it at home, but that does not matter to us; it seemed to me that everything in memory of Mauve must be at once tender and very gay, and not a study in any graver key. . . .

*

. . . I'm up to my ears in work, for the trees are in blossom and I want to paint a Provençal orchard of astounding gaiety. It is very difficult to write collectedly. . . .

*

To Wilhelmina . . . Now I know that it is hardly to be supposed that the white potato and salad grubs which later change into cockchafers should be able to form tenable ideas about their supernatural existence in the hereafter. And that it would be premature for them to enter upon supernatural researches for enlightenment about this problem, seeing that the gardener or other persons interested in salad and vegetables would crush them underfoot, considering them harmful insects.

But for parallel reasons I have little confidence in the correctness of our human concepts of a future life. We are as little able to judge of our own metamorphoses without bias and prematureness as the white salad grubs can of theirs, for the very cogent reason that the salad worms ought to eat salad roots in the very interest of their higher development.

In the same way I think that a painter ought to paint pictures; possibly something else may come after that. . . .

*

To Theo . . . I think what Kahn said is very true, that I have not sufficiently considered values, but they'll be saying very different things in a little while – and no less true.

It isn't possible to get values and colour.

Th. Rousseau did it better than anyone else, and with the mixing of his colours, the darkening caused by time has increased and his pictures are now unrecognizable.

You can't be at the pole and the equator at the same time.

You must choose your own line, as I hope to do, and it will probably be colour. . . .

*

To Émile Bernard

. . . I saw a brothel here last Sunday — not counting the other days — a large room, the walls covered with blued whitewash — like a village school. Fifty or more military men in red and civilians in black, their faces a magnificent yellow or orange (what hues there are in the faces here), the women in sky blue, in vermilion, as unqualified and garish as possible. The whole in a yellow light. A good deal less lugubrious than the same kind of offices in Paris.

There is no 'spleen' in the air here. . . .

*

To Theo

. . . You were right to tell Tasset that he must put in the geranium lake all the same; he has sent it, I have just checked it. *All the colours that the Impressionists have brought into fashion are unstable*, so there is all the more reason not to be afraid to lay them on too crudely — time will tone them down only too much. . . .

*

. . . Happily for me, I am not the sort of fellow who cares for nothing in the world but pictures.

On the contrary, since I believe it's possible to produce a work of art at less cost than one must spend on a painting, I've begun the series of pen-and-ink drawings. . . .

*

. . . I think very often of Renoir and that pure clean line of his. That's just how things and people look in this clean air.

. . . I think there would be something to do here in portraits. Although the people are blankly ignorant of painting in general, they are much more artistic than in the North in their own persons and their manner of life. I have seen figures here quite as beautiful as those of Goya or Velazquez. They will put a touch of pink on a black frock, or devise a garment of white, yellow and pink, or else green and pink, or else *blue and yellow*, in which there is nothing to be altered from the artistic point of view. Seurat would find some very picturesque men's figures here in spite of their modern clothes.

. . . My poor boy, our neurosis, etc., comes, it's true, from our way of living, which is too purely the artist's life, but it is also a fatal inheritance, since in civilization the weakness increases from generation to generation. If we want to face the real truth about our constitution, we must acknowledge that we belong to the number of those who suffer from a neurosis which already has its roots in the past.

I think Gruby [a doctor in Paris] is right about such cases — to eat well, to live well, to see little of women, in short to arrange one's life in advance exactly as if one were already suffering from a disease of the brain and spine, without counting the neurosis which is actually there. Certainly that is taking the bull by the horns, which is never a bad policy. And Degas did it, and succeeded. All the same, don't you feel, as I do, that it is frightfully hard? . . .

*

To Émile Bernard
. . . Those tattooed races, Negroes, Indians, all of them, all, all are disappearing or degenerating. And the horrible white man with his bottle of alcohol, his money and his syphilis – when shall we see the end of him? The horrible white man with his hypocrisy, his greediness and his sterility.

And those savages were so gentle and so loving!

You are damned right to think of Gauguin. That is high poetry, those Negresses, and everything his hands make has a gentle, pitiful, astonishing character. People don't understand him yet, and it pains him so much that he does not sell anything, just like other true poets. . . .

*

To Theo
. . . You will see some lovely things at Claude Monet's. And you will think what I send very poor stuff in comparison. Just now I am dissatisfied with myself and dissatisfied with what I do, but I have just a glimmer of hope that I'm going to do better in the end.

And then I hope that later on other artists will rise up in this lovely country and do for it what the Japanese have done for theirs. And it's not so bad to work toward that end. . . .

*

To Émile Bernard
. . . More and more it seems to me that the pictures which must be made so that painting should be wholly itself, and should raise itself to a height equivalent to the serene summits which the Greek sculptors, the German musicians, the writers of French novels reached, are beyond the power of an isolated individual; so they will probably be created by groups of men combining to execute an idea held in common.

One may have a superb orchestration of colours and lack ideas. Another one is cram-full of new concepts, tragically sad or charming, but does not know how to express them in a sufficiently sonorous manner because of the timidity of a limited palette. All the more reason to regret the lack of corporate spirit among the artists, who criticize and persecute each other, fortunately without succeeding in annihilating each other.

You will say that this whole line of reasoning is banal – so be it! However, the thing itself – the existence of a renaissance – this fact is certainly no banality. . . .

*

To Theo
. . . In the fullness of artistic life there is, and remains, and will always come back at times, that homesick longing for the truly ideal life that can never come true.

And sometimes you lack all desire to throw yourself heart and soul into art, and to get well for that. You know you are a cab horse and that it's the same old cab you'll be hitched up to again: that you'd rather live in a meadow with the sun, a river and other horses for company, likewise free, and the act of procreation.

And perhaps, to get to the bottom of it, the disease of the heart is caused by this: it would not surprise me. One does not rebel against things, nor is one resigned to them; one's ill because of them, and one does not get better, and it's hard to be precise about the cure.

I do not know who it was who called this condition – being struck by death and immortality. The cab you drag along must be of some use to people you do not know. And so, if we believe in the new art and artists of the future, our faith does not cheat us. When

good old Corot said a few days before his death — 'Last night in a dream I saw landscapes with skies all pink', well, haven't they come, those skies all pink, and yellow and green into the bargain, in the impressionist landscapes? All of which means that there are things one feels coming, and they are coming in very truth.

And as for us who are not, I am inclined to believe, nearly so close to death, we nevertheless feel that this thing is greater than we are, and that its life is of longer duration than ours.

We do not feel we are dying, but we do feel the truth that we are of small account, and that we are paying a hard price to be a link in the chain of artists, in health, in youth, in liberty, none of which we enjoy, any more than the cab horse which hauls a coachful of people out to enjoy the spring. . . .

*

. . . I feel more and more that we must not judge of God from this world, it's just a study that didn't come off. What can you do with a study that has gone wrong? — if you are fond of the artist, you do not find much to criticize — you hold your tongue. But you have a right to ask for something better. We should have to see other works by the same hand though; this world was evidently slapped together in a hurry on one of his bad days, when the artist didn't know what he was doing or didn't have his wits about him. All the same, according to what the legend says, this good old God took a terrible lot of trouble over this world-study of his.

I am inclined to think that the legend is right, but then the study is ruined in so many ways. It is only a master who can make such a blunder, and perhaps that is the best consolation we can have out of it, since in that case we have a right to hope that we'll see the same creative hand get even with itself. . . .

*

. . . You understand so well that 'to prepare oneself for death', the Christian idea (happily for him, Christ himself, it seems to me, had no trace of it, loving as he did people and things here below to an unreasonable extent, at least according to the folk who can only see him as a little cracked) — if you understand so well that to prepare oneself for death is idle — let it go for what it's worth — can't you see that similarly self-sacrifice, living for other people, is a mistake if it involves suicide, for in that case you actually turn your friends into murderers. . . .

*

. . . As for me, it worries me to spend so much money on myself alone, but the only way to remedy it is to find a woman with money, or some fellows who will join me to paint pictures.

I don't see the woman, but I do see the fellows.

If this will suit him [Gaugin], we must not keep him dangling.

And this would be the beginning of an association. Bernard, who is also coming South, will join us, and truly, I can see you at the head of an Impressionist Society in France yet. And if I can be of any use in getting them together, I would willingly look on them all as better artists than I. . . .

*

. . . If you send me the next letter on Sunday *morning*, I shall probably take myself off that day to Saintes-Maries to spend a week there. I am reading a book on Wagner which I will send you afterward. What an artist — one like that in painting would be something. It *will come.* . . .

*

To Gauguin

. . . I wanted to let you know that I have just rented a four-room house here in Arles.

And that it would seem to me that if I could find another painter inclined to work in the South, and who, like myself, would be sufficiently absorbed in his work to be able to resign himself to living like a monk who goes to the brothel once a fortnight — who for the rest is tied up in his work, and not very willing to waste his time, it might be a good job. Being all alone, I am suffering a little under this isolation.

So I have often thought of telling you so frankly.

You know that my brother and I greatly appreciate your painting, and that we are most anxious to see you quietly settled down.

Now the fact is that my brother cannot send you money in Brittany and at the same time send me money in Provence. But are you willing to share with me here? If we combine, there may be enough for both of us, I am sure of it, in fact. . . .

*

To Theo

. . . Early tomorrow I start for Saintes-Maries on the Mediterranean. I shall stay there till Saturday evening.

I am taking two canvases, but I'm afraid it will probably be too windy to paint.

You go by diligence, it is 50 kilometres from here. You cross the Camargue, grass plains where there are herds of fighting bulls and also herds of little white horses, half wild and very beautiful.

I am taking especially whatever I need for drawing. I must draw a great deal, for the very reason you spoke of in your last letter. Things here have so much line. And I want to get my drawing more spontaneous, more exaggerated. . . .

*

. . . If you saw the Camargue and many other places, you would be surprised, just as I was to find that they are exactly in Ruysdael's style.

I am working on a new subject, fields green and yellow as far as the eye can reach. I have already drawn it twice, and I am starting it again as a painting; it is exactly like a Salomon Konink [Philips Konink] — you know, the pupil of Rembrandt who painted vast level plains. . . .

*

. . . If Gauguin were willing to join me, I think it would be a step forward for us. It would establish us squarely as the explorers of the South, and nobody could complain of that.

. . . The country near Aix where Cézanne works is just the same as this, it is still the Crau. If coming home with my canvas, I say to myself, 'Look! I've got the very tones of old Cézanne!' I only mean that Cézanne like Zola is so absolutely part of the countryside, and knows it so intimately, that you must make the same calculations in your head to arrive at the same tones. Of course, if you saw them side by side, mine would hold their own, but there would be no resemblance. . . .

*

. . . One night I went for a walk by the sea along the empty shore. It was not gay, but neither was it sad – it was – beautiful. The deep blue sky was flecked with clouds of a blue deeper than the fundamental blue of intense cobalt, and others of a clearer blue, like the blue whiteness of the Milky Way. In the blue depth the stars were sparkling, greenish, yellow, white, pink, more brilliant, more sparklingly gemlike than at home – even in Paris: opals you might call them, emeralds, lapis lazuli, rubies, sapphires. The sea was very deep ultramarine – the shore a sort of violet and faint russet as I saw it, and on the dunes (they are about seventeen feet high) some bushes Prussian blue. . . .

*

. . . I wish you could spend some time here, you would feel it after a while, one's sight changes: you see things with an eye more Japanese, you feel colour differently. The Japanese draw quickly, very quickly, like a lightning flash, because their nerves are finer, their feeling simpler.

I am convinced that I shall set my individuality free simply by staying on here.

I have only been here a few months, but tell me this – could I, in Paris, have done the drawing of the boats *in an hour*? Even without the perspective frame, I do it now without measuring, just by letting my pen go. . . .

*

. . . I have had a letter from Bernard, who says that he is feeling very lonesome, but that he is working all the same, and has written a new poem on himself in which he makes fun of himself rather pathetically. And he asks, 'What's the use of working?' Only he asks that *while he is working*; he says that work is no earthly good at all *while he is working*, which is not at all the same thing as saying it when one is not working: I should very much like to see what he is doing. . . .

*

To Émile Bernard

. . . But the consolation of that saddening Bible which arouses our despair and our indignation – which distresses us once and for all because we are outraged by its pettiness and contagious folly – the consolation which is contained in it, like a kernel in a hard shell, a bitter pulp, is Christ.

The figure of Christ, as I feel it, has been painted only by Delacroix and Rembrandt . . . and later Millet painted . . . the doctrine of Christ.

The rest makes me smile a little, all the rest of religious painting – from the religious point of view, not from the point of view of painting. And the Italian primitives – Botticelli; or say the Flemish primitives – Van Eyck; Germans – Cranach – they are nothing but heathens who interest me only in the same respect as the Greeks, as Velazquez and so many other naturalists.

Christ alone – of all the philosophers, Magi, etc. – has affirmed, as a principal certainty, eternal life, the infinity of time, the nothingness of death, the necessity and the *raison d'être* of serenity and devotion. He lived serenely, *as a greater artist than all other artists*, despising marble and clay as well as colour, working in living flesh. That is to say, this matchless artist, hardly to be conceived of by the obtuse instrument of our modern, nervous, stupefied brains, made neither statues nor pictures nor books; he loudly proclaimed that he made . . . *living men*, immortals.

. . . Science – scientific reasoning – seems to me an instrument that will lag far, far behind. For look here: the earth has been thought to be flat. It was true, so it still is today, for instance between Paris and Asnières. Which, however, does not prevent science from proving that the earth is principally round. Which no one contradicts nowadays.

But notwithstanding this they persist nowadays in believing that *life is flat* and runs from birth to death. However, life too is probably round, and very superior in expanse and capacity to the hemisphere we know at present.

Future generations will probably enlighten us on this so very interesting subject; and then maybe Science itself will arrive – willy-nilly – at conclusions more or less parallel to the sayings of Christ with reference to the other half of our existence. . . .

*

To Theo

. . . What often vexes me is that painting is like having a bad mistress who spends and spends and it's never enough, and I tell myself that even if a tolerable study comes out of it from time to time, it would have been much cheaper to buy it from somebody else.

. . . It is great that Claude Monet managed to paint those ten pictures between February and May. Quick work doesn't mean less serious work, it depends on one's self-confidence and experience. In the same way Jules Guérard, the lion hunter, says in his book that in the beginning young lions have a lot of trouble killing a horse or an ox, but that the old lions kill with a single blow of the paw or a well-placed bite, and that they are amazingly sure at the job.

I see nothing here of the Southern gaiety that Daudet talks about so much, but on the contrary, all kinds of insipid airs and graces, a sordid carelessness. But the country is beautiful in spite of it. . . .

*

. . . I must warn you that everyone will think that I work too fast.

Don't you believe a word of it.

Is it not emotion, the sincerity of one's feeling for nature, that draws us, and if the emotions are sometimes so strong that one works without knowing one works, when sometimes the strokes come with a continuity and a coherence like words in a speech or a letter, then one must remember that it has not always been so, and that in time to come there will again be hard days, empty of inspiration.

So one must strike while the iron is hot, and put the forged bars on one side.

. . . it's not the *number* of canvases, but just that the very mass of them represents real labour, on your part as well as on mine. The wheatfields have been a reason for working, just like the orchards in bloom. And I only just have time to get ready for the next campaign, that of the vineyards.

And between the two I'd like to do some more marines.

The orchards meant pink and white; the wheatfields, yellow; and the marines, blue. Perhaps now I shall begin to look around for greens. There's the autumn, and that will give the whole scale of the lyre. . . .

*

To Wilhelmina

. . . However, at the present moment I look different, insofar as I am wearing neither hair nor beard, the same having been shaved off clean. Furthermore, my complexion has changed from green-greyish-pink to greyish-orange, and I am wearing a white suit instead of a blue one, and I am always very dusty, always more bristlingly loaded, like a porcupine, with sticks, painter's easel, canvases and further merchandise. Only the green eyes have remained the same, but of course another colour in the portrait is the yellow straw hat, like a hannekenmaaier's [seasonal harvest labourers from Germany], and a very black little pipe – I live in a little yellow house with a green door and green blinds, whitewashed inside – on the white walls very brightly coloured Japanese prints, red tiles on the floor – the house in the full sunlight – and over it an intensely blue sky, and – the shadows in the middle of the day much shorter than in our country. Well – can you understand that one may be able to paint something like this with only a few strokes of the brush? . . .

*

To Theo

. . . I have scraped off a big painted study, an olive garden, with a figure of Christ in blue and orange, and an angel in yellow. Red earth, hills green and blue, olive trees with violet and carmine trunks, and green-grey and blue foliage. A citron-yellow sky. I scraped it off because I tell myself that I must not do figures of that importance without models. . . .

*

. . . It certainly is a strange phenomenon that all artists, poets, musicians, painters, are unfortunate in material things – the happy ones as well – what you said lately about Guy de Maupassant is fresh proof of it. That brings up again the eternal question: Is the whole of life visible to us, or isn't it rather that this side of death we see only one hemisphere?

. . . For my own part, I declare I know nothing whatever about it, but looking at the stars always makes me dream, as simply as I dream over the black dots representing towns and villages on a map. I ask myself, shouldn't the shining dots of the sky be as accessible as the black dots on the map of France? Just as we take the train to get to Tarascon or Rouen, we take death to reach a star. One thing undoubtedly true in this reasoning is that we *cannot* get to a star while we are *alive*, any more than we can take the train when we are dead.

So to me it seems possible that cholera, gravel, tuberculosis and cancer are the celestial means of locomotion, just as steamboats, buses and railways are the terrestrial means. To die quietly of old age would be to go there on foot.

Now I am going to bed because it is late, and I wish you good night and good luck. . . .

<center>*</center>

. . . And very often indeed I think of that excellent painter Monticelli – who they said was such a drinker, and off his head – when I come back myself from the mental labour of balancing the six essential colours, red – blue – yellow – orange – lilac – green. Sheer work and calculation, with one's mind strained to the utmost, like an actor on the stage in a difficult part, with a hundred things to think of at once in a single half hour.

After that, the only thing to bring ease and distraction, in my case and in other people's too, is to stun oneself with a lot of drinking or heavy smoking. Not very virtuous, no doubt, but it's to return to the subject of Monticelli.

. . . Don't think that I would maintain a feverish condition artificially, but understand that I am in the midst of a complicated calculation which results in a quick succession of canvases quickly executed but calculated long *beforehand*. So now, when anyone says that such and such is done too quickly, you can reply that they have looked at it too quickly. . . .

<center>*</center>

To Émile Bernard . . . Listen, one of the first days after I came to this spot I talked to a painter friend of mine, who said, 'How boring it would be to do this.' I didn't say anything, but I thought it so astounding that I didn't even have the strength to give that idiot a piece of my mind. And I am still going there, over and over again. All right! I have done two drawings of it – of that flat landscape, where there was nothing but . . . infinity – eternity.

All right! While I was drawing there came along a fellow who is not a painter but a soldier. I said to him, 'Does it amaze you that I think this as beautiful as the sea?'

Now this fellow knew the sea. 'No, it doesn't amaze me', he said, 'that you think this as beautiful as the sea, but I myself think it even more beautiful than the ocean; because it is *inhabited*.'

Which of the two spectators was more of an artist, the first or the second, the painter or the soldier? Personally I prefer the soldier's eye – am I right or not? . . .

<center>*</center>

To Theo . . . But don't let's forget that this earth is a planet too, and consequently a star, or celestial orb. And if all the other stars were the same! ! ! ! That would not be much fun; nothing for it but to begin all over again. But in art, for which one needs *time*, it would not be so bad to live more than one life. And it is rather attractive to think of the Greeks, the old Dutch masters, and the Japanese continuing their glorious school on other orbs. There, that's enough for today. . . .

<center>*</center>

. . . I am getting older than you, and my ambition is to be less of a burden to you. And, if no actual obelisk of too pyramidal a catastrophe occurs, and there's no rain of frogs in the meantime, I hope to achieve it sometime.

. . . Why, a canvas I have covered is worth more than a blank canvas.

That – believe me my pretensions go no further – that is my right to paint, my reason for painting, and by the Lord, I have one!

All it has cost me is a carcass pretty well destroyed and wits pretty well crazed, and only to lead the same life I might and should lead if I were a philanthropist.

. . . If I were to think of and dwell on disastrous possibilities, I could do nothing. I throw myself headlong into my work, and come up again with my studies; if the storm within gets too loud, I take a glass too much to stun myself.

Cracked, of course; when you look at what one *ought to be*.

But in the old days I used to feel less of a *painter*, now painting is becoming a distraction for me, like rabbit-hunting for the cracked-brained: they do it to distract themselves.

My concentration becomes more intense, my hand more sure.

That is why I almost dare to swear to you that my painting will improve. Because I have nothing left but that. . . .

*

To Émile Bernard

. . . Why do you say Degas is impotently flabby? Degas lives like a small lawyer and does not like women, for he knows that if he loved them and fucked them often, he, intellectually diseased, would become insipid as a painter.

Degas's painting is virile and impersonal for the very reason that he has resigned himself to be nothing personally but a small lawyer with a horror of going on a spree. He looks on while human animals, stronger than himself, get excited and fuck, and he paints them well, exactly because he doesn't have the pretension to get excited himself.

Rubens! Ah, that one! he was a handsome man and a good fucker, Courbet too. Their health permitted them to drink, eat, fuck. . . . As for you, my poor dear comrade Bernard, I already told you in the spring: eat a lot, do your military exercises well, don't fuck too much; when you do this your painting will be all the more spermatic.

. . . P.S. Cézanne is a respectable married man just like the old Dutchmen; if there is plenty of male potency in his work it is because he does not let it evaporate in merrymaking.

*

To Theo

. . . That is to say that if you paint *indirectly*, you are more productive than I am, for instance. The more irrevocably you become a dealer, the more you become an artist.

And in the same way I hope the same thing for myself. The more I am spent, ill, a broken pitcher, by so much more am I an artist – a creative artist – in this great renaissance of art of which we speak.

. . . As for drinking too much . . . if it is bad, I can't tell. But look at Bismarck, who is in any case very practical and very intelligent, his good doctor told him he was drinking too much, and that all his life he had overtaxed his stomach and his brain. Bismarck immediately stopped drinking. After that he got run down and couldn't pick up. Secretly he must be laughing heartily at his doctor, because fortunately for him he did not consult him sooner. . . .

*

. . . I need some studies of figures very much. Just now I have a sort of exhibition at home, that is to say I have taken all the studies from the stretchers, and have nailed them up on the wall to get thoroughly dry. You will see that when there are a lot of them and one can choose among them, it comes to the same thing as if I had studied them more and worked on them longer. Because to paint and repaint a subject on the same or several canvases comes to the same thing in the end. I am in rather a hurry, so a handshake. . . .

*

. . . The change I am going to try to make in my painting is to do more figures.

Altogether it is the only thing in painting that excites me to the depths of my soul, and which makes me feel the infinite more than anything else. . . .

*

To Wilhelmina
. . . I am working very hard now, and I think the summer here extremely beautiful, more beautiful than I ever saw it in the North, but people here are complaining loudly that it is not the same as usual. Now and then some rain in the morning or the afternoon, but infinitely less than in our country. The harvest was gathered long ago. There is much wind here, however, a very ill-natured, whining wind — *le mistral* — very troublesome for the most part, when I have to paint in it, in which case I put my canvas down flat on the ground, and work on my knees. For the easel does not stand firm.

. . . I am now engaged on a portrait of a postman in his dark-blue uniform with yellow. A head somewhat like Socrates, hardly any nose at all, a high forehead, bald crown, little grey eyes, bright red chubby cheeks, a big pepper-and-salt beard, large ears. This man is an ardent republican and socialist, reasons quite well, and knows a lot of things. His wife was delivered of a child today, and he is consequently feeling as proud as a peacock, and is all aglow with satisfaction.

In point of fact I greatly prefer painting a thing like this to doing pictures of flowers.

. . . Now as regards what you ask, as to whether it is hot here, and whether I am going to live with somebody else. Well, this is rather probable, and with a very clever painter too [Gauguin] who, like the other impressionists, is leading a life full of cares, and who is the proud owner of a liver complaint besides. . . .

*

Arles/July—August 1888

. . . And meanwhile I am in my own hide, and my hide caught in the wheels of the Fine Arts, like wheat between the millstones. . . .

*

. . . Under the blue sky the orange, yellow, red splashes of the flowers take on an amazing brilliance, and in the limpid air there is a something or other happier, more lovely than in the North. It vibrates like the bouquet by Monticelli which you have. I reproach myself for not painting flowers here. And although I've knocked off some fifty drawings and painted studies here, I seem to have done absolutely nothing. I'd gladly content myself with being a pioneer for the other painters of the future who come to work in the South. . . .

*

. . . What a mistake Parisians make in not having a palate for crude things, for Monticellis, for common earthenware. But there, one must not lose heart because Utopia is not coming true. It is only that what I learned in Paris is leaving me, and I am returning to the ideas I had in the country before I knew the impressionists. And I should not be surprised if the impressionists soon find fault with my way of working, for it has been fertilized by Delacroix's ideas rather than by theirs. Because instead of trying to reproduce exactly what I have before my eyes, I use colour more arbitrarily, in order to express myself forcibly.

*

. . . The only choice I have is between being a good painter and a bad one. I choose the first. But the needs of painting are like those of a wasteful mistress, you can do nothing without money, and you never have enough of it. That's why painting ought to be done at the public expense, instead of the artists being overburdened with it.

But there, we had better hold our tongues, because *no one is forcing us to work*, fate having ordained that indifference to painting be widespread and by way of being eternal. . . .

*

. . . Provided that on the 10 metres of canvas I paint only masterpieces half a metre in size and sell them cash down and at exorbitant prices to distinguished connoisseurs of the Rue de la Paix, nothing will be easier than to make a fortune on this package. . . .

*

. . . Why am I so little an artist that I always regret that the statue and the picture are not alive? Why do I understand the musician better, why do I see the *raison d'être* of his abstractions better? . . .

*

. . . Oh, my dear brother, sometimes I know so well what I want. I can very well do without God both in my life and in my painting, but I cannot, ill as I am, do without something which is greater than I, which is my life – the power to create.

And if, frustrated in the physical power, a man tries to create thoughts instead of children, he is still part of humanity.

And in a picture I want to say something comforting, as music is comforting. I want to paint men and women with that something of the eternal which the halo used to symbolize, and which we seek to convey by the actual radiance and vibration of our colouring.

. . . So I am always between two currents of thought, first the material difficulties, turning round and round to make a living; and second, the study of colour. I am always in hope of making a discovery there, to express the love of two lovers by the wedding of two complementary colours, their mingling and their opposition, the mysterious vibration of kindred tones. To express the thought of a brow by the radiance of a light tone against a sombre background.

To express hope by some star, the eagerness of a soul by a sunset radiance. Certainly there is no delusive realism in that, but isn't it something that actually exists? . . .

*

. . . Neither Gauguin nor Bernard has written again. I think that Gauguin doesn't give a damn about it, because it isn't going to be done at once, and I for my part, seeing that Gauguin has managed to muddle along by himself for six months, am ceasing to believe in the urgent necessity of helping him.

So let's be prudent. If it does not suit him here, he may be forever reproaching me with, 'Why did you bring me to this rotten country?' And I don't want any of that.

Naturally we can still remain friends with Gauguin, but I see only too clearly that his mind is elsewhere. So I say, let's behave as if he were not there; then if he comes, so much the better – if he doesn't, so much the worse. . . .

*

. . . In my picture of the 'Night Café' I have tried to express the idea that the café is a place where one can ruin oneself, go mad or commit a crime. So I have tried to express, as it were, the powers of darkness in a low public house, by soft Louis XV green and malachite, contrasting with yellow-green and harsh blue-greens, and all this in an atmosphere like a devil's furnace, of pale sulphur.

And all with an appearance of Japanese gaiety, and the good nature of Tartarin.

But what would Monsieur Tersteeg say about this picture when he said before a Sisley – Sisley, the most discreet and gentle of the impressionists – 'I can't help thinking that the artist who painted that was a little tipsy.' If he saw my picture, he would say that it was delirium tremens in full swing. . . .

*

. . . I wrote to you already, early this morning, then I went away to go on with a picture of a garden in the sunshine. Then I brought it back and went out again with a blank canvas, and that also is finished. And now I want to write you again.

Because I have never had such a chance, nature here being so *extraordinarily* beautiful. Everywhere and all over the vault of heaven is a marvellous blue, and the sun sheds a radiance of pale sulphur, and it is soft and as lovely as the combination of heavenly blues and yellows in a Van der Meer [Vermeer] of Delft. I cannot paint it as beautifully as that, but it absorbs me so much that I let myself go, never thinking of a single rule.

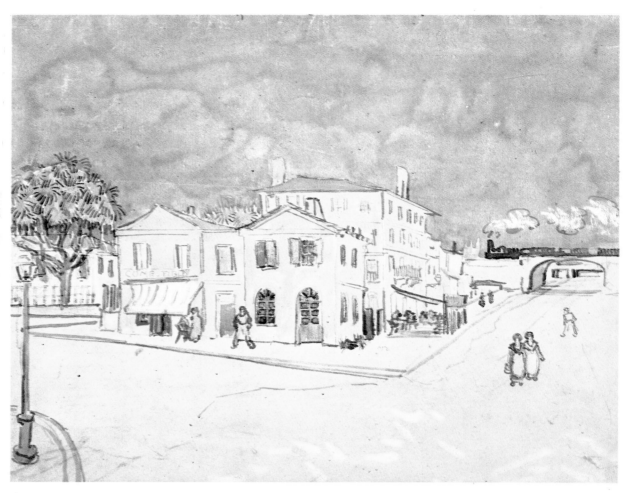

VINCENT'S HOUSE

. . . And Petrarch lived quite near here in Avignon, and I am
seeing the same cypresses and oleanders.

I have tried to put something of that into one of the pictures painted in a very thick
impasto, citron yellow and lime green. Giotto moved me most – *always in pain*, and always
full of kindness and enthusiasm, as though he were already living in a different world from
ours.

And besides, Giotto is extraordinary. I understand him better than the poets Dante,
Petrarch and Boccaccio.

I always think that poetry is more *terrible* than painting, though painting is a dirtier and
much more worrying job. And then the painter never says anything, he holds his tongue,
and I like that too.

. . . Tomorrow I am going to draw, until the paints come.
But I have deliberately arrived at the point where I will not draw a picture with charcoal.
That's no use, you must attack drawing with the colour itself in order to draw well.

. . . But I have got back to where I was in Nuenen, when
I made a vain attempt to learn music, so much did I already feel the relation between our
colour and Wagner's music. . . .

*

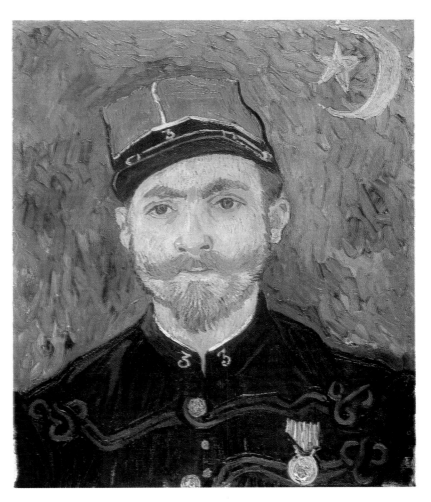

LIEUTENANT MILLIET

. . . Even if it is some time before anyone comes here to stay with me, it won't make me change my mind about this step being urgent and being useful in the long run. This art that we are working in, we feel that it has a long future before it, and one must be quietly settled, like steady people, and not like decadents. Here my life will become more and more like a Japanese painter's, living close to nature like a petty tradesman. And that, you well know, is a less lugubrious affair than the decadent's way. If I can live long enough, I shall be something like old Tanguy.

After all, we don't really know anything about our own personal future, but we nevertheless feel that impressionism will last. . . .

*

. . . Milliet is lucky, he has as many Arlésiennes as he wants; but then he cannot paint them, and if he were a painter he would not get them. I must bide my time without rushing things.

. . . In the end we shall have had enough of cynicism and scepticism and humbug, and we shall want to live more musically. How will that come about, and what will we really find? It would be interesting to be able to prophesy, but it is even better to be able to feel that kind of foreshadowing, instead of seeing absolutely nothing in the future beyond the disasters that are all the same bound to strike the modern

world and civilization like terrible lightning, through a revolution or a war, or the bankruptcy of worm-eaten states. If we study Japanese art, we see a man who is undoubtedly wise, philosophic and intelligent, who spends his time doing what? In studying the distance between the earth and the moon? No. In studying Bismarck's policy? No. He studies a single blade of grass.

But this blade of grass leads him to draw every plant and then the seasons, the wide aspects of the countryside, then animals, then the human figure. So he passes his life, and life is too short to do the whole.

Come now, isn't it almost a true religion which these simple Japanese teach us, who live in nature as though they themselves were flowers? . . .

*

. . . I have a terrible lucidity at moments, these days when nature is so beautiful, I am not conscious of myself any more, and the picture comes to me as in a dream. I am rather afraid that this will mean a reaction and depression when the bad weather comes, but I will try to avoid it by studying this business of drawing figures from memory.

. . . The one thing I do hope is that by working hard I shall have enough pictures at the end of a year to have a show if I want to, or, if you wish it, at the time of the exhibition. I am not set on it myself, but what I am set on is showing you something that is not wholly bad.

I need not exhibit, but we would have work of mine that would prove that I am neither a slacker nor a good-for-nothing and I should be content. But the main thing is, I think, that I must not take less trouble than the painters who are working expressly for it.

Whether one exhibits or doesn't exhibit, one must produce, and after that one has the right to smoke one's pipe in peace. . . .

*

To Gauguin

. . . I always think my artistic conceptions extremely ordinary when compared to yours.

I have always had the coarse lusts of a beast.

I forget everything in favour of the external beauty of things, which I cannot reproduce, for in my pictures I render it as something ugly and coarse, whereas nature seems perfect to me.

However, at present the *élan* of my bony carcass is such that it goes straight for its goal. The result of this is a sincerity, perhaps original at times, in what I feel, if only the subject can lend something to my rash and clumsy execution. . . .

*

To Theo

. . . I am working on a portrait of Mother, because the black-and-white photograph annoys me so. Ah, what portraits could be made from nature with photography and painting! I always hope that we are still to have a great revolution in portraiture. . . .

*

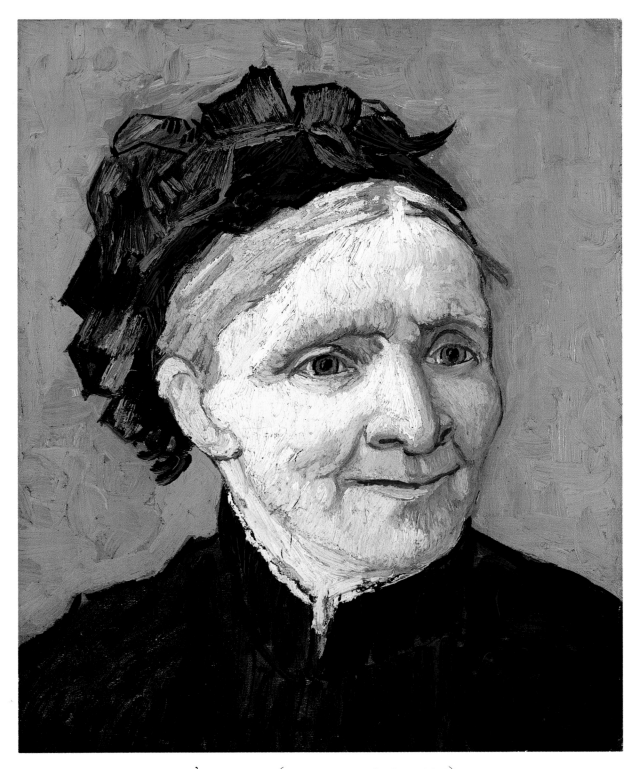

PORTRAIT OF VAN GOGH'S MOTHER (AFTER A PHOTOGRAPH)

. . . What a lot of things there are that ought to be changed. Isn't it true that all painters ought to live like workmen? A carpenter or blacksmith is accustomed to producing infinitely more than they do. And in painting too we should have large studios where each man would work with greater regularity.

I am really falling asleep and I can't see any more, my eyes are so tired. . . .

*

. . . Say, what is Seurat doing? If you see him, tell him once more from me that I am working on a scheme of decoration which has now got to 15 square size 30 canvases, and which will take at least 15 others to make a whole, and that in this work on a larger scale, it is often the memory of his personality and of the visit we made to his studio to see his beautiful great canvases that encourages me in this task. . . .

*

To Eugène Boch

. . . Many thanks for your letter which pleased me very much. I congratulate you on not having hesitated this time and on having attacked the Borinage. There you have a field where you will be able to work all your life (*illegible*) – the extraordinary scenery [as well as] the figure.

The tip girls in their pit rags especially are superb. If you should ever go to Petit Wasmes, please enquire whether Jean Baptiste Denis, farmer, and Joseph Quinet, miner, are still living there, and tell them from me that I have never forgotten the Borinage and that I should still be delighted to see it again. . . .

*

THE STARRY NIGHT

To Theo . . . I am not ill, but without the slightest doubt I'd get ill if I did not eat plenty of food and if I did not stop painting for a few days. As a matter of fact, I am again pretty nearly reduced to the madness of Hugo van der Goes in Emil Wauters's picture. And if it were not that I have almost a double nature, that of a monk and that of a painter, as it were, I should have been reduced, and that long ago, completely and utterly, to the aforesaid condition.

Yet even then I do not think that my madness could take the form of persecution mania, since when in a state of excitement my feelings lead me rather to the contemplation of eternity, and eternal life.

But in any case I must beware of my nerves, etc. . . .

<div align="center">*</div>

To Émile Bernard . . . Gaugin interests me very much as a man – very much.

For a long time now it has seemed to me that in our nasty profession of painting we are most sorely in need of men with the hands and the stomachs of workmen. More natural tastes – more loving and more charitable temperaments – than the decadent dandies of the Paris boulevards have.

Well, here we are without the slightest doubt in the presence of a virgin creature with savage instincts. With Gaugin blood and sex prevail over ambition. . . .

<div align="center">*</div>

BRETON WOMEN AND CHILDREN (AFTER ÉMILE BERNARD)

SOWER WITH SETTING SUN

To Theo

 . . . What Gaugin tells of the tropics seems marvellous to me. Surely the future of a great renaissance in painting lies there. Just ask your new Dutch friends whether they have ever thought of how interesting it would be if some Dutch painters were to found a colourist school in Java. If they heard Gauguin describe the tropical countries, it would certainly make them desire to do it directly. Everybody is not free and [in] circumstances [that allow them] to emigrate. But what things could be done there!

 I regret I am not ten or twenty years younger, then I would certainly go there.

 Now it is most unlikely that I shall leave the shore to put to sea, and the little yellow house here in Arles will remain a way station between Africa, the Tropics, and the people of the North. . . .

<p align="center">*</p>

 . . . But I have made portraits *of a whole family*, that of the postman whose head I had done previously – the man, his wife, the baby, the little boy, and the son of sixteen, all characters and very French, though the first has the look of a Russian. Size 15 canvases. You know how I feel about this, how I feel in my element, and that it consoles me up to a certain point for not being a doctor. . . .

<p align="center">*</p>

 . . . If by the time I am forty I have done a picture of figures like the flowers Gauguin was speaking of, I shall have a position in art equal to that of anyone, no matter who. So, perseverance. . . .

<p align="center">*</p>

. . . Gauguin and I talked a lot about Delacroix, Rembrandt, etc. Our arguments are terribly *electric*, sometimes we come out of them with our heads as exhausted as a used electric battery. We were in the midst of magic, for as Fromentin says so well: Rembrandt is above all a magician. . . .

*

To Gauguin . . . I take the opportunity of my first absence from the hospital [after Vincent's first nervous crisis and Gauguin's departure from Arles] to write you a few words of very deep and sincere friendship. I often thought of you in the hospital, even at the height of fever and comparative weakness.

Look here – was my brother Theo's journey really necessary, old man?

Now at least do reassure him completely, and I entreat you, be confident yourself that after all no evil exists in this best of worlds in which everything is for the best. . . .

*

To Theo . . . So as to reassure you completely on my account, I write you these few lines in the office of M. Rey, the house surgeon, whom you met yourself. I shall stay here at the hospital a few days more, then I think I can count on returning to the house very quietly.

Now I beg only one thing of you, not to worry, because that would cause me one worry *too many*.

Now let's talk about our friend Gauguin. Have I scared him? In short, why doesn't he give me any sign of life? He must have left with you. Besides, it was necessary for him to go back to Paris, and he will perhaps feel more at home in Paris than here. Tell Gauguin to write me, and that I am always thinking about him. . . .

*

. . . I have written a note to Mother and Wil and *addressed it to our sister*, with the sole intention of setting their minds at rest in case you have said anything about my having been ill.

Just tell them on your part that I have been a bit beat, the way I used to be in the past, when I had that venereal trouble in The Hague, and that I got myself looked after in the hospital. Only that it is not worth mentioning since I have completely recovered, and that I was only in the aforesaid hospital for a few days.

. . . I assure you that some days at the hospital were very interesting, and perhaps it is from the sick that one learns how to live.

I hope I have just had simply an artist's fit, and then a lot of fever after *very* considerable loss of blood, as an artery was severed; but my appetite came back at once, my digestion is all right and my blood recovers from day to day, and in the same way serenity returns to my brain day by day. So please quite deliberately forget your unhappy journey and my illness. . . .

*

. . . What you tell me about Gauguin gives me tremendous pleasure, that is to say that he has not given up his project of returning to the tropics. That is the right road for him. I think I see light in his plan, and I approve of it heartily. Naturally I regret it, but you understand that if all goes well with him, that is all I want.

. . . Gauguin and I had been talking about Degas before, and I had pointed out to Gauguin that Degas had said . . .

'I am saving myself up for the Arlésiennes.'

Now you know how subtle Degas is, so when you get back to Paris, just tell Degas that I admit that up to the present I have been powerless to paint the women of Arles as anything but poisonous, and that he must not believe Gauguin if Gauguin speaks well of my work too early, for it has only been a sick man's so far.

Now if I recover, I must *begin again*, and I shall not again reach the heights to which sickness partially led me. . . .

*

. . . And now, dissecting the situation in all boldness, there is nothing to prevent us seeing him [Gauguin] as the little Bonaparte tiger of impressionism as far as . . . I don't quite know how to say it, his vanishing, say, from Arles would be comparable or analogous to the return from Egypt of the aforesaid Little Corporal, who also presented himself in Paris afterward and who always left the armies in the lurch.

Fortunately Gauguin and I and other painters are not yet armed with machine guns and other very destructive implements of war. I for one am quite decided to go on being armed with nothing but my brush and my pen.

But with a good deal of clatter, Gauguin has nonetheless demanded in his last letter 'his masks and fencing gloves' hidden in the little closet in my little yellow house.

I shall hasten to send him his toys by parcel post. . . .

*

. . . Meanwhile the great thing is that your marriage should not be delayed. By getting married you will set Mother's mind at rest and make her happy, and it is after all almost a necessity in view of your position in society and in commerce. Will it be appreciated by the society to which you belong? Perhaps not, any more than the artists ever suspect that I have sometimes worked and suffered for the community. . . . So from me, your brother, you will not want banal congratulations and assurances that you are about to be transported straight into paradise. And with your wife you will not be lonely any more, which I could wish for our sister as well.

That, after your own marriage, is what I should set my heart on more than anything else.

. . . During my illness I saw again every room in the house at Zundert, every path, every plant in the garden, the views of the fields outside, the neighbours, the graveyard, the church, our kitchen garden at the back – down to a magpie's nest in a tall acacia in the graveyard.

It's because I still have earlier recollections of those first days than any of the rest of you. There is no one left who remembers all this but Mother and me.

I say no more about it, since I had better not try to go over all that passed through my head then.

Only you know how happy I shall be when your marriage has taken place. Look here now, if for your wife's sake it might be advisable to have a picture of mine at Goupil's from time to time, then I will forget my grudge against them, in this way:

I said I did not want to go back to them with too innocent a picture.

But if you like, you can exhibit the two pictures of sunflowers. . . .

. . . It astonishes me already when I compare my condition today with what it was a month ago. Before that I knew well enough that one could fracture one's legs and arms and recover afterward, but I did not know that you could fracture the brain in your head and recover from that too.

I still have a sort of 'what is the good of getting better?' feeling about me, even in the astonishment aroused in me by my getting well, which I hadn't dared hope for.

. . . Since it is still winter, look here, let me go quietly on with my work; if it is that of a madman, well, so much the worse. I can't help it.

However, the unbearable hallucinations have ceased, and are now getting reduced to a simple nightmare, in consequence of my taking bromide of potassium, I think.

. . . As for me, being in this little country of mine, I have no need at all to go to the tropics. I believe and shall always believe in the art that is to be created in the tropics, and I think it will be marvellous, but personally I am too old and (especially if I have a papier mâché ear put on) too jerry-built to go there.

DORMITORY IN THE HOSPITAL

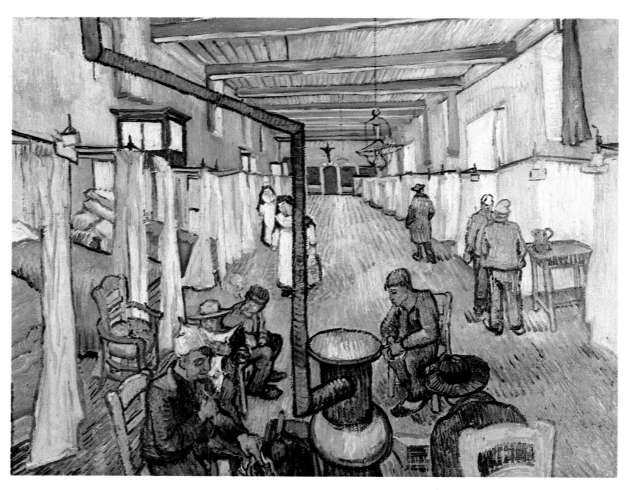

. . . Old Gauguin and I understand each other basically, and if we are a bit mad, what of it? Aren't we also thoroughly artists enough to contradict suspicions on that score by what we say with the brush?

Perhaps someday everyone will have neurosis, St Vitus' dance, or something else. . . .

*

. . . I know already that several people here would ask me for portraits if they dared. Roulin, quite a poor fellow and lowly employee though he is, is much respected, and it is known that I have done his whole family.

Today I am working on a third 'Berceuse'. I know very well that it is neither drawn nor painted as correctly as a Bouguereau, and I rather regret this, because I have an earnest desire to be correct. But though it is doomed, alas, to be neither a Cabanel nor a Bouguereau, yet I hope that it will be French.

It has been a magnificent day with no wind, and I have such a longing to work that I am astonished, as I did not expect it any more.

I will finish this letter like Gauguin's, by telling you that there certainly are signs of previous overexcitement in my words, but that is not surprising, since everyone in this good Tarascon country is a trifle cracked. . . .

*

. . . When I came out of the hospital with kind old Roulin, who had come to get me, I thought that there had been nothing wrong with me, but *afterward* I felt that I had been ill. Well, well, there are moments when I am twisted by enthusiasm or madness or prophecy, like a Greek oracle on the tripod. . . .

*

. . . I seemed to see so much brotherly anxiety in your kind letter that I think it my duty to break my silence. I write to you in the full possession of my faculties and not as a madman, but as the brother you know. This is the truth.
A certain number of people here (there were more than 80 signatures) addressed a petition to the Mayor (I think his name is M. Tardieu), describing me as a man not fit to be at liberty, or something like that.

The commissioner of police or the chief commissioner then gave the order to shut me up again.

Anyhow, here I am, shut up in a cell all the livelong day, under lock and key and with keepers, without my guilt being proved or even open to proof.

Needless to say, in the secret tribunal of my soul I have much to reply to all that. Needless to say, I cannot be angry, and it seems to me a case of qui s'excuse s'accuse.

Only to let you know that as for setting me free – mind, I do not ask it, being persuaded that the whole accusation will be reduced to nothing – but I do say that as for getting me freed, you would find it difficult. If I did not restrain my indignation, I should at once be thought a dangerous lunatic. Let us hope and have patience. Besides, strong emotion can only aggravate my case. That is why I beg you for the moment to let things be without meddling. . . .

. . . M. Rey says that instead of eating enough and at regular times, I kept myself going on coffee and alcohol. I admit all that, but all the same it is true that to attain the high yellow note that I attained last summer, I really had to be pretty well keyed up. And after all, an artist is a man with his work to do, and it is not for the first idler who comes along to crush him for good. . . .

*

. . . And now I am returning to my portrait of 'La Berceuse' for the fifth time. And when you see it, you will agree with me that it is nothing but a chromograph from the cheap shops, and again that it has not even the merit of being photographically correct in its proportions or in anything else.

But after all, I want to make a picture such as a sailor at sea who could not paint would imagine to himself when he thinks of his wife ashore.

. . . These last three months do seem so strange to me. Sometimes moods of indescribable mental anguish, sometimes moments when the veil of time and the fatality of circumstances seem to be torn apart for an instant.

. . . Oh, I must not forget to tell you a thing I have often thought of. Quite accidentally I found in an article in an old newspaper some words written on an ancient tomb in the country between here and Carpentras.

Here is this very, very, very old epitaph, say dating from the time of Flaubert's *Salammbô*. 'Thebe, daughter of Thelhui, priestess of Osiris, who never complained of anyone.'

. . . What does it mean, this 'she never complained of anyone'? Imagine a perfect eternity, why not, but don't let us forget that even in those old days reality had this – 'and she never complained of anyone'.

Do you remember that one Sunday good old Thomas came to see us and said, 'Ah but – are those the kind of women to make a man horny?'

It is not exactly a question of being horny, but from time to time in your life you feel thrilled through and through as if you were actually striking root in the soil. . . .

*

. . . Roulin, though he is not quite old enough to be like a father to me, nevertheless has a silent gravity and a tenderness for me such as an old soldier might have for a young one. All the time – but without a word – a something which seems to say, We do not know what will happen to us tomorrow, but whatever it may be, think of me. And it does one good when it comes from a man who is neither embittered, nor sad, nor perfect, nor happy, nor always irreproachably just. But such a good soul and so wise and so full of feeling and so trustful. I tell you I have no right to complain of anything whatever in Arles when I think of some things I have seen there which I shall never be able to forget. . . .

*

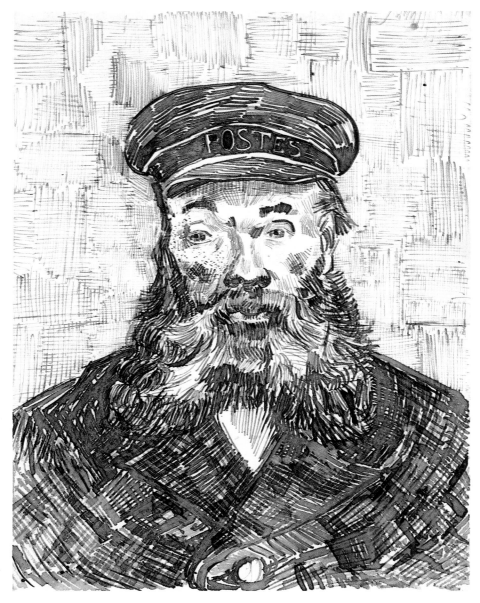

JOSEPH ROULIN, HEAD

To Paul Signac　　　　　　　　　　　　　　　. . . As to my brother's not having replied to your letter, I am inclined to think that it is hardly his fault. I myself have not heard from him for a fortnight. The fact is that he is in Holland, where he is getting married one of these days.

Well, look here, without denying the least bit in the world the advantages of marriage, once it has been contracted, and of being quietly settled down in one's own home, when I think of the obsequial pomp of the reception and lamentable congratulations on the part of the two families (still in a state of civilization), not to mention the fortuitous appearances in those chemist's jars where the antediluvian civil and religious magistrates are kept – goodness gracious – mustn't one pity the poor wretch who is obliged, after having provided himself with the necessary documents, to repair to a locality, where, with a ferocity unequalled by the cruellest cannibals, he is married alive at a slow fire of receptions and the aforesaid funereal pomp.

. . . But at times it is not easy for me to take up living again, for there remain inner seizures of despair of a pretty large calibre.

My God, those anxieties – who can live in the modern world without catching his share of them? The best consolation, if not the best remedy, is to be found in deep friendships, even though they have the disadvantage of anchoring us more firmly in life than would seem desirable in the days of our great sufferings. . . .

*

To Wilhelmina

. . . Mother will doubtless be pleased with Theo's marriage, and he writes me that she seems to be getting younger in appearance. This pleases me very much indeed. Now he too is very contented with his experience of matrimony, and feels considerably reassured. He has very few illusions about it all, for he possesses to a rare degree that strength of mind which enables him to take things as they are without expressing himself about the good or the bad of them. And he is quite right in this, for what do we know about what we are doing?

As for myself, I am going to an asylum in St Rémy, not far from here, for three months. I have had in all four great crises, during which I didn't in the least know what I said, what I wanted and what I did. Not taking into account that I had previously had three fainting fits without any plausible reason, and without retaining the slightest remembrance of what I felt.

. . . I read little in order to meditate all the more. It is very probable that I shall have to suffer a great deal yet. And to tell the honest truth, this does not suit me at all, for under no circumstances do I long for a martyr's career. For I have always sought something different from heroism, which I do not have, which I certainly admire in others, but which, I tell you again, I consider neither my duty nor my ideal.

. . . Every day I take the remedy which the incomparable Dickens prescribes against suicide. It consists of a glass of wine, a piece of bread with cheese and a pipe of tobacco. This is not complicated, you will tell me, and you will hardly be able to believe that this is the limit to which melancholy will take me; all the same, at some moments – oh dear me . . .

Well, it is not always pleasant, but I do my best not to forget altogether how to make contemptuous fun of it. I try to avoid everything that has any connection with heroism or martyrdom; in short, I do my best not to take lugubrious things lugubriously. . . .

*

To Theo

. . . For myself, I shouldn't be unhappy or discontented if some time from now I could enlist in the Foreign Legion for five years (they take men up to forty, I think). From the physical point of view my health is better than it used to be, and perhaps being in the army would do me more good than anything else.

. . . But if not, naturally I can always do painting or drawing as long as it will work, and I do not in the least say No to that.

. . . Sometimes, just as the waves pound against the sullen, hopeless cliffs, I feel a tempest of desire to embrace something, a woman of the domestic hen type, but after all, we must take this for what it is, the effect of hysterical overexcitement rather than a vision of actual reality. . . .

*

. . . Today I am busy packing a case of pictures and studies. One of them is flaking off, and I have stuck some newspapers on it; it is one of the best, and I think that when you look at it you will see better what my now shipwrecked studio might have been.

This study, like some others, has got spoiled by moisture during my illness.

The flood water came to within a few feet of the house, and on top of that, the house itself had no fires in it during my absence, so when I came back, the walls were oozing water and saltpetre.

That touched me to the quick, not only the studio wrecked, but even the studies which would have been a souvenir of it ruined; it is so final, and my enthusiasm to found something very simple but lasting was so strong. It was a fight against the inevitable, or rather it was weakness of character on my part, for I am left with feelings of profound remorse, difficult to describe. I think that was the reason I have cried out so much during the attacks. It was because I wanted to defend myself and could not do it. For it was not for myself, it was just for painters like the unfortunates the enclosed article speaks of that that studio would have been of some use. . . .

*

. . . I have been 'in a hole' all my life, and my mental condition is not only vague *now*, but *has always been so*, so that whatever is done for me, I *cannot* think things out so as to balance my life. Where I *have* to follow a rule, as here in the hospital, I feel at peace. . . .

*

To Wilhelmina

. . . Joking apart, I am of the opinion that a man or a woman ought to be desperately in love with something or somebody, and the only precaution one might be able to take is to do it in a certain way according to one's ideas, and not in any other way.

As to knowing one's own mind in matters of this kind – alas, we know ourselves so little.

As a matter of fact I am inclined to believe that women are apt to take the offensive in these things; that those among them who are wise, or rather have the surest and truest instincts, do not wait for somebody else to love them before they fall in love themselves – which (and I am disposed to think there are good reasons for this) seems to them to be the essential thing. . . .

*

To Theo ... Now I as a painter shall never amount to anything important, I am absolutely sure of it. Suppose all were changed, character, education, circumstances, then this or that might have been. But we are too positive to get confused. I sometimes regret I did not simply stick to the Dutch palette with its grey tones, and brush away at landscapes of Montmartre without any fuss.

... So many distinctions in impression have *not* the importance that people have chosen to see in them.

Crinolines had something pretty about them and consequently good, but in the end the fashion was fortunately short-lived for all that. Not for some people.

And thus we shall always keep a sort of passion for impressionism, but I feel that I return more and more to the ideas that I already had before I came to Paris. ...

... I really must make up my mind, it is only too true that lots of painters go mad, it is a life that makes you, to say the least, very absent-minded. If I throw myself fully into my work again, very good, but I shall always be cracked.

WINDOW OF VINCENT'S STUDIO AT THE ASYLUM

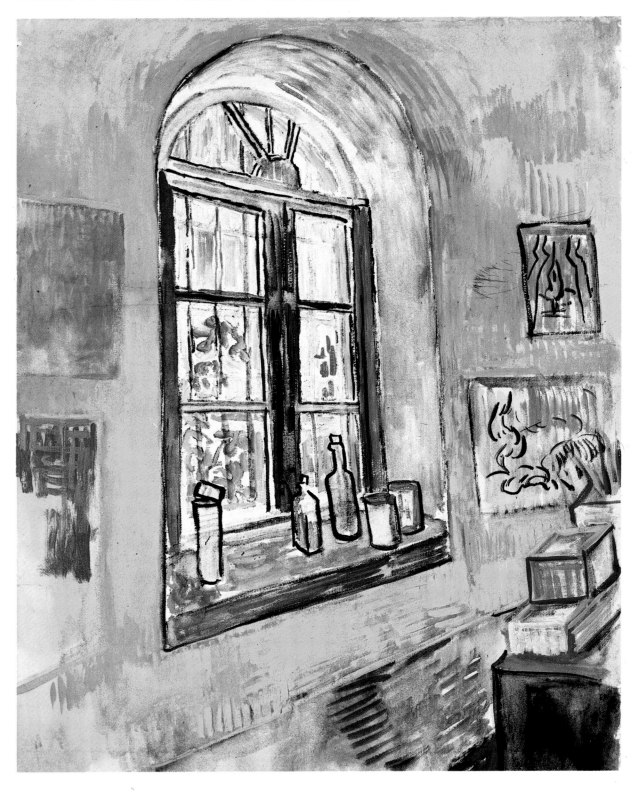

To Theo . . . As far as I can make out, the doctor here is inclined to consider what I have had some sort of epileptic attack. But I did not ask him about it. Have you received the case of pictures? I am anxious to know whether or not they have suffered.

I am working on two others – some violet irises and a lilac bush, two subjects taken from the garden.

The idea of work as a duty is coming back to me very strongly, and I think that all my faculties for work will come back to me fairly quickly. Only work often absorbs me so much that I think I shall always remain absent-minded and awkward in shifting for myself for the rest of my life too.

*

 . . . What you say about 'La Berceuse' pleases me; it is very true that the common people, who are content with chromos [popular coloured prints] and melt when they hear a barrel organ, are in some vague way right, perhaps more sincere than certain men about town who go to the Salon. . . .

*

 . . . But then to come back to the point, the Egyptian artists, having a *faith*, working by feeling and by instinct, express all these intangible things – kindness, infinite patience, wisdom, serenity – by a few knowing curves and by the marvellous proportions. That is to say once more, when the thing represented and the manner of representing it agree, the thing has style and quality. . . .

*

 . . . The cypresses are always occupying my thoughts, I should like to make something of them like the canvases of the sunflowers, because it astonishes me that they have not yet been done as I see them.

It is as beautiful of line and proportion as an Egyptian obelisk.

And the green has a quality of such distinction.

It is a splash of *black* in a sunny landscape, but it is one of the most interesting black notes, and the most difficult to hit off exactly that I can imagine. . . .

*

 . . . It is just in learning to suffer without complaint, in learning to look on pain without repugnance, that you risk vertigo, and yet it is possible, yet you may even catch a glimpse of a vague likelihood that on the other side of life we shall see some good reason for the existence of pain, which seen from here sometimes so fills the whole horizon that it takes on the proportions of a hopeless deluge. We know very little about this, about its proportions, and it is better to look at a wheat field, even in the form of a picture. . . .

*

To his mother . . . Then I never get tired of the blue sky. One never sees buckwheat or rape here, and perhaps there is in general less variety than with us. And I should so much like to paint a buckwheat field in flower, or the rape in bloom, or flax, but maybe I will have an opportunity for this later on in Normandy or Brittany. Also, here one never sees those moss-covered roofs on the barns or cottages as at home, nor the oak

coppices, nor spurry, nor beech hedges with their white tangled old stems. Nor the real heather, nor the birches which were so beautiful in Nuenen. But what is beautiful in the South are the vineyards, but they are in the flat country or the hillsides. I have seen some, and even sent a picture of them to Theo, in which a vineyard was quite purple, fire-red, and yellow and green and violet, like the Virginia creeper in Holland. I like to see a vineyard as much as a wheatfield. Besides, the hills full of thyme and other aromatic plants are very nice here, and because of the clearness of the air, from the heights one can see so much farther here than at home. . . .

*

To Theo and Johanna . . . Outside the cicadas are singing fit to burst, a harsh screeching, ten times stronger than that of the crickets, and the scorched grass takes on lovely tones of old gold. And the beautiful towns of the South are in the same state as our dead towns along the Zuyder Zee that once were so bustling. Yet in the decline and decadence of things, the cicadas dear to the good Socrates abide. And here certainly they still sing in ancient Greek. . . .

*

To Wilhelmina . . . What you write about Theo's health is something I know quite well. Nevertheless I hope that his domestic life will fully restore his health. I think his wife sensible and affectionate enough to take very good care of him, and to see to it that he does not eat that restaurant stuff exclusively, but that he once more comes to know the true Dutch cookery. That Dutch cookery is very good, so let her more or less change into a cook and let her assume a reassuring attitude, even if she should have to be a bit tart about it. . . .

*

To Theo . . . I am sending you enclosed a sketch of the cicadas here.
 Their song in the great heat here has the same charm for me as the cricket on the hearth for the peasants at home. Old man – don't let's forget that the little emotions are the great captains of our lives, and that we obey them without knowing it. If it is still hard for me to take courage again in spite of faults committed, and to be committed, which must be my cure, don't forget henceforth that neither our spleen nor our melancholy, nor yet our feelings of good nature or common sense, are our sole guides, and above all not our final protection, and that if you too find yourself faced with heavy responsibilities to be risked if not undertaken, honestly, don't let's be too much concerned about each other, since it so happens that the circumstances of living in a state so far removed from our youthful conceptions of an artist's life must make us brothers in spite of everything, as we are in so many ways companions in fate. . . .

*

. . . Are you really well? – damn it all, I so wish that you were two years further on and that these first days of your marriage, however lovely they must be at moments, were behind you. I believe so firmly that marriage is at its best after some time, and that then your constitution will recover.
 So take things with a sort of northern equanimity, and both of you take very good care of yourselves. This blasted artistic life is shattering, it seems.

. . . I am writing this letter little by little in the intervals when I am tired of painting. Work is going pretty well – I am struggling with a canvas begun some days before my indisposition, a 'Reaper'; the study is all yellow, terribly thickly painted, but the subject was fine and simple. For I see in this reaper – a vague figure fighting like a devil in the midst of the heat to get to the end of his task – I see in him the image of death, in the sense that humanity might be the wheat he is reaping. So it is – if you like – the opposite of that sower I tried to do before. But there's nothing sad in this death, it goes its way in broad daylight with a sun flooding everything with a light of pure gold.

. . . My dear brother – it is always in between my work that I write to you – I am working like one actually possessed, more than ever I am in a dumb fury of work. And I think that this will help cure me. Perhaps something will happen to me like what Eug. Delacroix spoke of, 'I discovered painting when I no longer had any teeth or breath left'. . . .

*

. . . During the attacks I feel a coward before the pain and suffering – more of a coward than I ought to be, and it is perhaps this very moral cowardice which, whereas I had no desire to get better before, makes me eat like two now, work hard, limit my relations with the other patients for fear of a relapse – altogether I am now trying to recover like a man who meant to commit suicide and, finding the water too cold, tries to regain the bank.

. . . I reproach myself with my cowardice, I ought rather to have defended my studio, even if I had had to fight with the *gendarmes* and the neighbours. Others in my place would have used a revolver, and certainly if as an artist one had killed some rotters like that, one would have been acquitted. I'd have done better that way, and as it is I've been cowardly and drunk.

Ill as well, and I have not been brave. Then I also feel very frightened, faced with the sufferings of these attacks, and I do not know if my zeal is anything different from what I said, it is like someone who meant to commit suicide and, finding the water too cold, struggles to regain the bank.

. . . I have given up the hope that it will not come back – on the contrary, we must expect that from time to time I shall have an attack. But then at those times it would be possible to go to a nursing home or even into the town prison, where there is generally a cell.

. . . Good Lord, Good Lord, the good people among the artists who say that Delacroix is not of the real East. Look here, is the real East the kind of thing that Parisians like Gérôme do?

. . . I very much wish that when your child comes, I should be back – not with *you*, certainly *not*, that is impossible, but in the vicinity of Paris with another painter. . . .

*

. . . I let the black and white by Delacroix or Millet or something made after their work pose for me as a subject.

And then I improvise colour on it, not, you understand, altogether myself, but searching for memories of *their* pictures – but the memory, 'the vague consonance of colours which are at least right in feeling' – that is my own interpretation.

Many people do not copy, many others do – I started on it accidentally, and I find that it teaches me things, and above all it sometimes gives me consolation. And then my brush goes between my fingers as a bow would on the violin, and absolutely for my own pleasure.

. . . Do you know what I think of pretty often, what I already said to you some time ago – that even if I did not succeed, all the same I thought that what I have worked at will be carried on. Not directly, but one isn't alone in believing things that are true. And what does it matter personally then! I feel so strongly that it is the same with people as it is with wheat, if you are not sown in the earth to germinate there, what does it matter? – in the end you are ground between the millstones to become bread. . . .

*

. . . What you say of Auvers is nevertheless a very pleasant prospect, and either sooner or later – without looking further – we must fix on that. If I come North, even supposing that there were no room at this doctor's house, it is possible that after your recommendation and old Pissarro's he would find me board either with a family or quite simply at an inn. The main thing is to know the doctor, so that in case of an attack I do not fall into the hands of the police and get carried off to an asylum by force. . . .

*

To Wilhelmina . . . But the ideal of simplicity renders life more difficult in modern society – and whoever has this ideal will not be able to do what he wants to in the end, as is the case with me. But so it is after all, yet this is what society should grant an artist in my opinion, whereas nowadays one is obliged to live in cafés and low inns.

The Japanese have always lived in very simple interiors, and what great artists have not lived in that country? If a painter is rich in our society, then he has to live in a house which is like a curiosity shop, and this isn't very artistic either to my taste. As for me, I often suffered under the fact that I had to live in conditions in which order was impossible, with the result that I lost the notion of order and simplicity.

That good fellow Isaäcson wants to write an article about me in one of the Dutch papers, on the subject of pictures which are *exactly* like those I am sending you, but reading such an article would make me very sad, and I wrote to tell him so. . . .

*

To Theo . . . Ah, now certainly you are yourself deep in nature, since you say that Jo already feels her child move – it is much more interesting even than landscapes, and I am very glad that things should have changed so for you.

How beautiful that Millet is, 'A Child's First Steps'! . . .

*

To his mother . . . I certainly agree with you that it is much better for Theo now than before, and I hope everything will go well with Jo's confinement; that will set them up for quite a while. It is always good to experience the way in which a human being comes into the world, and that leads many a character to more quietness and truth.

. . . You will see from the self-portrait I add that though I saw Paris and other big cities for many years, I keep looking more or less like a peasant of Zundert, Toon, for instance, or Piet Prins, and sometimes I imagine I also feel and think like them, only the peasants are of more use in the world. Only when they have all the other things, they get a feeling, a desire for pictures, books, etc. In my estimation I consider myself certainly below the peasants.

Well, I am ploughing on my canvases as they do on their fields. . . .

*

To J. J. Isaäcson . . . As it is possible that in your next article you will put in a few words about me, I will repeat my scruples, so that you will not go beyond a *few* words, because it is *absolutely certain* that I shall never do important things. . . .

*

To Theo . . . The thing is that this month I have been working in the olive groves, because their [Gauguin and Bernard] Christs in the Garden, with nothing really observed, have gotten on my nerves. Of course with me there is no question of doing anything from the Bible – and I have written to Bernard and Gauguin too that I considered that our duty is thinking, not dreaming, so that when looking at their work I was astonished at their letting themselves go like that. For Bernard has sent me photos of his canvases. The trouble with them is that they are a sort of dream or nightmare – that they are erudite enough – you can see that it is someone who is gone on the primitives – but frankly the English Pre-Raphaelites did it much better, and then again Puvis and Delacroix, much more healthily than the Pre-Raphaelites.

. . . It is really my opinion more and more, as I said to Isaäcson, if you work diligently from nature without saying to yourself beforehand – 'I want to do this or that', if you work as if you were making a pair of shoes, without artistic preoccupations, you will not always do well, but the days you least expect it, you find a subject which holds its own with the work of those who have gone before. You learn to know a country which is basically quite different from what it appears at first sight. . . .

*

To his mother . . . And then I think so much of you and of the past. You and Father have been, if possible, even more to me than to the others, so much, so very much, and I do not seem to have had a happy character. I discovered that in Paris, how much more Theo did his best to help Father practically than I, so that his own interests were often neglected. Therefore I am so thankful now that Theo has got a wife and is expecting his baby. Well, Theo had more self-sacrifice than I, and that is deeply rooted in his character. And after Father was no more and I came to Theo in Paris, then he became so attached to me that I understood how much he had loved Father. And now I am saying this to you, and not to him – it is a good thing that I did not stay in Paris, for we, he and I, would have become too interested in each other. . . .

*

St Rémy/October 1889

To Joseph and Mme Ginoux . . . I assure you that last year I almost hated the idea of regaining my health – of only feeling somewhat better for a shorter or longer time – always living in fear of relapses – I almost hated the idea, I tell you – so little did I feel inclined to begin again. Often I said to myself that I preferred that there be nothing further, that this be the end. Ah, well – it would seem that we are not the masters of this – of our existence – it would seem that what matters is that one should learn to want to go on living, even when suffering. Oh, I feel so cowardly in this respect; even when my health has returned, I am still afraid. So who am I to encourage others, you will say, for actually this is hardly my style. Well, it is only to tell you, my dear friends, that I hope so ardently, and even dare believe, that Mrs Ginoux's illness will be of very short duration, and that she will rise from her sickbed a much stronger fellow, but she knows only too well how fond we all are of her, and how much we wish to see her in good health. In my own case my disease has done me good – it would be ungrateful not to acknowledge it. It has made me easier in my mind, and is wholly different from what I expected and imagined; this year I have had better luck than I dared hope for.

But if I had not been so well cared for, if people had not been so good to me as they have been, I am convinced I should have dropped dead or lost my reason completely. Business is business, and in the same way duty is duty, and therefore it is only fair that I go back to see my brother soon, but I assure you that it will be hard for me to leave the South; I say this to all of you who have become my friends – my friends for a long time.

I have forgotten to thank you for the olives you sent me some time ago, they were excellent; I shall bring back the boxes in a little while . . .

So I write you this letter, my dear friends, in order to try and distract our dear patient for a moment, so that she may once again show us her habitual smile and give pleasure to all who know her. As I told you, within a fortnight I hope to visit you, wholly recovered.

Diseases exist to remind us that we are not made of wood, and it seems to me this is the bright side of it all. . . .

*

To Wilhelmina . . . Did you meet Bernard yet? I should very much like him to come here for a while in order to see the pictures I did here lately; I ought to write him a letter, but I am waiting for a letter from him at any moment. I suppose he has a lot of trouble fighting his way through. He is a Parisian from top to toe, and to my mind he is a model of vivacity. He uses his brains quite in the manner of Daudet, but then more ingenuously, and naturally much less fully. . . .

*

To John Russell . . . How much it pleases me to write you after such a long silence! Do you remember when we met our friend Gauguin almost at the same time – I think you were the first, and I the second?

He is still struggling on – alone, or almost alone, like the brave fellow he is. I feel sure you have not forgotten him.

I assure you that he and I are still friends, but perhaps you are not unaware that I am ill, and that I have had serious nervous crises and delirium more than once. This was the cause of our parting company, he and I, for I had to go into a lunatic asylum. But, before that, how many times we spoke of you! . . .

*

To Johanna

. . . It moves me so much that you write to me and are so calm and master of yourself on one of your difficult nights. How I am longing to get the news that you have come safely through, and that your child is living. How happy Theo will be, and a new sun will rise inside him when he sees you recovering. . . .

*

To Theo

. . . Today I received your good news that you are at last a father, that the most critical time is over for Jo, and finally that the little boy is well. That has done me more good and given me more pleasure than I can put into words. Bravo – and how pleased Mother is going to be. The day before yesterday I received a fairly long and very contented letter from her too. Anyhow, here it is, the thing I have so much desired for such a long time. No need to tell you that I have often thought of you these days, and it touched me very much that Jo had the kindness to write to me the very night before. She was so brave and calm in her danger, it moved me deeply. . . .

*

To Wilhelmina

. . . I am touched by what you write further about Jo's confinement – how very brave and very good you have been, staying with her all the time. In those circumstances in which we feel the strain of anxiety, I should probably be, much more than you, like a frightened wet chicken.

BRANCHES OF AN ALMOND TREE IN BLOSSOM

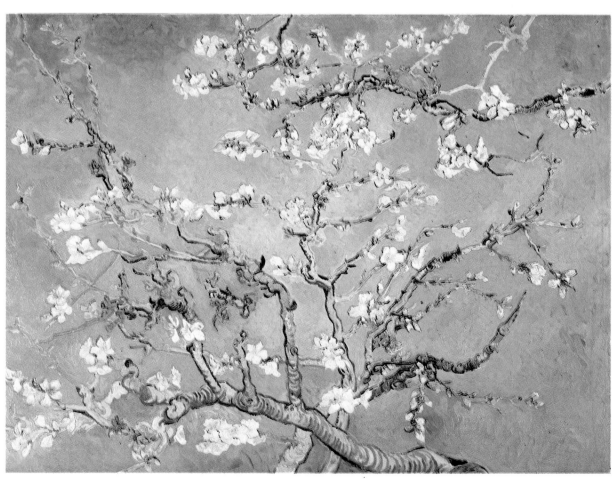

Well, the result is after all that the child is there – and also that I shall write a letter to Mother telling her so; a day or two ago I started painting a picture for her of a blue sky with branches full of blossoms standing out against it. It is possible that I shall send it soon – at least I hope so – toward the end of March. Tomorrow or the day after I shall try to make the trip to Arles again as a kind of trial, in order to see if I can stand the strain of travelling and of ordinary life without a return of the attacks.

*

To Theo . . . I think you will like the canvas for M. Aurier; it is in a terribly thick impasto and worked over like some Monticellis; I have kept it for almost a year. But I think I must try to give him something good for this article, which is very much a work of art in itself; and it will do us a real service against the day when we, like everybody else, shall be obliged to try to recover what the pictures cost. Anything beyond that leaves me pretty cold, but recovering the money it costs to produce is the very condition of being able to go on.

. . . Aurier's article would encourage me if I dared to let myself go, and venture even further, dropping reality and making a kind of music of tones with colour, like some Monticellis. But it is so dear to me, this truth, *trying to make it true*, after all I think, I think, that I would still rather be a shoemaker than a musician in colours. . . .

*

. . . Letters from home have come too, which I have not yet had the courage to read, I feel so melancholy. Please ask M. Aurier not to write any more articles on my painting, insist upon this, that to begin with he is mistaken about me, since I am too overwhelmed with grief to be able to face publicity. Making pictures distracts me, but if I hear them spoken of, it pains me more than he knows. How is Bernard? As there are some canvases in duplicate, if you like you can exchange with him, for a good canvas by him would be a fine thing to have in your collection. . . .

*

To his mother and Wilhelmina . . . As soon as I heard that my work was having some success, and read the article in question, I feared at once that I should be punished for it; this is how things nearly always go in a painter's life: success is about the worst thing that can happen.

*

To Theo . . . Oh, if I could have worked without this accursed disease – what things I might have done, isolated from others, following what the country said to me. But there, this journey is over and done with. Anyway, what consoles me is the great, the very great desire I have to see you again, you and your wife and child, and the many friends who remembered me in my misfortune, as indeed I too never cease thinking of them. . . .

*

. . . I'll send you a wire from Tarascon. Yes, I also feel that there is a very long stretch of time between the day we said good-bye at the station and now.

But another strange thing, just as we were struck by Seurat's canvases on that day, these last days here are like a fresh revelation of colour to me. As for my work, my dear brother, I feel more confidence than when I left, and it would be ungrateful on my part to curse the Midi, and I confess to you that I leave it with great grief. . . .

*

. . . In any case I hope to be in Paris before Sunday so as to spend your free day quietly with you all. I very much hope to see André Bonger too at the first opportunity.

I have just finished another canvas of pink roses against a yellow-green background in a green vase.

I hope that the canvases I am doing now will make up for the expense of the journey.

This morning when I had been to pay for my luggage, I saw the country again after the rain, quite fresh and full of flowers – what things I could still have done. . . .

*

To Joseph Ginoux . . . This is to ask you to be so kind as to send my two beds, which are still with you, by goods train.

I think it will be wise to empty the pallets, for buying new straw will not be more expensive than the money paid for carriage.

The rest of the furniture, goodness yes, there is the mirror, for instance, which I should like to have. Will you kindly paste strips of paper across the glass to prevent its breaking? – but the two chests of drawers, the chairs, tables, you may keep for your trouble, and if there are extra expenses, please let me know.

I greatly regret I fell ill on the day I came to Arles to say good-bye to you all – after that I was ill for two months without being able to work. However, at present I am quite well again.

But I am going to return to the North, and so, my dear friends, I vigorously shake your hands in thought, as well as the hands of the neighbours, and believe me when I say that over there I shall often think of you all, for what Mrs Ginoux said is true – if you are friends, you are friends for a long time. If you should happen to see the Roulins, you will surely not forget to remember me to them. . . .

*

To Theo and Johanna . . . Auvers is very beautiful, among other things a lot of old thatched roofs, which are getting rare.

 . . . I have seen Dr Gachet, who gives me the impression of being rather eccentric, but his experience as a doctor must keep him balanced enough to combat the nervous trouble from which he certainly seems to me to be suffering at least as seriously as I.

 . . . His house is full of black antiques, black, black, black, except for the impressionist pictures mentioned. The impression I got of him was not unfavourable. When he spoke of Belgium and the days of the old painters, his grief-hardened face grew smiling again, and I really think I shall go on being friends with him and that I shall do his portrait. . . .

<p style="text-align:center">*</p>

 . . . I am very sorry not to see the Raffaelli exhibition; I should especially like to see also your arrangements of those drawings on cretonne that you spoke of. Someday or other I think I shall find a way to have an exhibition of my own in a café. . . .

<p style="text-align:center">*</p>

To Wilhelmina . . . As for myself, the travelling and all the rest have come off very well so far, and coming back North has been a great distraction for me. And then I have found a true friend in Dr Gachet, something like another brother, so much do we resemble each other physically and also mentally. He is a very nervous man himself and very queer in his behaviour; he has extended much friendliness to the artists of the new school, and he has helped them as much as was in his power. I painted his portrait the other day, and I am also going to paint a portrait of his daughter, who is nineteen years old. He lost his wife some years ago, which greatly contributed to his becoming a broken man. I believe I may say we have been friends from the very first. . . .

<p style="text-align:center">*</p>

To Joseph and Mme Ginoux . . . This gentleman knows a good deal about painting, and he greatly likes mine; he encourages me very much, and two or three times a week he comes and visits me for a few hours to see what I am doing.

Twice they have written articles on my pictures. Once in a Paris newspaper, and the other time in a newspaper in Brussels, where I had an exhibition, and now, a very short time ago, there was an article in a newspaper of my native country, Holland, and the consequence was that many people went to look at my pictures. And this is not the end. Besides, it is a certain fact that I have done better work than before since I stopped drinking, and that is so much gained. . . .

<p style="text-align:center">*</p>

To Wilhelmina . . . I painted a portrait of Dr Gachet with an expression of melancholy, which would seem to look like a grimace to many who saw the canvas. And yet it is necessary to paint it like this, for otherwise one could not get an idea of the extent to which, in comparison with the old portraits, there is expression in our modern heads, and passion – like a waiting for things as well as a growth. Sad and yet gentle, but clear and intelligent – this is how one ought to paint many portraits.

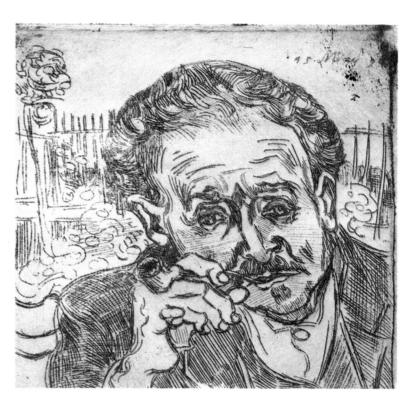

PORTRAIT OF DOCTOR GACHET WITH PIPE

At times this might make a certain impression on people. There are modern heads which people will go on looking at for a long time to come, and which perhaps they will mourn over after a hundred years. . . .

*

To Gauguin . . . Thank you for having written to me again, old fellow, and rest assured that since my return I have thought of you every day. I stayed in Paris only three days, and the noise, etc., of Paris had such a bad effect on me that I thought it wise for my head's sake to fly to the country; but for that, I should soon have dropped in on you.

And it gives me enormous pleasure when you say the Arlésienne's portrait, which was based strictly on your drawing, is to your liking. I tried to be religiously faithful to your drawing, while nevertheless taking the liberty of interpreting through the medium of colour the sober character and the style of the drawing in question. It is a synthesis of the Arlésiennes, if you like; as syntheses of the Arlésiennes are rare, take this as a work belonging to you and me as a summary of our months of work together. For my part I paid for doing it with another month of illness, but I also know that it is a canvas which will be understood by you, and by a very few others, as we would wish it to be understood. My friend Dr Gachet here has taken to it altogether after two or three hesitations, and says, 'How difficult it is to be simple'. . . .

*

To Theo and Johanna . . . I always foresee that the child will suffer later on for being brought up in the city. Does Jo think this exaggerated? I hope so, but anyway I think that one ought to be cautious all the same.

And I say what I think, because you quite understand that I take an interest in my little nephew and am anxious for his well-being: since you were good enough to call him after me, I should like him to have a soul less unquiet than mine, which is foundering. . . .

*

. . . Jo's letter was really like a gospel to me, a deliverance from the agony which has been caused by the hours I had shared with you which were a bit too difficult and trying for us all. It was no slight thing when we all felt our daily bread was in danger, no slight thing when for reasons other than that we felt that our means of subsistence were fragile.

. . . There — once back here I set to work again — though the brush almost slipped from my fingers, but knowing exactly what I wanted, I have painted three more big canvases since.

They are vast fields of wheat under troubled skies, and I did not need to go out of my way to express sadness and extreme loneliness. I hope you will see them soon — for I hope to bring them to you in Paris as soon as possible, since I almost think that these canvases will tell you what I cannot say in words, the health and restorative forces that I see in the country.

. . . I often think of the little one. I think it is certainly better to bring up children than to give all your nervous energy to making pictures, but what then, I am — at least I feel — too old to retrace my steps or to desire anything different. That desire has left me, though the mental suffering of it remains. . . .

*

To his mother and Wilhelmina . . . I myself am quite absorbed in the immense plain with wheatfields against the hills, boundless as a sea, delicate yellow, delicate soft green, the delicate violet of a dug-up and weeded piece of soil, chequered at regular intervals with the green of flowering potato plants, everything under a sky of delicate blue, white, pink, violet tones.

I am in a mood of almost too much calmness, in the mood to paint this. . . .

*

To Theo . . . Thanks for your letter of today and the 50-fr. note it contained.

Perhaps I'd rather write you about a lot of things, but to begin with, the desire to do so has completely left me, and then I feel it is useless.

I hope that you will have found those worthy gentlemen [Theo's employers] well disposed toward you.

As far as I'm concerned, I apply myself to my canvases with all my mind, I am trying to do as well as certain painters whom I have greatly loved and admired.

Now I'm back, what I think is that the painters themselves are fighting more and more with their backs to the wall.

Very well . . . but isn't the moment for trying to make them understand the usefulness of a union already gone? On the other hand a union, if it should take shape, would founder if the rest should have to founder. Then perhaps you would say that some dealers might combine on behalf of the impressionists, but that would be very short-lived. Altogether I think that personal initiative remains powerless, and having had experience of it, should we start again?

. . . Daubigny's garden, foreground of grass in green and pink. To the left a green and lilac bush and the stem of a plant with whitish leaves. In the middle a border of roses, to the right a wicket, a wall, and above the wall a hazel tree with violet foliage. Then a lilac hedge, a row of rounded yellow lime trees, the house itself in the background, pink, with a roof of bluish tiles. A bench and three chairs, a figure in black with a yellow hat and in the foreground a black cat. Sky pale green.

*

. . . Thanks for your kind letter and for the 50-fr. note it contained.

There are many things I should like to write to you about, but I feel it is useless. I hope you have those worthy gentlemen favourably disposed toward you.

Your reassuring me as to the peacefulness of your household was hardly worth the trouble, I think, having seen the weal and woe of it for myself. And I quite agree with you that rearing a boy on a fourth floor is a hell of a job for you as well as for Jo.

Since the thing that matters most is going well, why should I say more about things of less importance? My word, before we have a chance to talk business more collectedly, we shall probably have a long way to go.

The other painters, whatever they think, instinctively keep themselves at a distance from discussions about the actual trade.

Well, the truth is, we can only make our pictures speak. But yet, my dear brother, there is this that I have always told you, and I repeat it once more with all the earnestness that can be expressed by the effort of a mind diligently fixed on trying to do as well as possible – I tell you again that I shall always consider you to be something more than a simple dealer in Corots, that through my mediation you have your part in the actual production of some canvases, which will retain their calm even in the catastrophe.

For this is what we have got to, and this is all or at least the main thing that I can have to tell you at a moment of comparative crisis. At a moment when things are very strained between dealers in pictures of dead artists, and living artists.

Well, my own work, I am risking my life for it and my reason has half foundered because of it – that's all right – but you are not among the dealers in men as far as I know, and you can still choose your side, I think, acting with humanity, but que veux-tu?

Note on the letter in Theo's handwriting: 'Letter found on him on July 29.'

BOWL WITH POTATOES

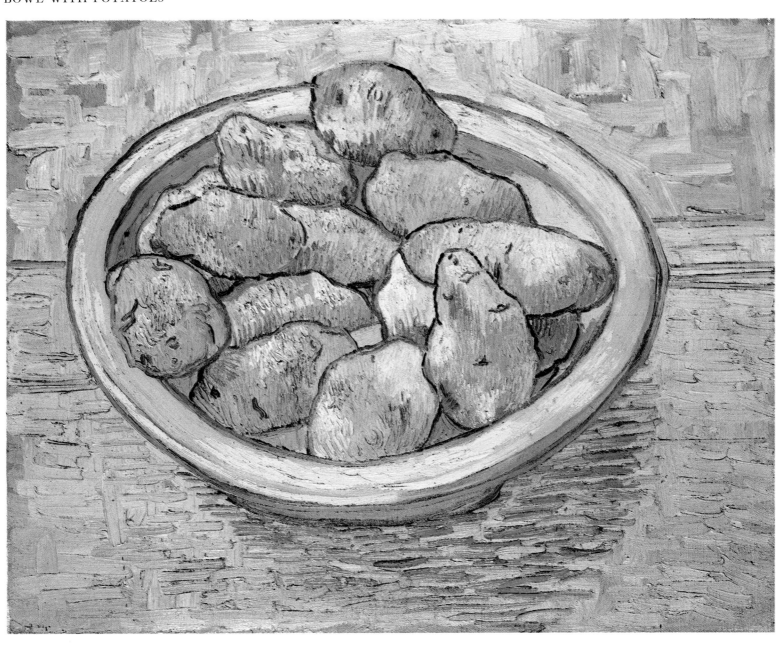

PINK PEACH TREES

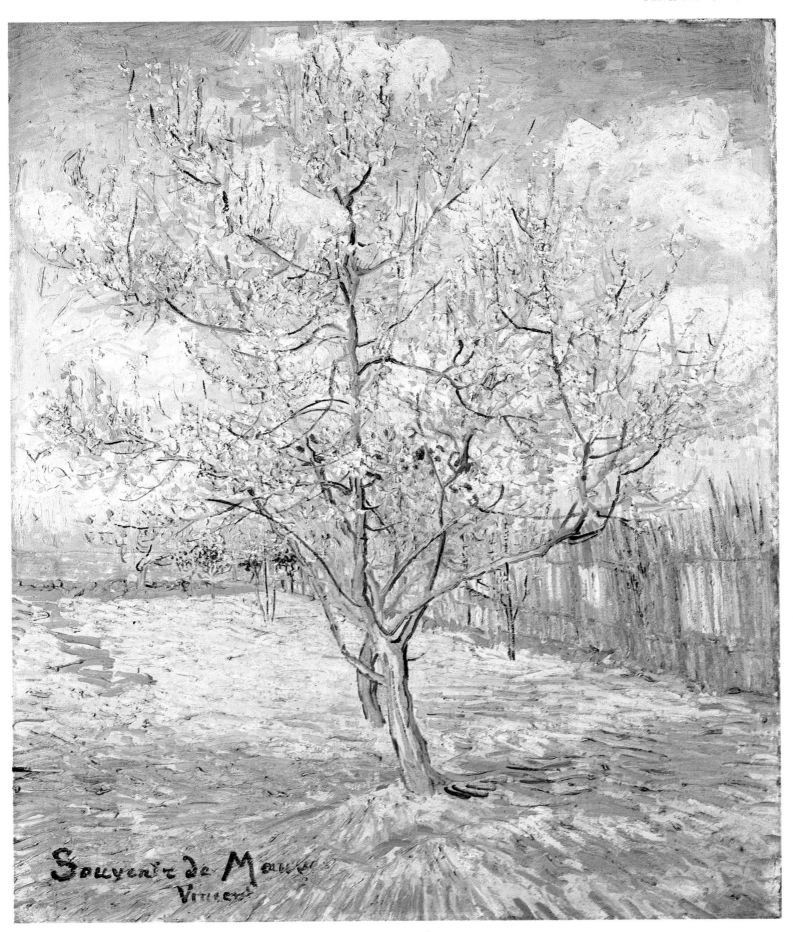

DRAWBRIDGE WITH CARRIAGE

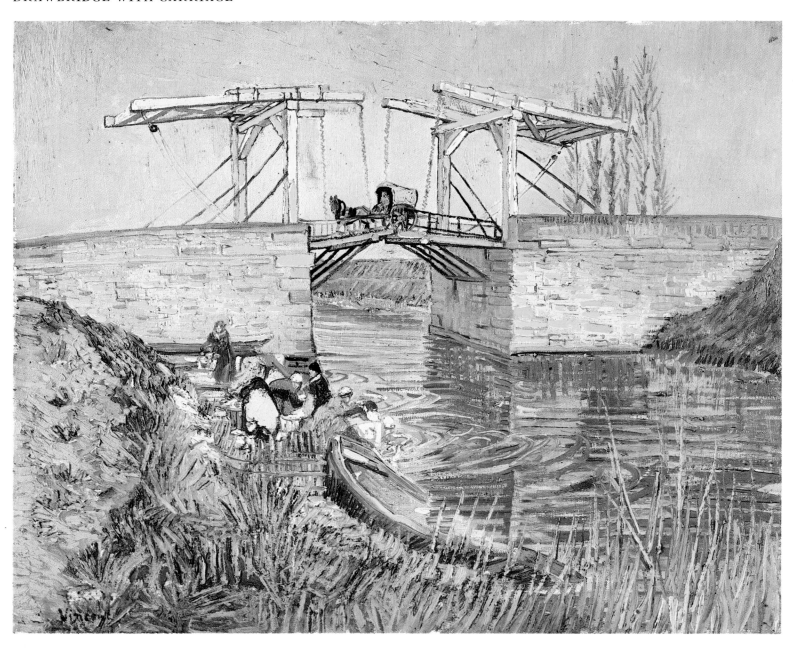

WALKING COUPLE (FRAGMENT)

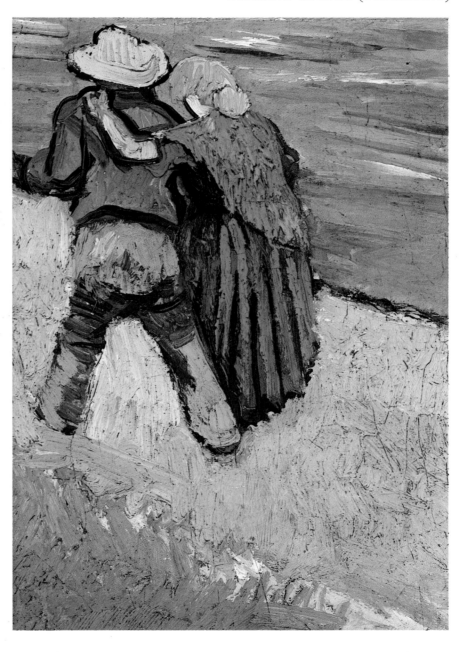

FARMERS WORKING IN A FIELD

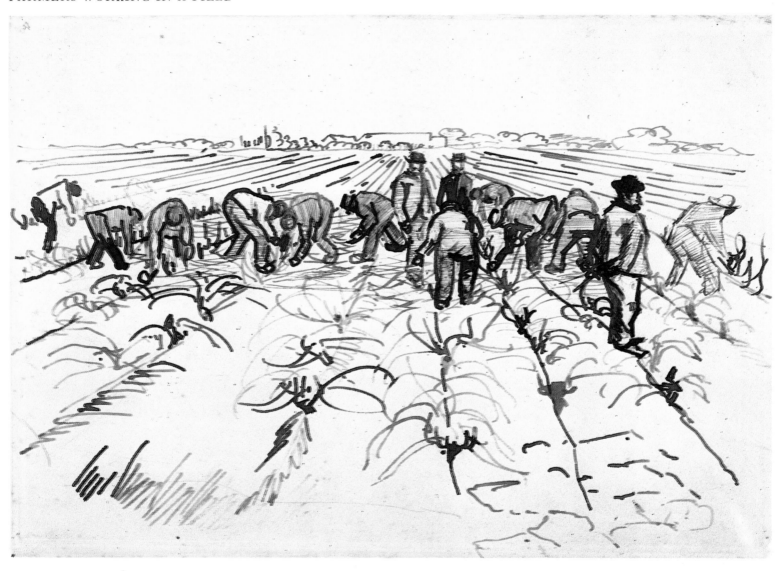

BASKET WITH LEMONS

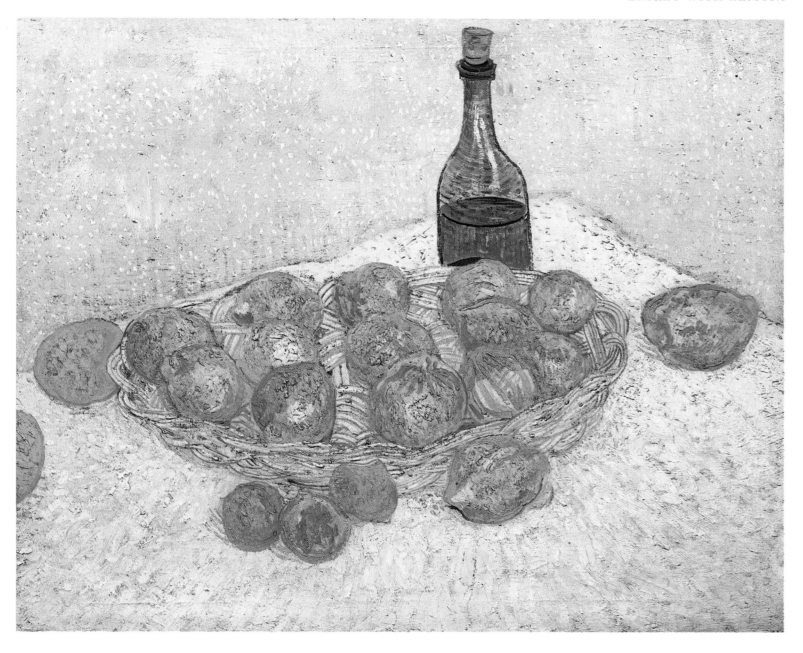

HARVEST LANDSCAPE

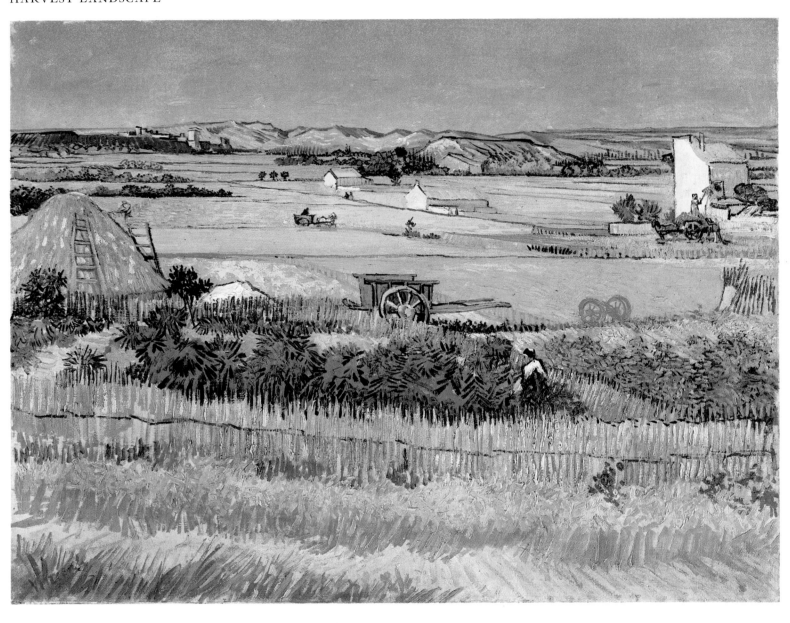

HAYSTACK NEAR A FARM

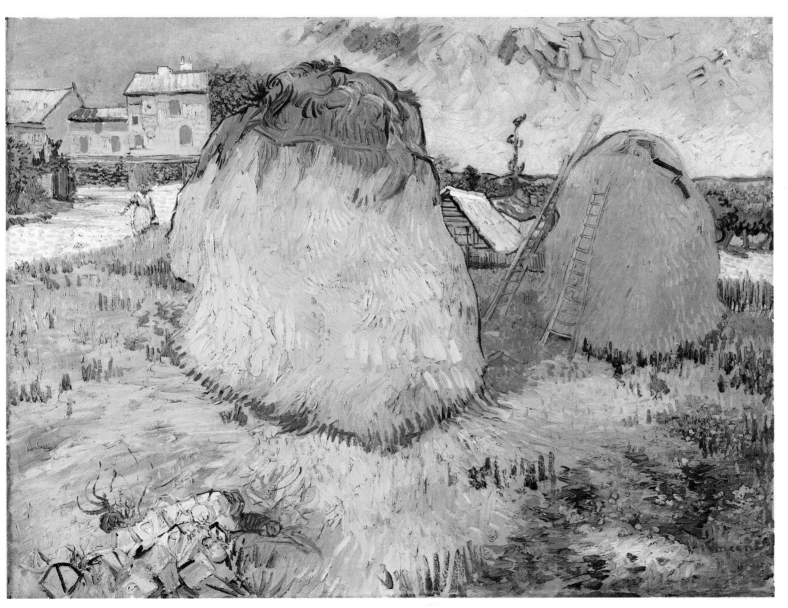

STREET IN SAINTES-MARIES

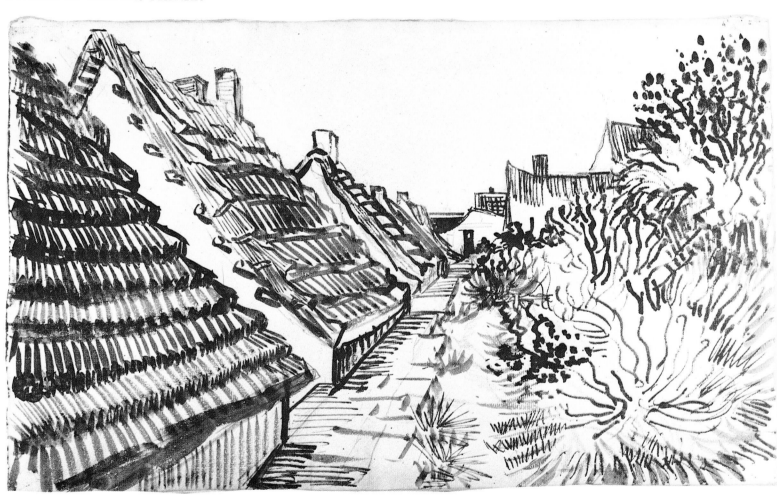

THREE COTTAGES IN SAINTES-MARIES

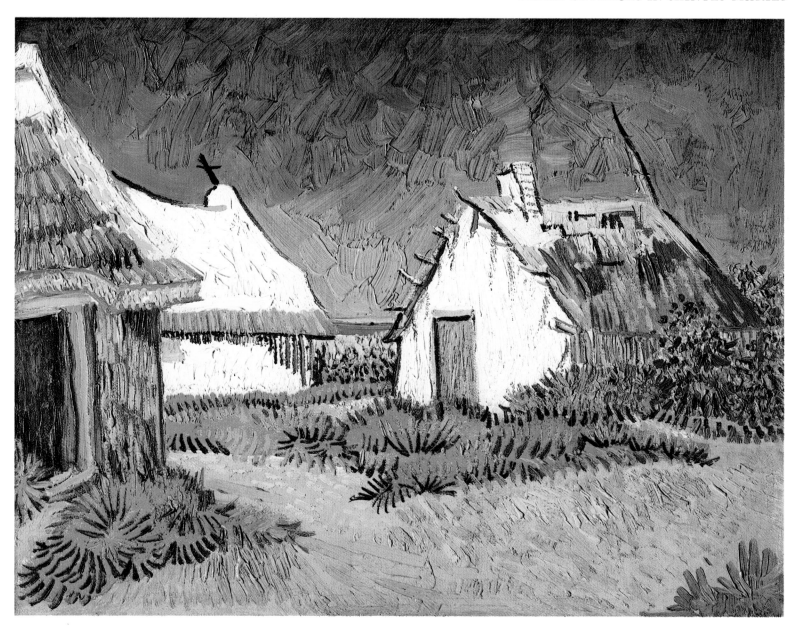

FISHING BOATS AT SEA

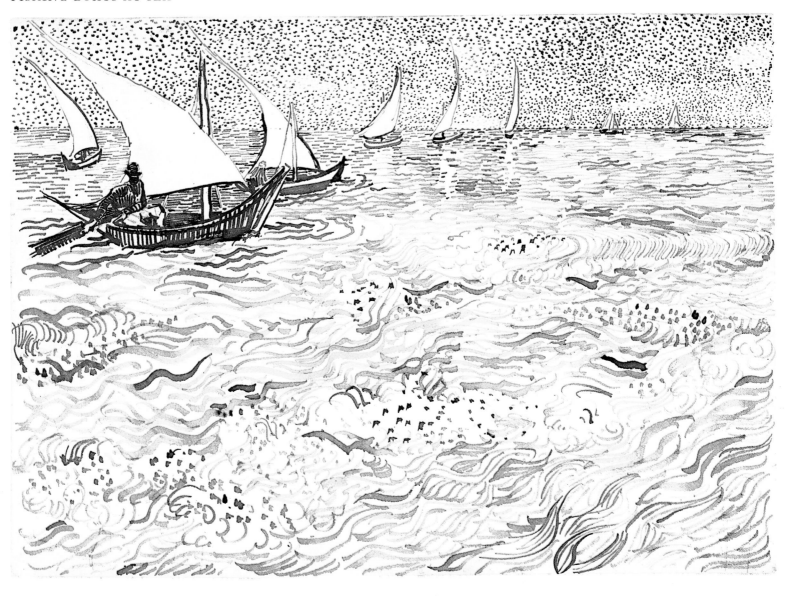

FISHING BOATS ON THE BEACH

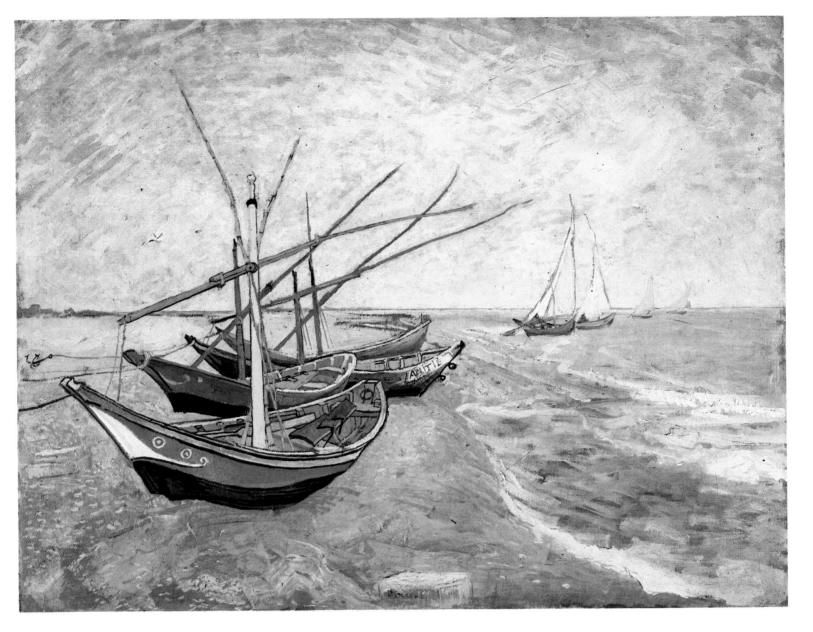

CANAL WITH WOMEN WASHING

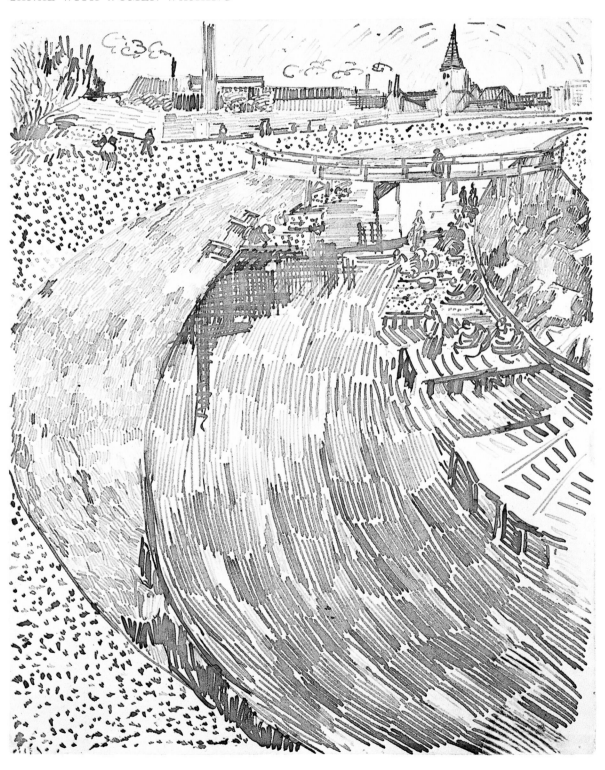

Arles/July 1888

CANAL WITH WOMEN WASHING

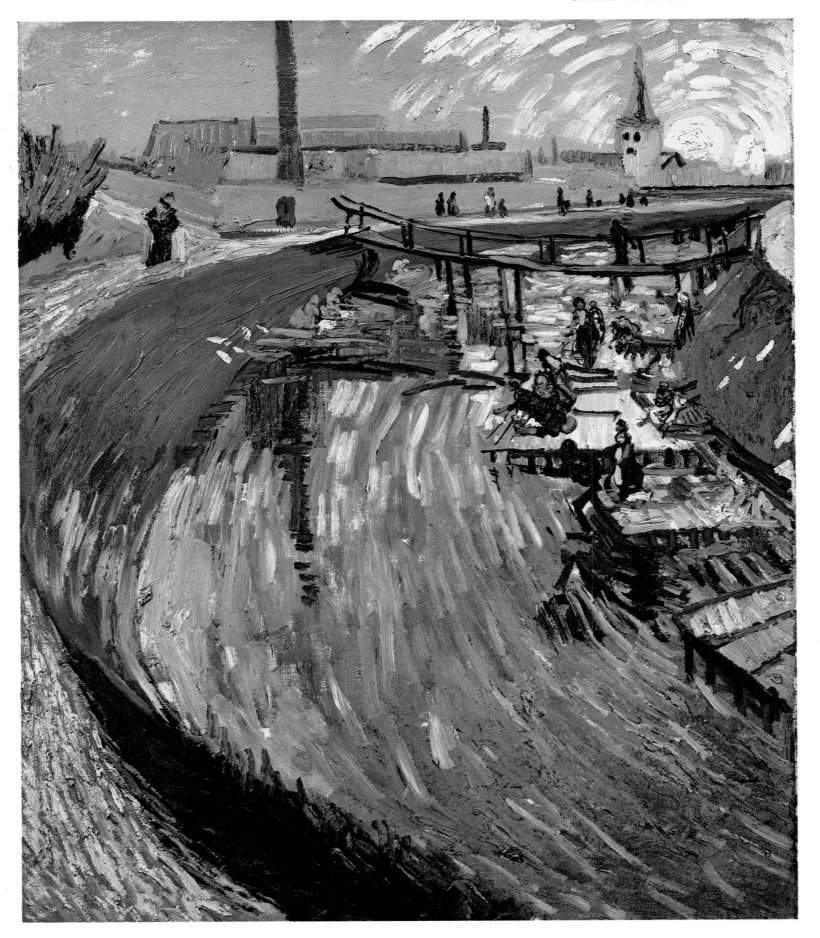

HILL WITH THE RUINS OF MONTMAJOUR

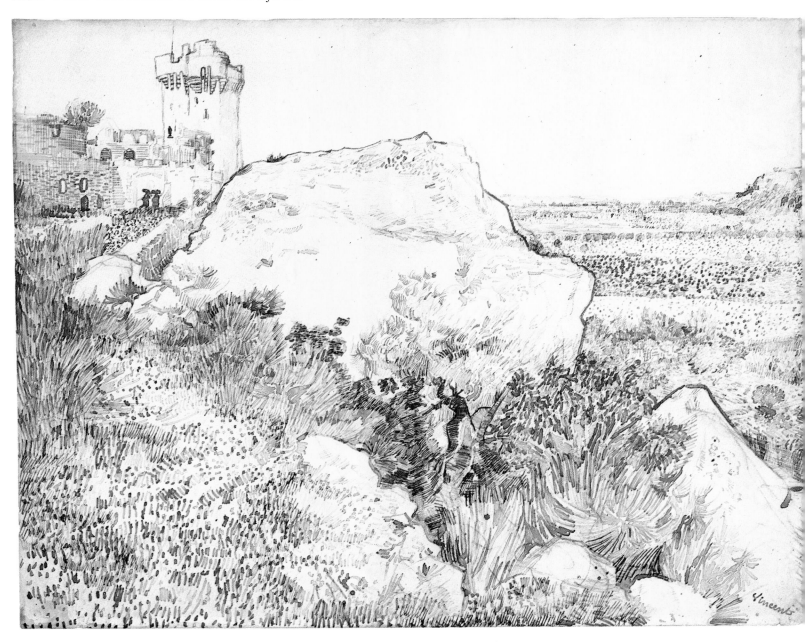

LANDSCAPE NEAR MONTMAJOUR WITH TRAIN

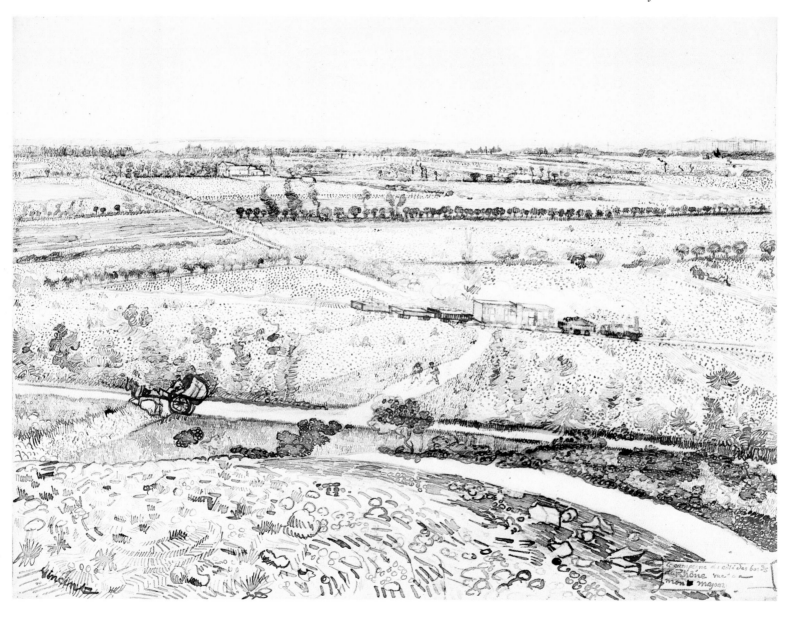

THE ROAD TO TARASCON

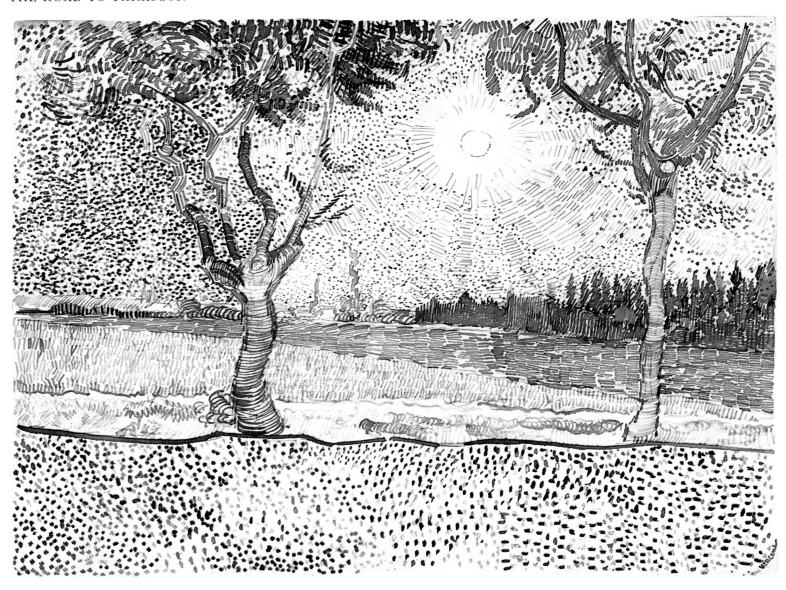

GARDEN WITH FLOWERS

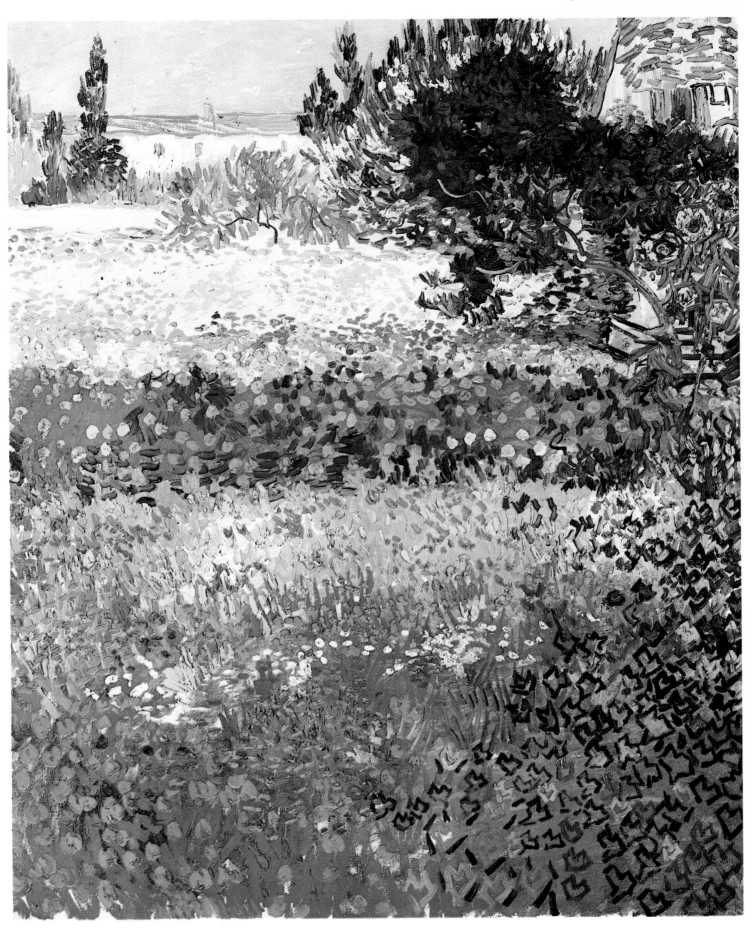

Arles/June 1888

WHEAT FIELD WITH SETTING SUN

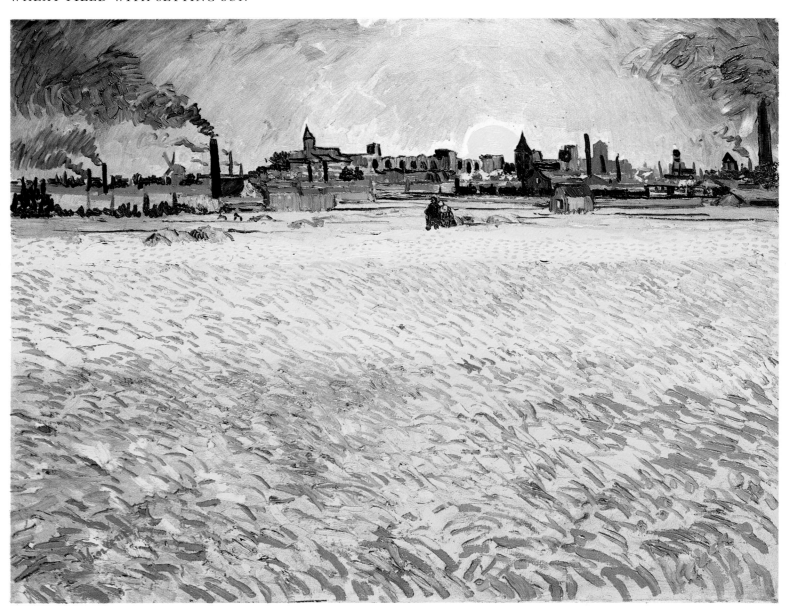

GARDEN WITH SUNFLOWERS

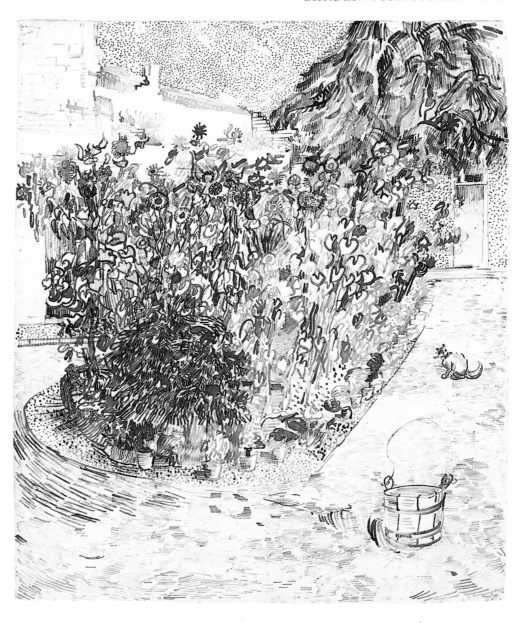

MOUSMÉ SITTING IN A CANE CHAIR, HALF-FIGURE

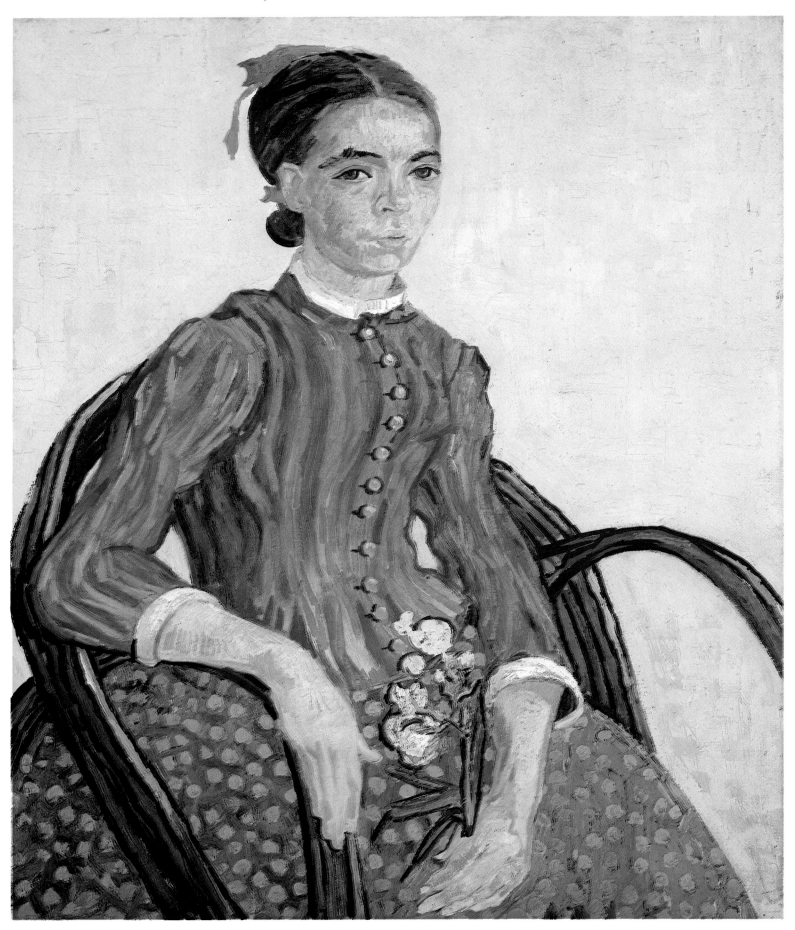

JOSEPH ROULIN, SITTING IN A CANE CHAIR, THREE-QUARTER LENGTH

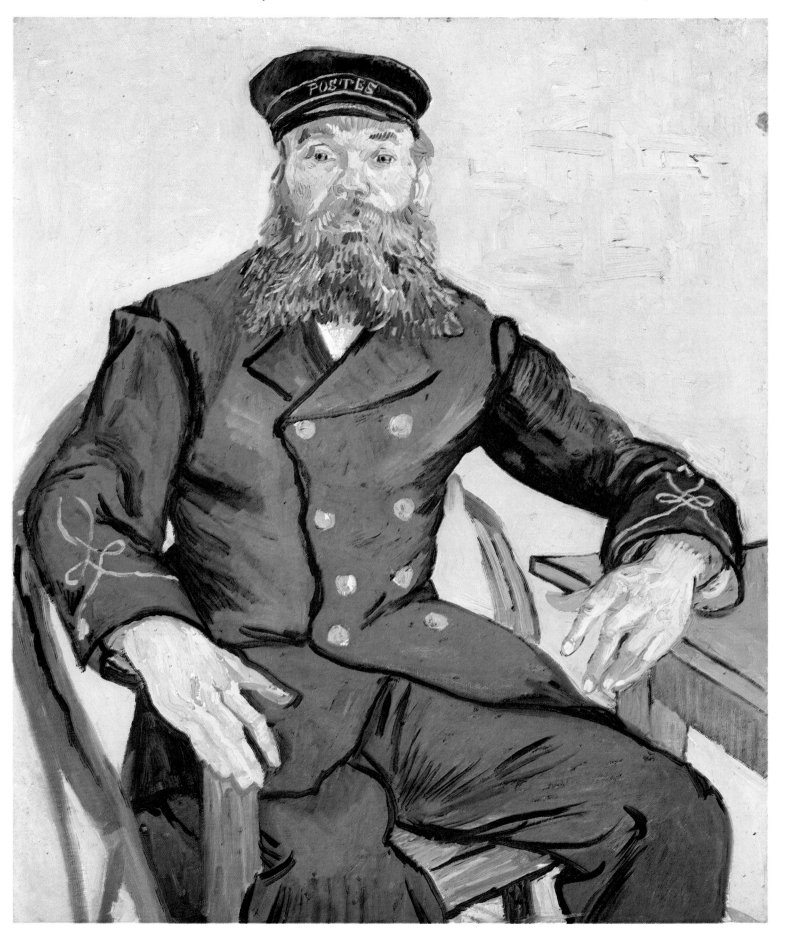

THE OLD PEASANT PATIENCE ESCALIER

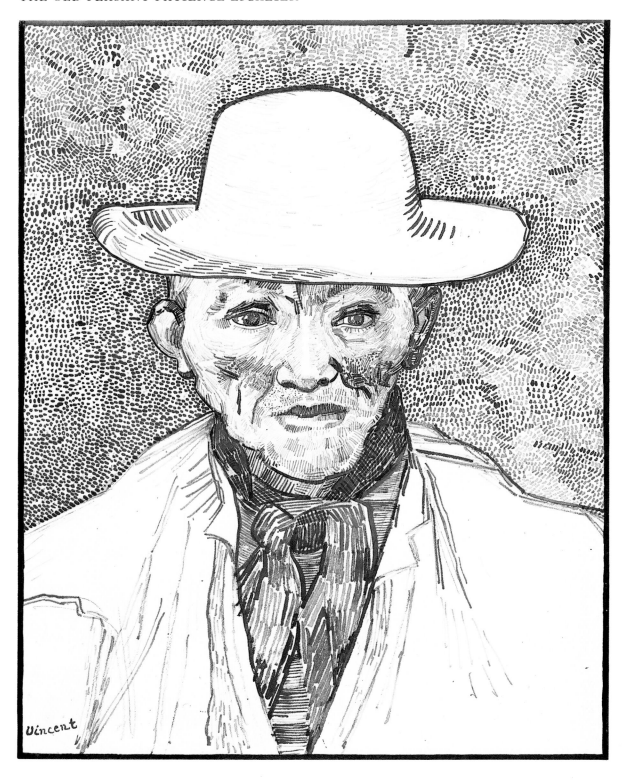

Vincent

THE OLD PEASANT PATIENCE ESCALIER, HALF-FIGURE

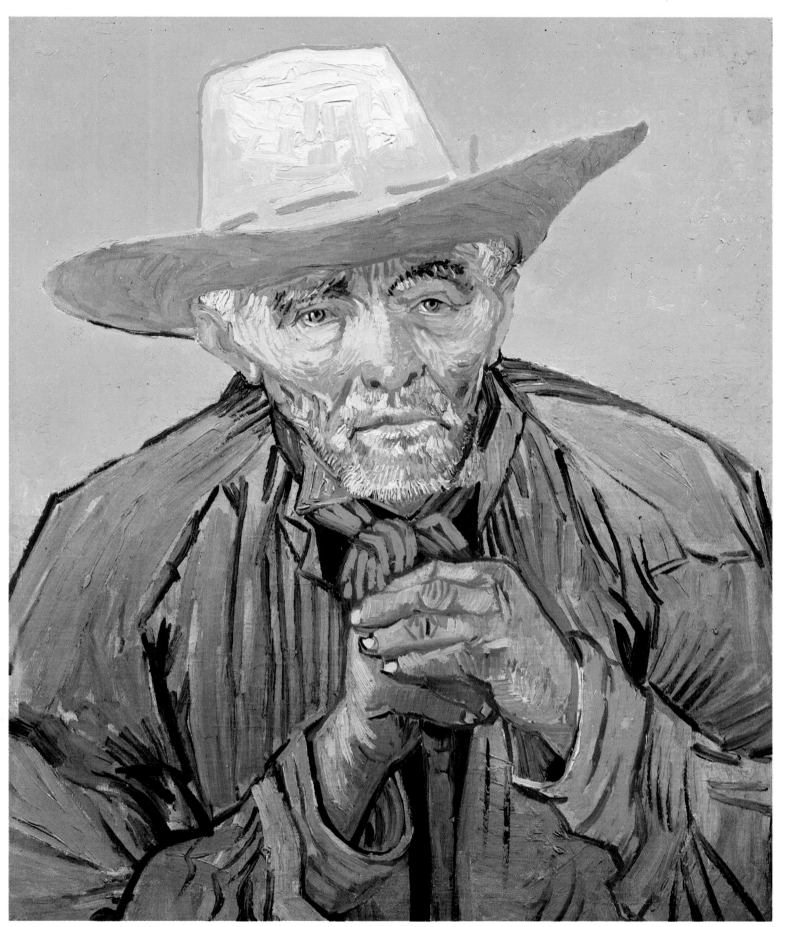

QUAY WITH MEN UNLOADING SAND BARGES

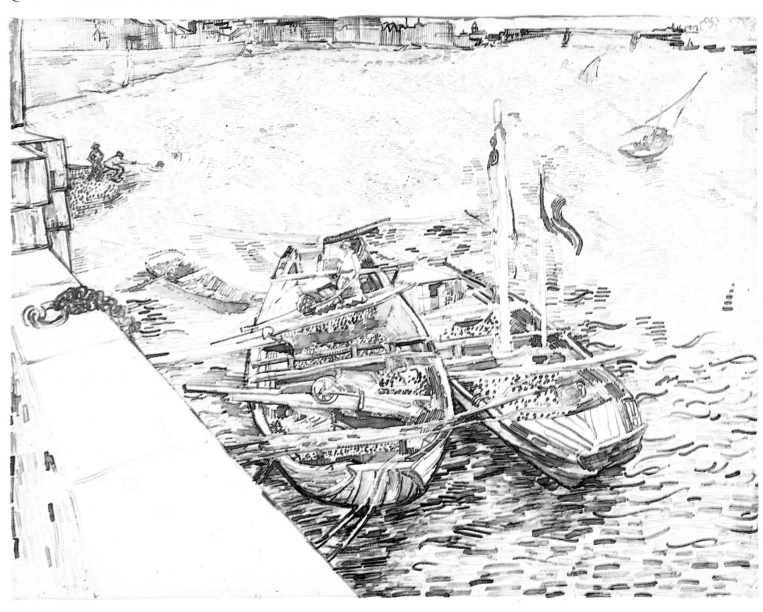

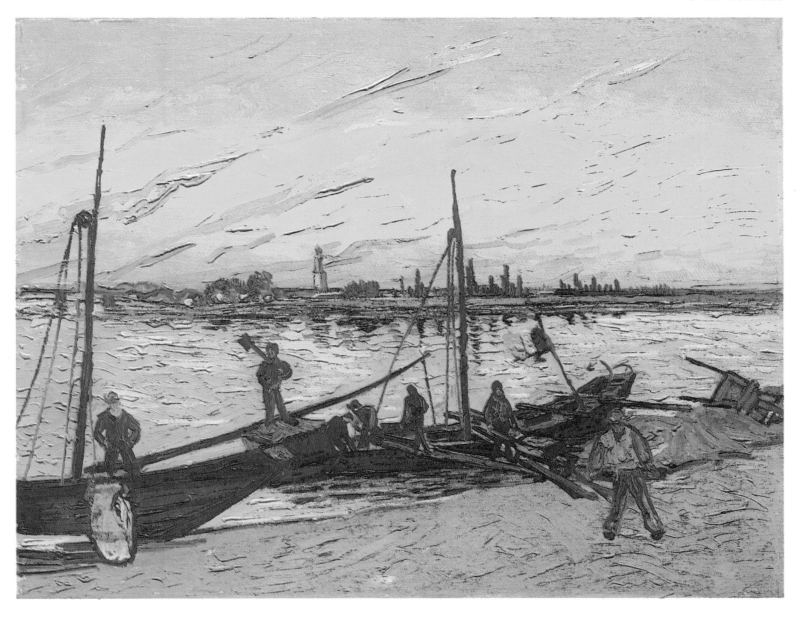

COAL BARGES

SELF-PORTRAIT

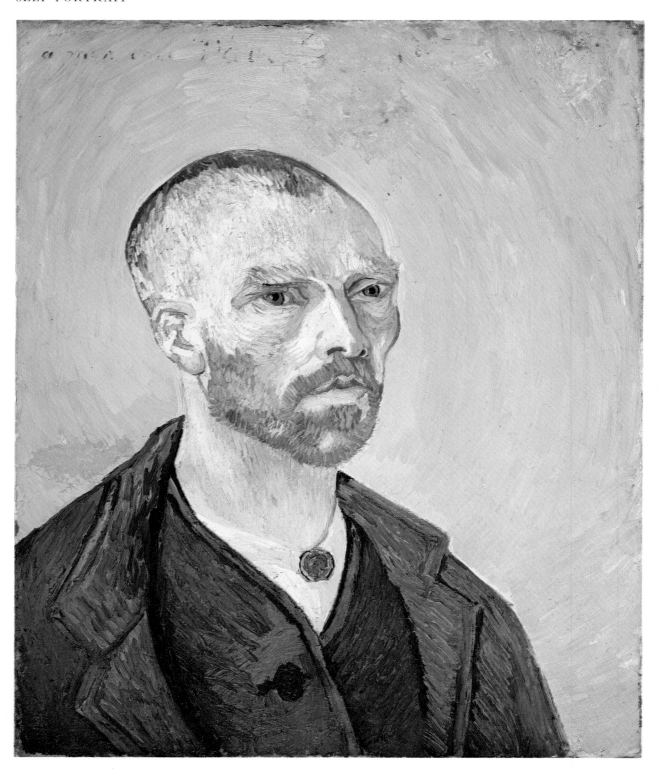

CAFÉ TERRACE AT NIGHT

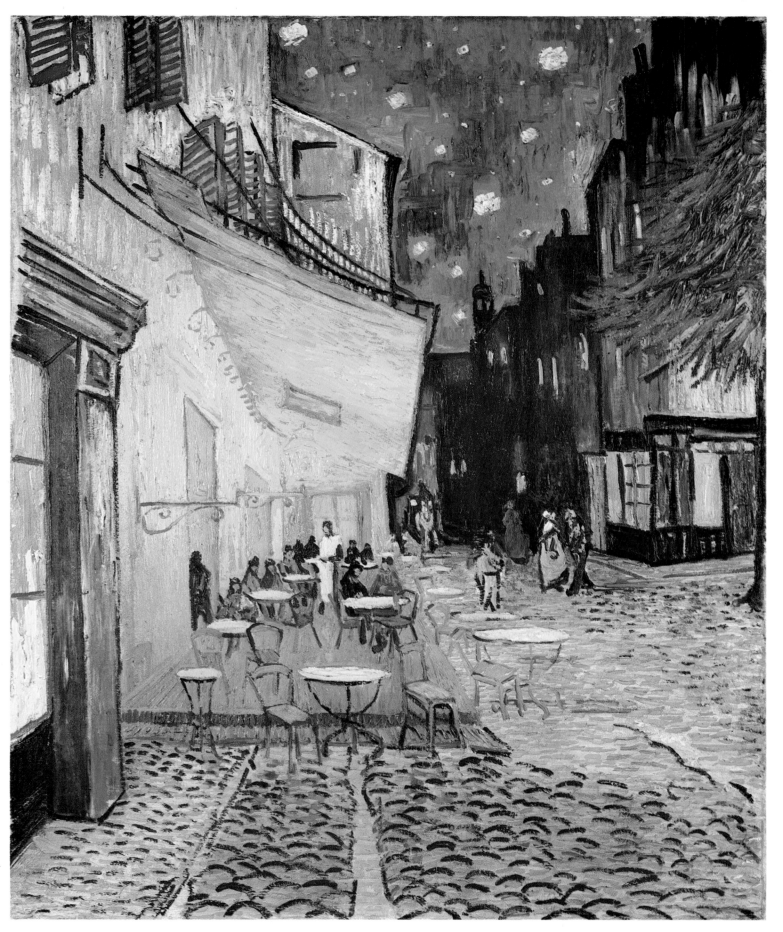

THE NIGHT CAFÉ

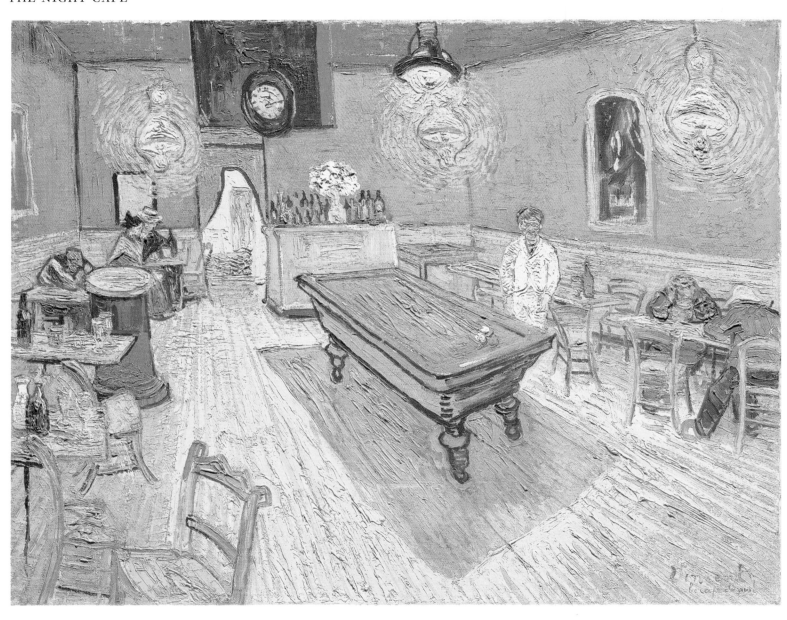

PUBLIC GARDEN WITH ROUND CLIPPED SHRUB AND WEEPING TREE

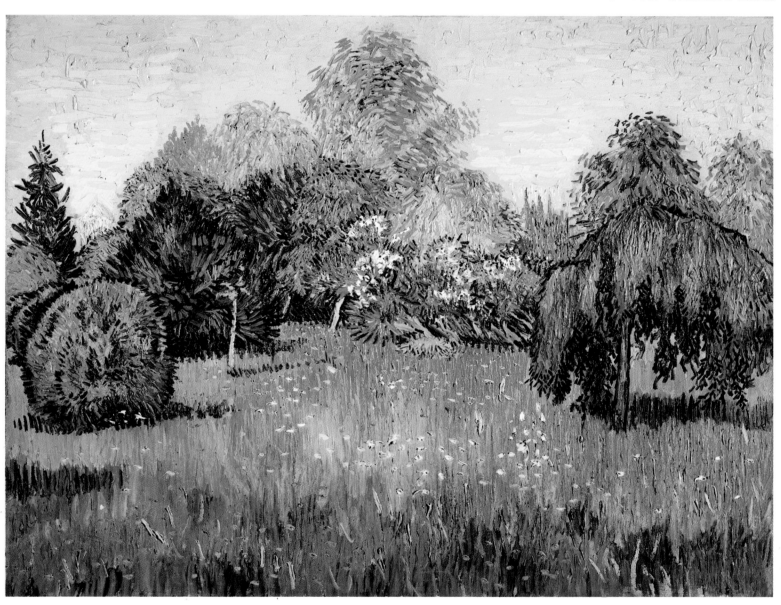

PUBLIC GARDEN WITH A COUPLE AND A BLUE FIR TREE

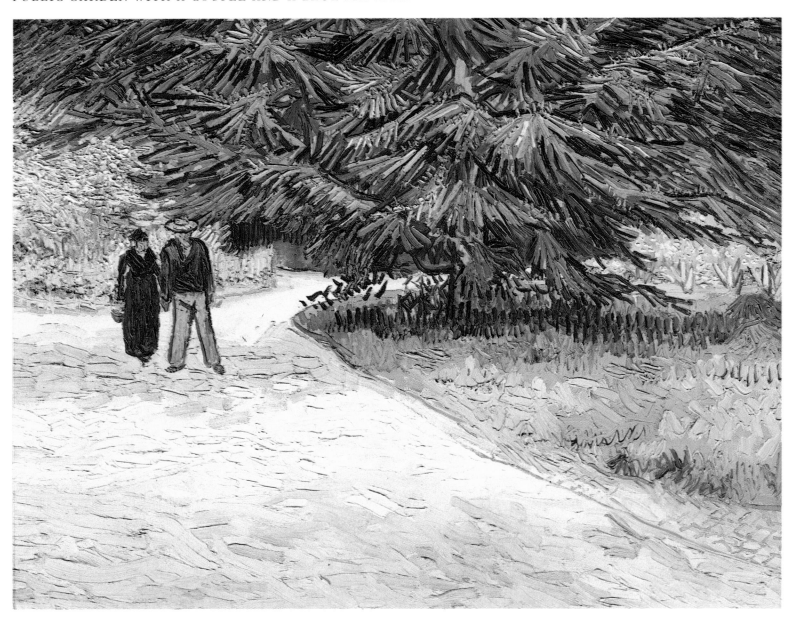

ENTRANCE TO THE PUBLIC GARDENS AT ARLES

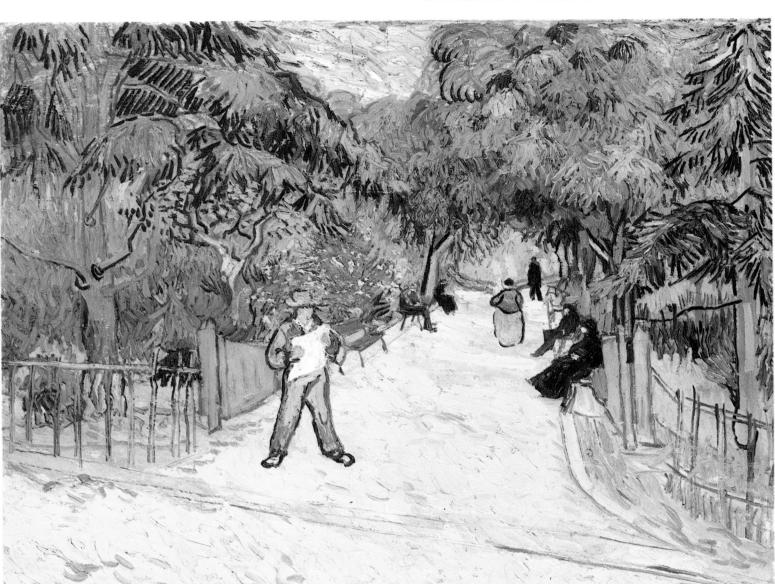

FOURTEEN SUNFLOWERS IN A VASE

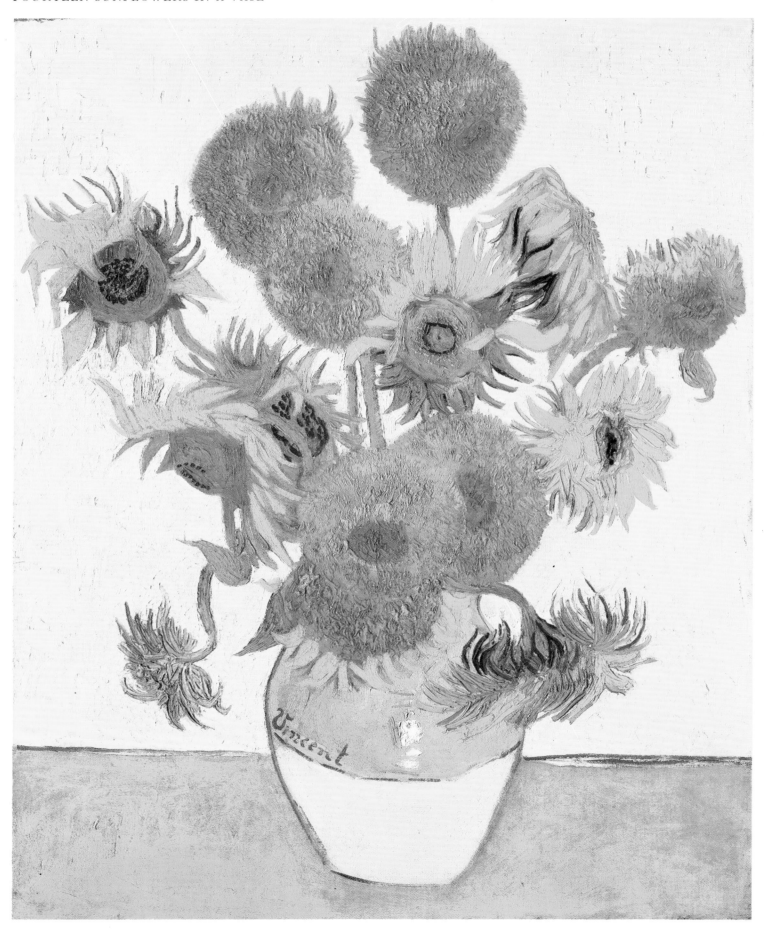

A PAIR OF OLD SHOES

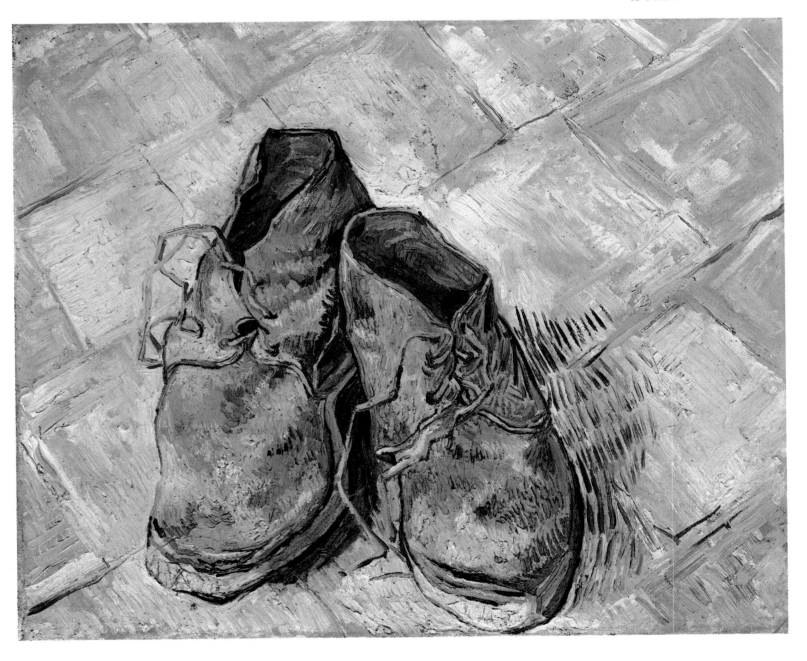

VINCENT'S BEDROOM

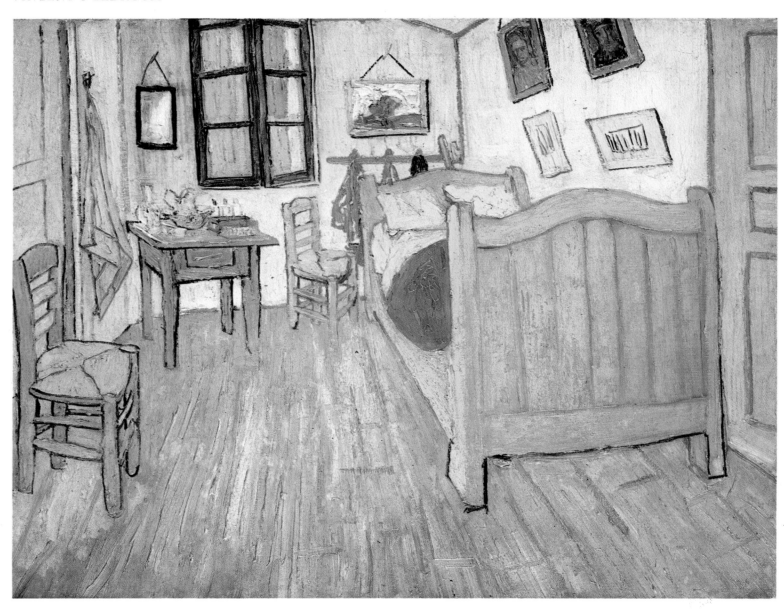

Arles/October 1888

PORTRAIT OF CAMILLE ROULIN

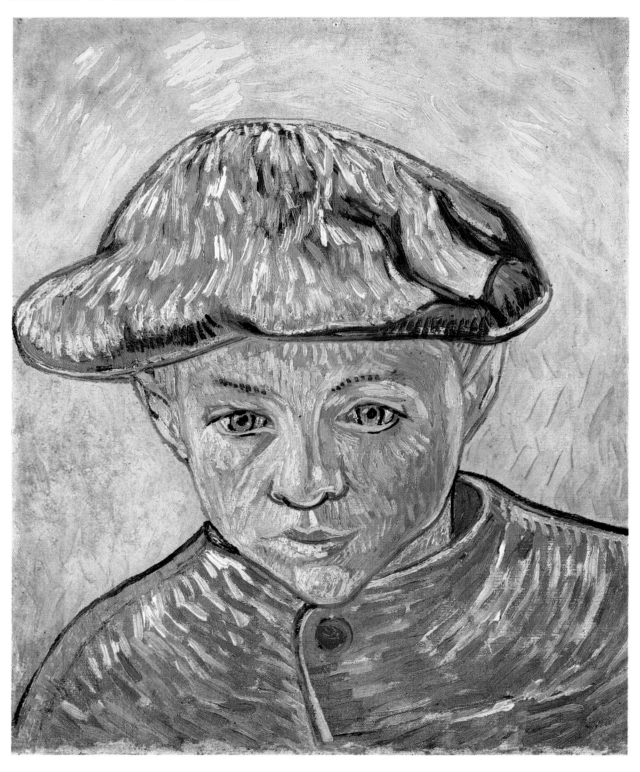

AUGUSTINE ROULIN WITH BABY

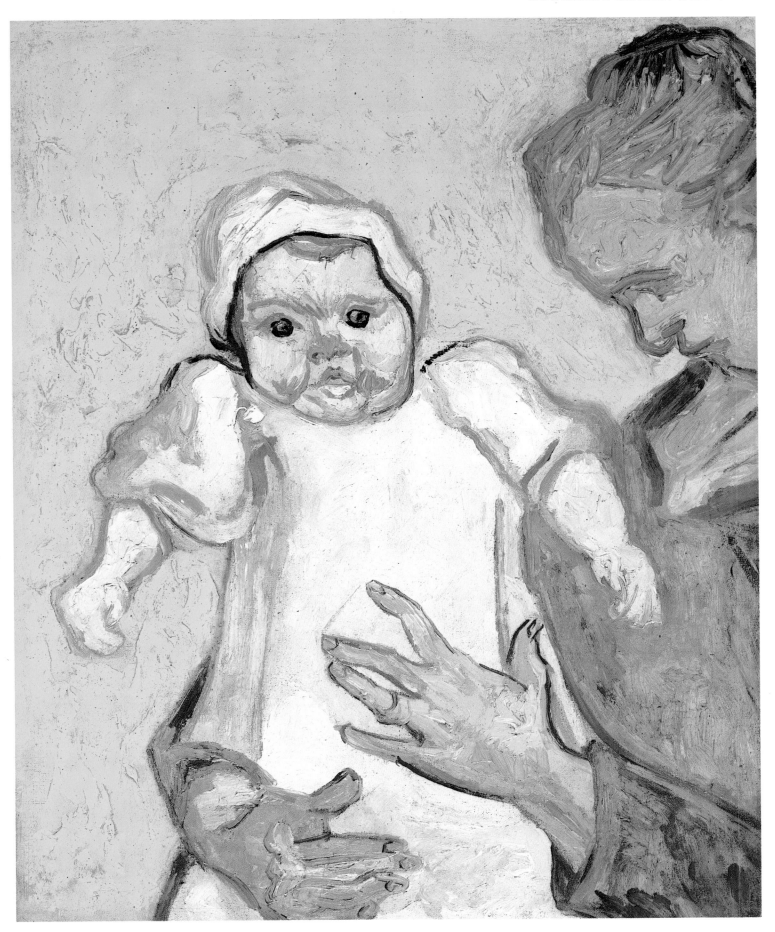

PORTRAIT OF ARMAND ROULIN

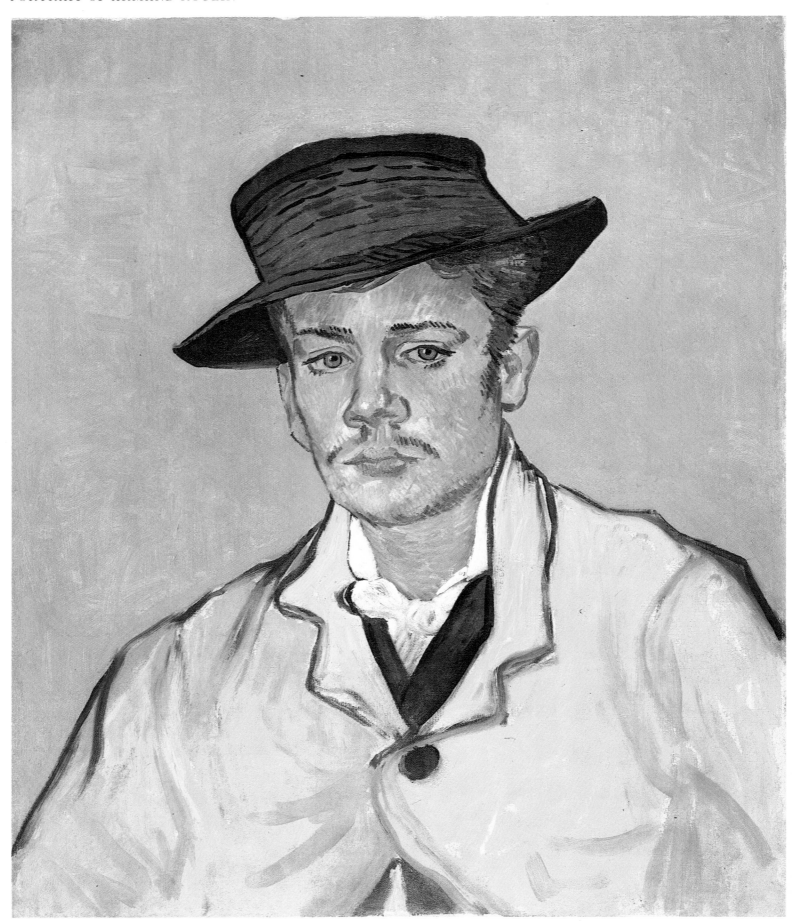

PORTRAIT OF A MAN

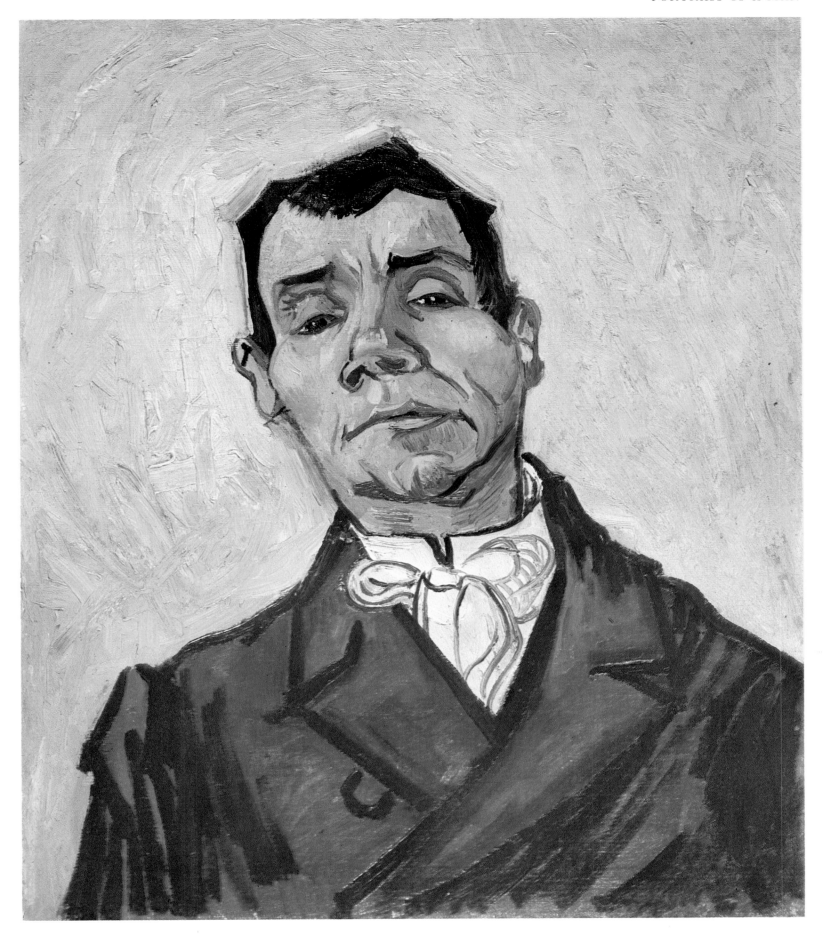

VINCENT'S CHAIR

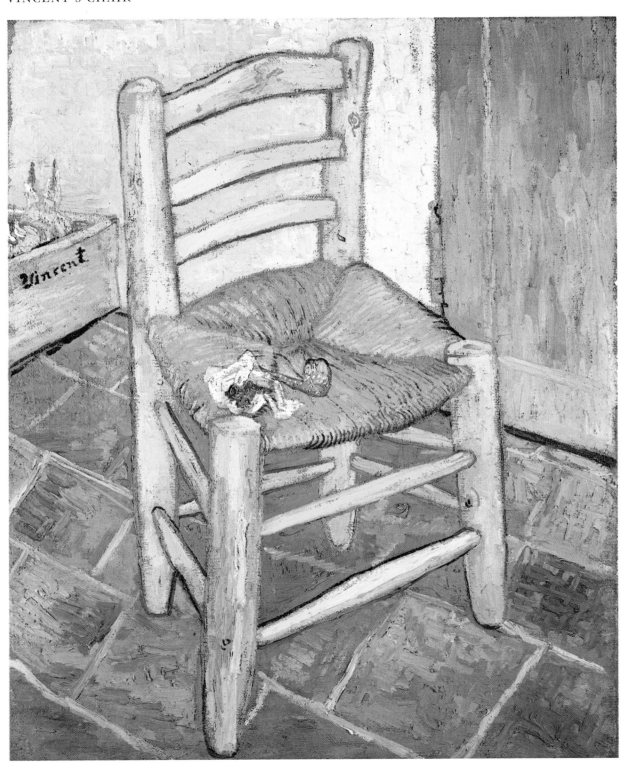

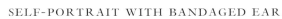

SELF-PORTRAIT WITH BANDAGED EAR

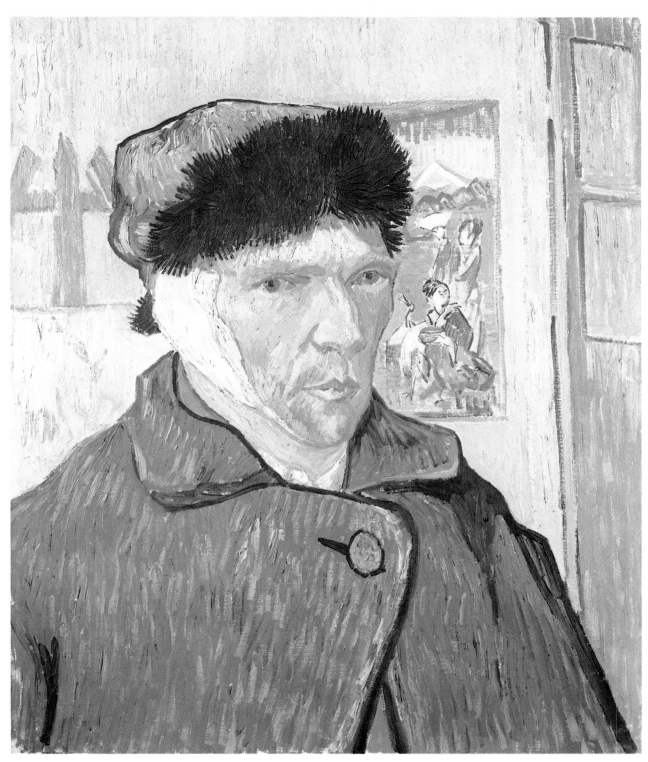

PLATE WITH ONIONS, ANNUAIRE DE LA SANTÉ AND OTHER OBJECTS

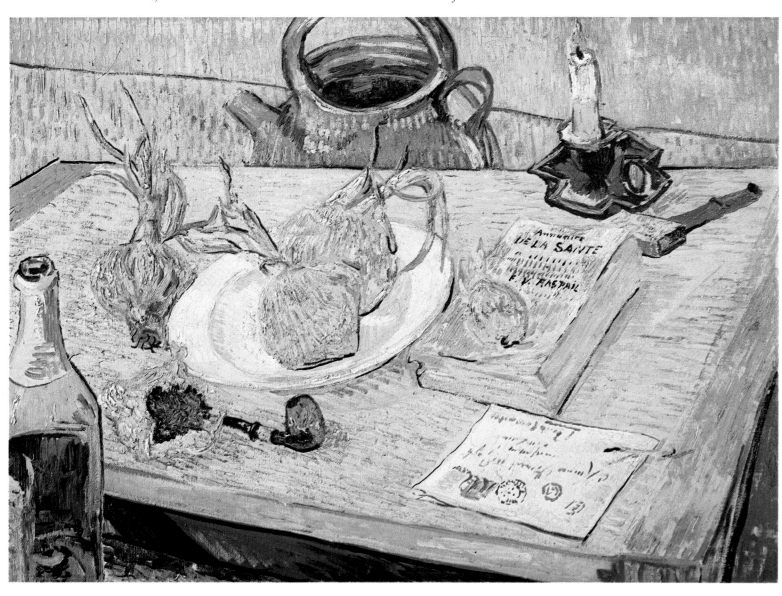

VASE WITH FOURTEEN SUNFLOWERS

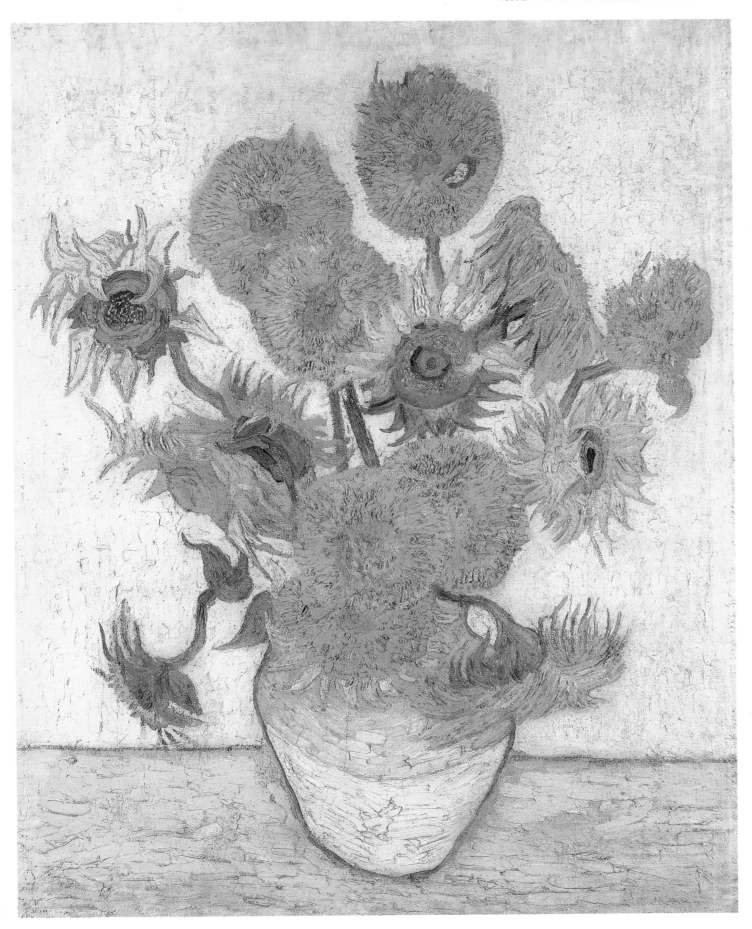

AUGUSTINE ROULIN (LA BERCEUSE)

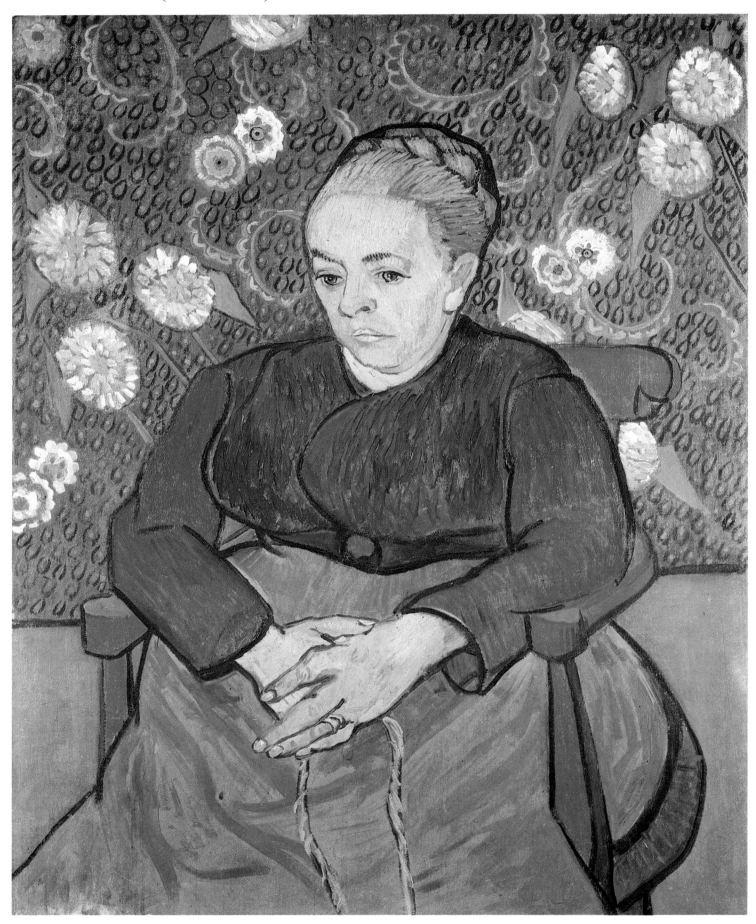

JOSEPH ROULIN, BUST

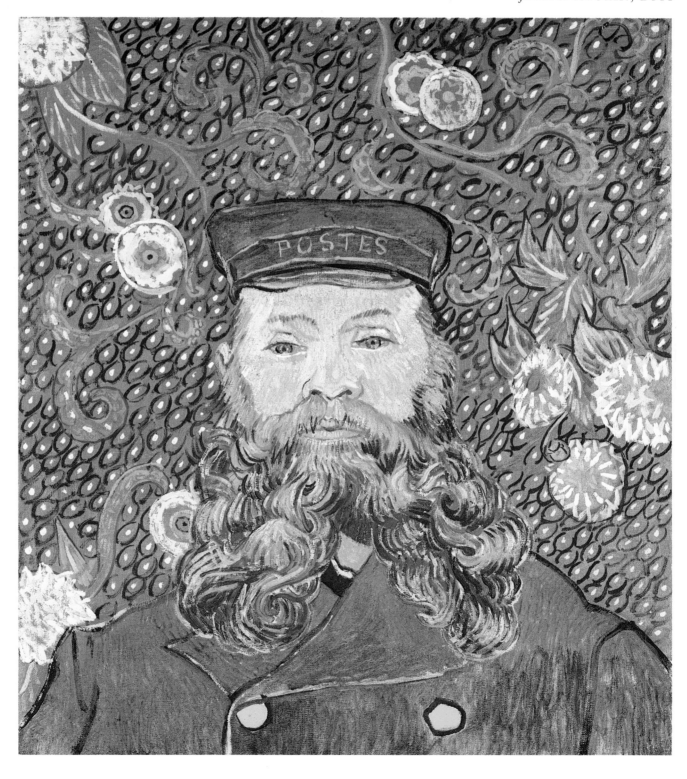

THE CRAU WITH PEACH TREES IN BLOOM

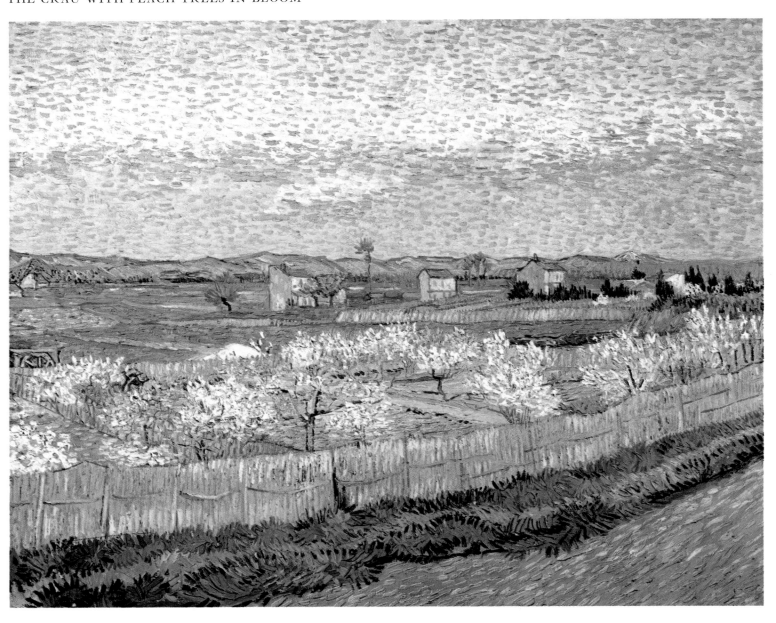

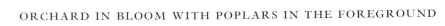

ORCHARD IN BLOOM WITH POPLARS IN THE FOREGROUND

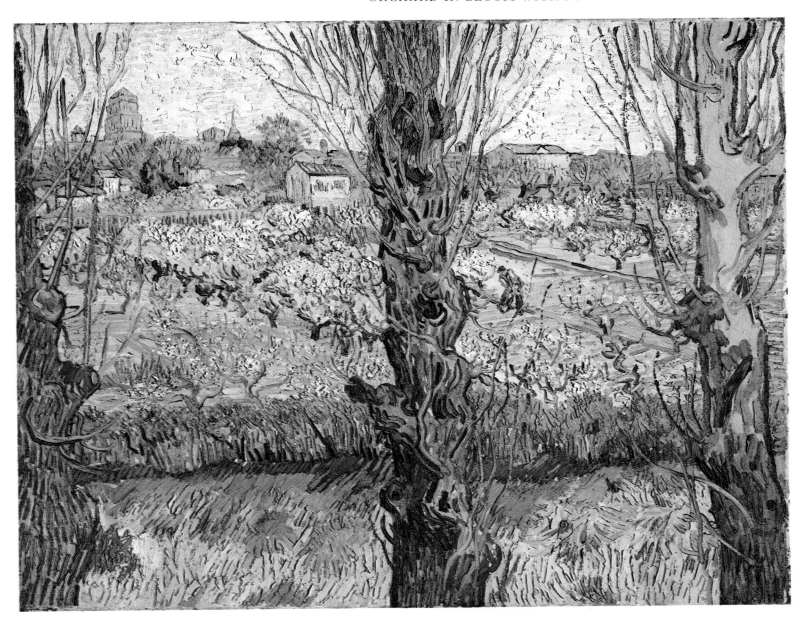

ASYLUM AND GARDEN

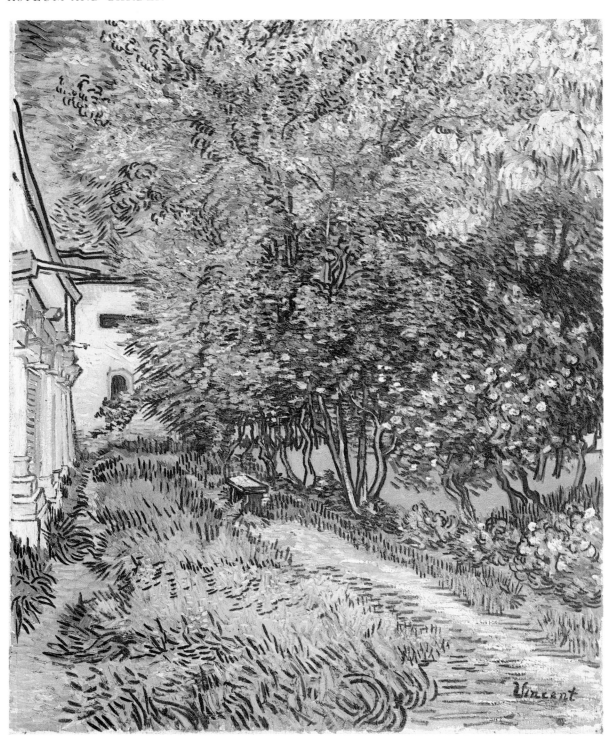

IRISES

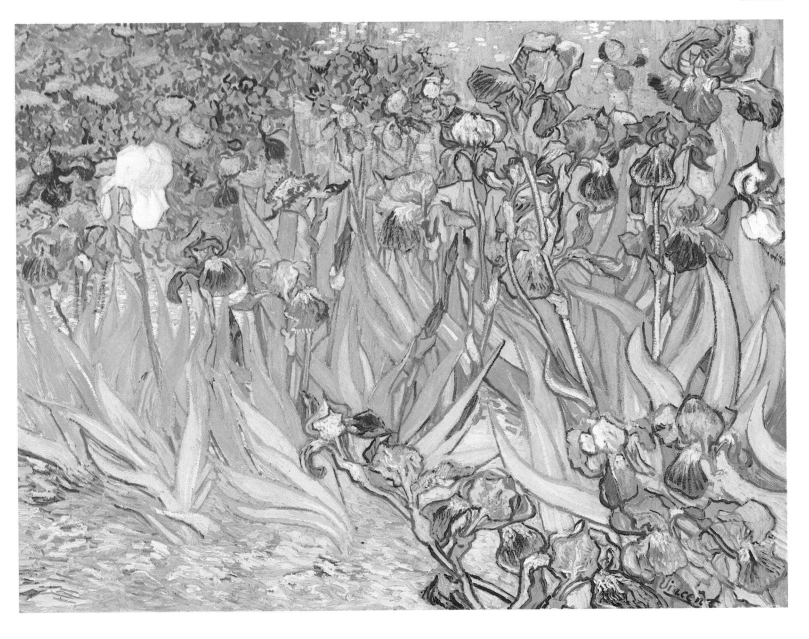

LILACS

TREES WITH IVY

DEATH'S-HEAD MOTH

FOUNTAIN IN THE GARDEN OF THE ASYLUM

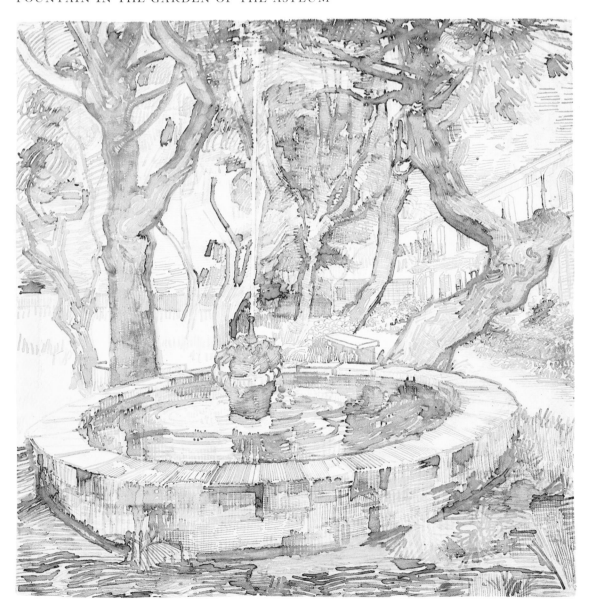

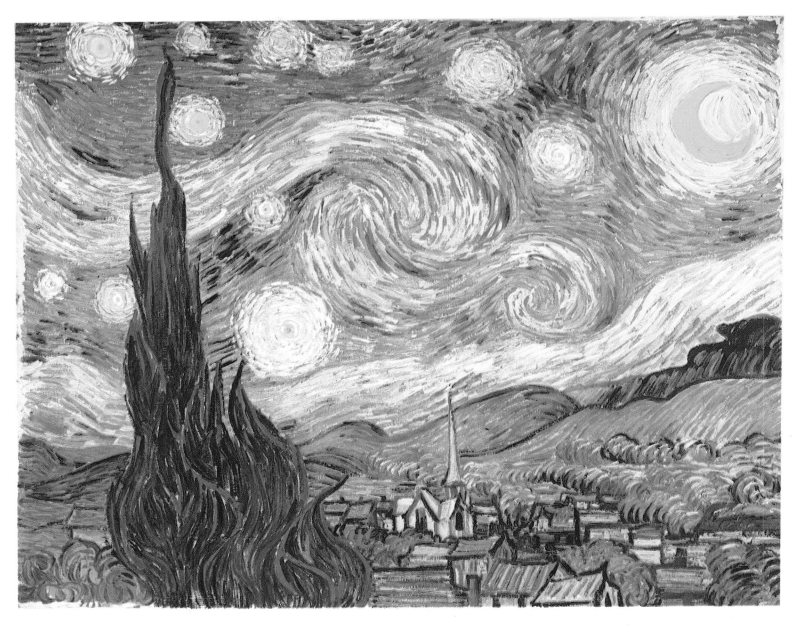

MOUNTAIN LANDSCAPE SEEN ACROSS WALLS WITH RISING SUN AND GREEN FIELD

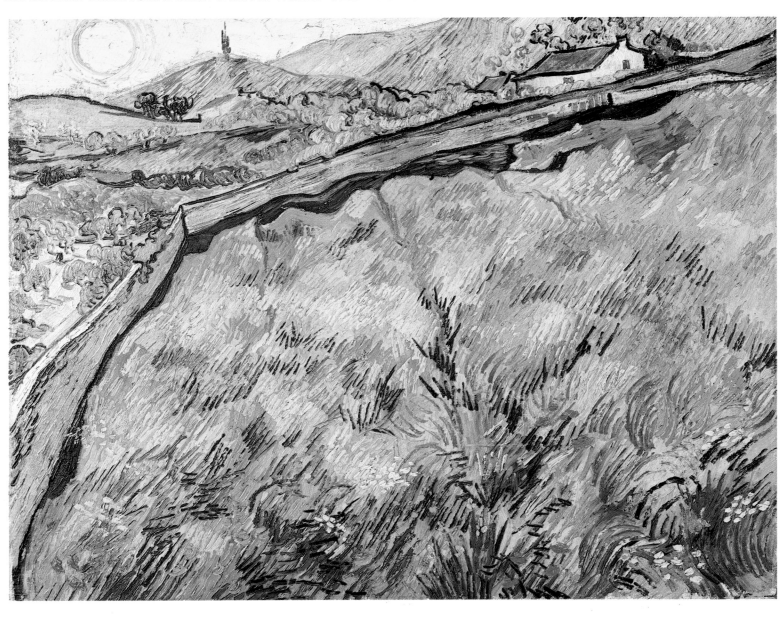

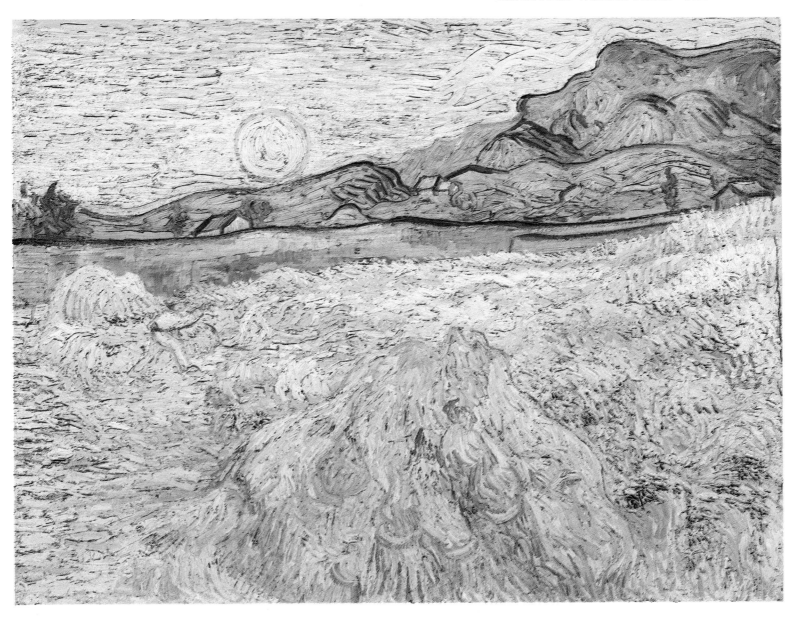

TRUNKS OF TREES WITH IVY

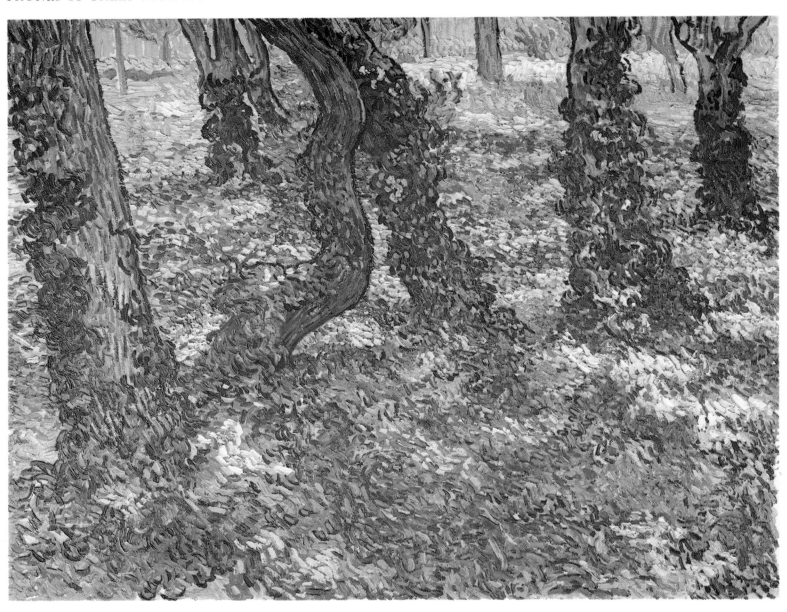

WILD VEGETATION IN THE MOUNTAINS

CYPRESSES

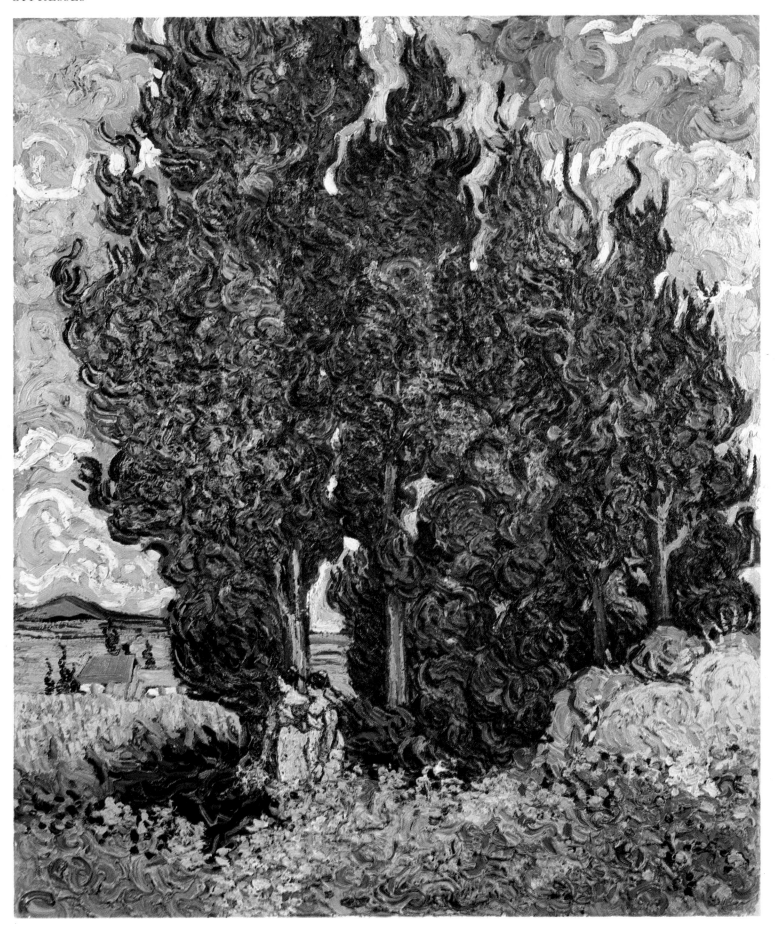

St Rémy/June 1889

CYPRESSES

St Rémy/June 1889

OLIVE TREES IN A MOUNTAIN LANDSCAPE

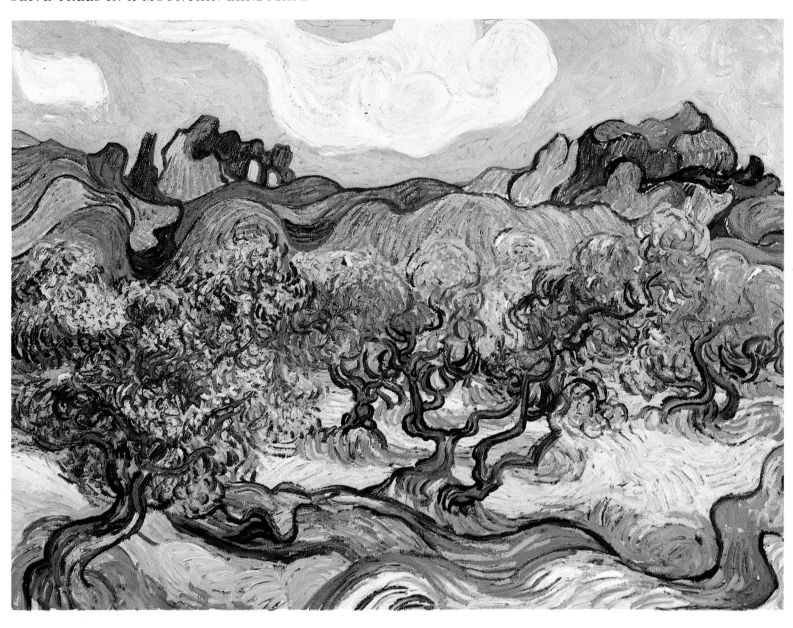

FIELDS WITH POPPIES

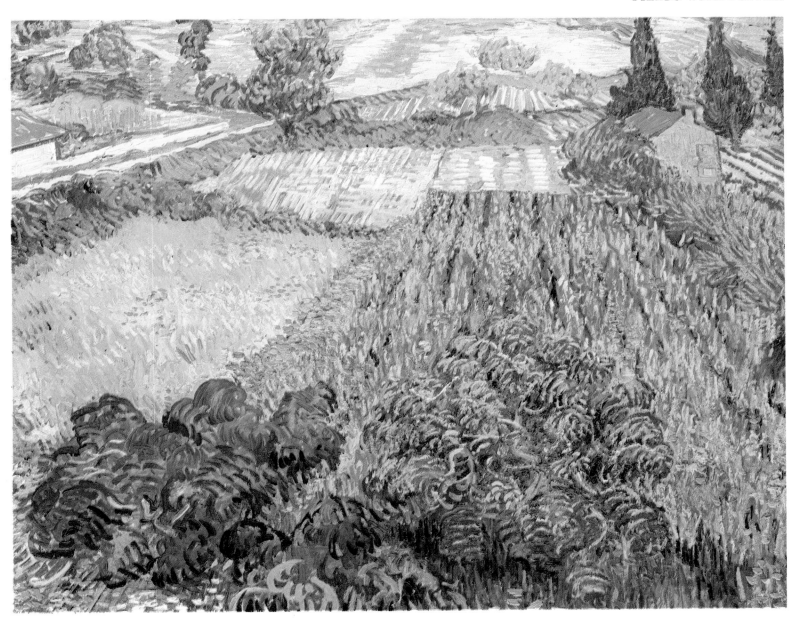

PORTRAIT OF THE CHIEF ORDERLY (TRABU)

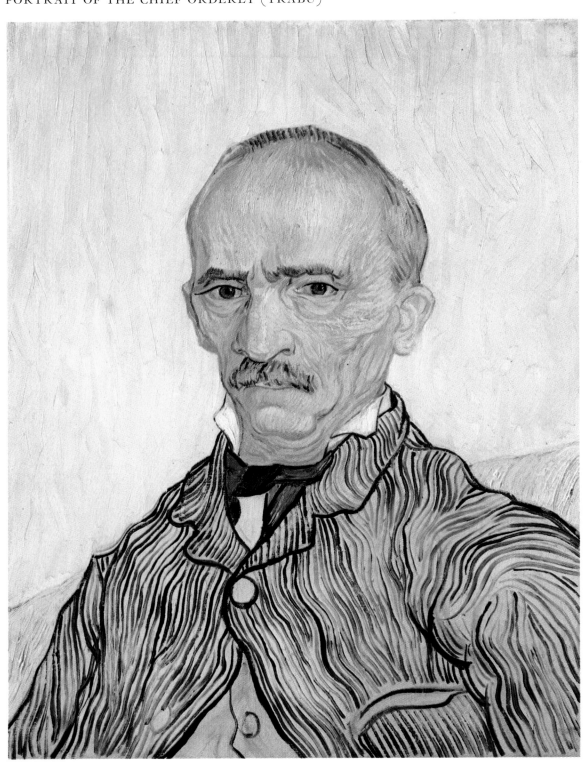

St Rémy/September 1889

SELF-PORTRAIT

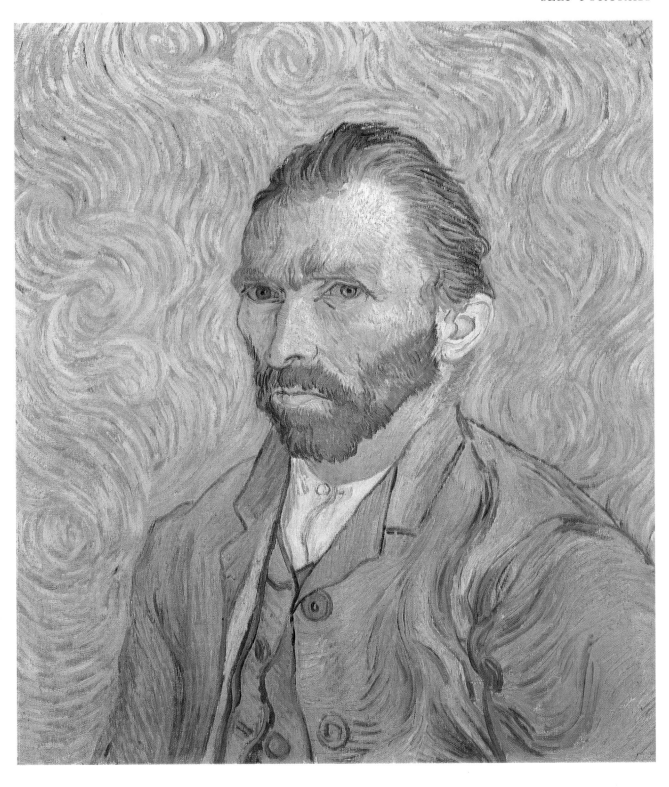

PEASANT WOMAN CUTTING STRAW (AFTER MILLET)

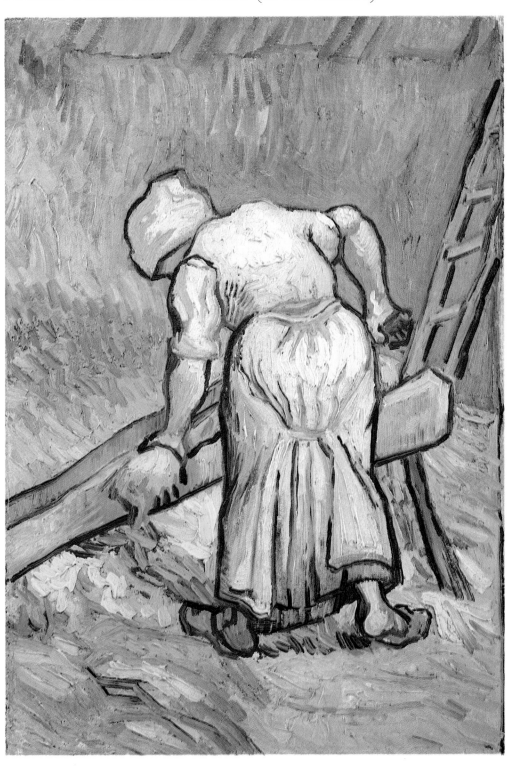

St Rémy/September 1889

SHEAF BINDER (AFTER MILLET)

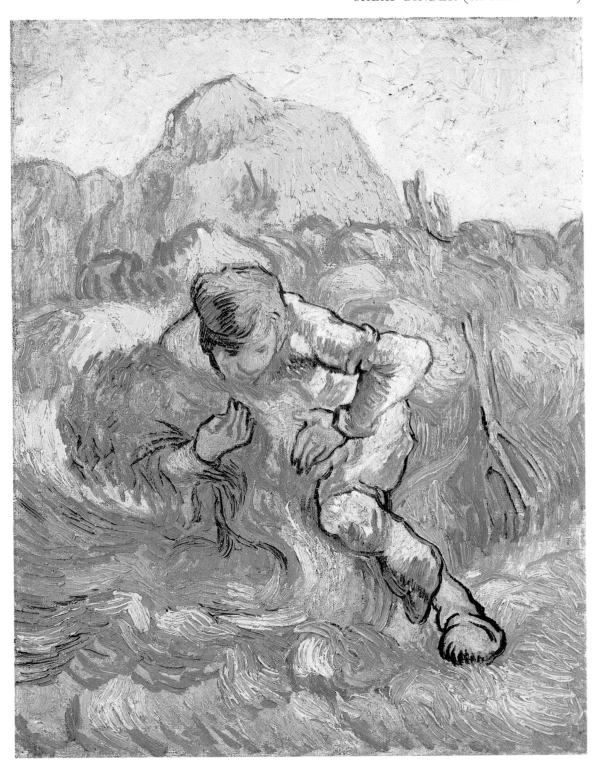

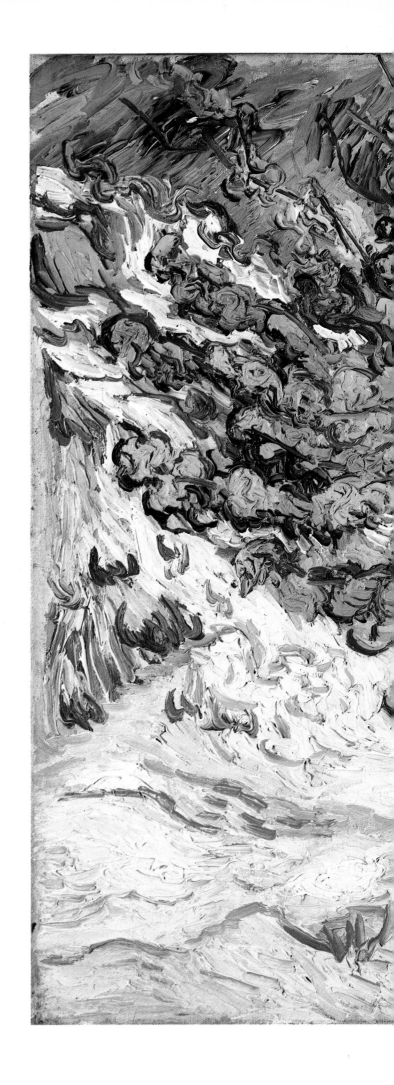

MULBERRY TREE

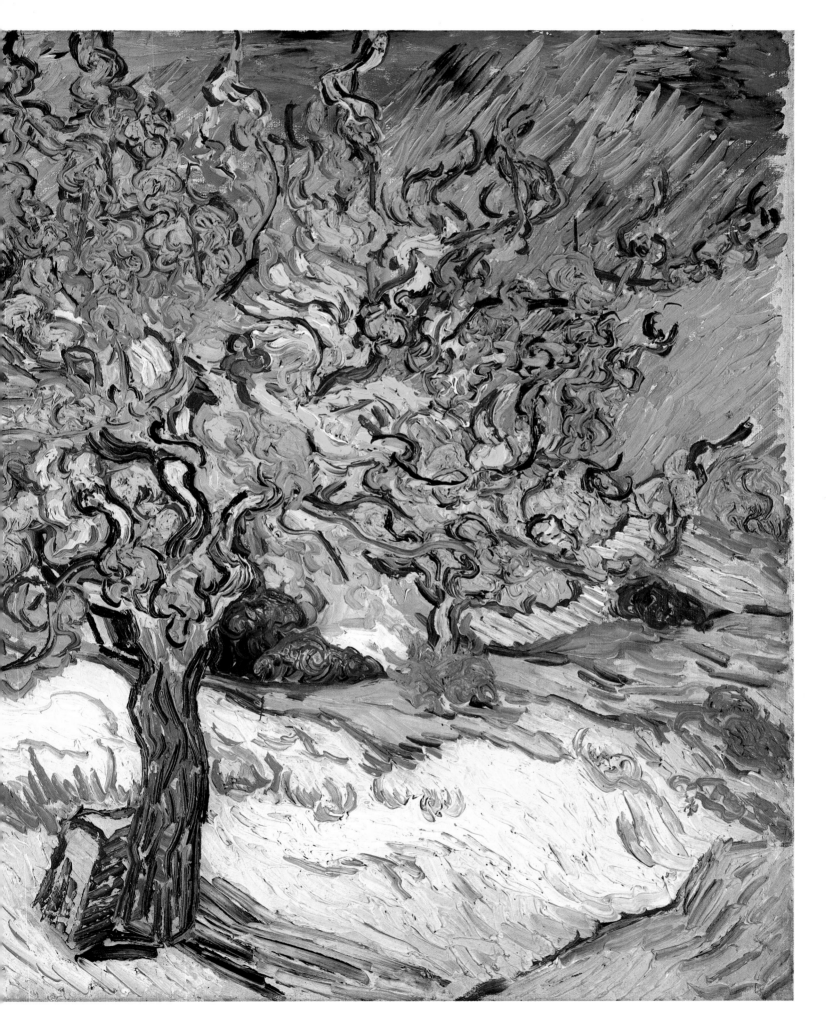

A PASSAGEWAY AT THE ASYLUM

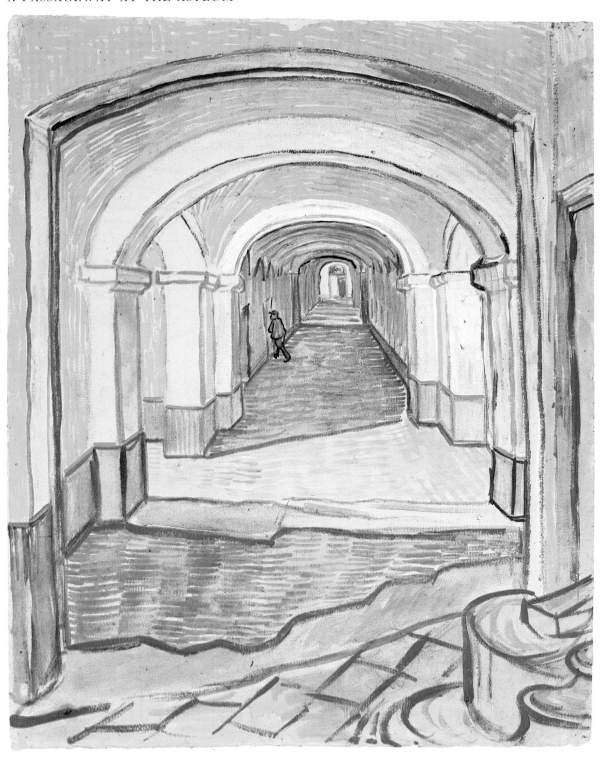

TREES IN FRONT OF THE ENTRANCE TO THE ASYLUM

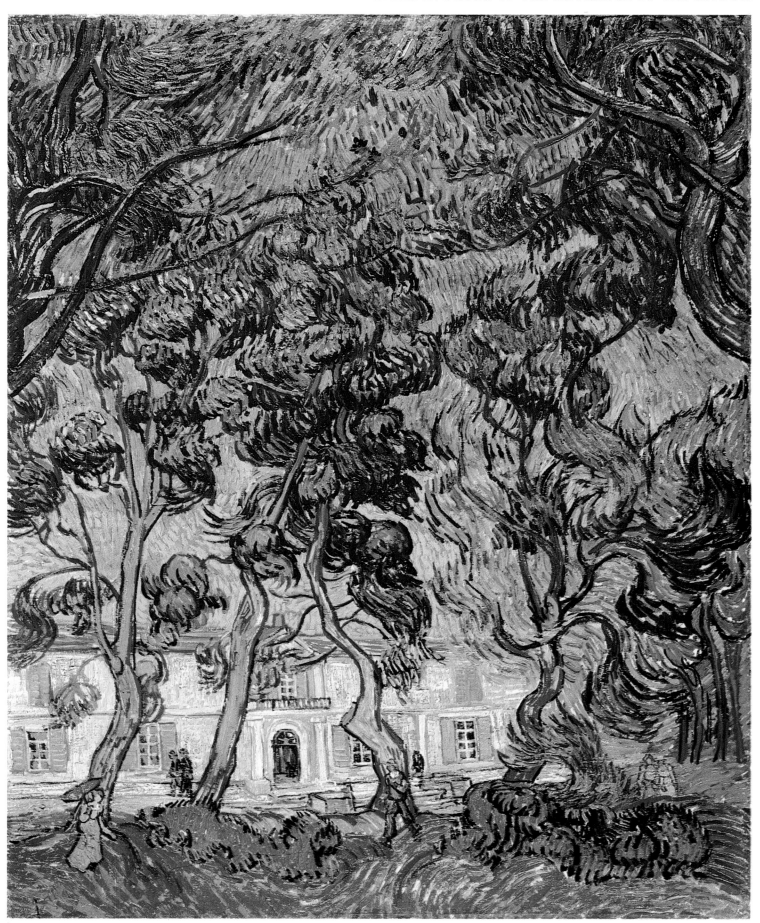

TWO POPLARS WITH A BACKGROUND OF MOUNTAINS

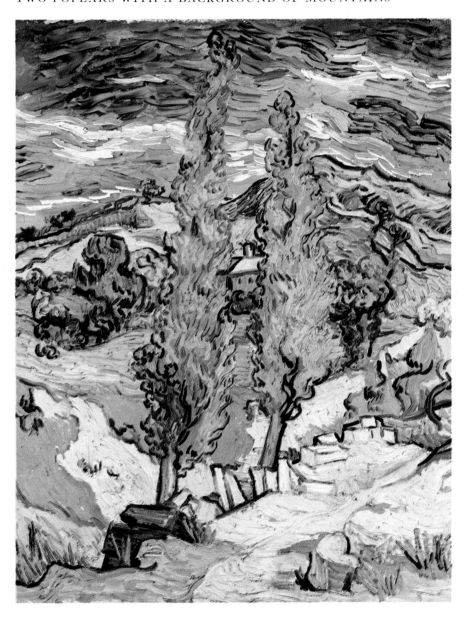

A PATH THROUGH THE RAVINE

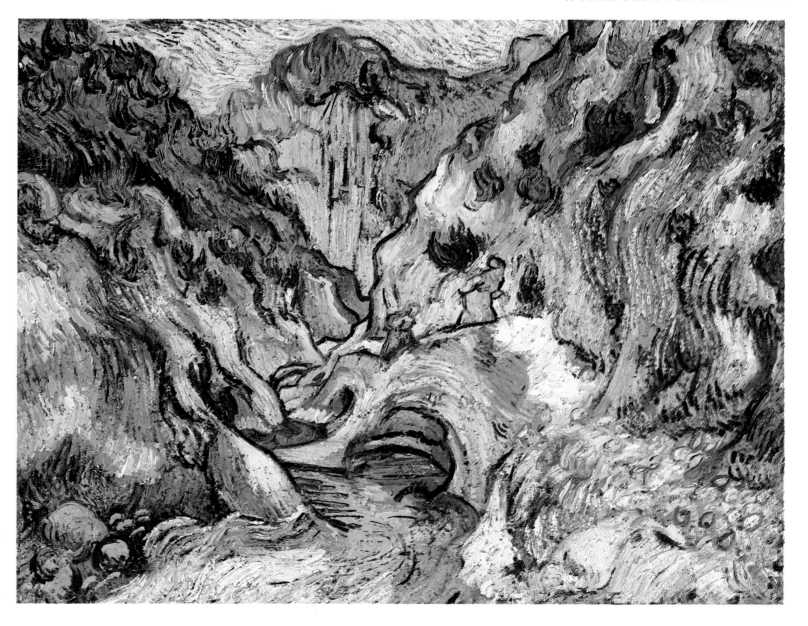

ENCLOSED FIELD WITH YOUNG WHEAT AND RISING SUN

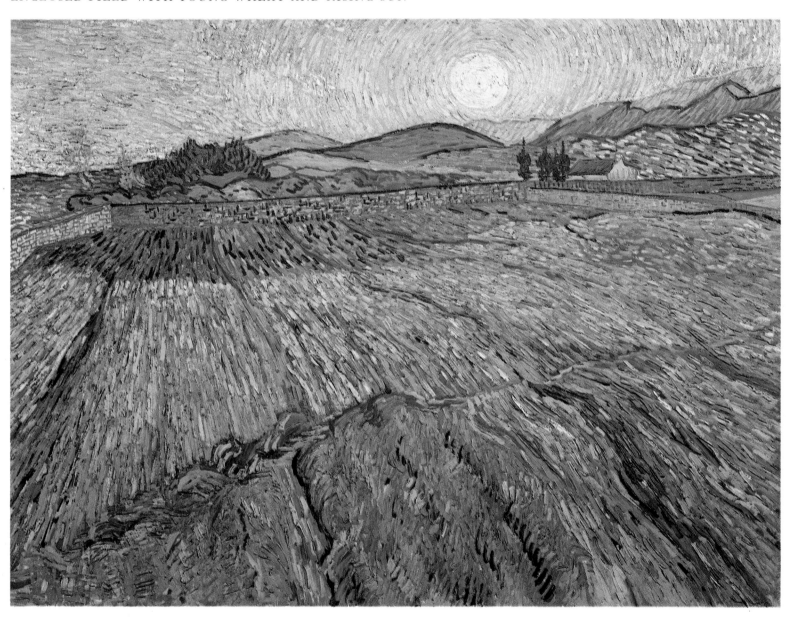

NOON: REST (AFTER MILLET)

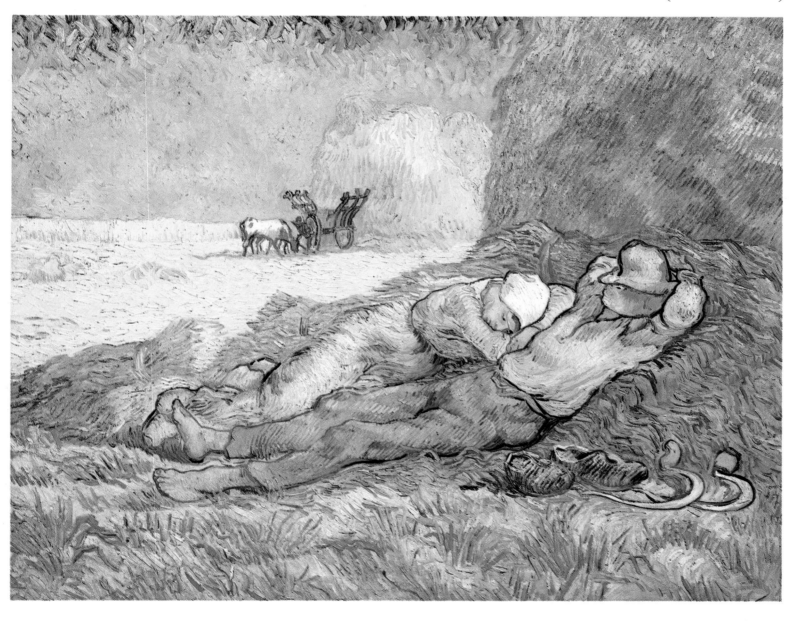

WOMAN PICKING OLIVES

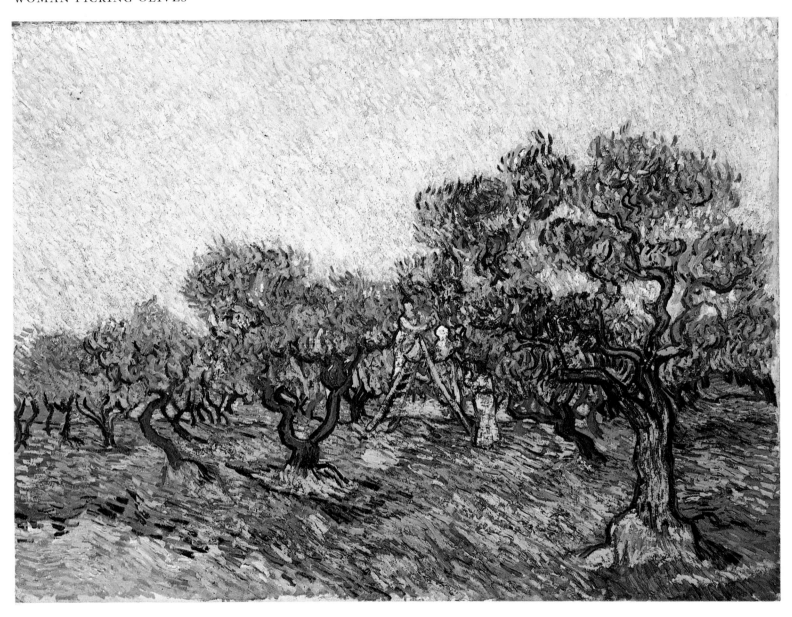

THE FIRST STEPS (AFTER MILLET)

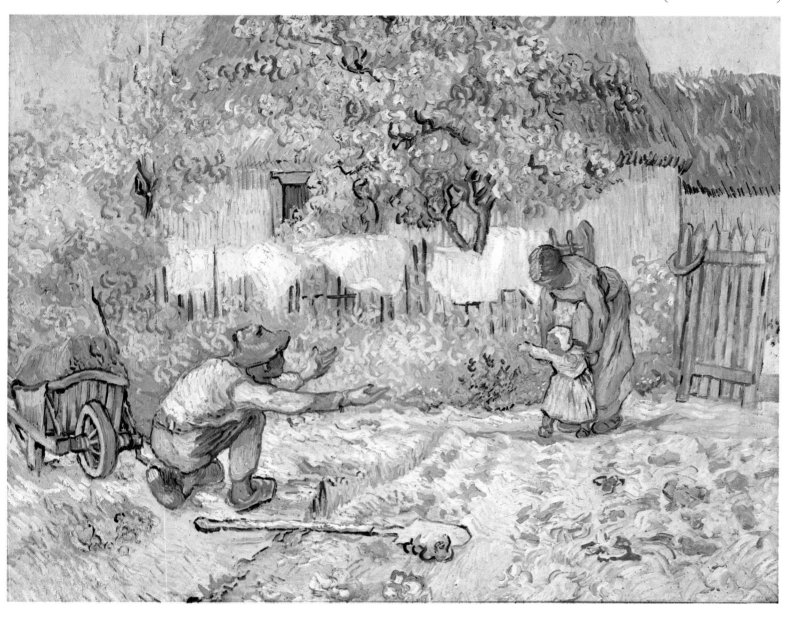

MEN DRINKING (AFTER DAUMIER)

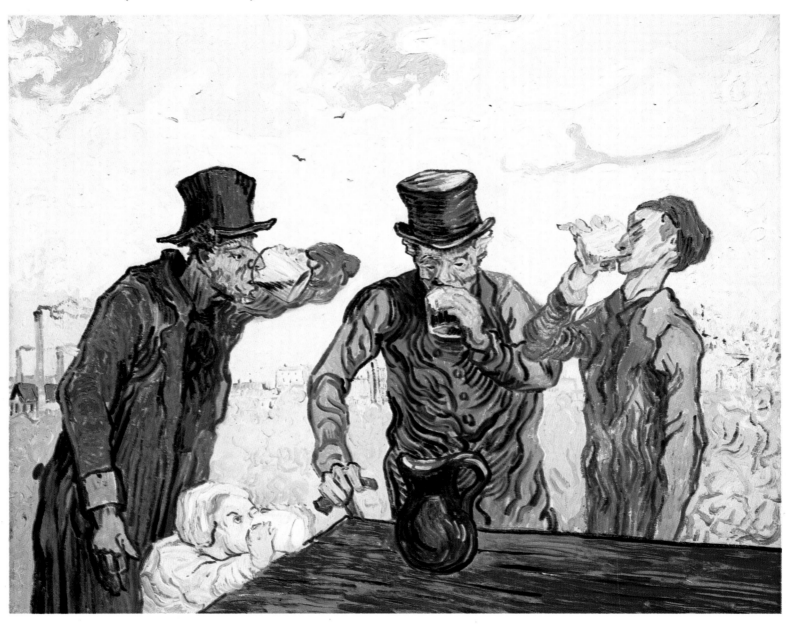

THE ARLÉSIENNE (MADAME GINOUX), WITH LIGHT PINK BACKGROUND

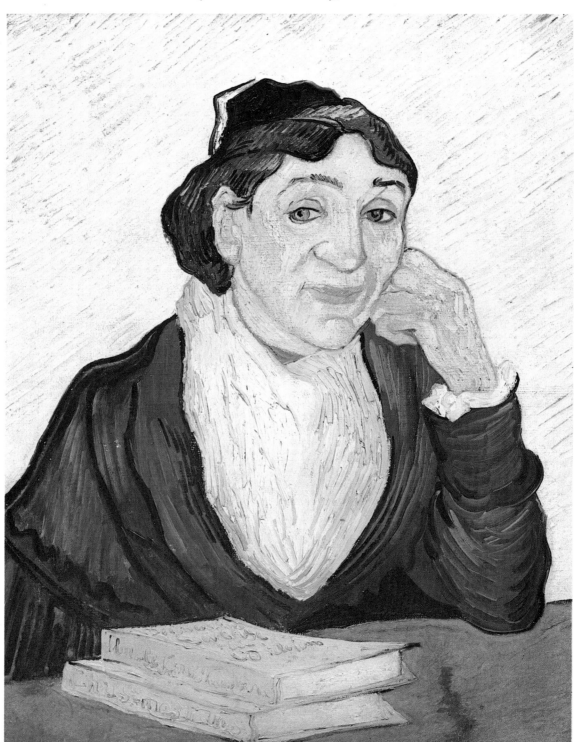

SNOW-COVERED COTTAGES, A COUPLE WITH A CHILD, AND OTHER WALKERS

SHEET WITH SKETCHES OF DIGGERS AND OTHER FIGURES

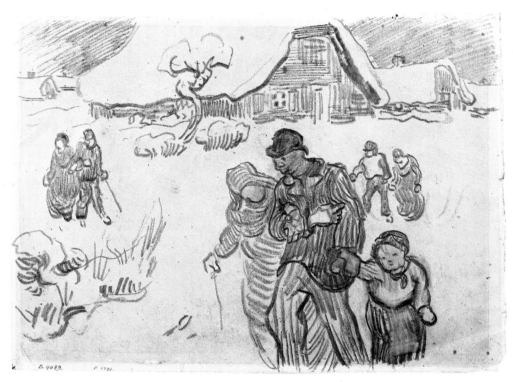

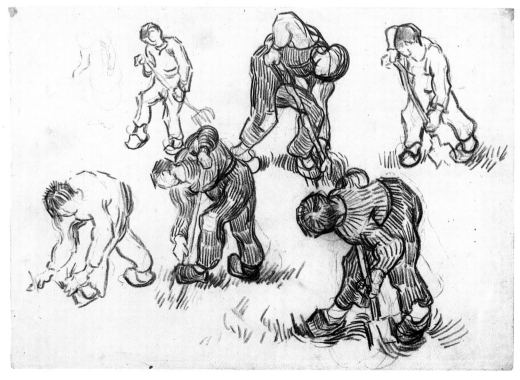

COTTAGES AND CYPRESSES AT SUNSET WITH STORMY SKY

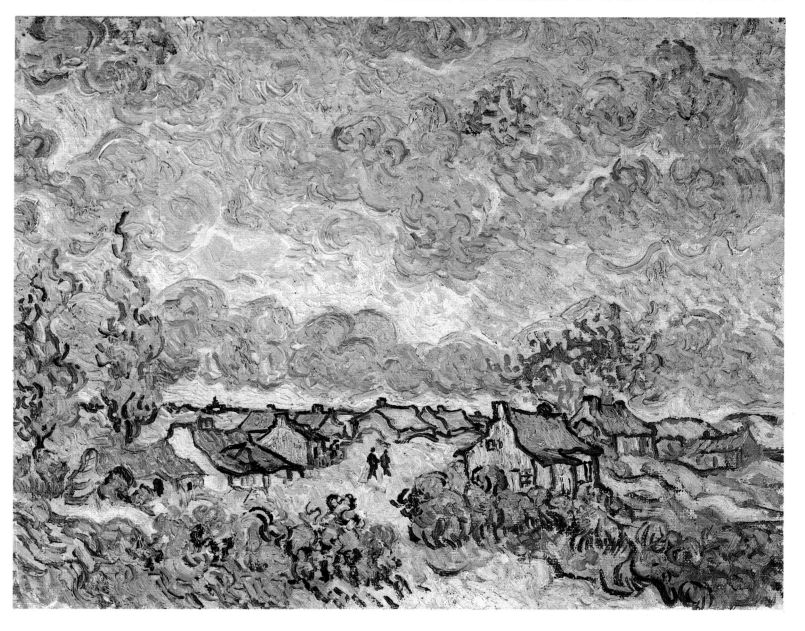

THE GOOD SAMARITAN (AFTER DELACROIX)

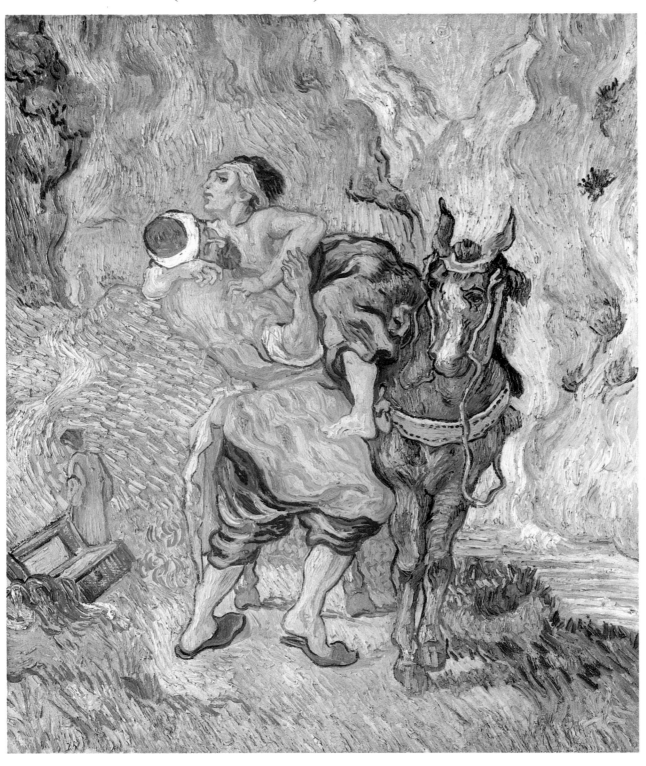

THE RAISING OF LAZARUS (AFTER A DETAIL FROM AN ETCHING BY REMBRANDT)

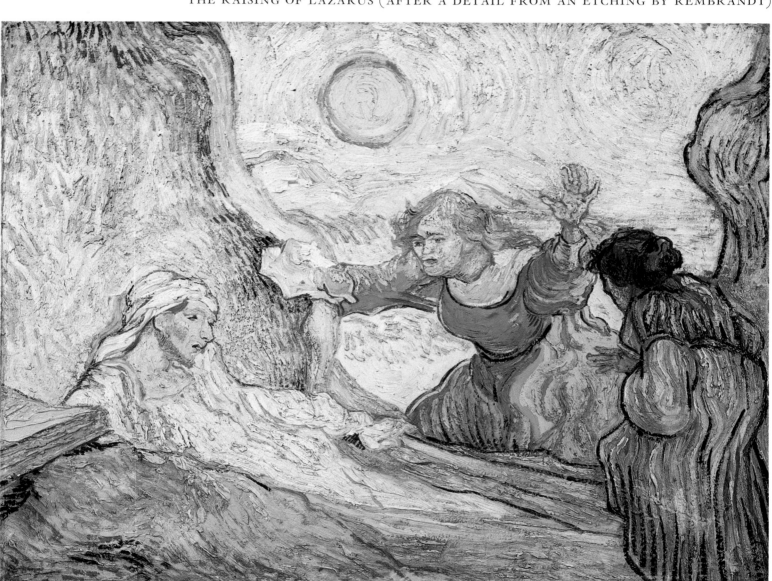

ROAD WITH MEN WALKING, CARRIAGE, CYPRESS, STAR AND CRESCENT MOON

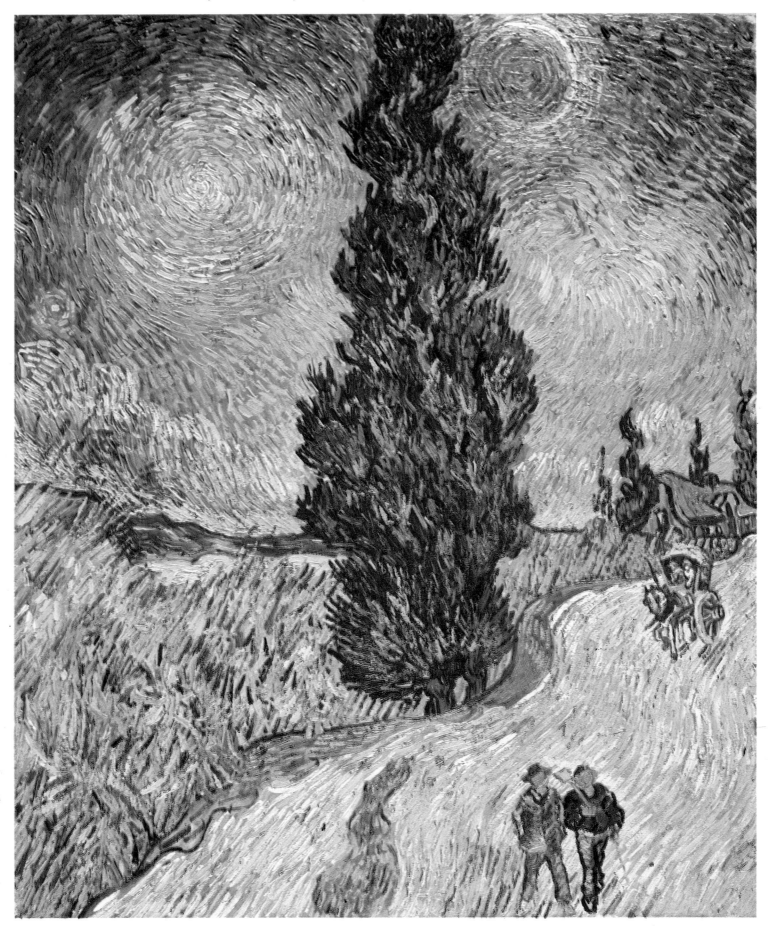

VASE WITH VIOLET IRISES AGAINST A YELLOW BACKGROUND

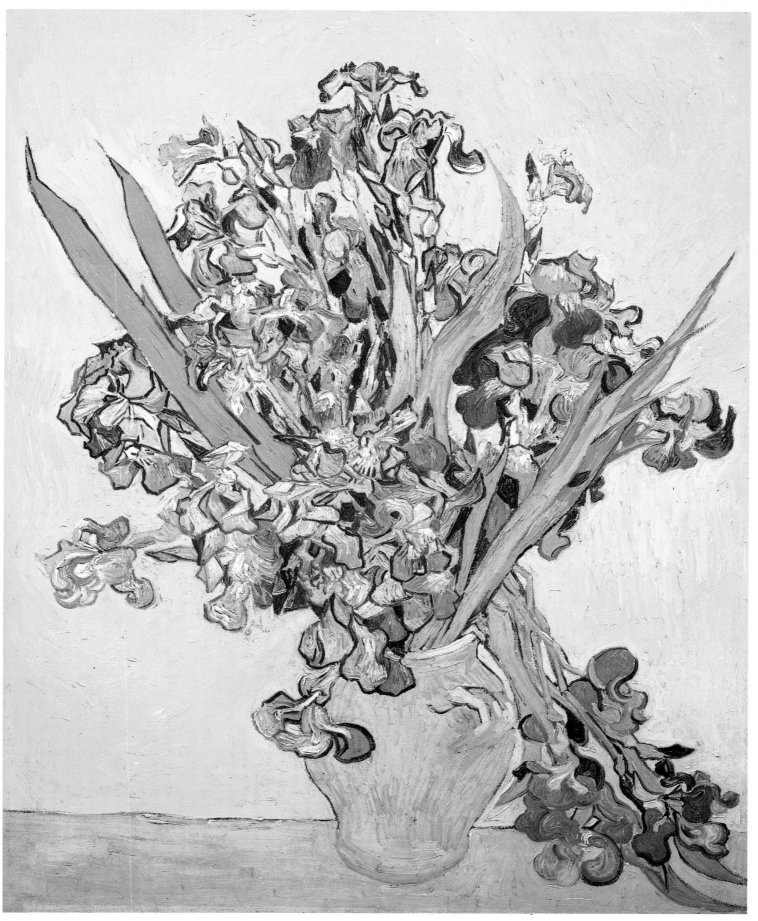

THE CHURCH AT AUVERS

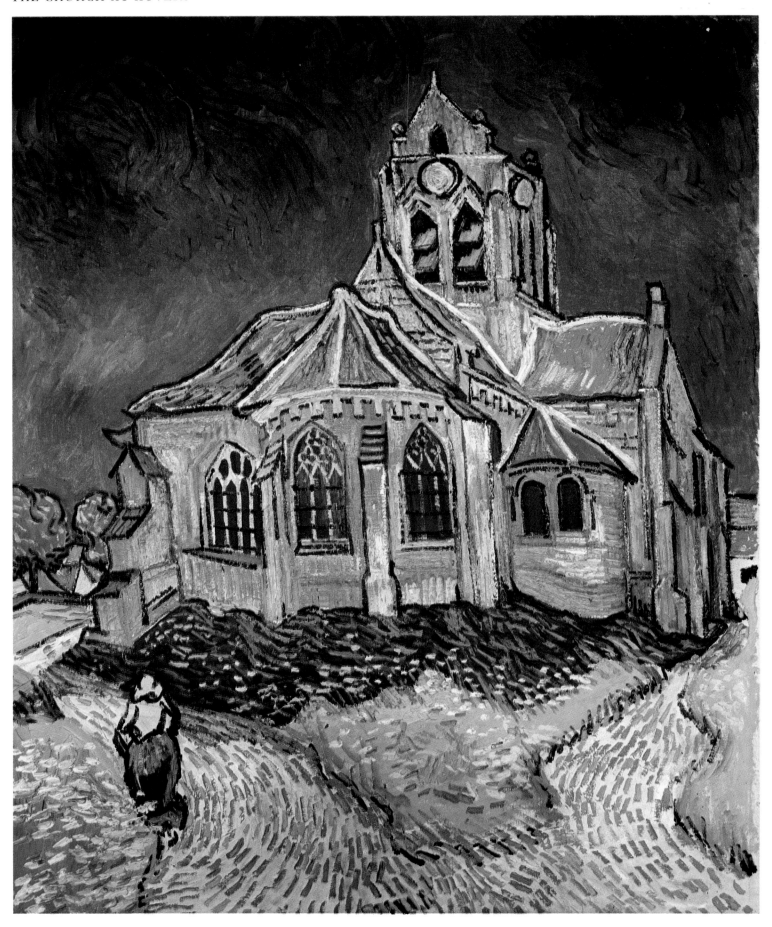

DOCTOR GACHET SITTING AT A TABLE WITH BOOKS AND A GLASS
WITH SPRIGS OF FOXGLOVE

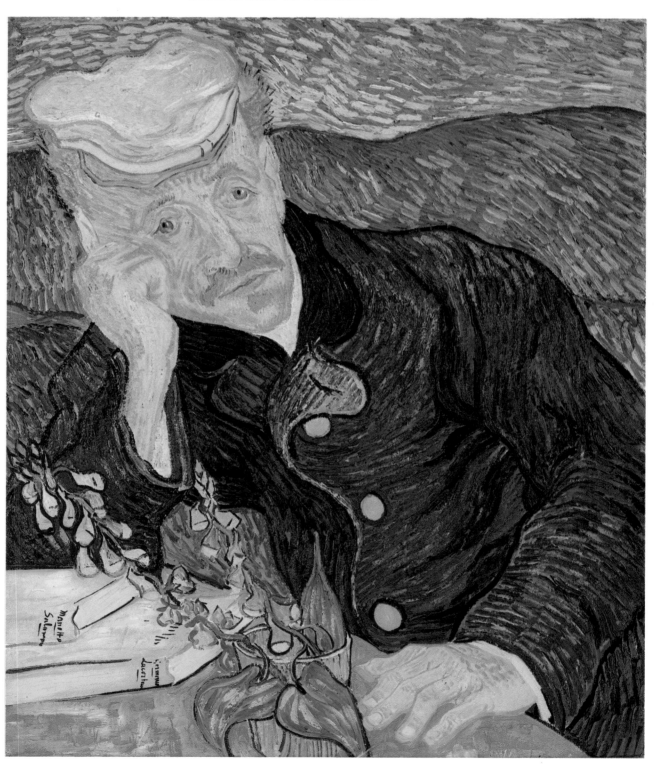

HEAD OF A GIRL

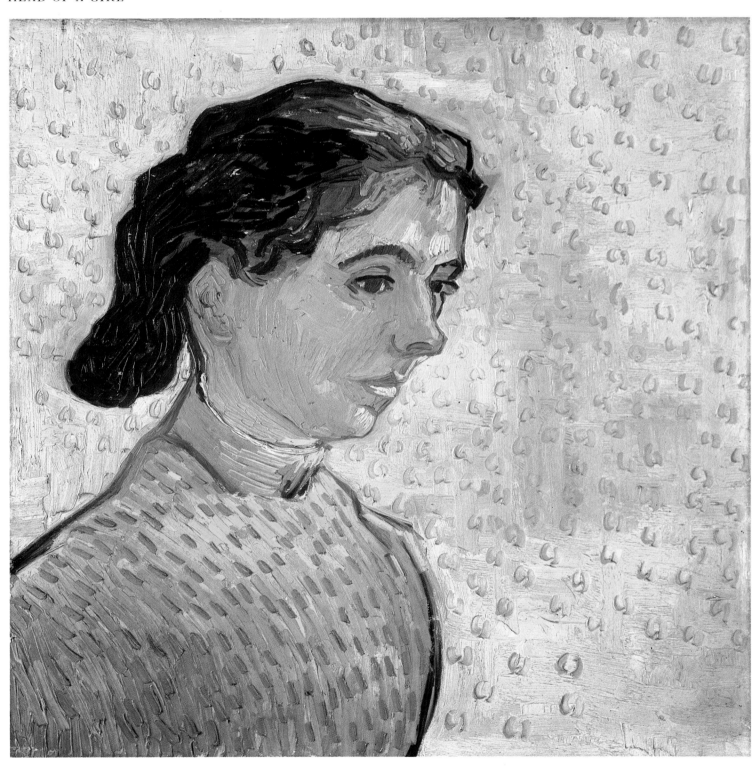

Auvers-sur-Oise/June 1890

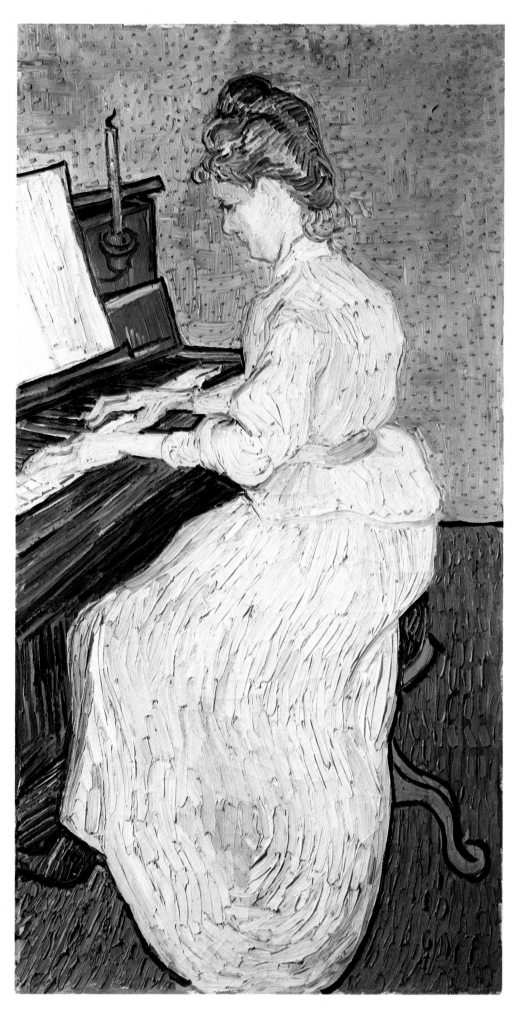

BLOSSOMING CHESTNUT BRANCHES

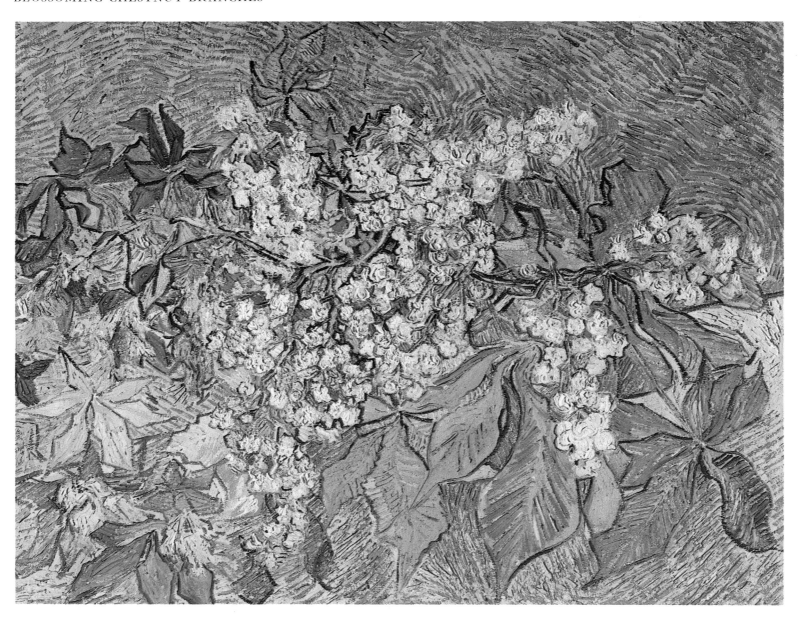

BLOSSOMING BRANCHES

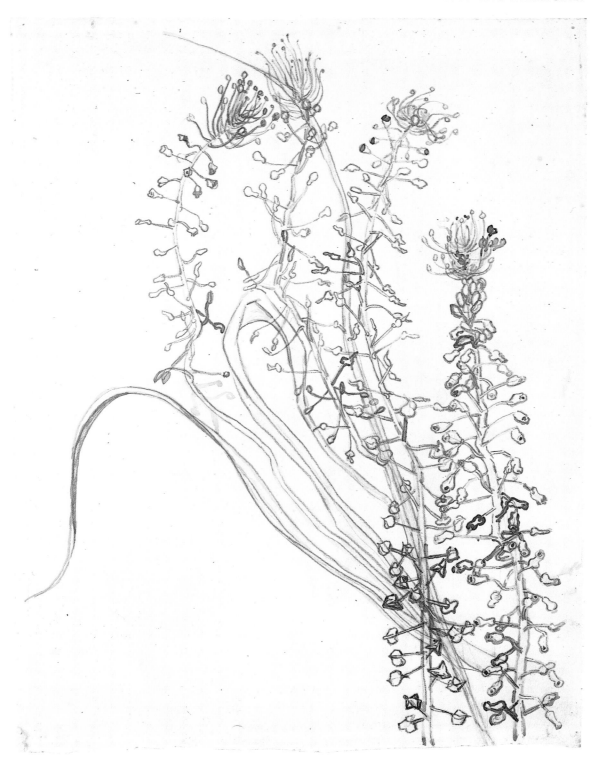

POPPIES WITH BUTTERFLIES

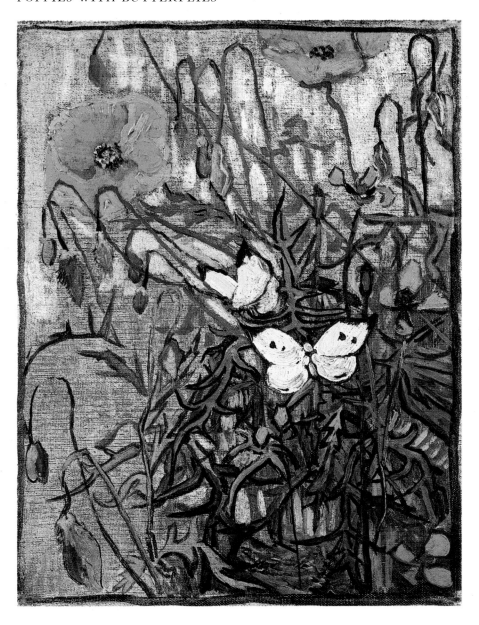

FIELD WITH POPPIES

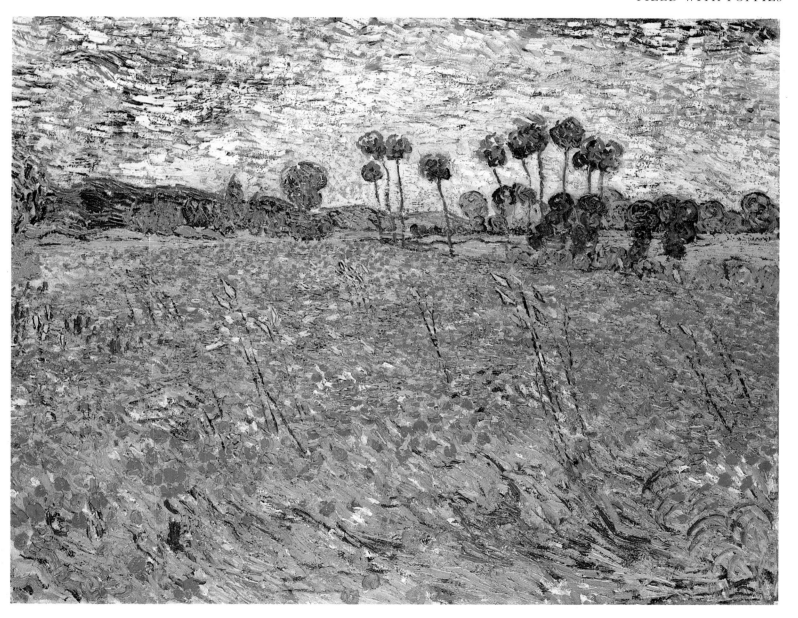

TWO CHILDREN

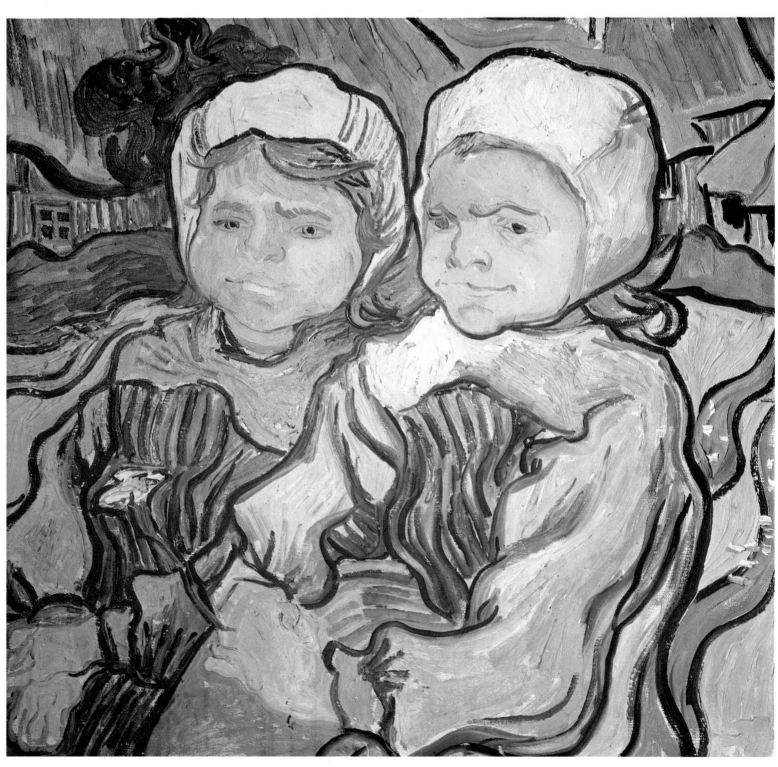

SKETCH OF A LADY WITH STRIPED DRESS AND HAT AND
OF ANOTHER LADY, HALF-FIGURE

SKETCH OF TWO WOMEN

LANDSCAPE IN THE RAIN

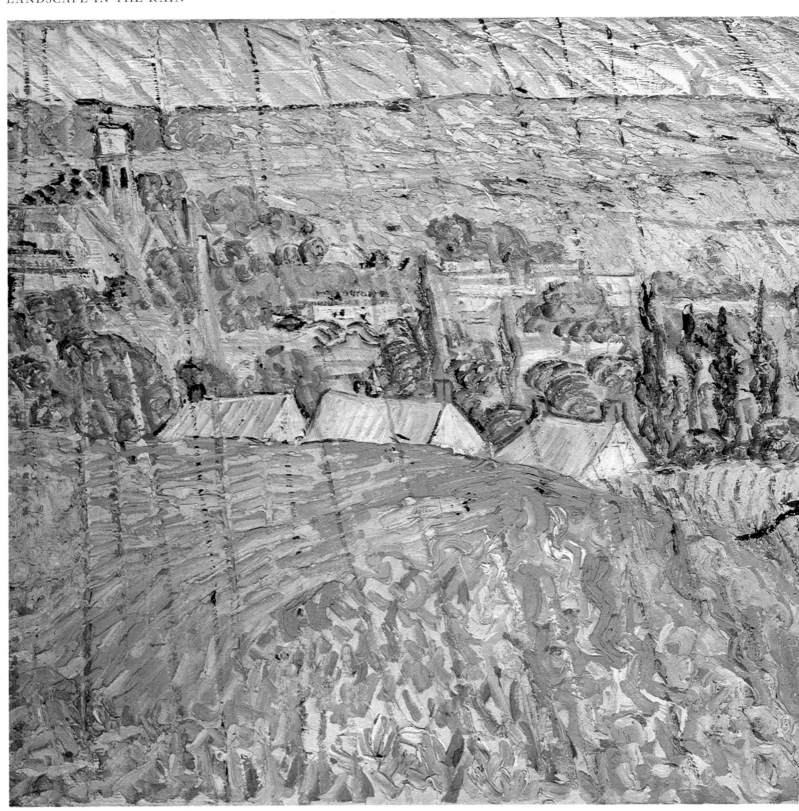

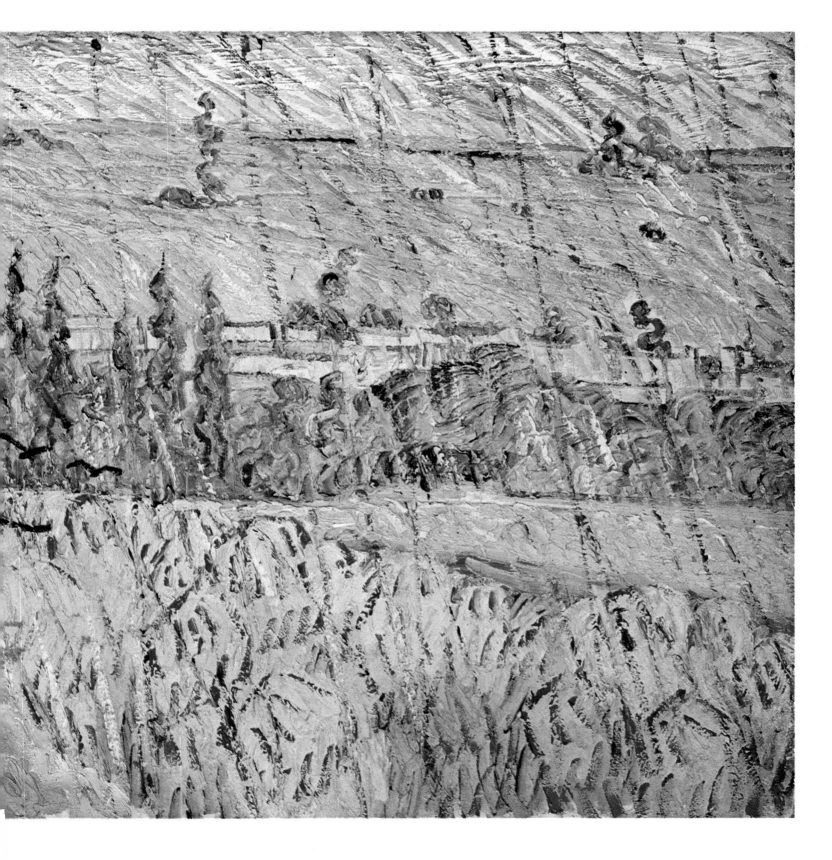

WHEAT FIELD UNDER CLOUDED SKIES

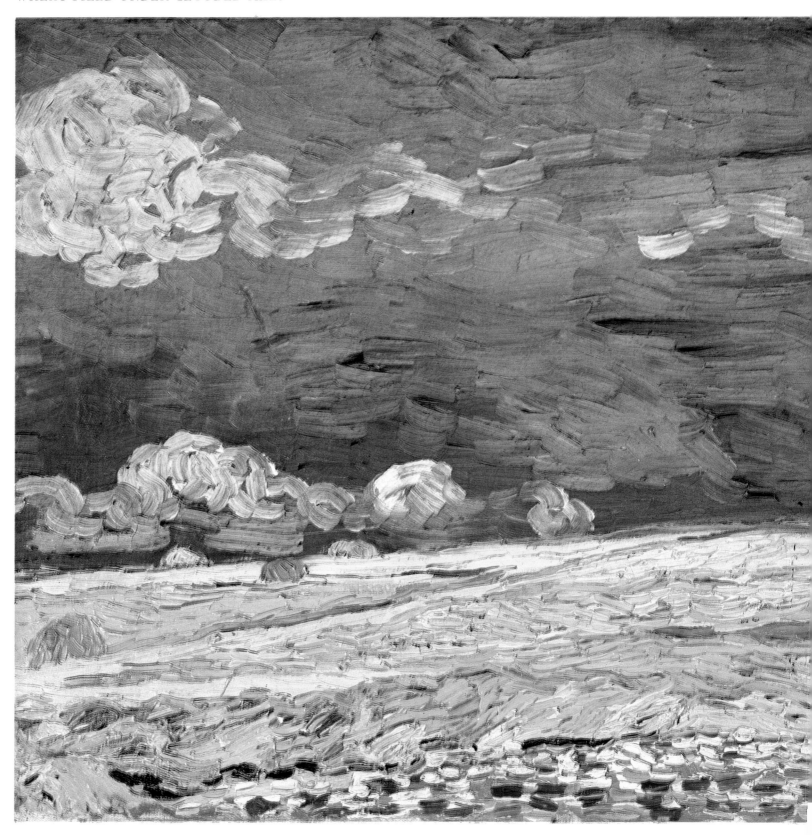

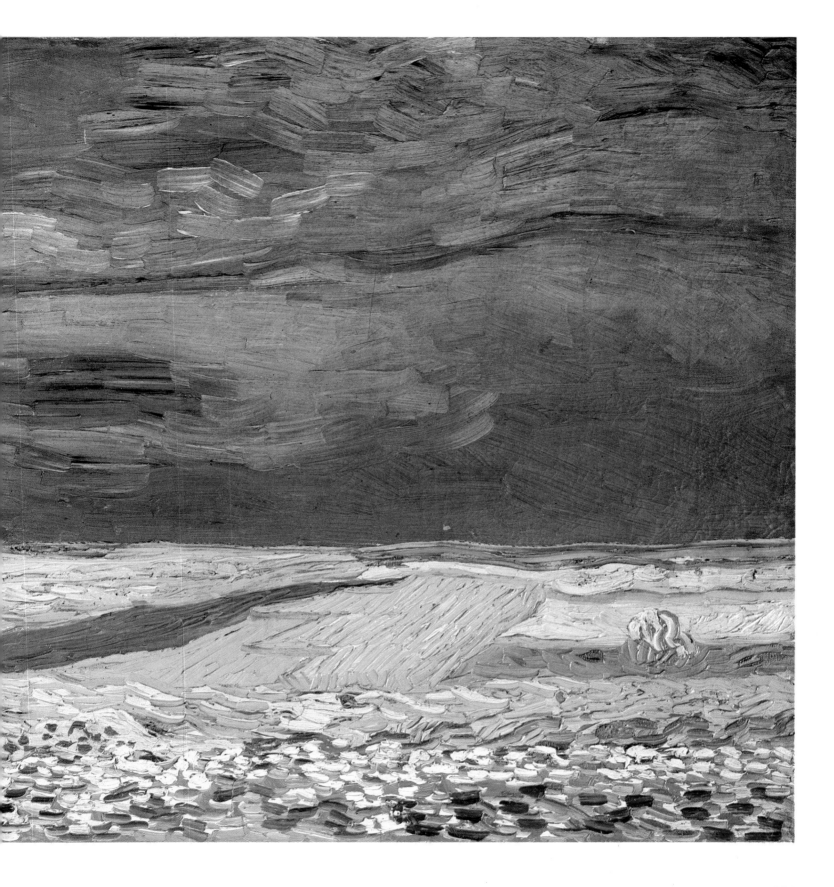

WHEAT FIELDS

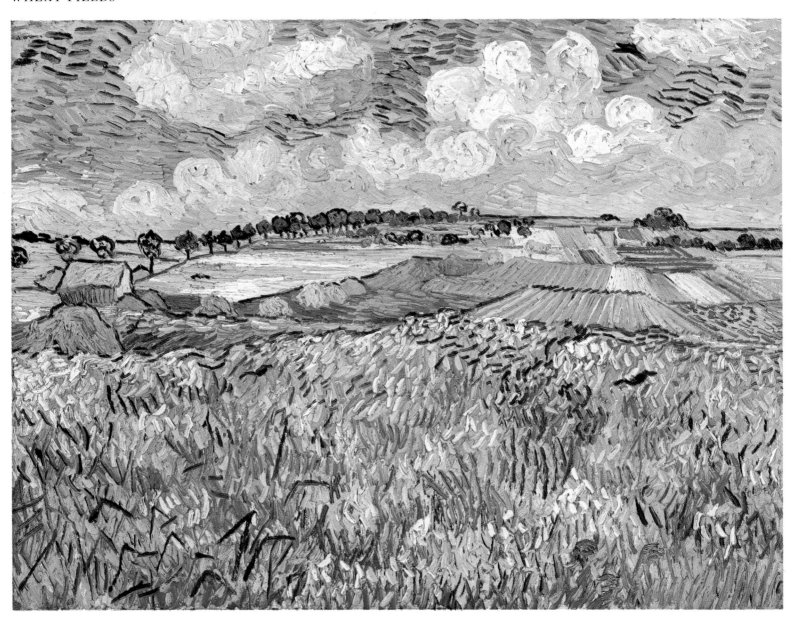

COTTAGES WITH THATCHED ROOFS AND FIGURES

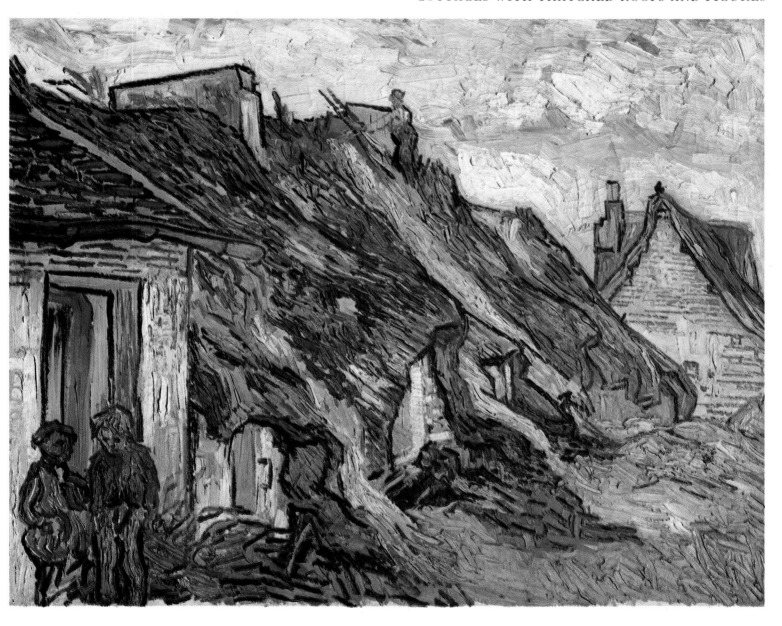

WHEAT FIELD UNDER THREATENING SKIES WITH CROWS

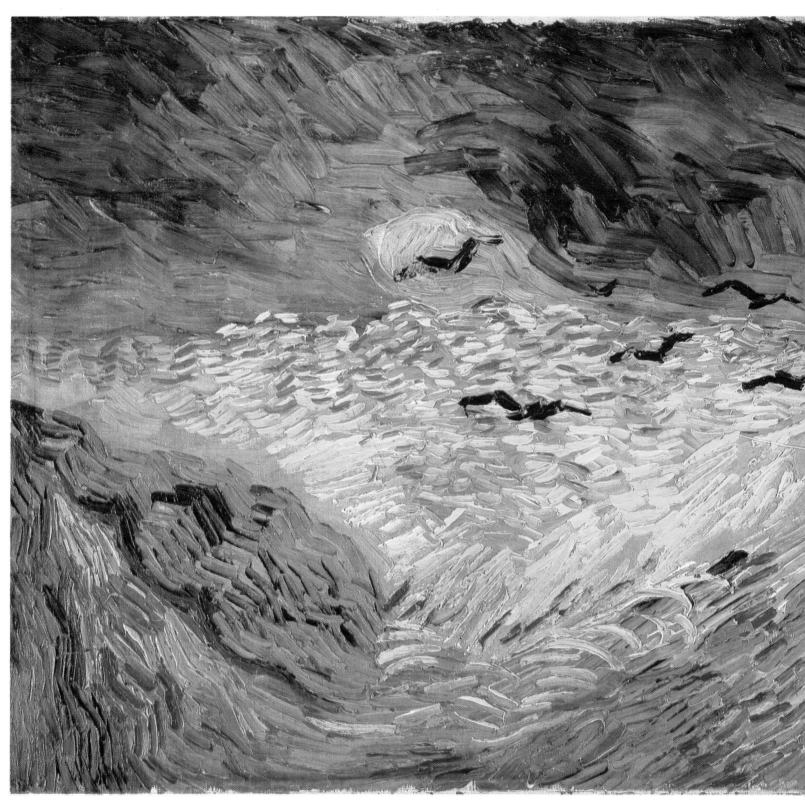

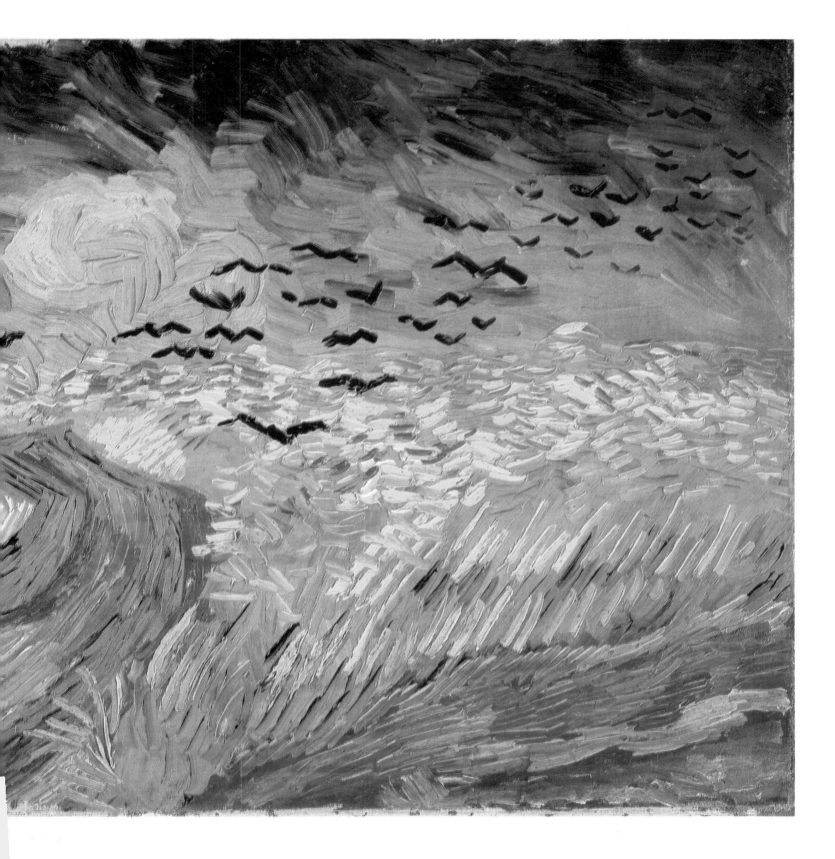

List of plates

84 WOMEN MINERS, November 1882
Watercolour, heightened with white, 32×50cm ($12\frac{5}{8} \times 19\frac{5}{8}$in)
Rijksmuseum Kröller-Müller, Otterlo

85 OLD MAN WITH HIS HEAD IN HIS HANDS, HALF-FIGURE,
November 1882
Black lithographic chalk, pencil, washed, heightened with white,
45.5×47.5cm ($18\frac{1}{8} \times 18\frac{7}{8}$in)
Rijksmuseum Kröller-Müller, Otterlo

86 THE STATE LOTTERY OFFICE, September 1882
Watercolour, 38×57cm ($15 \times 22\frac{1}{2}$in)
Rijksmuseum Vincent van Gogh, Amsterdam

87 ORPHAN MAN WITH LONG OVERCOAT, GLASS AND
left HANDKERCHIEF, October 1882
Pencil, 49×25cm ($19\frac{1}{4} \times 9\frac{7}{8}$in)
Rijksmuseum Kröller-Müller, Otterlo

87 ORPHAN MAN WITH TOP HAT AND STICK,
right SEEN FROM BEHIND,
October 1882
Pencil, 47.5×26cm ($18\frac{7}{8} \times 10\frac{1}{4}$in)
Rijksmuseum Vincent van Gogh, Amsterdam

88 DIGGER, November 1882
Pencil, 49.5×28.5cm ($19\frac{5}{8} \times 11\frac{3}{8}$in)
Rijksmuseum Vincent van Gogh, Amsterdam

89 ORPHAN MAN WITH TOP HAT, HEAD, December 1882
Pencil, black lithographic chalk, washed, pen, brown ink,
60.5×36cm ($24 \times 14\frac{1}{8}$in)
Rijksmuseum Vincent van Gogh, Amsterdam

90 WOMAN, BAREHEADED (SIEN'S MOTHER?), HEAD, March 1883
Pencil, black lithographic chalk, washed with black,
39×24.5cm ($15\frac{3}{8} \times 9\frac{7}{8}$in)
Rijksmuseum Vincent van Gogh, Amsterdam

91 WOMAN SITTING ON A BASKET, HEAD IN HANDS,
February 1883
Black chalk, washed, heightened with white,
47.5×29.5cm ($18\frac{7}{8} \times 11\frac{3}{4}$in)
Rijksmuseum Kröller-Müller, Otterlo

92 BABY, February 1883
Black lithographic chalk, washed, 31×24cm ($12\frac{1}{4} \times 9\frac{1}{2}$in)
Rijksmuseum Vincent van Gogh, Amsterdam

93 POTATO FIELD IN THE DUNES, August 1883
Brush, ink, heightened with white, 27.5×42cm ($11 \times 16\frac{1}{2}$in)
Rijksmuseum Kröller-Müller, Otterlo

94 FARMS, September 1883
Canvas on cardboard, 36×55.5cm ($14\frac{1}{8} \times 22$in)
Rijksmuseum Vincent van Gogh, Amsterdam

95 LANDSCAPE AT NIGHTFALL, September 1883
Watercolour, 40×53cm ($15\frac{3}{4} \times 20\frac{7}{8}$in)
Rijksmuseum Vincent van Gogh, Amsterdam

96 TWO WOMEN WORKING IN THE PEAT, October 1883
Oil on canvas, 27×35.5cm ($10\frac{5}{8} \times 14\frac{1}{8}$in)
Rijksmuseum Vincent van Gogh, Amsterdam

97 PEAT BOAT WITH TWO FIGURES, October 1883
Canvas on panel, 37×55.5cm ($14\frac{5}{8} \times 22$in)
Collection R.W. van Hoey Smith, Rockanje, The Netherlands

98 BEHIND THE HEDGES, March 1884
Pencil, pen, 40×53cm ($15\frac{3}{4} \times 20\frac{7}{8}$in)
Rijksmuseum Vincent van Gogh, Amsterdam

99 POLLARDED BIRCHES WITH WOMAN AND FLOCK OF SHEEP,
March 1884
Pencil, pen, 39.5×54.5cm ($15\frac{3}{4} \times 21\frac{5}{8}$in)
Rijksmuseum Vincent van Gogh, Amsterdam

100 WEAVER, INTERIOR WITH THREE SMALL WINDOWS, July 1884
Oil on canvas, 61×93cm ($24 \times 36\frac{5}{8}$in)
Rijksmuseum Kröller-Müller, Otterlo

101 WEAVER, SEEN FROM THE FRONT, July 1884
Canvas on panel, 48×61cm ($18\frac{7}{8} \times 24$in)
Museum Boymans-van Beuningen, Rotterdam

102 LANE OF POPLARS AT SUNSET, October 1884
Oil on canvas, 46×33cm ($18\frac{1}{8} \times 13$in)
Rijksmuseum Kröller-Müller, Otterlo

103 PEASANT WOMAN, HEAD, December 1884
Canvas on panel, 42.5×34cm ($16\frac{7}{8} \times 13\frac{3}{8}$in)
Rijksmuseum Vincent van Gogh, Amsterdam

104 PEASANT, HEAD, December 1884
Pen, pencil, black chalk, brown ink, washed,
14.5×10.5cm ($5\frac{7}{8} \times 4\frac{3}{8}$in)
Rijksmuseum Vincent van Gogh, Amsterdam

105 PEASANT WOMAN, HEAD, January 1885
Pencil, pen, brown ink, washed, 14×10.5cm ($5\frac{1}{2} \times 4\frac{3}{8}$in)
Rijksmuseum Vincent van Gogh, Amsterdam

106 THE OLD TOWER IN THE SNOW, January 1885
Canvas on cardboard, 30×41.5cm ($11\frac{3}{4} \times 16\frac{1}{2}$in)
Stavros S. Niarchos Collection

107 THE PARSONAGE GARDEN IN THE SNOW, January 1885
Canvas on panel, 53×78cm ($20\frac{7}{8} \times 30\frac{3}{4}$in)
The Armand Hammer Collection

108 HANDS, March 1885
Black chalk, 42×34.5cm ($16\frac{1}{2} \times 13\frac{3}{4}$in)
Rijksmuseum Vincent van Gogh, Amsterdam

109 TWO HANDS, April 1885
Canvas on panel, 29.5×19cm ($11\frac{3}{4} \times 7\frac{1}{2}$in)
Private collection, The Hague

110 HANDS IN REPOSE, January 1885
Black chalk, 21×34cm ($8\frac{1}{4} \times 13\frac{3}{8}$in)
Rijksmuseum Vincent van Gogh, Amsterdam

111 STUDIES OF A DEAD SPARROW, January 1885
Black chalk, 24×32cm ($9\frac{1}{2} \times 12\frac{5}{8}$in)
Rijksmuseum Vincent van Gogh, Amsterdam

112 PEASANT, HEAD, March 1885
Oil on canvas, 39×30.5cm ($15\frac{3}{8} \times 12\frac{1}{4}$in)
Musées Royaux des Beaux-Arts de Belgique, Brussels

113 SKETCHES OF THE OLD TOWER AND FIGURES, May 1885
Black chalk, 35.5×20.5cm ($14\frac{1}{8} \times 8\frac{1}{4}$in)
Rijksmuseum Kröller-Müller, Otterlo

114 PEASANT WOMAN, HEAD, April 1885
Oil on canvas, 42.5×29.5cm ($16\frac{7}{8} \times 11\frac{3}{4}$in)
Rijksmuseum Vincent van Gogh, Amsterdam

115 FIVE PERSONS AT A MEAL (THE POTATO EATERS), April 1885
Oil on canvas, 82×114cm ($32\frac{1}{4} \times 44\frac{7}{8}$in)
Rijksmuseum Vincent van Gogh, Amsterdam

116 AUCTION OF CROSSES NEAR THE OLD TOWER, May 1885
Black chalk, 21 ×34.5cm (8¼ ×13¾in)
Rijksmuseum Vincent van Gogh, Amsterdam

117 AUCTION OF CROSSES NEAR THE OLD TOWER, May 1885
Watercolour, 37.5 ×55cm (15 ×21⅝in)
Rijksmuseum Vincent van Gogh, Amsterdam

118 PLATE, KNIVES AND KETTLE, April 1885
left Black chalk, 34.5 ×20.5cm (13¾ ×8¼in)
Rijksmuseum Vincent van Gogh, Amsterdam

118 PEASANT, April 1885
right Black chalk, 35 ×21cm (13¾ ×8¼in)
Rijksmuseum Kröller-Müller, Otterlo

119 PEASANT WOMAN, SITTING BY THE FIRE, June 1885
Pen, 10 ×13.5cm (3⅞ ×5½in)
Rijksmuseum Kröller-Müller, Otterlo

120 COTTAGE WITH DECREPIT BARN AND STOOPING WOMAN,
July 1885
Oil on canvas, 62 ×113cm (24⅜ ×44½in)
Private collection

121 TWO PEASANT WOMEN, DIGGING, August 1885
Canvas on panel, 31.5 ×42.5cm (12⅝ ×16⅞in)
Rijksmuseum Kröller-Müller, Otterlo

122 PEASANT WOMAN, STOOPING AND GLEANING, July 1885
Black chalk, 51.5 ×41.5cm (20½ ×16½in)
Museum Folkwang, Essen

123 PEASANT WOMAN, DIGGING, August 1885
Canvas on panel, 42 ×32cm (16½ ×12⅝in)
Barber Institute of Fine Arts, University of Birmingham, England

124 SHORT-LEGGED MAN WITH FROCK COAT, April 1885
left Black chalk, 34.5 ×21cm (13¾ ×8¼in)
Rijksmuseum Vincent van Gogh, Amsterdam

124 OLD PEASANT WOMAN WITH SHAWL OVER HER HEAD,
right June 1885
Black chalk, 34.5 ×20.5cm (13¾ ×8¼in)
Rijksmuseum Vincent van Gogh, Amsterdam

125 PEASANT WITH SICKLE, SEEN FROM BEHIND, August 1885
Black chalk, 41.5 ×58cm (16⅞ ×21⅝in)
Rijksmuseum Vincent van Gogh, Amsterdam

126 STILL-LIFE WITH A BASKET OF POTATOES, September 1885
Oil on canvas, 44.5 ×60cm (17¾ ×23⅝in)
Rijksmuseum Vincent van Gogh, Amsterdam

127 STILL-LIFE WITH AN EARTHEN BOWL WITH POTATOES,
September 1885
Oil on canvas, 44.5 ×57cm (17¾ ×22½in)
Museum Boymans-van Beuningen, Rotterdam

128 STILL-LIFE WITH BIRDS' NESTS, October 1885
Oil on canvas, 33.5 ×50.5cm (13⅜ ×20⅛in)
Rijksmuseum Kröller-Müller, Otterlo

129 STILL-LIFE WITH OPEN BIBLE, CANDLESTICK AND NOVEL,
October 1885
Oil on canvas, 65 ×78cm (25⅝ ×30¾in)
Rijksmuseum Vincent van Gogh, Amsterdam

130–1 LANE WITH POPLARS, November 1885
Oil on canvas, 78 ×97.5cm (30¾ ×38⅝in)
Museum Boymans-van Beuningen, Rotterdam

135 VIEW FROM VINCENT'S WINDOW, April–June 1887
Oil on canvas, 46 ×38cm (18⅛ ×15in)
Rijksmuseum Vincent van Gogh, Amsterdam

138 DANCE HALL WITH DANCING WOMEN, November 1885
top Black and coloured chalk, 9 ×16cm (3½ ×6¼in)
Rijksmuseum Vincent van Gogh, Amsterdam

138 TWO WOMEN IN A BOX AT THE THEATRE, November 1885
bottom Black and coloured chalk, 9 ×16cm (3½ ×6¼in)
Rijksmuseum Vincent van Gogh, Amsterdam

139 SPIRE OF THE CHURCH OF OUR LADY, December 1885
Black chalk, 30 ×22.5cm (11¾ ×9in)
Rijksmuseum Vincent van Gogh, Amsterdam

140 WOMAN WITH HER HAIR LOOSE, HEAD, November 1885
Oil on canvas, 32 ×24cm (13¾ ×9½in)
Rijksmuseum Vincent van Gogh, Amsterdam

141 HEAD OF A WOMAN, January 1886
Charcoal, black and red chalk, 51 ×39cm (20⅛ ×15⅜in)
Rijksmuseum Vincent van Gogh, Amsterdam

142 SKETCH OF A KNEE, January 1886
Black chalk, 11.5 ×9.5cm (4¾ ×3⅞in)
Rijksmuseum Vincent van Gogh, Amsterdam

143 FEMALE NUDE, STANDING, SEEN FROM THE SIDE, February 1886
Pencil, 50 ×39.5cm (19⅝ ×15¾in)
Rijksmuseum Vincent van Gogh, Amsterdam

144 SELF-PORTRAIT WITH DARK FELT HAT, April–June 1886
Oil on canvas, 41 ×32.5cm (16⅛ ×13in)
Rijksmuseum Vincent van Gogh, Amsterdam

145 THE ROOFS OF PARIS, April–June 1886
Oil on canvas, 54 ×72cm (21¼ ×28⅜in)
Rijksmuseum Vincent van Gogh, Amsterdam

146 PLASTER STATUETTE (TYPE B), April–June 1886
Oil on canvas, 41 ×32.5cm (16⅛ ×13in)
Rijksmuseum Vincent van Gogh, Amsterdam

147 PLASTER STATUETTE (TYPE C), SEEN FROM THE BACK,
April–June 1866
Charcoal, 61 ×45cm (24 ×17¾in)
Rijksmuseum Vincent van Gogh, Amsterdam

148 THE MOULIN DE BLUTE-FIN, July–September 1886
Oil on canvas, 46 ×38cm (18⅛ ×15in)
Glasgow Art Gallery and Museum

149 BOWL WITH ZINNIAS, July–September 1886
Oil on canvas, 61 ×45.5cm (24 ×18⅛in)
Collection Mr and Mrs David Lloyd Kreeger, Washington, D.C.

150 VIOLINIST, July–September 1886
Blue and green chalk, 35 ×26cm (13¾ ×10¼in)
Rijksmuseum Vincent van Gogh, Amsterdam

151 DOUBLE-BASS PLAYER, July–September 1886
Green chalk, 34 ×25.5cm (13¾ ×10⅛in)
Rijksmuseum Vincent van Gogh, Amsterdam

152 BOWL OF SUNFLOWERS, ROSES AND OTHER FLOWERS,
July–September 1886
Oil on canvas, 50 ×61cm (19⅝ ×24in)
Städtische Kunsthalle, Mannheim

220 FARMERS WORKING IN A FIELD, April 1888
Reed pen, 26 × 34.5 cm (10¼ × 13¾ in)
Rijksmuseum Vincent van Gogh, Amsterdam

221 BASKET WITH LEMONS, May 1888
Oil on canvas, 53 × 63 cm (20⅞ × 24¾ in)
Rijksmuseum Kröller-Müller, Otterlo

222 HARVEST LANDSCAPE, June 1888
Oil on canvas, 72.5 × 92 cm (28¾ × 36¼ in)
Rijksmuseum Vincent van Gogh, Amsterdam

223 HAYSTACKS NEAR A FARM, June 1888
Oil on canvas, 72.5 × 92 cm (28¾ × 36¼ in)
Rijksmuseum Kröller-Müller, Otterlo

224 STREET IN SAINTES-MARIES, June 1888
Reed pen, 30.5 × 47 cm (12¼ × 18½ in)
Private collection

225 THREE COTTAGES IN SAINTES-MARIES, June 1888
Oil on canvas, 33.5 × 41.5 cm (13⅜ × 16½ in)
Kunsthaus Zürich, on loan

226 FISHING BOATS AT SEA, August 1888
Pencil and ink, 25.5 × 32 cm (9⅞ × 12⅝ in)
Solomon R. Guggenheim Museum, New York, gift of Justin K. Tannhauser

227 FISHING BOATS ON THE BEACH, June 1888
Oil on canvas, 64.5 × 81 cm (25⅝ × 31⅞ in)
Rijksmuseum Vincent van Gogh, Amsterdam

228 CANAL WITH WOMEN WASHING, July 1888
Pen, 31.5 × 24 cm (12⅝ × 9½ in)
Rijksmuseum Kröller-Müller, Otterlo

229 CANAL WITH WOMEN WASHING, July 1888
Oil on canvas, 74 × 60 cm (29⅛ × 23⅝ cm)
Private collection

230 HILL WITH THE RUINS OF MONTMAJOUR, July 1888
Pen, 47.5 × 59 cm (18⅞ × 23¼ in)
Rijksmuseum (Rijksprentenkabinet), Amsterdam

231 LANDSCAPE NEAR MONTMAJOUR WITH TRAIN, July 1888
Pen, reed pen, black chalk, 49 × 61 cm (19¼ × 24 in)
British Museum, London

232 THE ROAD TO TARASCON, August 1888
Pen, reed pen, 24.5 × 32 cm (9⅞ × 12⅝ in)
Solomon R. Guggenheim Museum, New York

233 GARDEN WITH FLOWERS, July 1888
Oil on canvas, 95 × 73 cm (37⅜ × 28¾ in)
Private collection, on long-term loan to the Metropolitan Museum of Art, New York

234 WHEAT FIELD WITH SETTING SUN, June 1888
Oil on canvas, 74 × 91 cm (29⅛ × 23⅝ in)
Kunstmuseum, Winterthur, Switzerland

235 GARDEN WITH SUNFLOWERS, August 1888
Pencil, reed pen, brown ink, 60 × 48.5 cm (23⅝ × 19¼ in)
Rijksmuseum Vincent van Gogh, Amsterdam

236 MOUSMÉ, SITTING IN A CANE CHAIR, HALF-FIGURE, July 1888
Oil on canvas, 74 × 60 cm (29⅛ × 23⅝ in)
National Gallery of Art, Washington, D.C., Chester Dale Collection

237 JOSEPH ROULIN, SITTING IN A CANE CHAIR, THREE-QUARTER LENGTH, July 1888
Oil on canvas, 81 × 65 cm (31⅞ × 25⅝ in)
Museum of Fine Arts, Boston, gift of Robert Treat Pain, II

238 THE OLD PEASANT PATIENCE ESCALIER, August 1888
Pencil, pen, reed pen, brown ink, 49.5 × 38 cm (19⅝ × 15 in)
Fogg Art Museum, Harvard University Bequest – Grenville L. Winthrop

239 THE OLD PEASANT PATIENCE ESCALIER, HALF-FIGURE, August 1888
Oil on canvas, 69 × 56 cm (27⅛ × 22 in)
Stavros S. Niarchos Collection

240 QUAY WITH MEN UNLOADING SAND BARGES, August 1888
Pen, reed pen, 48 × 62.5 cm (18⅞ × 24¾ in)
Cooper-Hewitt Museum, New York, gift of Edith Wetmore

241 COAL BARGES, August 1888
Oil on canvas, 71 × 95 cm (28 × 37⅜ in)
Private collection

242 SELF-PORTRAIT, September 1888
Oil on canvas, 62 × 52 cm (24⅜ × 20½ in)
Courtesy Fogg Art Museum, Harvard University Bequest – Collection of Maurice Wertheim, Class of 1906

243 CAFÉ TERRACE AT NIGHT, September 1888
Oil on canvas, 81 × 65.5 cm (31⅞ × 26 in)
Rijksmuseum Kröller-Müller, Otterlo

244 THE NIGHT CAFÉ, September 1888
Oil on canvas, 70 × 89 cm (27⅞ × 35 in)
Yale University Art Gallery, bequest of Simon Carlton Clark, B.A. 1903

245 PUBLIC GARDEN WITH ROUND CLIPPED SHRUB AND WEEPING TREE, September 1888
Oil on canvas, 73 × 92 cm (28¾ × 36¼ in)
Art Institute of Chicago, Mr and Mrs Lewis L. Coburn Memorial Collection

246 PUBLIC GARDEN WITH A COUPLE AND A BLUE FIR TREE, October 1888
Oil on canvas, 73 × 92 cm (28¾ × 36¼ in)
Stavros S. Niarchos Collection

247 ENTRANCE TO THE PUBLIC GARDENS AT ARLES September 1888
Oil on canvas, 72.5 × 91 cm (28¾ × 35⅞ in)
Phillips Collection, Washington, D.C.

248 FOURTEEN SUNFLOWERS IN A VASE, August 1888
Oil on canvas, 93 × 73 cm (36⅝ × 28¾ in)
National Gallery, London

249 A PAIR OF OLD SHOES, August 1888
Oil on canvas, 44 × 53 cm (17⅞ × 20⅞ in)
Private collection, USA

250 VINCENT'S BEDROOM, October 1888
Oil on canvas, 72 × 90 cm (28⅜ × 35⅝ in)
Rijksmuseum Vincent van Gogh, Amsterdam

251 MEMORY OF THE GARDEN AT ETTEN, December 1888
Oil on canvas, 73.5 × 92.5 cm (29⅛ × 36⅝ in)
The Hermitage, Leningrad

252 PORTRAIT OF CAMILLE ROULIN, December 1888
Oil on canvas, 37.5 × 32.5 cm (15 × 13 in)
Rijksmuseum Vincent van Gogh, Amsterdam

253 AUGUSTINE ROULIN WITH BABY, December 1888
Oil on canvas, 63.5 × 51 cm (25¼ × 20⅛ in)
Metropolitan Museum of Art, New York, Robert Lehmann Collection

254 PORTRAIT OF ARMAND ROULIN, December 1888
Oil on canvas, 66 × 55 cm (26 × 21⅝ in)
Museum Folkwang, Essen

255 PORTRAIT OF A MAN, December 1888
Oil on canvas, 65 × 54.5 cm (25⅝ × 21⅝ in)
Rijksmuseum Kröller-Müller, Otterlo

256 VINCENT'S CHAIR, December 1888
Oil on canvas, 93 × 73.5 cm (36⅝ × 29⅛ in)
National Gallery, London

257 SELF-PORTRAIT WITH BANDAGED EAR, January 1889
Oil on canvas, 60 × 49 cm (23⅝ × 19¼ in)
Courtauld Institute Galleries, London (Courtauld Collection)

258 PLATE WITH ONIONS, ANNUAIRE DE LA SANTÉ AND OTHER
OBJECTS, January 1889
Oil on canvas, 50 × 64 cm (19⅝ × 24¼ in)
Rijksmuseum Kröller-Müller, Otterlo

259 VASE WITH FOURTEEN SUNFLOWERS, January 1889
Oil on canvas, 100 × 76 cm (39⅜ × 29⅞ in)
Private collection, London

260 AUGUSTINE ROULIN (LA BERCEUSE), March 1889
Oil on canvas, 91 × 71.5 cm (35⅞ × 28⅜ in)
Stedelijk Museum, Amsterdam

261 JOSEPH ROULIN, BUST, April 1889
Oil on canvas, 64 × 54.5 cm (25¼ × 21⅝ in)
Kunsthaus Zürich, on loan

262 THE CRAU WITH PEACH TREES IN BLOOM, April 1889
Oil on canvas, 65.5 × 81.5 cm (26 × 32¼ in)
Courtauld Institute Galleries, London (Courtauld Collection)

263 ORCHARD IN BLOOM WITH POPLARS IN THE FOREGROUND,
April 1889
Oil on canvas, 72 × 92 cm (28⅜ × 36¼ in)
Bayerische Staatsgemäldesammlungen, Munich

264 ASYLUM AND GARDEN, May 1889
Oil on canvas, 95 × 75.5 cm (37⅜ × 29⅞ in)
Rijksmuseum Kröller-Müller, Otterlo

265 IRISES, May 1889
Oil on canvas, 71 × 93 cm (28 × 36⅝ in)
Joan Whitney Payson Gallery of Art, Westbrook College, Portland, Maine

266 LILACS, May 1889
Oil on canvas, 73 × 92 cm (28¾ × 36¼ in)
The Hermitage, Leningrad

267 TREES WITH IVY, May 1889
Pencil, reed pen, brown ink, 62 × 47 cm (24⅜ × 18½ in)
Rijksmuseum Vincent van Gogh, Amsterdam

268 DEATH'S-HEAD MOTH, May 1889
top Black chalk, pen, brown ink, 16 × 26 cm (6¼ × 10¼ in)
Rijksmuseum Vincent van Gogh, Amsterdam

268 FOUNTAIN IN THE GARDEN OF THE ASYLUM, May 1889
bottom Black chalk, pen, reed pen, brown ink, 49.5 × 46 cm (19⅝ × 18⅛ in)
Rijksmuseum Vincent van Gogh, Amsterdam

269 THE STARRY NIGHT, June 1889
Oil on canvas, 73 × 92 cm (28¾ × 35¼ in)
Museum of Modern Art, New York, acquired through the Lillie P. Bliss Bequest

270 MOUNTAIN LANDSCAPE SEEN ACROSS WALLS WITH RISING
SUN AND GREEN FIELD, June 1889
Oil on canvas, 72 × 92 cm (28⅜ × 36¼ in)
Rijksmuseum Kröller-Müller, Otterlo

271 ENCLOSED WHEAT FIELD WITH REAPER, June 1889
Oil on canvas, 72 × 92 cm (28¾ × 36¼ in)
Rijksmuseum Kröller-Müller, Otterlo

272 TRUNKS OF TREES WITH IVY, July 1889
Oil on canvas, 74 × 92 cm (29⅛ × 36¼ in)
Rijksmuseum Vincent van Gogh, Amsterdam

273 WILD VEGETATION IN THE MOUNTAINS, June 1889
Reed pen, brown ink, 47 × 62 cm (18½ × 24¼ in)
Rijksmuseum Vincent van Gogh, Amsterdam

274 CYPRESSES, June 1889
Oil on canvas, 92 × 73 cm (36¼ × 18½ in)
Rijksmuseum Kröller-Müller, Otterlo

275 CYPRESSES, June 1889
Pen, reed pen, 62.5 × 42.5 cm (24¾ × 18½ in)
Art Institute of Chicago, gift of Robert Allerton

276 OLIVE TREES IN A MOUNTAIN LANDSCAPE, June 1889
Oil on canvas, 72.5 × 92 cm (28¾ × 36¼ in)
Collection of Mrs John Hay Whitney

277 FIELDS WITH POPPIES, June 1889
Oil on canvas, 71 × 91 cm (28 × 38⅞ in)
Kunsthalle, Bremen

278 PORTRAIT OF THE CHIEF ORDERLY (TRABU), September 1889
Oil on canvas, 61 × 46 cm (24 × 18⅛ in)
Collection of Mrs G. Dübi-Müller, on loan to the Kunstmuseum, Solothurn

279 SELF-PORTRAIT, September 1889
Oil on canvas, 65 × 54 cm (25⅝ × 21¼ in)
The Louvre, Paris (Jeu de Paume)

280 PEASANT WOMAN CUTTING STRAW (AFTER MILLET),
September 1889
Oil on canvas, 40.5 × 26.5 cm (16⅛ × 10⅝ in)
Rijksmuseum Vincent van Gogh, Amsterdam

281 SHEAF BINDER (AFTER MILLET), September 1889
Oil on canvas, 44 × 32.5 cm (17⅜ × 13 in)
Rijksmuseum Vincent van Gogh, Amsterdam

282–3 MULBERRY TREE, October 1889
Oil on canvas, 54 × 65 cm (21¼ × 25⅝ in)
Norton Simon Art Foundation, Los Angeles

284 A PASSAGEWAY AT THE ASYLUM, October 1889
Black chalk, gouache, 65 × 49 cm (25⅝ × 19¼ in)
Museum of Modern Art, New York, Abby Aldrich Rockefeller Bequest

285 TREES IN FRONT OF THE ENTRANCE TO THE ASYLUM,
October 1889
Oil on canvas, 90 × 71 cm (35⅜ × 28 in)
The Armand Hammer Collection

286 TWO POPLARS WITH A BACKGROUND OF MOUNTAINS,
October 1889
Oil on canvas, 61 × 45.5 cm (24 × 18⅛ in)
Cleveland Museum of Art, bequest of Leonard C. Hanna, Jr

287 A PATH THROUGH THE RAVINE, October 1889
Oil on canvas, 73 × 92 cm (28¾ × 36¼ in)
Museum of Fine Arts, Boston, bequest of Keith McLeod

288 ENCLOSED FIELD WITH YOUNG WHEAT AND RISING SUN,
December 1889
Oil on canvas, 71 × 90.5 cm (28 × 35⅞ in)
Private collection

289 NOON: REST (AFTER MILLET), January 1890
Oil on canvas, 73 × 91 cm (28¾ × 35⅞ in)
The Louvre, Paris (Jeu de Paume)

290 WOMEN PICKING OLIVES, December 1889
Oil on canvas, 73 × 92 cm (28¾ × 36¼ in)
Private collection, West Germany

291 THE FIRST STEPS (AFTER MILLET), January 1890
Oil on canvas, 73 × 92 cm (28¾ × 36¼ in)
Metropolitan Museum of Art, New York, gift of George W. and Helen H. Richard

292 MEN DRINKING (AFTER DAUMIER), February 1890
Oil on canvas, 60 × 73 cm (23⅝ × 28¾ in)
Art Institute of Chicago, Joseph Winterbotham Fund

293 THE ARLÉSIENNE (MADAME GINOUX), WITH LIGHT PINK BACKGROUND, February 1890
Oil on canvas, 65 × 49 cm (25⅝ × 19¼ in)
Rijksmuseum Kröller-Müller, Otterlo

294 SNOW-COVERED COTTAGES, A COUPLE WITH A CHILD,
top AND OTHER WALKERS, March–April 1890
Pencil, 24 × 32 cm (9½ × 12⅝ in)
Rijksmuseum Vincent van Gogh, Amsterdam

294 SHEET WITH SKETCHES OF DIGGERS AND OTHER FIGURES,
bottom March–April 1890
Black chalk, 23.5 × 32 cm (9½ × 12⅝ in)
Rijksmuseum Vincent van Gogh, Amsterdam

295 COTTAGES AND CYPRESSES AT SUNSET WITH STORMY SKY,
March–April 1890
Canvas on panel, 29 × 36.5 cm (11⅜ × 14⅜ in)
Rijksmuseum Vincent van Gogh, Amsterdam

296 THE GOOD SAMARITAN (AFTER DELACROIX), May 1890
Oil on canvas, 73 × 60 cm (28¾ × 23⅝ in)
Rijksmuseum Kröller-Müller, Otterlo

297 THE RAISING OF LAZARUS (AFTER A DETAIL FROM AN ETCHING BY REMBRANDT), May 1890
Oil on canvas, 48.5 × 63 cm (19¼ × 24¾ in)
Rijksmuseum Vincent van Gogh, Amsterdam

298 ROAD WITH MEN WALKING, CARRIAGE, CYPRESS, STAR AND CRESCENT MOON, May 1890
Oil on canvas, 92 × 73 cm (36¼ × 28¾ in)
Rijksmuseum Kröller-Müller, Otterlo

299 VASE WITH VIOLET IRISES AGAINST A YELLOW BACKGROUND, May 1890
Oil on canvas, 92 × 73.5 cm (36¼ × 29⅛ in)
Rijksmuseum Vincent van Gogh, Amsterdam

300 THE CHURCH AT AUVERS, June 1890
Oil on canvas, 94 × 74 cm (37 × 29⅛ in)
The Louvre, Paris (Jeu de Paume)

301 DOCTOR GACHET SITTING AT A TABLE WITH BOOKS AND A GLASS WITH SPRIGS OF FOXGLOVE, June 1890
Oil on canvas, 66 × 57 cm (26 × 22½ in)
Private collection, USA

302 HEAD OF A GIRL, June 1890
Oil on canvas, 51 × 49 cm (20⅛ × 19¼ in)
Rijksmuseum Kröller-Müller, Otterlo

303 MARGUERITE GACHET AT THE PIANO, June 1890
Oil on canvas, 102 × 50 cm (40⅛ × 19⅝ in)
Kuntsmuseum, Basel

304 BLOSSOMING CHESTNUT BRANCHES, June 1890
Oil on canvas, 72 × 91 cm (28⅜ × 35⅞ in)
Collection of E.G. Bührle, Zürich

305 BLOSSOMING BRANCHES, June 1890
Pencil, reed pen, brown ink, 41 × 31 cm (16⅛ × 12¼ in)
Rijksmuseum Vincent van Gogh, Amsterdam

306 POPPIES WITH BUTTERFLIES, June 1890
Oil on canvas, 33.5 × 24.5 cm (13⅜ × 9⅞ in)
Rijksmuseum Vincent van Gogh, Amsterdam

307 FIELD WITH POPPIES, June 1890
Oil on canvas, 73 × 91.5 cm (28¾ × 36¼ in)
Gemeentemuseum, The Hague (on loan from the State)

308 TWO CHILDREN, June 1890
Oil on canvas, 51.5 × 51.5 cm (20½ × 20½ in)
The Louvre, Paris (Jeu de Paume)

309 SKETCH OF A LADY WITH STRIPED DRESS AND HAT AND OF ANOTHER LADY, HALF-FIGURE, July 1890
Pencil, 22 × 18.5 cm (8⅝ × 7½ in)
Vassar College Art Gallery, Poughkeepsie, New York, gift of Alastair B. Martin

310 SKETCH OF TWO WOMEN, July 1890
Black chalk, pen, violet ink, 23.5 × 30 cm (9½ × 11¾ in)
Rijksmuseum Vincent van Gogh, Amsterdam

311 SHEET WITH MANY SKETCHES OF FIGURES, July 1890
Black chalk, 43.5 × 27 cm (17⅞ × 10⅝ in)
Thomas Gibson Fine Art Limited, London

312–13 LANDSCAPE IN THE RAIN, July 1890
Oil on canvas, 50 × 100 cm (19⅝ × 39⅜ in)
National Museum of Wales, Cardiff

314–15 WHEAT FIELD UNDER CLOUDED SKIES, July 1890
Oil on canvas, 50 × 100 cm (19⅝ × 39⅜ in)
Rijksmuseum Vincent van Gogh, Amsterdam

316 WHEAT FIELDS, July 1890
Oil on canvas, 73.5 × 92 cm (29⅛ × 36¼ in)
Bayerische Staatsgemäldesammlungen, Munich

317 COTTAGES WITH THATCHED ROOFS AND FIGURES, July 1890
Oil on canvas, 65 × 81 cm (25⅝ × 31⅞ in)
Kunsthaus, Zürich

318–19 WHEAT FIELD UNDER THREATENING SKIES WITH CROWS,
July 1890
Oil on canvas, 50.5 × 100.5 cm (20⅛ × 39¾ in)
Rijksmuseum Vincent van Gogh, Amsterdam

Acknowledgments

I would like to express my gratitude to everyone who has helped me in the compilation of this book. I wish to thank particularly the very helpful curators of the two great Dutch museums which hold the largest quantity of essential works, Han van Crimpen at the Rijksmuseum Vincent van Gogh in Amsterdam and Johannes van der Wolk of the Rijksmuseum Kröller-Müller at Otterlo. Others in Holland to whom I owe considerable thanks include Mrs Daalder-Vos of the Stedelijk Museum, Amsterdam, who has taken a great deal of trouble in arranging the necessary photography, and also Suse Meijer.

I must also thank with no less warmth Martin Heller, Chairman of Orbis Publishing, for embracing the idea without the slightest hesitation, as well as Graham Mason, who has worked with me so hard in many ways and but for whom several essential pictures would have eluded capture. Of the many others at Orbis who have helped me in the preparation of this book I would like to mention particularly Ann Davies, Cherry Jaquet, David Joyce, Anne Lansdown, Martyn Longly and Andrée Thorpe. I am glad to have this opportunity of thanking also Mr Roberto Capelli of La Cromolito, Milan, who has been tirelessly conscientious in the analysis of the film from the Dutch museums and the correction of the colour proofs.

At least as important as anyone in the production of this book has been Derek Birdsall, its distinguished designer, ably assisted by Andrew Gossett. Their very encouraging belief in the basic idea of the book, professional skill and willingness to discuss every aspect of the design have left all the project's deficiencies where they belong, at the author's door.

In addition to *The Complete Letters of Vincent van Gogh* (New York Graphic Society Books/Little, Brown & Co and Thames and Hudson) there are three books that have been especially helpful to me and one of these, namely *The Complete Van Gogh: Paintings, Drawings, Sketches* by Jan Hulsker (Phaidon and Harrison House/Abrams), has been utterly indispensable. The others for which I am grateful are *Van Gogh: A Documentary Biography*, by A.M. and Renilde Hammacher (Thames and Hudson) and *Vincent Van Gogh* by Marc Edo Tralbaut (Macmillan). I would also like to express my admiration for and thanks to Ken Wilkie, editor of *Holland Herald*, who in Devonshire found Vincent's drawing of his lodgings in London and many interesting facts elsewhere, which are recounted in his book *The Van Gogh Assignment* (Paddington Press).

The publishers join me in expressing gratitude to the museums, galleries and collections credited with the note to each plate for permission to reproduce the works in this book. Photographs were kindly supplied by the collections concerned with the exception of the following: Artothek, Munich (p. 316), Colorphoto Hans Hinz, Switzerland (p. 303), A.C. Cooper, London (pp. 106, 239, 246), Walter Dräyer, Zürich (p. 304), Foto Saporetti, Milan (p. 191), Gerhard Howald, Switzerland (p. 198), Eric Lessing/Magnum Photos (pp. 300, 308), Réunion des Musées Nationaux, Paris (p. 160), Studio Lourmel, Paris/Georges Routhier (pp. 169, 279, 289), and Thomas Gibson Fine Art Limited, London (p. 311).

All the paintings at the Rijksmuseum van Gogh were photographed by Tom Haartsen.